THE OFFICIAL PHOTODEX® GUIDE TO PROSHOW®

James Karney

Course Technology PTR

A part of Cengage Learning

COURSE TECHNOLOGY
CENGAGE Learning

Australia, Brazil, Japan, Korea, Mexico, Singapore, Spain, United Kingdom, United States

COURSE TECHNOLOGY
CENGAGE Learning™

The Official Photodex Guide to ProShow
James Karney

Publisher and General Manager, Course Technology PTR:
Stacy L. Hiquet

Associate Director of Marketing:
Sarah Panella

Manager of Editorial Services:
Heather Talbot

Marketing Manager:
Jordan Casey

Acquisitions Editor:
Megan Belanger

Project Editor:
Dan Foster, Scribe Tribe

Technical Reviewer:
Stephanie Redding

PTR Editorial Services Coordinator:
Erin Johnson

Copy Editor:
Brad Crawford

Interior Layout Tech:
Bill Hartman

Cover Designer:
Mike Tanamachi

CD-ROM Producer:
Brandon Penticuff

Photographers:
Cody Clinton, Mike Fulton, James Karney

Indexer:
Katherine Stimson

Proofreader:
Laura Gabler

For product information and technology assistance, contact us at
Cengage Learning Customer & Sales Support Center, 1-800-354-9706

For permission to use material from this text or product,
submit all requests online at **cengage.com/permissions**
Further permissions questions can be emailed to
permissionrequest@cengage.com

Photodex, ProShow, CompuPic, Photodex PictureCD, ViewSafe, and ClickSearch are registered trademarks of Photodex Corporation.

Microsoft, Windows, and Internet Explorer are either registered trademarks or trademarks of Microsoft Corporation in the United States and/or other countries. All other marks are property of their respective owners.

WASP photos courtesy of Texas Woman's University. Permission to reproduce images must be obtained by Texas Woman's University. Please visit http://www.twu.edu/library/wasp/ for more information.

All other photography provided by James Karney and TriCoast Photography photographers Mike Fulton and Cody Clinton. Permission to reproduce or use images other than as part of personal exercise in conjunction with the material in this book requires the express permission of the photographer.

Library of Congress Control Number: 2007903972

ISBN-13: 978-1-59863-408-2 (1-59863-408-9)

ISBN-10: 1-59863-408-9

Course Technology
25 Thomson Place
Boston, MA 02210
USA

Cengage Learning is a leading provider of customized learning solutions with office locations around the globe, including Singapore, the United Kingdom, Australia, Mexico, Brazil, and Japan. Locate your local office at:
international.cengage.com/region

Cengage Learning products are represented in Canada by Nelson Education, Ltd.

For your lifelong learning solutions, visit **courseptr.com**

Visit our corporate website at **cengage.com**

Printed in the United States of America
1 2 3 4 5 6 7 11 10 09 08

To my youngest daughter, Rhyannon Karney. Her smiles and hugs brightened many a long day of writing and working in ProShow. Very patient throughout the process, she is always a delight.

Foreword

"Why do we take photos?" is a question with a very simple answer, regardless of the photographer's subject or level of expertise: "So someone can see them." Just as the digital camera replaced film, digital presentation is rapidly becoming the way our photographs fulfill their purpose. The explosions of digital photography and personal computing have collided, producing a powerful revolution in presentation.

When our team began working on ProShow in early 2000, we knew the market was evolving past "slide shows" that were merely a series of pictures on a screen.

ProShow presentations are the future of digital media: robust productions with professional quality and high-resolution output. Our challenge was to create a program easy enough for a novice to use, with the features that professionals demand—and at an affordable price. The challenge is ever expanding, with increasing user expectations in functionality and complexity.

Watch a professionally produced television commercial closely. The best demonstrate a polished quality that is both exciting and easy on the eyes. Matching that kind of flow and feel with a presentation is easier said than done. There are literally hundreds of tricks that are not immediately apparent to the novice. Timing, adjustment effects, the composition of images, and the flow of information must be carefully woven together. That takes skill and the right tools.

ProShow offers the tools. Mastering them requires learning. It isn't just a matter of choosing a prefab style in a combo box and clicking "Create Slide Show." A quality presentation is more than just images and transitions. This book is an excellent guide to teach not only the basics but also a host of tips and tricks that the pros use all the time. The first step is to know what you are trying to accomplish. Once you know that, the techniques presented in this book will help you make the most of your presentations.

We are very pleased to work with James Karney in bringing this book to you. His well-paced writing style and clear examples make even the most complex features of the software easy to follow. A best-selling computer author, educator, and an experienced professional photographer, he has the experience required to write *The Official Photodex Guide to ProShow*.

After learning from this book, many of you will change your approach to the creative process. Instead of taking photos and then figuring out how to present them, you'll start taking photos to use within high-quality presentations. That's a good thing, because that's the future of sharing.

Paul Schmidt
President, Photodex Corporation

Acknowledgments

This is my 24th book project. Like all the others, it would not have made it to your hands without the support of friends and the skills of a professional support staff. I am indebted to fellow photographers Mike Fulton and Cody Clinton of TriCoast Photography for the images we used in most of the exercises. The staff at the Texas Woman's University provided pictures from their World War II WASP archives collection for the shows in the first chapter. Max and Vera Shafiq of PhotoIdentities provided Web server support and use of their excellent templates and custom design services for the sections of the book that called for Web hosting. ProShow expert Jennifer Weeks (VidQueen in the Sharing section of the Photodex Web site) shared valuable insights from her long experience with the program.

The Photodex team provided excellent support during the project. President Paul Schmidt provided insight into the company's vision for the project. Amanda Sahliyeh was an unflagging principle point of contact who (as always) managed to find just the right person or resource needed to keep the project on track. I'd also like to thank Leslie, Min, Evan, Brandon, and the entire support team at Photodex for the exceptional help they provided with this project.

Publisher Stacy Hiquet guided this book through the maze that is the book world, and Megan Belanger was the original acquisitions editor. Both women are valued friends for their steady hand and industry insights. The rest of the Cengage Learning team for this book included project editor Dan Foster, copy editor Brad Crawford, layout technician Bill Hartman, proofreader Laura Gabler, indexer Katherine Stimson, and CD producer Brandon Penticuff.

Thanks to all as we end this project and begin on the next. This is an exciting time to be involved in photography and working with the latest tools and technology.

About the Author

James Karney brings a unique viewpoint to this book developed through his experience as an award-winning author, professional photographer, and educator. His work has appeared in *PC Magazine*, *Computer Shopper*, *Windows Magazine*, and *Internet World*. His books include *Mastering Digital Wedding Photography* (named a Book of the Year by Shutterbug magazine), the Golden-Lee best-seller *Upgrade and Maintain Your PC*, *Power of CorelDraw!*, and the *Microsoft Press A+ Certification Training Kit and Readiness Review*.

His professional photography experience includes the areas of weddings, photojournalism, medicine, and a tour as a U.S. Marine Corps photographer. He developed and taught the 18-month photography certificate program at South Georgia Tech and teaches computer technology and graphics at the college level.

He is a graduate of the U.S. Naval Photographic School, holds a bachelor's degree in communications from Excelsior College, and a Master of Science in computer technology from Nova Southeastern University.

Contents

Introduction . xv

Chapter 1
A World of Sight, Sound, and Motion 1

Formal Introductions . 2
Organization: ProShow's Trilogy of Slides, Shows, and Projects 4
Creating Your First Show . 7
 Adding Images . 7
 Adding a Caption . 9
 Adding a Soundtrack . 10
 Previewing the Production . 10
On with the Show(s) . 12
Comparing the Two Versions . 12
 The Title Slide . 12
 The Four Pilots . 13
 The Welding Shop . 15
 The Flying Flag . 15
Up Next . 16

Chapter 2
Sight: The Realm of Images 17

A Slide Is More Than Just a Picture . 17
Creating the Title Slide and Adding a Background 19
 Adding the Background Image . 20
 Exploring the Slide Options Window 20
 Adjusting and Cropping the Foreground Image 23
 Framing, Layers, and the Elements of Design 24
 Image Sizing and Placement . 25
 Fine-Tuning the Background . 26
 Adding the Trailer Slide . 29

Customizing the ProShow User Interface . 29
 Closer Inspection Using the Timing Indicator and Track Bar . . . 31
Developing the Primary Content: Variations on a Theme 33
 Converting to Black and White . 33
 Adding a Custom Background . 35
 Workflow, Adding More Slides, and Adjusting Defaults 36
Setting Timing and Selecting Transitions 38
 Adjusting Intervals . 38
 Working with Transitions . 39
Total Timing Control . 41
Up Next . 42

Chapter 3
Frames, Motion, and the Layered Look 43

The Slide as a Stage . 43
 Framing Images: A Working Demonstration 44
Setting the Stage, Defining the Show . 46
 Setting a Title and the Aspect Ratio 46
 Adding a Show Thumbnail . 47
 Determining the Correct Safe Zone 47
 Scaling Images within the Frame . 48
 Determining the Proper Output Resolution 49
Working with Layers . 50
Adding Content and Adjusting Layers 56
 Positioning Layers Precisely within the Frame 58
 Adding and Ordering New Layers 59
 Adjusting Size and Rotation . 60
Getting Things Moving . 63
 Beginnings and Ends: Motion Effects Demystified 64
 Working with the Motion Effects Window 64
Putting It All Together . 72
 Two Slides, Two Backgrounds, Eight Layers, and a
 Disappearing Act . 72
 Matching Motion Speed Between Layers 72
 Who Says We Have to Start at the Beginning? 74
Up Next . 76

Chapter 4
Adding and Editing Soundtracks 77

Working with Audio Files . 77

 Adding, Positioning, and Removing Audio Files. 78

 Simple Audio Synchronizing. 79

Going Interactive: Advanced Sound Controls. 80

 Mastering the Audio Trimmer . 80

 Scaling and Positioning the Waveform 81

 Setting the Start and End Points . 82

 Adjusting Fade In and Fade Out Intervals 83

 Editing Soundtracks Using the Timeline. 84

 Adjusting Offsets, Fades, and Volume Using the Timeline

 Tools . 85

 Creating a Crossfade Effect with the Timeline 87

 Recording Slide Timings. 89

Menu-Based Volume, Fade, and Offset Controls 90

Adding Audio Tracks from a CD . 91

Adding Soundtracks and Voice-Overs to Individual Slides 92

Up Next. 94

Chapter 5
Caption Fundamentals: More Than
Just a Way with Words 95

A Special Type of Layer, with Its Own Special Effects 96

 Blending Text and Motion in the Design 98

ProShow's Common Caption Toolkit and a Bit of Typography . . . 101

 Selecting and Sizing Fonts . 101

 All Fonts Are Not Created Equal . 103

Adding Another Slide and Caption . 105

Making Captions Move Using Text Effects 108

Alignment and Anchor Points . 110

"Automatic" Captions—the Power of Macros. 112

 Inserting Special Characters into a Slide with Macros 113

Show Captions, Globalization, and the Art of Invisibility 116

 Adding a Global Caption. 116

 All Captions Are Not Created Equal 116

 Modifying Caption Behavior Using the Caption List Options . 120

Basic Caption Design Considerations. 122
A Closer Look. 123
Up Next. 126

Chapter 6
Getting Fancy: Keyframing Basics and Advanced Caption Tools 127

Keyframes Defined, Captions Redefined 128
 Producer's Captions Window. 132
Keyframing, Motion Effects, and the Magic of Timing 136
 Working with the Keyframe Timeline. 138
 Adjusting Keyframes and Text Effects 139
 Working with Multiple Keyframes 140
 Adding and Adjusting Keyframes. 142
Keyframes Move More Than Words . 144
 Setting Adjustments Effects and Keyframes 144
Adding and Adjusting the Captions . 146
Up Next. 149

Chapter 7
Advanced Motion Effects Using Keyframes 151

A Traffic Control Lesson . 151
 The Smoothing Effect. 154
Getting Things in Proper Order . 155
Simple Keyframe Effects: There and Back Again 158
 Adjusting Keyframe Timing and Position. 158
 Closing the Square . 161
 Zooming in for a Closer Look . 162
Motion Keyframing with Multiple Layers 164
 Managing the Preview Area . 164
 Multilayer Motion Effects Workflow 166
 Placing and Adjusting the Images. 167
 Setting the First Keyframes. 169
 Matching the Layer's Position to the Keyframe Timing 170
 Adding Keyframes 4 and 5. 172
 Adding a Little Spin . 173

Revisiting the Copy Commands . 175

Adjusting Keyframes 1 through 3 for Layer 2 178

Adjusting Keyframes 5, 6, and 7 . 181

Designing Complex Motion Effects: The Real Deal 181

A Quick Shuffle and Laying Down the Cards 182

Examining the Table . 183

The Second Collage . 184

Blow-Up and Drop-Out . 187

There and Back Again: Keyframes 6 and 7 189

Up Next . 190

Chapter 8
Advanced Motion Keyframing with Editing and Adjustments Effects

191

Working with the Colorize Controls 194

The Oz Effect: Black and White to Color 194

Opacity: It's Not Just an Adjustment Control 201

Smooth Moves: Creating a Composition with Opacity and
Transitions . 204

Creating an Overlay with Opacity 208

Hue Adjustments: Playing with Color on the Move 209

Setting Up the Layers . 211

Motion and Adjustments Effects: An Intricate Dance, with
Some Sleight of Hand . 213

A Closer Look at Layer 1 . 214

Cloning the Effects and Adjusting the Keyframe Timeline 215

Variations on a Theme . 217

Up Next . 222

Chapter 9
Advanced Layer Techniques: Masks, Vignettes, and Chroma Key

223

The Alpha Channel and a Spotlight on Masking 226

Creating a Simple Transparency Mask 226

Combining Transparent Masks with Vignettes 229

Isolating Portions of the Frame with Transparent Masks 231

Intensity Masking: White Reveals while Black Conceals 234
 Slide 1: A Simple Stencil. 235
 Slide 2: A Role Reversal . 238
 Combining Adjustments Effects with Intensity Masking 240
Alpha Channel Masks and a Selective Bit of Color 241
Working with Multiple Masks . 243
Vignetting Reconsidered. 245
 It's Not a Mask, It's a Vignette . 247
 A Final Spotlight on Vignettes and Masking 248
Chroma Key: More Than Just a Green Screen 250
 Setting the Chroma Key Index on an Existing Color 252
 Adjusting the Effect . 253
 Employing a Traditional Green-Screen Chroma Key 254
 Fade to Black Reconsidered . 255
 Fast-Moving Clouds: Using Video Clips with Chroma Key . . . 256
 Working with Video Clips in ProShow. 257
Up Next. 261

Chapter 10
Templates and Live Shows 263

Working with Templates . 263
 Creating and Saving and Templates 265
 Adding Content to Template Layers. 266
 Template Planning and Workflow 267
 Importing and Exporting Templates. 268
 Modifying and Using Templates. 269
Producing Live Shows . 270
 Setting Up a Basic Live Show . 270
 Creating an Executable Live Show. 273
 Creating Advanced Live Shows with Templates 273
 Setting Fixed Slides and Content 273
 Adjusting for Vertical and Horizontal Composition. 274
 Setting the Live Show Options and Placing the Content. 276
 The Camera Connection . 277
Up Next. 279

Chapter 11
Creating Menus and Branding Shows 281

Designing Professional Menus and Adding Interactivity. 282
 The Menus Window. 283
 Menus with Multiple Shows. 284
 Customizing ProShow Menus 285
Personalizing Shows with Branding 292
 Announcing Your Work with an Intro Show 292
 Using the Branding Tab Options 293
 Setting a Disc Label Before Writing to the Media. 296
 Adding a Watermark to the Slides 296
Up Next. 297

Chapter 12
Getting the Story Out 299

Show-Creation Basics. 299
 Choosing an Output Format and Understanding Common
 Setting Options . 300
Output Formats and Files Demystified. 304
 Supported Output File Formats and Media Types 305
 Photodex Presenter Files and Plug-In 306
Selecting Options for Different Output Formats 306
 DVD/VCD/CD Production. 307
Autorun CD and Executable Files 310
Screen Savers . 311
Portable Device Output . 312
 Creating Device Output Using an Existing Profile 313
 Creating a Custom Device Profile. 313
ProShow File Types and File Management 314
 Show Files . 315
 Menu Files . 316
 Output Files . 316
 Workspace Files . 317
Up Next. 317

Chapter 13
ProShow and the Web 319

Internet Hosting Basics319
 ISPs and Bandwidth319
 Copyright Considerations322
 Sharing Shows with a Free Photodex Account323
 Hosting Presenter Files on Other Web Sites326
Sending a Show via E-Mail327
Flash FLV Shows and the Web.........................329
The YouTube Connection330
Wrapping Up331

Appendix A
ProShow Product Comparison Guide 333

Appendix B
Keyboard Shortcuts 337

Appendix C
About the CD-ROM 341

Index 343

Introduction

This book is a shortcut to mastering one of the most interesting and exciting computer programs available today. Digital photography is changing the way we look at pictures just as much as the way we take them. Web sharing, digital frames, iPods, and DVD shows are making inroads on the venerable paper photographic print. Photodex is changing the way we see "slide shows."

ProShow offers incredible power in an easy-to-use program. It turns the average PC into a multimedia production platform. I use it regularly as a professional photographer and included an entire chapter on using the program for online and DVD proofing in my book *Mastering Digital Wedding Photography*.

Why This Book?

Like many ProShow users, I quickly discovered that "easy to use" is not the same as "easy to master." The novice can create a slide show in minutes, but crafting a real multimedia production requires learning how to use special effects, keyframes, and output formats. Today's viewers are demanding more visually from all types of multimedia—thanks in part to expensive commercials and movies rich with special effects.

The standard ProShow manual offers basic information on how to use the menus but provides only limited tutorials. My searches of bookstores uncovered a surprising fact: there was nothing on the shelves that explained the basics of slide show production, let alone the really good stuff—the techniques that make a show stand out from the crowd. The photographer in me was disappointed, but the author in me was excited. This was a subject worthy of a book. It took a couple of months to work out the details with my publisher and Photodex, and it took several more to learn (with the help of Photodex experts) all the advanced skills and figure out how to teach them in a book. The results are in your hands.

How to Use This Book

The book is written for novice and expert users alike. (Expert is a step below mastery, requiring the development of personal style.) It covers all the features of both ProShow Gold and ProShow Producer. The material includes complete exercises with all the files you need (such as professional images and designs) to explore every aspect of developing high-quality shows. The first chapter comes with two advanced productions to demonstrate what is possible with the program, introducing the basic concepts and terms needed to discuss the program and multimedia production.

The rest of the book is a hands-on seminar in a progressive format. If you are new to the program, be sure to check out Chapter 2, which covers the basics of the ProShow interface, program setup, and proper workflow. Chapters 3 through 5 focus on the core features common to both ProShow Gold and Producer: working with slides, manipulating layers, and working with transparency; setting transitions, editing soundtracks, adjusting images, and working with text; and adding motion and special effects to a show.

Chapters 6 through 10 get into advanced features and special effects: masking, keyframes, adjustment effects, templates, live shows, advanced motion controls, vignettes, and Chromakey transparency. Chapters 11 and 12 detail output, from designing menus and setting copy protection to selecting the right type of media and file formats for a given application. Chapter 13 covers ProShow's ability to produce a variety of Internet-ready formats—even complete streaming video Web pages—and place shows directly on sites like YouTube and Photodex's Sharing section (http://www.photodex.com/sharing).

The best way to use the book is with ProShow open and the CD's exercise materials handy. Working from front to back is the best way to really get the most out of the material. Skills build on the preceding exercises. Coming back to a topic is a good way to review and experiment with blending together different styles of effects. Most of all, have fun with the really incredible tools that ProShow offers.

A World of Sight, Sound, and Motion

The simple slide show is a thing of the past. Viewers expect sizzle. Movies, television, and even our cell phones and MP3 players bring high-quality video and eye-catching special effects into every aspect of our lives. Personal computers double as entertainment centers, showing HDTV programs and movies at home and at work. It's becoming impossible to catch people's eyes or keep them watching without professional polish.

Photodex ProShow is the solution. It's a powerful, versatile, and deceptively simple tool for creating high-quality multimedia with virtually any current Windows computer. A novice can quickly create a pleasing slide show replete with images, fancy transitions, a soundtrack, and even motion effects with only a basic understanding of the program.

Creating more than a pleasing slide show—really impressing the audience with your message—requires taking advantage of ProShow's advanced features and developing a good sense of design. This book will help you do both. ProShow offers an incredible array of tools that allow you to blend sight, sound, and motion with incredible precision and clarity. Even a basic knowledge of layers, masking, and keyframing will set your work apart from the crowd and spark your creative imagination.

This chapter is a warm-up. If you are new to ProShow, it will serve as an introduction. We'll tour the ProShow interface, introduce basic concepts and terms, and build a simple first show. Keep in mind that this chapter is a walk-through, not a detailed lesson. Subsequent chapters will thoroughly cover the program, its

features, and the process of design. Along the way we'll view two shows prepared by Photodex designers that showcase and compare the features and power of the Gold and Producer editions. If you are already a seasoned user familiar with the program interface and basic operations, feel free to skip to the "On with the Show(s)" section later in this chapter.

You'll get the most benefit by following along with your own copy of ProShow—preferably the Producer edition—rather than just reading the material and watching the videos. The more advanced features (and the exercises in the book that use them) will require Producer. A fully functional trial version can be downloaded at http://www.photodex.com. You should install the program before continuing into the rest of this chapter. We will be using content on the companion CD-ROM, so have that ready as well.

Notice I didn't mention the ProShow Standard Edition. This book covers only the Gold and Producer versions. I won't make a detailed comparison between them here. I'll save that for when we view the shows and build our first show.

Throughout the book, as we focus on a subject, the discussion will usually begin with features common to both editions and then explore the expanded tools Producer provides. (When referring to the different version, I'll drop the ProShow part of the program name.)

Formal Introductions

Both Gold and Producer use the same interface, with some variations to provide access to the expanded features in Producer. The main program workspace (shown in Figure 1.1) is divided into sections underneath the usual menu and tool buttons displayed on the top of the main window. You can add, remove, and adjust the layout of the various panes to suit your personal style using the Windows menu. I'll start with the default settings. There are some variations between Gold and Producer. You'll need Producer to take full advantage of ProShow's advanced features.

Mastering the interface requires understanding a key fact about how the program works. ProShow is a multimedia production platform. It "borrows" image files, music and video clips, and other content that we place in a show and gives us tools for crafting their appearance and adding special effects and then previewing the results. The source files are not modified. When we are satisfied with our work, it renders and exports the show in the desired format (DVD, CD-ROM, MP3, etc).

What happens during an editing session is both simple and complex. (ProShow handles the complicated stuff.) As the user adds content, the program keeps track of all the files and settings used in the design. That includes how long a slide will stay visible onscreen, how it enters and exits the screen visually (the transition),

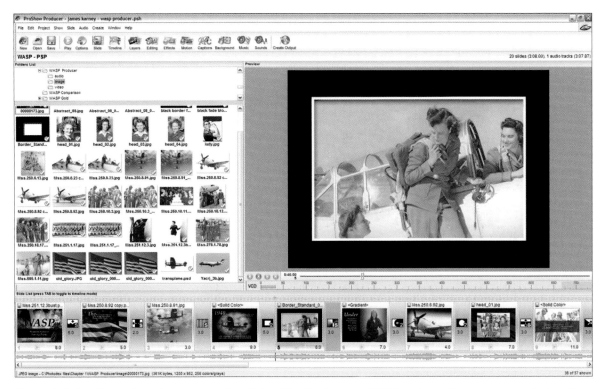

Figure 1.1 ProShow with a show opened for editing. The Producer and Gold versions of the program look virtually identical, except for a few tools and dialog boxes.

and any special effects. When we are ready to make the DVD, CD, Flash Movie, or Podcast, the ProShow rendering engine takes over. The instructions and content are rendered into the appropriate video format and placed on the media.

Think of the main interface as a workspace and ProShow as a multimedia production environment. We use this workspace to place and organize elements in a show, and preview the production as we work. It's where we perform tasks like cut, copy, paste, and save. To work on those elements, create captions, fine-tune the presentation, and craft special effects, we use an array of dialog boxes to manage slides, shows, and projects.

The menu bar and the buttons at the top of the interface work the same as most other Windows programs. I'll cover their functions as we use them. Just under the buttons, on the left-hand side of the interface, are the Folder List and the File List. Choose a folder to see the contents in the File List. You can navigate and select files in these sections the same way as you would in the operating system. The File List shows only items that can be imported into a show. It won't show the master show file or unsupported file formats. (For example, you can see RAW files in Producer, but not in Gold, because only Producer supports them.)

A set of thumbnails is displayed under the File List. If you right-click inside that area, a content-sensitive menu will appear that lets you choose between the thumbnails and a list of filenames and properties. In Thumbnail mode, a green check mark is placed in the lower-right corner of images that are currently used in the show.

To the right of the Folder and File List area is the Preview window. It displays the current selected portion of the show during editing as well as full-motion previews using the controls just below the preview image. Below those tools is the Size Meter. It graphs the size of the current contents of the show based on the files and the type of output. (A Web version will take less room than a DVD, for example.) This is a very handy tool, allowing the user to track and adjust file sizes to meet the capacity of the output media.

See the horizontal row of pictures near the bottom of Figure 1.2? This is the Slide List, which holds the images in a show in the order they will play in the production, running from left to right. Between the slides are icons that show the type of transition, the effect that displays as the show moves from one slide to the next. Just below the Slide List is the Soundtrack area. The green waveform is a visual representation of the audio clip playing during that portion of the show.

Figure 1.2
A close-up view of the Slide List and Soundtrack area of the ProShow user interface. Notice the numbers under each slide on the right side and also beneath each transition. These show the length of time that each element will appear. You can change the duration here by selecting the desired item with a mouse click. The number in the left-hand corner of each slide is the slide number.

The main interface is used to bring items into a show, arrange their order, and access menu items. The detail work—activities like editing images, adding motion and special effects, adjusting soundtracks, and working with captions—is almost all performed in individual windows. Understanding how the program organizes its tools makes using them much easier.

Organization: ProShow's Trilogy of Slides, Shows, and Projects

ProShow organizes its content in three layers: slides, shows, and projects. Think of them as a set of nested containers. I noted that ProShow is deceptively easy to use. It's possible to build working productions with little or almost no knowledge of how slides, shows, and projects work. But gaining full use of the program's

features demands an understanding of how they interact and function. In the next several chapters, you'll increase your understanding as you enhance your skills.

Slides, shows, and projects all have separate menus and tools. We'll go into more detail as we use their tools. Here are the basics:

Slides are the primary element of a show. Slides play in sequence with a transition before and after each one. Transitions are represented by the rectangular icons located between slides. Skilled users sometimes craft an entire short production using a single slide.

A single slide can contain layers, and a layer can hold an image, a video clip, a solid or gradient fill, or a caption. Each layer can be treated with its own set of effects. The available effects vary based on what the layer contains and which edition of ProShow is being used.

Producer adds the ability to blend and transform objects using opacity controls and masking to hide and reveal objects on different layers. It also provides keyframing, which precisely controls timing of events for every layer in the slide. An effect can be set to interact with effects on others layers, with stunning results. We'll look at examples later in this chapter and learn how to use them later in the book.

Double-click on a slide in the Slide List, and the **Slide Options** window, shown in Figure 1.3, appears. As you can see by the array of icons on the left

Figure 1.3
The Slide Options window is really a control panel used to create and manage all the settings and special effects on a slide, including captions. The white line running from the center woman's wrist to the straps of her parachute denotes the path of the motion effect for the layer.

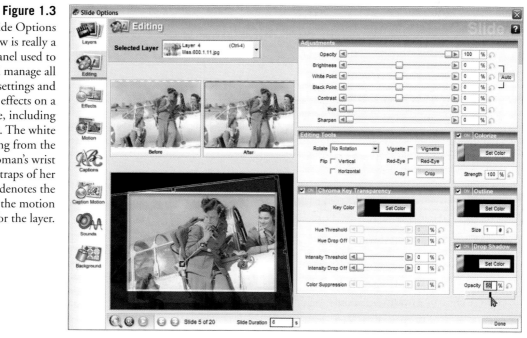

side, this is the place where the "real" slide editing is done. The options vary with the different versions of ProShow. Keep in mind that edits made to an image change the way the picture looks *only* in the slide show. The original file remains unaltered. You can also set up an external editor and make permanent changes to the source file. We'll do that later.

Show files are actually a set of instructions containing all the information needed to construct a complete show. The program reads a show file and assembles the collection of images, audio, video clips, or whatever you have. This is what we work with and see in the Slide List and in the Preview window. Show files can be output into a wide variety of formats, including DVD, CD, Flash, Photodex Presenter, and QuickTime. The show file does *not* actually contain the content, but that's a topic for later discussion.

The **Show Options** window (shown in Figure 1.4) offers tools using the same basic interface as the Slide Options version. Clicking one opens a secondary window that provides a specific set of tools. Changes made here apply globally to all slides in the show. (Some settings can be adjusted to exclude selected slides.) We'll explore these tools in detail later.

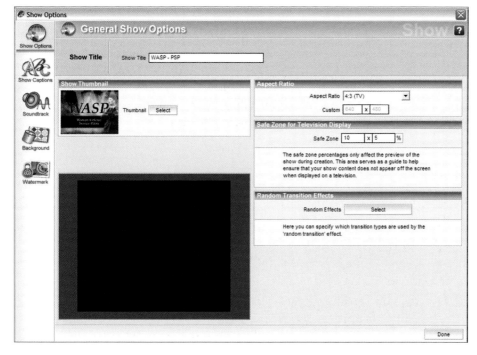

Figure 1.4

The Show Options window is where we adjust global settings that apply to more than one slide. This is where you choose the image used as the show thumbnail in menus, match the rendered aspect ratio to the targeted display device (TV, wide screen, etc.), and choose audio clips to be used as soundtracks.

Project files are collections of two or more shows. When a project is open, each show in the collection is given a tab just under the menu bar. Projects are used to collect several files and place them, complete with fancy menus, on a single disc. It's also possible to copy and paste slides from one show to another when they are part of a single project.

Creating Your First Show

Our tour is about to turn into a simple exercise so we can actually work with the interface. Don't worry about the details. This is a walk-through tour just to familiarize you with the program. ProShow makes it easy to transform a folder of images into a basic slide show with a few clicks of the mouse. First, we'll add images, then insert a caption on the title slide, and then add a soundtrack. It will take only a few minutes.

Our subject is the WASP (Women Airforce Service Pilots) program, a select group of women that ferried aircraft around the globe during World War II to free Allied combat aircrews for front-line duties. Once we're done, we'll compare the results to two more sophisticated versions that showcase the advanced features we'll explore in the rest of this book and that demonstrate the differences between the Gold and Producer versions.

You can use either Gold or Producer to create this first show. Go ahead and open the program now. We'll compare the results with the two polished versions provided by Photodex after we view our creation. Don't worry if we move quickly through the process—it's just an introduction to familiarize you with the basic process and the controls on ProShow's user interface.

Adding Images

The first step is to locate and add images to the Slide List. Use your mouse and open the Chapter 1/First Project Files/ folder in the File Folder panel. Once you've selected the directory, either the thumbnails or a list of filenames and details will appear in the File List window. You can toggle the display between the two modes by right-clicking in the File Folder and using the context-sensitive menu to toggle the setting.

You use the same menu to quickly add slides to the show. Right-click inside the File List and choose the Add All Files to Show option. Release the mouse button and the images will appear in the Slide List, arranged alphabetically by their filenames. Figure 1.5 shows the open menu and the images already placed in the show. (We could also drag and drop the files from the File List or right out of a directory.) The thumbnails in the File List window now all have a green check mark in the lower right-hand corner to denote that they are used in the show.

Figure 1.5
Adding a folder of images to the Slide List requires little more than a few mouse clicks, thanks to ProShow's well-designed user interface and content-sensitive commands.

Just what kinds of images you can import into a production depends on which version of the program you have. Gold can handle most standard still and video image formats, including Photoshop PSD. Producer adds the ability to import RAW images directly from a digital camera. (At this point, RAW support is limited to the unedited file data, so you won't be able to see changes made to the RAW file in a sidecar file. You can, however, see the results by exporting the RAW file into another format in your external editor.)

Importing files can take several minutes when bringing in a large number of files, or when importing a large video clip. The program is generating thumbnails and

Tip

ProShow's flexibility and wide range of features make it easy to modify a design and invite creative fine-tuning. Users tend to develop their own ways of building projects. Even so, the basic workflow for most projects begins with adding and arranging images.

Before actually importing the images, I usually collect them all into a single folder. Remember that ProShow only borrows the files; they are not copied into the production. Having them all in one location makes it easier to both import them into the show and make sure they are in an accessible location. If any of the files in a show are moved to a new location or stored on an inactive removable or temporary drive, ProShow won't be able to find them until you tell the program where they are and make that drive available.

previews and indexing the new material as available project resources. The same thing happens when you import a soundtrack or other materials. While the program is working, a green bar moves from left to right between the File List and the Slide List indicating progress.

Adding a Caption

Right now, we have 15 slides in our show but no captions. We are going to add a black, blank slide before the first picture and place a caption there. Blank slides are great for adding captions and credits at the end of a show and can play short runs of extra audio at the end of a show after the screen goes dark. (Sound in this case has to be linked to a slide for timing purposes.)

Right-click on the very first slide in the Slide List. Choose the Insert option from the content-sensitive menu that appears, and then select Insert Title Slide. ProShow will add a blank slide at the beginning of the show and open the Slide Options window in Captions mode. (If you clicked on any slide other than the first one, your title slide may be somewhere else, but you can still follow the lesson with the slide in that location.)

Think of a slide as a sandwich of layers. Captions are text layers that sit on the top layer. Click on the white text-entry area just under words "Selected Caption" on the upper-right portion of the Slide Options window, located above the Caption Format tools. Type in the phrase "This is a caption," as shown in Figure 1.6. (Your

Figure 1.6
The Slide Options window opens in Caption mode while setting a Fly Out effect. Notice how the tools in the window are different from the ones seen in Figure 1.3. That's because the mode has been changed from Editing to Captions.

text will look smaller than the letters in the screenshot; I enlarged them for better visibility.)

You now have a basic caption. ProShow captions are a lot more than just simple words. They are design elements. The text can move across the screen with special effects. You can tweak it with fancy enhancements like gradient fills, outlines, and typography (custom fonts, kerning, and leading)—in short, almost all the tools found in drawing programs. Don't let ProShow's array of buttons, data boxes, sliders, and menus intimidate you; most are context-specific and offer interactive modes that save you from having to actually enter numbers. We'll cover these features later in the book as we use them.

If you wish, set the Fly In and Fly Out effects using the drop-down menu shown in Figure 1.6. You can preview the way the effects look using the Play button (the third one in from the left at the bottom of the window). When ready to proceed, click the Done button in the lower-right corner.

Adding a Soundtrack

Someone once said the difference between normal life and a movie was that movies have a soundtrack. Producer provides some very sophisticated soundtrack tools, but we don't have to get that fancy yet. The basic steps to incorporate an audio clip are no more complicated than the ones used to add images to slides.

See the Music icon on the Button bar? Click on it, and the Show Soundtrack window will open. To add an audio file to the list, click on the green Add button, located under the large open area. When the Windows Explorer dialog box opens, navigate to the Chapter 1 folder. The MP3 file named Larry_Allen_ Brown_Shenandoah will be visible. Your screen should look like the one in Figure 1.7. Select the file and click Open. The audio track will be added to the show. Click the Done button to return to the show.

Previewing the Production

It didn't take long to build this simple show, and there is no need to output it to see how it looks. We'll view the results directly in ProShow using the Preview feature. As you watch, keep in mind that this is a basic slide show. Its purpose is to introduce the ProShow interface and the program's basic operation, not generate a polished production.

Some users buy ProShow and never move much beyond adding a few motion effects to their shows. We are going to move way beyond that level of skill in the following chapters, and have fun along the way. See the set of control buttons just below the Preview pane on the left side in Figure 1.8? These are similar to the ones on a media player or DVD remote control. After reading the next paragraph, click

Figure 1.7
The Show Soundtrack window lets you select, preview, and add audio files to a production.

Figure 1.8
Use the Play button just below the Preview window to start the show, and the content-sensitive menu to enable full-screen playback. The menu sets the default display mode. The next time you run a preview, it will start in Full-Screen mode.

on the Play button (the green one with the arrow pointing to the right, just above "EXE" in the illustration).

Once the show begins, right-click on the images playing in the Preview pane. Choose Full-Screen from the menu (see Figure 1.8) that appears and the slides will fill the computer's display. After the last slide is displayed, the preview will close, and the program will reappear.

On with the Show(s)

Now it's time to see how an experienced user can turn our simple slide show into a multimedia production. The two shows you are about to see focus on showing the program's possibilities. As the presentations play, watch how the designers used timing, transparency, motion, and similar effects to bring life to the images and action to the screen. I won't take time to explain each technique in detail here. This is just to whet your appetite.

We won't need ProShow to view the completed shows. They have been exported as executable files. There are three versions, all located in the EXE subfolder in the Chapter 1 folder. Here is a quick explanation of each file and how to use it.

WASP Gold.exe is the Gold version of the program. View it first by double-clicking on the program icon. You can use the same right-click menu as in ProShow Preview mode to see the slides play in Full-Screen mode. Notice the dramatic change in the contents and remember that these are the same pictures and soundtrack used in the one we just created.

Once the Gold version is finished, return to the same folder and use the same procedure to view the **WASP Producer.exe** edition. This program makes full use of the advanced tools and features of Photodex's flagship product. Some slides may look like they have video clips, but all the images are stills. Again, these are the same pictures we used, but with the addition of masks, keyframing, and similar tools. The exercises in this book provide a solid foundation for creatively using these features in your productions.

The third file in the folder, **WASP Comparison.exe**, contains selected slides from both shows shown with the Gold version first, followed by the Producer rendition. The Producer slides will transition by dropping in from the top of the frame, making it easy to see when it arrives. View this show before reading the rest of this chapter.

Comparing the Two Versions

As you can see, Gold puts on a pretty good show, but professionals choose the Producer edition for its greater power and productivity. To conclude our tour and discussion, let's look more closely at the way the designers added punch to Producer.

The Title Slide

The Producer title slide (see Figure 1.9) adds a caption layer to the design that slides between the background and the black caption in the foreground. The letters are white, and the opacity setting can make the type transparent. Opacity

Figure 1.9
Title slides give
viewers their first
glimpse of a show and
tell about what is to
come. Effective title
slides spark interest
and draw attention to
the screen.

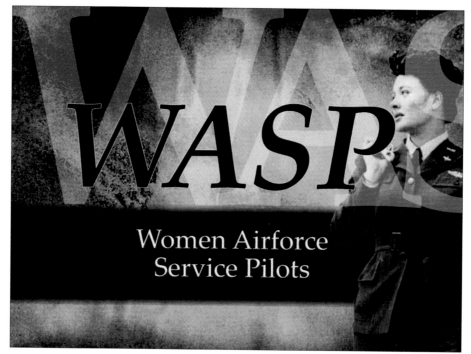

combines with the caption's right-to-left motion to draw the viewer's eye to the text—without distracting from the imagery of the pilot.

The Four Pilots

Multimedia design is part art, part craft, and part technology. In this example, the designer used all three and an external editor to produce a really slick slide. Both Gold and Producer let you set up an external image editor. Right-click on a slide and tell it you want to edit the slide. The selected editor opens the source file so you can make your adjustments. Save the work, and the file is updated in ProShow.

The image in Figure 1.10 is actually four "cuts." Each is placed on an individual layer and set into a collage with the complete picture. As the slide plays, a combination of individual motion effects and opacity adjustments makes it look like the smaller pictures merge into the larger one.

The precise timing of each layer's movement and the fade effect are crucial to the illusion of the small pictures seeming to blend into the complete portrait. The designer combined two of Producer's most powerful features: opacity and keyframing. The opacity control lets the user make a layer (and its contents) appear and disappear at will. That's how the images faded as they arrived over the background photograph.

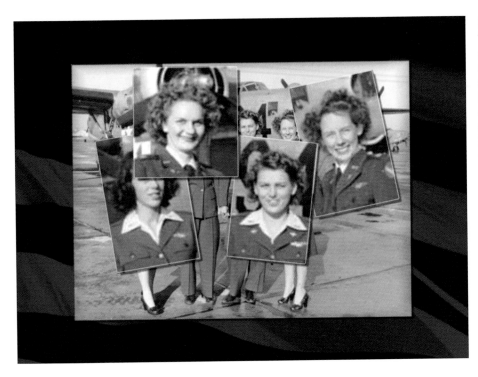

Figure 1.10
This slide transforms a group portrait into an engaging composite by using a little Photoshop work to create "mug shots" and a bit of keyframing combined with motion.

Keyframes are a major reason for the extra power Producer offers us. A video, a film movie, or an animation is a sequence of frames presented fast enough that the viewer's eye and brain are fooled into seeing motion. How fast each image is replaced by the next is called the *frame rate* and is measured in frames per second (fps). Early movies look jerky because the frame rate was too slow. Depending on the technology, modern frame rates vary from about 24 fps to 60 fps. The faster the rate, the smoother the perceived motion—and the larger the file size or physical length of the film.

Keyframing lets us create precise motion and special effects. Gold does offer motion but not the ability to adjust and control it with keyframes. Producer does. A keyframe is a user-defined control point that can start, stop, and change the setting of an effect. Producer does all the math and handles the settings to make the amount of change or movement exactly right—down to 1/1000th of a second. That's how the small photos could each be independently moved in different directions and brought to an exact point at an exact time. And at exactly that time, the opacity setting made the small images disappear.

The Welding Shop

It wasn't hard to spot the enhancements in the Producer version of this slide. No, it isn't a video clip, and there is only one copy of the image. As the slide plays, keyframes rapidly adjust the brightness of the image—one way the keyframe feature can be used (see Figure 1.11). It's acting like a set of switches. When a keyframe is reached, an effect can be started or turned off.

Figure 1.11
Once again, Producer adds real punch with a "simple" timing trick. The result makes a six-decade-old picture look like a movie clip.

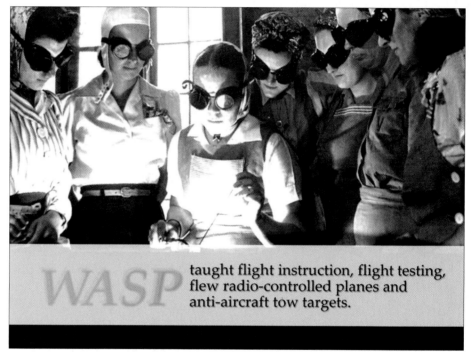

The Flying Flag

Our final example contains a foreground picture that has been made partially transparent (see Figure 1.12). Three copies of the same flag picture are layered behind the plane and pilot. Each has been "faded" using the opacity control and given a slight motion effect. Now we can see each flag and the motion. If this were a single picture in full color, moving the red, white, and blue flag would visually overwhelm the woman.

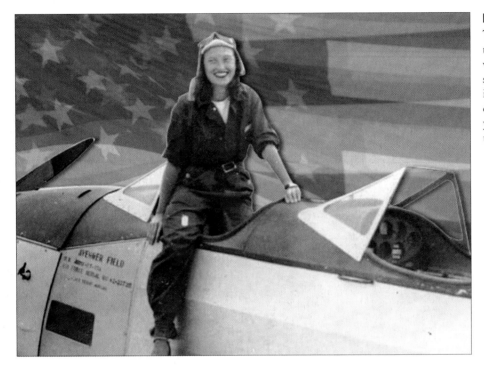

Figure 1.12
The flag waving in
the background adds
visual appeal and a
sense of motion to the
image. It is simple to
do in Produce—if
you know the basic
technique.

Up Next

The introductions are over. It's time to dig deeper. We'll start with a close look at how to use images, tweak their appearance, and add effects. Along the way, we'll consider design and workflow. While you can follow along for much of this material using ProShow Gold, getting the most from the sessions (and being able to create all the shows) will require loading Producer.

2

Sight: The Realm of Images

We humans are visual creatures. For most of us, sight is the primary sense. Phrases like "A picture is worth a thousand words," "See what I mean?" and "Let me show you" underscore that simple fact. No matter how sophisticated your presentation, images will act as its foundation.

This chapter focuses on learning more about the program interface and on developing the basics skills required for editing and manipulating slides. The individual slide is the program's creative foundry. You'll also see how making simple adjustments to slide timing and choosing the right transitions between slides can produce compelling special effects.

A Slide Is More Than Just a Picture

In the days of slide projectors, a slide was simply a picture—a piece of film with a positive image (rather than a negative). A slide show was a series of slides displayed in order and separated by a moment of darkness called a *transition*. The ProShow slide is more like a cross between a script and a container. It holds the visual content for a specific slice of time in the production. The ProShow transition is a special effect, displayed with that same level of precision, between two slides.

A slide can contain a single image, or it can be a layered affair with images, video, background, captions, motion effects, and even its own soundtrack. A slide in ProShow is really a lot more than just a picture. (In fact, some expert users produce entire shows with just one image.) Keep in mind that this chapter is really just the start of our detailed discussion of slides. Later chapters will focus in detail on advanced topics, including captions, layers, motion effects, and the art of keyframing.

Modern multimedia "slide shows" range from the simple (like an unedited collection of party or vacation pictures) to the complex and even sublime (consider the works of Ken Burns). No matter the subject matter, nor how long or short the show, they all share two things in common—a story to tell and pictures to tell it with. We're going to begin exploring the basics of how to create and manipulate slides by building a show. Notice I used the word "begin." The full discussion of crafting slides and designing a presentation will take several chapters.

Open either Gold or Producer. The first figure shown was taken from Gold and the rest from Producer so you can see how they share a common interface. Producer has more controls to help you take full advantage of its additional power and advanced features.

Figure 2.1
Placing the images into slides using the drag-and-drop method. The individual picture is not the slide. A ProShow slide is more like a container, and it can hold more than one image—in fact, more than just images.

Once the program is running, open the File menu and choose New to create a new show. Then use the Folder List to locate and access the Chapter 2/content directory as shown in Figure 2.1. There are six pictures in the folder. We are going to import three images into our show. We'll import two of them twice so that we can create a simple but very useful effect. Use your mouse and the drag-and-drop method to place the first image (a silhouette of a couple kissing against a dark-blue sky) in the first slide position in the show. The filename starts with "c2-1 TriCoast."

Drag and drop the second image ("C2-2TriCoast," the three-quarter-length portrait of the couple standing side by side) twice into the second and third slide positions in the show. Finally, drag and drop the close-up picture of the couple ("c2-3 TriCoast") twice so that it becomes the fourth and fifth images in our production. When you're finished, the Slide List (the row of slides displayed at the bottom of the user interface) should look like the one in Figure 2.1.

Creating the Title Slide and Adding a Background

The first image in the show is going to be part of our title slide. Most productions begin with a title slide and close with one that lists credits or contact information. I often wait to do the title and credit slides toward the end of the workflow, but here we're going to start with them and use the title slide to explore ProShow's editing tools and work with adding a background image.

The simplest form of a title slide is the type we created in Chapter 1, a solid fill with text. We are going to get a bit fancier. ProShow lets you incorporate images, videos, and even interactive features like menus and live links to Web sites into your slides. We are going to add an image as the background for this show. To do that, we need to open the Slide Options window. Double-click on the first slide. The window that opens should be similar to the one in Figure 2.2. Click on the Background icon in the left column of the Slide Options window. Backgrounds are the lowest layer on all slides in ProShow. An automatic background layer is generated for the entire show when it is created. Usually this defaults to a solid black fill that appears in any area not covered by an object above it. We could have picked a solid color, or even a gradient fill, using this same window. For just this slide, we're going to insert an illustration.

Figure 2.2
The Slide Options window comes into play frequently when you're building shows. Each of the icons on the left-hand side provides access to a different set of tools. Here we have selected the Slide Background mode. A background is a special layer that can contain an image or a solid color or can be left undefined.

Adding the Background Image

Now we have to enable the slide background. Click and place a check mark in the box where it says "Override show background options for this slide," at the top of window, as shown in Figure 2.2. Then enable the Image Background radio button below it. That enables the Background Image area of the window. Now click on the Browse button, located on the right side of the area. Use the window that opens to navigate to the Chapter 2/content folder. Select the file with the name that begins "C2-1 background."

We have created a compound slide—one with more than just a single image. We have added a background layer. Keep in mind that ProShow treats a slide background as a separate element from the other elements of a slide. We can define and adjust the backgrounds of all the slides in a show using the Show Options window, or we can set custom backgrounds for individual slides, as we are doing now, with the Slide Options window settings.

Exploring the Slide Options Window

It's possible to control virtually every aspect of a slide using the tools provided in the Slide Options window. The array of icons, boxes, and buttons can appear daunting to new users, but they are all very logical and easy to use once you get to know them. Let's examine the controls before moving on with the rest of the exercise.

The tools are divided into categories. You select a category by clicking on one of the icons located on the left-hand side of the window. If you're using Gold, there won't be quite as many icons as are shown in Figure 2.2. Producer has a few more than Gold. The following list provides a brief description of what each category controls, in the order they appear in the Producer version. We'll go into more detail as we work with each one.

Layers

Layer tools are used to add, order, and remove layers from a slide. (Remember that the layer can contain any kind of content object.) In Producer, you can use one layer to mask portions of another. This view (like all Slide Options modes) contains controls for setting the length of time the slide displays on the screen and adjusting the playback speed, play length, and audio volume of any embedded video clips. (We will cover the power of layers in detail in Chapter 3.)

Editing

ProShow offers an extensive range of tools for controlling the appearance of an image as it is used in the slide. You can adjust the brightness, white point, black point, contrast, and hue of the picture. You can convert a color image to black and white (which we will do in this chapter) and create outlines and drop shadows. You can also use tools in this mode to rotate, flip, and (in Producer) vignette the edges of a layer.

Effects (Producer Only)

The Effects window is the realm of keyframes, a major reason for using Producer for any serious multimedia project. Keyframes let you precisely slice the playback of an individual layer into very fine segments of time and control how one later interacts with another as a slide is displayed. You can also control how the image looks at the start and finish times of a keyframe, and Producer will handle the technical details to precisely produce the desired changes. Other effects include the flashbulb—which we saw in the Producer slide of the welders in Chapter 1—and the ability to change the appearance of an image during playback. For example, we can make it shift from color to black and white or a toned version using the Colorize feature.

Motion

The Motion window provides access to Pan and Zoom controls, as well as effects like a bouncing ball, stacked images, an image tilted in rotation over time, and a video overlaid with images within a single slide. These more advanced techniques require keyframes and so can only be used in Producer.

Captions

ProShow's abilities with words are almost as sophisticated as its tools for editing images. The Caption window includes a variety of desktop publishing–style controls along with the ability to precisely align, place, and even use images for textures within your text. You can also set a variety of text effects, including how a text element behaves as it enters the show, how it is displayed, and how it leaves the visual area of the slide. In Producer, you can make captions interactive, allowing viewers to pause the program, go to a Web site, or jump to a specific point in the show by clicking on the caption.

Caption Motions (Producer Only)

All of the keyframe controls used with image layers can adjust the behavior of captions inside Producer. This allows incredible control over how a caption works and how it visually interacts with other layers within the slide.

Sounds

The Sounds window is used to embed a sound clip or voice-over into a specific slide. You can also use it to preview sounds, record voice-overs, and specify whether the sound will continue playing after that slide stops being visible within the show. You can also find tools to override the defaults for the show's global soundtracks options and to adjust the volume and the fade out and fade in values.

Background

All ProShow slides have a background. The default is solid black. We can use the Slide Options window to set a solid color or gradient fill or to add an image as the background for a specific slide. (You can also apply a specific background setting to the entire show in the Show Options window.)

All of the various option windows in ProShow have a similar user interface. Check boxes are used to enable or disable the feature, and most use a combination of sliders and data entry blocks to allow the user to either interactively or precisely set values for a feature. In some cases, a tool may have a button that allows access to an additional set of tools or even an external editor.

The different mode with the Slide Options window logically divides the tools by function. The organization becomes intuitive quickly. Keep in mind that the Slide Options tools are designed to work on individual slides. The Show Options window contains the controls to manipulate global settings.

Adjusting and Cropping the Foreground Image

Now we have a background, but it's hidden behind the image we placed in the foreground. On my monitor, it has a green tint I don't like. (The images reproduced here may have a different color cast.) We'll start by cropping the appearance of the main image and shifting it. To do this, we have to switch to the Editing mode in the Slide Options window. Click on the Editing icon in the left column. That gives us access to the tools we need.

Figure 2.3

The adjustments in the Editing window, located in the Slide Options window, are used to adjust the appearance of an image without actually modifying the original image itself.

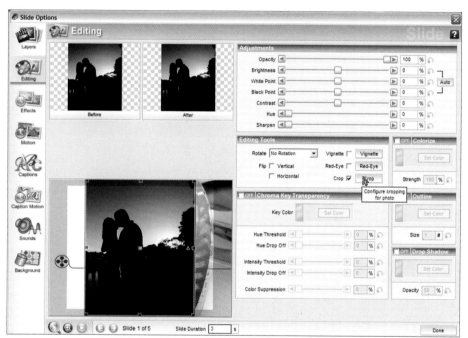

Notice the array of image-adjustment tools at the top right of the Editing window. The changes you can make using them are limited to the picture's appearance inside the show—the original is not modified. They all work by moving the slider to obtain the desired degree of effect or by entering a number in the box to the right of the slider bar. Clicking on the curved line with an arrow just to the right of each box will restore that tool's default setting.

Just below the Adjustments section are the Editing tools. Enable the Crop function by clicking on its adjacent check box. As soon as you press the Crop button, a new window, shown in Figure 2.4, appears. The image being manipulated will appear dim.

Figure 2.4
The Crop window is used to crop and rotate images. These actions can be done interactively using the mouse or by manually entering precise numbers.

The easiest way to crop an image is to hold down the left mouse button and drag over the area you wish to retain when the crop is completed. As you drag, a bounding box will appear, and the image inside the selected area will appear to return to normal brightness. This is the area that will be shown in the slide. Use the squares located in each corner and in the middle of each line to adjust the size of the bounding box. Place the mouse cursor inside the bounding box, and you can drag it over the image to position its location precisely.

Crop the image so it looks like the example in Figure 2.4. You can also enter numerical values for pixels in the appropriate boxes below the image in the Crop window. You can also rotate the image in the Crop window by using the Rotate slider or the numerical entry box immediately below the crop settings.

Click the OK button to close the window once you have finished adjusting the image. What we just did was crop the *appearance* of the image *inside* the slide. We did not actually crop the original source file. Just as with the adjustment tools, Photodex only "borrows" the image data, leaving the source file untouched.

Framing, Layers, and the Elements of Design

When you're creating slides, it's handy to think of the border of the slide area as a frame. Within that frame, we can position, crop, and design composite objects (which can include the background, pictures, and video) to create a composition.

Each object placed in a slide becomes a separate design element, resting on its own layer. (See Chapter 3 for a detailed discussion of layers.) In the following chapters, we'll use motion and other advanced effects to add visual appeal to our productions. Then the frame will be more of a window or screen. Right now, it's time to concentrate on the basic design skills of cropping and placement.

The background is obviously the rearmost element. In front of that, we can add any number of visual elements: pictures, video clips, solid and gradient fills, and (only in Producer) masks. In front of these objects are captions, if you choose to add them. ProShow offers a sophisticated collection of tools allowing us to easily adjust the size, orientation, and appearance of all of these elements.

We'll use these tools to position the silhouette of the couple over the background and then change the appearance of the background to blend in better with the main image. Finally, we will add a caption to complete the slide's design.

Image Sizing and Placement

Click on the Editing icon in the leftmost column again. Hold your mouse cursor over one of the picture's corner squares and the center of the line around the picture and drag in or out to size the image. Adjust the size and position of the image of the couple over the background so that it resembles the example shown in Figure 2.5. Place the mouse cursor over the picture and drag to position the image over the background layer once you have resized it.

Figure 2.5

Sizing and moving an image with a slide is as easy as cropping. All you have to do is use the bounding box handles to size the image; then click and drag to position it.

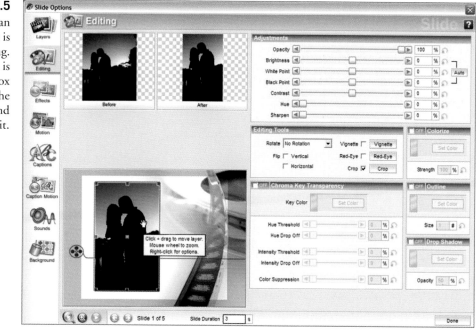

Fine-Tuning the Background

Crafting a professional slide show requires paying attention to details. When there is more than one picture in a slide, they have to complement each other. We cropped the foreground image to show more of the filmstrip. Now we are going to adjust the background using several tools located in the Editing window.

Colorizing the Background

Our first step is to make the color of the filmstrips and film-reel in the background match the dark-blue sky behind the kissing couple better. On my monitor they are gray with a slight green cast. You should still have the Slide Options window open, with the first slide selected. Click on the background icon in the left column, and then click to enable the Colorize Image tool, as shown in Figure 2.6. Now click on the Set Color button, and you'll see a color-selection wheel similar to the one in the illustration.

Just underneath the Cancel button is an eyedropper tool. Click on it and move your mouse cursor over the sky in the picture in the same area as it appears in Figure 2.6. As you move the eyedropper, numbers will appear in the RGB value fields located at the bottom of the Colorize Image box. We want a dark-blue color, but not so dark that the detail in the filmstrip blocks up or visually overpowers the sky. If you don't like the result, repeat the process.

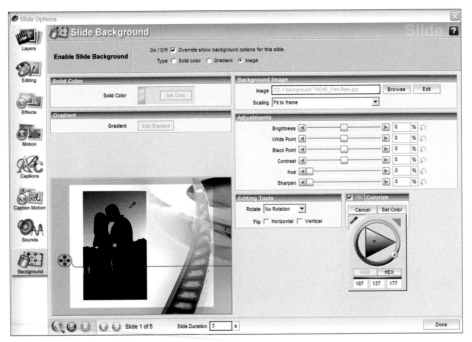

Figure 2.6
The Colorize Image tool can be used to convert a color image to grayscale or to create a toned appearance.

You can also mouse over the color wheel with the eyedropper tool for an appropriate color or manually enter values in the RGB boxes below the wheel. Click the Set Color button when you have what you want. This same interface works with a variety of tools to set color values.

Fine-Tuning Image Contrast and Density

The color is good, but the contrast and black point values look a bit weak when compared to the silhouette next to them. We are going to use the tools in the Adjustments section of the Background window to fine-tune them. Figure 2.7 shows the window as I was editing.

Figure 2.7

Adjusting contrast, brightness, and similar image settings can be done either by using the interactive slider or by entering numeric values in the appropriate box.

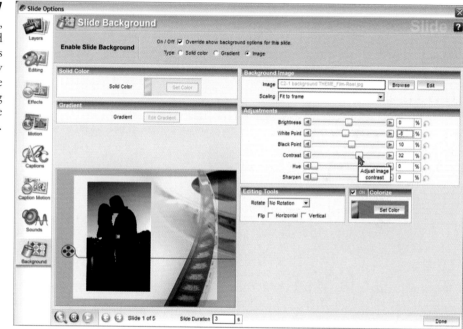

Once again, ProShow lets you either enter an exact number in a box or use an interactive control. It's often easiest to use the interactive controls to get things looking just right. Then you can copy the values to another slide when you need an exact match.

I manipulated the white and black points to get good solid colors and then tuned the contrast and brightness levels to achieve a good tonal range in the image. Adjust the various tools until the background image appearance pleases you.

Adding a Caption

Our final task with this slide is adding the caption that serves as the show title. Click on the Captions icon on the left-hand column of the Slide Options window. As you can see, the available tools have changed. All the options we need to quickly define and style our caption are in one place. The settings in Figure 2.8 have already been set as an example for you.

Figure 2.8
The same style of interactive controls found in the other components of the Slide Options window are used to define captions.

Click inside the white text box on the upper-right side of the window, just under the heading labeled Selected Caption. Type in the words "Joining Two Lives" and place each word on a separate line. As you begin to type, you will see the starting word appear in the Caption List at the top of the window's left column. Now set the Slide Duration field, at the bottom center of the window, to 6. This value is in seconds.

Now we're going to make some adjustments to attacks. Use the Font Selection drop-down menu in the Caption Format section to choose Copperplate Gothic Bold as the font. Then type the number 18 in the Size box. This will set our caption to 18-point text. Click on the bold and italicized letters "**T**" and "*T*" just below the Size box. These set our text to appear bold and italic.

Use the Caption Placement icons in the right column to set the alignment to Center. Once you've chosen all the settings, use your mouse to select the caption and position it properly in the slide window, as shown in Figure 2.8. Click Done to close the window.

Adding the Trailer Slide

The title slide is ready, and we are going to use it to quickly produce a final slide to close the show. Right-click on the first slide and choose Copy; then place the mouse cursor at the end of the show in the Slide List and right-click again. Choose Paste. Then double-click on the slide. Choose Captions in the Slide Options window. Select all of the text in the Selected Caption area. Type "The End," hitting Enter or Return to place the two words on separate lines. The new text will be formatted to match the existing font and size settings. Adjust the placement of the new caption to fit in the area between the picture of the kissing couple and the filmstrip.

Customizing the ProShow User Interface

So far, we have been using the default user interface as the work area. ProShow offers a variety of features that make it easy to sort, place, and edit images and then preview the results. There are lots of neat variations and shortcuts available to customize the work area to suit your needs. We'll use the standard settings in our discussions and for the figures in the book, but you can use the tools that fit your methods best. Let's explore a bit before working on the rest of the slide show.

Figure 2.9 is a composite screenshot showing an alternate work area layout with the related context-sensitive menus all displayed. As you can see, the ProShow designers also included a lot of keyboard shortcuts. The program also provides a variety of additional windows that we will discuss as we use them.

Figure 2.9
The ProShow user interface offers a variety of customization options that let you configure the program to suit your workflow needs and creative style. Each element provides context-sensitive menus to speed your workflow.

The Window/Show submenu shown at the top of Figure 2.9 lets you choose which panes are visible. Then you can use the mouse to adjust how much space each pane uses inside the main window. (Just place the cursor over the edge of the pane so that it changes to a double-headed arrow shape; then drag the boundary to the desired location.)

The Folders and/or Favorites Pane

The upper left-hand corner of the work area in the figure shows the Folders pane, which works just like the one in Windows Explorer. The Favorites pane looks the same but can be configured to show only selected folders. This makes navigating to locate and place content a lot easier than having to navigate through the computer's entire file structure to locate images. One of the first steps I take in designing a slide show is to collect the content into folders and add them to the favorites list. The procedure is simple: right-click on the desired folder in the File List and select the Add to Favorites option in the drop-down menu.

The File List

Below the Folders and Favorites panes is the File List. It can be set to show either thumbnail views or the names of the files in the currently selected chapter. You can either drag into a show from here or use the menu options to add files to your slide show. The File List menu provides an easy way to add slides to a show, sort images by their attributes (date, size, name, type, etc.), and adjust the thumbnail size. You can also add sound clips to the show's soundtrack.

The Slide List

The Slide List should be familiar by now. It offers two context-sensitive menus. Right-click on a silver area of the Slide List or a transition, and the Show Options menu, shown over the title slide in Figure 2.9, will open.

Right-click on the actual image area of a slide, and the menu shown over slides 3 and 4 in Figure 2.9 appears. This provides quick access to a wide variety of slide controls and customizing tools. For example, most of your choices among the Customize Slide options will open the Slide Options window with the appropriate mode already active.

Do you see the Open in Editor option listed on the submenu for the Customize Slide selection? Use it to set up a third-party program like Photoshop for advanced (and permanent) editing of show content. Choosing this option opens the file in the other program and then reloads it with the changes when you exit the editor. To define an editor, choose Preferences from the Edit menu. Then click on the External Editor icon on the left side of the window that opens. Use the Browse button to locate the program you wish to use. ProShow lets you define external image-, sound-, and video-editing programs.

The Light Box Slide View

The Light Box Slide View is very handy when it's time for sorting images or working with a lot of slides. It can be expanded to cover the entire workspace. Then you can drag, drop, copy, set timing and choose transitions, and easily arrange slides, insert blank slides, and adjust transitions. The associated context-sensitive menu also provides controls for previewing the show and opening the Show Options window.

The Preview Area

The right portion of the screenshot above the Slide List contains the Preview Area with the Producer menu visible. The Play and Stop menu commands perform the same functions as the green (Start) and red (Stop) buttons in the lower-left corner of the Preview Area (hidden in the figure by the menu). The Capture Frame(s) option is available in Producer only. The Full Screen option lets us toggle between previews that take over the entire screen or are limited to the Preview Area. Right-clicking on the show during full-screen playback opens the same menu to pause, start, or stop the preview. Be careful with the Open and Close options. Selecting Close will fully exit the ProShow program—and you will lose any unsaved changes.

Photodex's design team gave us a very flexible interface with lots of goodies that are often overlooked. As you work through the book, don't forget to experiment. It's a good way to develop a personal workflow and boost your productivity.

Closer Inspection Using the Timing Indicator and Track Bar

ProShow provides tools that tweak timing to intervals as small as a 1/1000th of a second. It also provides the ability to "walk" through the display in the Preview pane to see exactly how one element of a production interacts with another. This is a very powerful feature and one that we will use often throughout the book. There are two "handles" we can use to pull our show through its paces.

Look at the top of the Slide List in Figure 2.10. See the triangle-shaped pointer on the Slide Show Time bar? I've drawn a red circle around it, just above the transition between the first and second slides. It is a pointer you can drag along the Time bar. As it moves, the Preview pane shows exactly what the viewer will see at that point in the show. You can move the pointer back and forth, and the display will follow precisely. The Preview pane in Figure 2.10 displays the show just before the midway point of the transition. The vertical line inside the red circle in the soundtrack area marks the soundtrack's progress, but you can't grab or pull that.

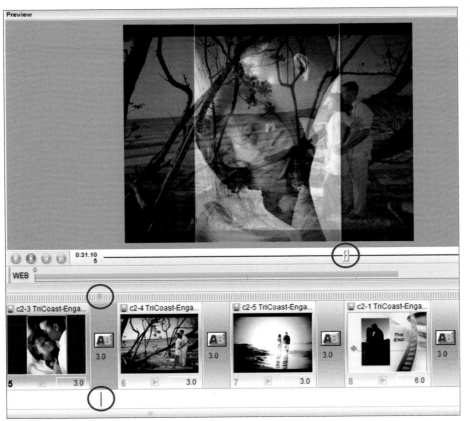

Figure 2.10
The Slide Show Time bar makes it easy to step through a transition of special effects to preview and tweak settings for maximum impact.

The open rectangle just below the main image display, also circled in red, is the second tool and is used the same way as the marker on the Time bar. You can drag the rectangle or the pointer forward or backward, and the show will run in the Preview window to match the pace.

If you want to run a preview in real time for the slide and transition times, use the icons to the left of the bar. They should be familiar to anyone who uses a DVD player. Just above the word "Web" are the green Play and red Stop buttons. The two buttons to their right jump to the beginning and end of the show. The top row of numbers to the right of the buttons gives the current preview's precise time. The number just under that is for the current slide.

Practicing with previews as you work and adjusting the relative timing for each slide and transition (as well as trying alternate transitions) are good ways to develop an eye for effective design. Remember that the "correct" settings are the ones that convey your message and engage the viewer. There may be a lot of science and technology used in multimedia production, but it is still an art and craft as well.

Developing the Primary Content: Variations on a Theme

Let's return to the show. We are going to use a combination of timing, specific transitions, and matched pairs of slides to create the appearance of images morphing from black and white into color and then color into a "toned" version. But before you adjust the timing, the images have to be edited so that you know how the slide display times need to be set.

Our first pair will be the two images of the couple turned to the left (slides 2 and 3). Click once on slide 2 and press the F3 key. This shortcut opens the Slide Options window in Edit mode. You could also right-click on the slide and choose Customize Slide/Edit, or double-click and then choose Edit mode when the Slide Options window appears. After this, I'll just ask you to open the Slide Options window when you need to use it and let you choose the method. There is a chart of keyboard shortcuts in the back of the book.

Converting to Black and White

Use your mouse to enable the colorize tool by placing a check mark in that section, as shown in Figure 2.11. The area just to the right of the check box will turn green. Now type 145 in each of the three HEX value boxes and then click on the Set Color button. Now the image should be visible as a grayscale rendition. Notice

Figure 2.11

Setting the color of the first part of the morphing sequence by using the Colorize feature in the Editing pane of the Slide Options window.

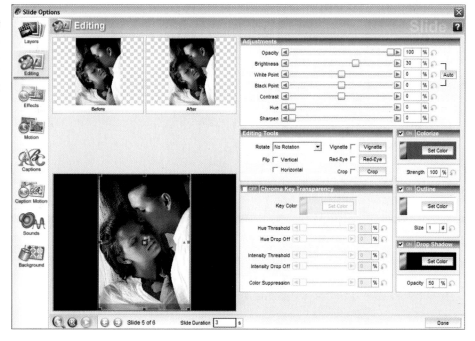

how I've adjusted the Brightness, White Point, Black Point, and Contrast values using the sliders. Adjust your settings to produce a pleasing appearance for your display.

Note

Notice that the same image in slide 3 is still in color. There are really two portions to the ProShow "platform," and mastering the program requires understanding how they work together. It's not complicated—at least for the user. For programmers it's another matter. The part of ProShow we use for arranging slides, working with effects, and adding sounds is the *authoring environment*—the front end. ProShow "reads" information from a source file (like a picture or an audio clip) and then produces its own variation of the information based on the settings. The original is never altered. If you choose to use an external editor to manipulate content (image, video, or sound clip), even if you launch the editor inside ProShow, the files *are* changed.

The back end of ProShow is the rendering engine. It takes over when we tell the program to produce output, like a DVD, an executable file, or a podcast. The program gathers all the files, edits, captions, special effects, and instructions and generates code for the output file.

When we save a ProShow file, we are saving all the information needed to *assemble* the show, but it does not include any *content*. When we start outputting shows, in Chapter 6, I'll cover all the details of file management and how to collect all the files in an archive to make a complete backup.

When finished with your adjustments, click on the right arrow just under the image in the Slide Options window (next to the note that says slide 2 or 6) until slide 5 is selected. (We've just added another ProShow shortcut to your collection.) We are going to get a bit fancier with this slide and define an outline, a drop shadow, and a custom background, as well as give it a sepia tone.

Make sure the Edit icon is selected. Now place a check mark in all three of the boxes located at the far right-hand side of the Slide Options window as shown in Figure 2.12. We are going to assign specific values for the slide's Colorize, Outline, and Drop Shadow options. Click on the associated Set Color button, and enter the following values in the HEX data entry boxes:

- **Colorize.** Use 147, 90, and 80. This gives a good bit more red than green and slightly more green than blue to our color-mix. The result adds sort of a milk chocolate tone to the darker areas of the image.

Figure 2.12
Choosing the Colorize, Outline, and Drop Shadow settings for the fifth slide using the Slide Options window's editing tools.

- **Outline.** The outline will set the image off from the underlying background. We want white, so use 254, 254, and 254. That maxes out the values for each color channel.

- **Drop Shadow.** Here the desired color is black, so the values are 0, 0, and 0— no color at all. If you have not already played with the background values they should already be properly set.

The results looked a little dark on my monitor, so I boosted the brightness to 30. Make whatever adjustments you need to yield a pleasing range of tones on your system. After seeing the effects as the slide show plays, you may want to fine-tune your settings. That's when ProShow's non-destructive editing ability really saves time.

Adding a Custom Background

There's one more modification left to make slide 5 complete: adjusting the background to blend in with the color of the image. Click on the Background icon in the Slide Options window. Then check the "Override show background options for this slide" box and select "Solid color" from the background choices as shown at the top of Figure 2.13.

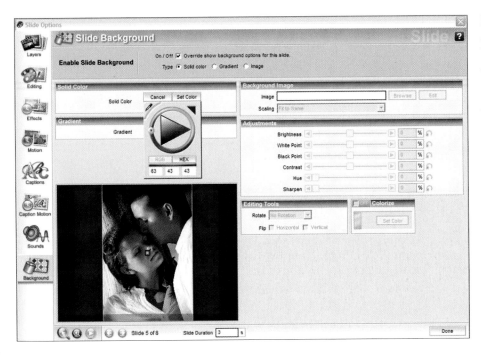

Figure 2.13
Set a solid color
background using the
same basic tools and
interface as the one
used for setting color
when editing images.

Now click on the Set Color button in the Solid Color area of the window and set the values to 63, 43, 43. That is very close to the darker shades in the picture. Then click the Done button to close the window and return to the main ProShow work area.

Workflow, Adding More Slides, and Adjusting Defaults

ProShow lets you add new content at any time, at any position in the show. Use the mouse and drag the remaining two images into the show. Place the file beginning with "c2-4" (the landscape view showing the couple with the driftwood) in the slide 6 position and the one of the couple walking down the beach in position for slide 7. The existing credit slide will now be slide 8.

That was easy. Now for a closer look. (See Figure 2.14.) Things may not appear exactly as expected. Open the Slide Background window by opening the Slide Options window and choosing Background. Both of the new slides have been imported with the title slide's custom background and its colorize options as well. Normally that would require changing the default background in the Show Options/Background window. Resetting the first slide produced the same effect because of the way we dragged the new images into the other new slides.

Figure 2.14

The Slide Options/Background window is where we set and adjust custom backgrounds for a slide. A background is a special layer that is always the farthest back. If the layer(s) in front take up the entire viewing area, the backgrounds won't be visible during preview or playback.

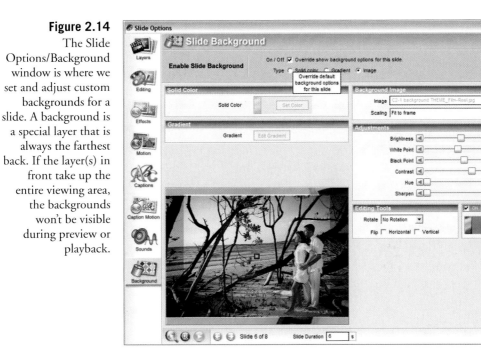

Custom slide values never adjust program defaults. When you drag a new image into the Slide List, ProShow attempts to match it to the slides in immediate proximity. If you drop the image between two slides, it will match the setting of the slide you were hovering over. For example, if slide 1 uses a custom background and slide 2 does not, dropping a new image between them, but hovering it on the slide 1 side of the break between the two will result in the new slide using the custom background. If you hover over slide 2 when you drop the new image, it will use the show defaults just as slide 2 does.

We want to set the background back to solid black. Uncheck the On/Off box that allows overriding of the show background options. The background layer will go black, and the custom colorize settings will be disabled. Now examine the Slide Duration time. It's set to six seconds (another example of adjustable default values). Set that back to three seconds. You will need to repeat this process for slide 7 as well.

The "variable defaults" can be a handy feature but can also make for extra work if you are not paying attention when editing and adding content. When you plan to import a number of slides, start with one first. Examine the settings and make adjustments strategically so you have fewer corrections to make after the fact. Let's say you want all the slides to display for five seconds. First set the "test" slide to five seconds, and then import the rest of the files.

Setting Timing and Selecting Transitions

Novices often underrate the power of proper timing and transitions. A slide show is a performance. Neglecting the dramatic effect of skillful pacing and transitions diminishes the impact of that performance. The two together are powerful tools for establishing the mood of a show and controlling the way slides are presented to the viewer. It is easy to simply use the ProShow defaults or use the Slide menu to assign random effects, but not as effective as crafting them to complement your content and the overall effect you are trying to achieve.

Adjusting Intervals

The default settings for ProShow allow three seconds each for new slide and transition. That's okay for simply displaying pictures. But the complexity of the image, the time needed to accomplish a special effect or enable movement, and the way a slide works with the ones placed before and after it are all factors you should consider to get professional results. Sounds daunting, doesn't it? Not to worry. It's really a matter of developing an educated eye, which comes with practice, and using the right tools—which are conveniently built right into ProShow.

For example, an image with several points of interest might require more time on-screen combined with a few motion effects. But what if you want to keep the pace fast with shorter display times and quick transitions? Then consider showing the image more than once, each time cropped to focus on specific parts of the picture.

The show we are working on is a case in point. Do you want to place the emphasis on the color or the black-and-white rendition of the image in slides 2 and 3? You can change the focus by making one visible for a longer period of time and selecting an appropriate transition. Do you want the viewer to see black and white gradually bloom into full color or burst onto the scene like Dorothy arriving in the Land of Oz? ProShow gives us the controls; we have to craft the design.

Notice the mouse pointer in Figure 2.15 in the lower right-hand corner of the first slide? Click there, and the time displayed becomes a text box, like the one already selected under the transition between the first and second slides. Enter the new value in seconds (you can use a decimal for fractions) and hit the Return/Enter key. Continue that method now using the following settings, as shown in Figure 2.13:

Slide 1 to 6.0 and the following transition to 3.0

Slide 2 to 1.5 and the following transition to 6.0

Slide 3 to 1.5 and the following transition to 3.0

Slide 4 to 1.5 and the following transition to 6.0

Slide 5 to 1.5 and the following transition to 3.0

Figure 2.15
Setting the amount of time for several slides and transitions is easy to do using the Slide List (shown here) or the Light Box Slide View. Individual slides can be timed using the Slide Options window.

Leave the rest of the slides and transitions set to their current values.

The display time for each slide is set shorter than the transition that follows it. That structure smoothly blends the visual effect of shifting from black and white into color with the first pair of images and then from color to the colorized version with the second pair. With identical images in paired slides, the only visible change the viewer sees will be the editing effects performed in ProShow as the images display on the screen. That is due in part to the timing but also to the transitions we used. Use both interactive and real-time previews to see the effect. Experiment a bit with alternate settings to see how variations in timing and transitions make a difference in the quality and impact of the results.

Working with Transitions

Our desired effect requires that one image dissolve into another. If we used a transition that revealed just a portion of the image first, or used a pattern effect, the illusion of a picture blossoming into color or desaturating into a toned version would be lost. The default Crossfade (Blend)-Linear Transition (shown as a raised, beveled rectangular icon labeled A/B) works well, but we can improve the effect. First, let's explore how to choose and apply transitions.

Setting a transition is simple. Select the slide (or multiple slides by holding the Control key while selecting slides), click on the existing transition, and then click on the desired transition's icon in the Choose Transitions window.

ProShow comes with over 280 transitions, all available from the same interactive interface with its own preview function. That makes it easy to see just how a specific effect works with a given pair of slides. Click on the transition icon, located between the first and second slides in our show. Figure 2.16 shows the Choose Transitions window open over our current show with the transition between slide 4 and slide 5 selected. The following list describes the features of the interface.

Transition Chooser

The complete arrays of available transitions are arranged in seven columns. This takes up the majority of the area in the window. The icons are designed to provide a basic idea of how the transitions' effects work. For example, many have

Figure 2.16
The Choose
Transitions window
provides an integrated
environment for
previewing, selecting,
and applying a
transition between
slides.

arrows that show the direction of the effects' movements. Some have numbers to indicate that the transitions involve multiple passes. An *S* over an icon notes a "soft" version—that means that the effect has a soft, rather than a hard, edge during its operation. There are also linear and nonlinear versions of some fades. Linear fades have a constant speed, while nonlinear fades vary the rate of change for a smoother transition.

Transition Preview

This is located in the lower-left corner of the Transition Chooser window. Place the mouse pointer over an icon, and the Transition Preview pane continually demonstrates the selected transition. Move the mouse to a different icon, and the preview will change accordingly.

Current Transition

This is the icon and label displayed directly to the right of the Transition Preview pane, showing what transition you have selected.

Basic Selections

These are the four basic transitions offered on the far right-hand side of the window just under the rightmost column in the Chooser. They are the cut (the next slide simply replaces the preceding image), linear crossfade, nonlinear crossfade, and random transition (ProShow arbitrarily chooses an effect for each transition).

Most Recently Used

The bottom-right corner of the window has a quick-pick array of the most recently used transitions.

It can be tempting to use a variety of transition effects in a show. As a general rule, it's best to choose a few transitions that work well together. The most effective transitions enhance the visual appeal of the slides—without drawing attention to themselves.

We are going to use two types of transitions: one to produce a smooth blending effect within the pairs and another to enhance the distinction when a new picture (not one in a matched pair) appears. Notice the difference between the transitions on either side of slide 2 in Figure 2.16? They are both blend crossfades (A/B transitions). The one in front (lasting three seconds) is linear; the one following (lasting six seconds) is nonlinear.

Change the transitions in front of slides 3 and 5 to the nonlinear style to match Figure 2.16. Now set the transitions following slides 3 and 5 to Double Radar-Clockwise-Soft Edge. Figure 2.16 shows it as the current transition in the Transition Preview pane; it is located under the mouse pointer. The Slide List in the figure shows how your transitions should look after the new selections are in place. Preview the finished show after making the edits.

Tip

It's possible to change all the slide or transition times to the same value simultaneously. To do so, click on a slide (or transition). Then open the Edit menu and choose Select All. Finally, adjust the time as desired on one slide or transition and hit the Return/Enter key.

You can also change the default times for slides and transitions, as well as the default transition and image scaling (fit to frame, fill frame, etc.). To do so, select the Preferences option under the Edit menu, and then click on the Show Defaults icon.

Total Timing Control

Understanding how slide timing and transitions work together is fundamental to mastering ProShow and creating dynamic shows. Having precise control of timing will be essential when we start working with motion effects, layers, and keyframes in the following chapters. Figure 2.17 shows how the timing of the different visual components in each slide relate to each other and summarizes what we have worked with in this chapter.

The total slide viewing time begins with the first moment of the preceding transition, and all or part of it may be displayed right to the very end of the following transition. Just how much or little depends on the type of transition and the content of the slide. For example, a cut transition does just that—it "cuts" from one visual to the next. Use a cut, and the next picture will be shown at once. A fade blends from one image into another. As we have seen, increasing the transition time on a fade will lengthen the effect, and the image will appear more slowly.

During the transitions, portions of the slides before or after the current slide may be blended on the screen (as already shown in Figure 2.17). This is one reason that using the Slide Timeline preview is one of my favorite tools.

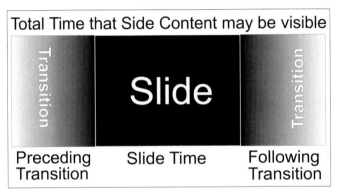

Figure 2.17
Building effective shows in ProShow requires that you master timing and transitions.

Between the two transition times, the visible content is completely under your control with the Slide Options settings. With simple, single-layer slides, controlling slide timing is easy. All you have to do is make sure that the bordering slides and transitions visually work well together. Complex slides (multiple layers, keyframes, caption effects, embedded sound, etc.) require specific timing for each element.

Taking a bit of time to play with slide timing, previews, and various transitions is a great way to get a better understanding of how slide timing works and develop a sense of design. Getting experience is the only way to develop a personal sense of style.

Up Next

Music sets the mood in multimedia, and ProShow has all the tools you need to sync and tune sophisticated soundtracks. We turn our attention to adding and editing audio files and producing professional-sounding fades and effects. You'll also see how ProShow lets you incorporate voice-overs and video clips into your shows.

3

Frames, Motion, and the Layered Look

Harnessing ProShow's full power requires moving past the traditional definitions of "slides" and "slide shows." Technology moves faster than language. We still use the term *movie*, yet modern special effects have taken cinematography far beyond a string of jerky black-and-white "moving pictures" from the days of silent films into an era when we see virtual worlds populated with living actors in high-definition color. The word *movie* is a label, not a description.

In the same way, the modern slide show has moved past the traditional series of still images projected onto a screen into a multimedia production platform. A skilled storyteller can use Producer to create shows with the same level of quality one expects from masters like Ken Burns. The key to mastery is in seeing that the slide is much more than a simple picture and developing the skills to exploit this new power. This is a theme that runs throughout the book. We'll keep expanding our understanding and our ability to use ProShow's advanced features in each chapter.

The Slide as a Stage

A still image is a frozen moment in time. The viewer is limited to the vision the photographer saw at the split second the shutter opened. Old slide shows were just collections of stills played one after the other. That changed when modern multimedia slide shows first appeared during the 1967 International and Universal Exposition in Montreal. Producers used multiple slide projectors to blend images,

transition slides, and special effects—combined with sounds on a wide screen. That broke the concept of the slide as a simple picture, and designers started looking for ways to add effects and more eye candy to their work. Today's digital slide is more like a stage on which we can introduce a variety of visual elements and allow them to interact under our direction.

A ProShow production can consist of a simple array of single images played one after the other. That's not very visually exciting. We are going to go deeper, using layers to stack multiple images into a single slide, control how they move, and give them the ability to interact. The boundaries of the display area become a frame in which we can make the pictures move. This lets us blend visual elements and combine pictures, or parts of pictures, into collages.

With motion effects, we can animate still images, drawing the viewer's focus to specific parts of the composition and adding vitality to the production. We can use transparency to reveal portions of underlying pictures and let multiple images share the spotlight at the same time. And we can make layers move in relation to each other. (That's why both subjects are presented in a single chapter.)

I'll focus most of the discussion on features common to Gold and Producer and on the basics of working with layers and motion effects. I'll save advanced concepts like keyframes, carrying effects across several slides, and Producer's masking and vignetting capabilities for later in the book. I have taken almost all of the screenshots in this chapter from Producer so you can examine its advantages for crafting basic motion effects. I've also included screenshots of the primary windows from Gold so you can compare the two products.

Framing Images: A Working Demonstration

Let's begin by watching a short slide show that uses layers, image transparency, and motion effects to showcase a series of wedding and engagement photographs created by TriCoast photographers Mike Fulton and Cody Clinton. After the show finishes, we'll dissect it so you can create a similar production of your own. Open the Chapter 03 folder on the companion CD-ROM, locate the file FrameLayers_01.exe, and double-click on it. The show lasts for just under 35 seconds and has four slides. It's possible to make the show using either Gold or Producer.

As you view the production, use a critical eye. Every time we watch a production, it is a chance to improve our own skills and techniques. See if you can identify the effects used and figure out how they were created. Notice the way each image is cropped. Does the crop produce a pleasing composition? How well do the motion effects draw the viewer's attention? Does one element overpower another? Should it? Would a longer or shorter time on a slide or a different transition improve the product?

These are not test questions. There are no right and wrong answers. As slide show creators, we should use every opportunity to extend our creative vision. Each time you view another person's production, or one of your own, it should be with the same critical eye. That is not negative, just an admission that the editing process can almost always improve a show and that every production has something to teach us.

This production could have been created in either Gold or Producer. The show's designer used image files with transparent sections to frame the eight pictures and added motion effects to increase visual interest and draw the viewer's eye. (Note that not all file formats support transparency, and an external editor, like Adobe Photoshop, is needed to add transparency to an image. Photodex does provide a selection of prepared files, like the frames in Figure 3.1, both with ProShow and in its MediaSource collections, sold separately.) We'll use these elements to explore both techniques and learn more about using layers and motion effects. The designer used Producer to craft the production, so the file will not open in Gold. We'll use Producer here so we can access all of its advanced features. If you do not have Producer, you can use the trial version to complete the activities in this chapter.

Figure 3.1

Transparent areas on one layer can be used as borders to frame images within a slide, creating a composite effect.

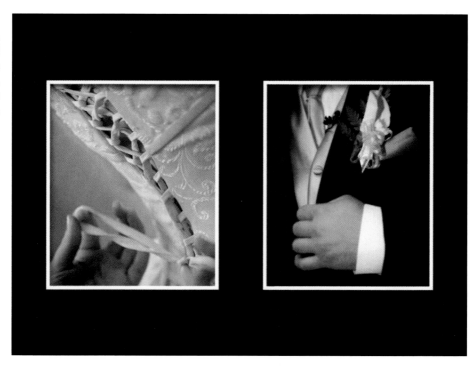

Examine the content thumbnails visible in Producer's File pane. The first two items are frames from the ProShow package. The first one is the double frame used in slide 2, and the next one is the single used in slide 4. The other frames you saw during the show were TriCoast wedding pictures that were modified using an external editor (like Adobe Photoshop) to render part of the image transparent. Gold and Producer both support transparency in Adobe Photoshop (.psd), Portable Network Graphic (.png), Graphics Interchange File Format (.gif), and Tagged Image File Format (.tiff). To make designing the examples easier, I've included all the necessary files in the Chapter 3 folder on the companion CD-ROM.

> **Note**
>
> PNG and Photoshop PSD formats will generally produce better results when working with transparency in ProShow. The GIF format has limitations that may reduce quality.

Setting the Stage, Defining the Show

ProShow shows can be placed on everything from a small iPod to a wall-sized HDTV. To fill the screen with a fast-loading image at the proper resolution requires planning ahead. Before we start working with layers, we should adjust the show and slide settings to match our desired target device, output media, and optimize overall performance. Here's how to do it.

Setting a Title and the Aspect Ratio

Every time you create a new show in ProShow, you have the ability to set the show title and aspect ratio via the New Slide Show dialog box (shown in Figure 3.2). The show title is used as a working title within the ProShow interface and in menus when you output your work. Setting it at the beginning saves time and ensures that you don't end up with "Untitled Show 1" as a name if you forget to change the default setting later.

It's also a good idea to set the specific aspect ratio for your primary desired output device right away. Aspect ratio is the relationship between the height and width of the slides in your show—it is not the exact dimensions in units of measure.

ProShow offers three aspect ratios: 4:3, 16:9, and custom. The 4:3 setting is for standard full-screen television and is the traditional format for computer monitors. The widescreen, or 16:9, setting should be used when you plan on showing your work on HDTV or widescreen devices. The custom setting is for any other aspect ratio.

In practice, I often skip entering options in the New Slide Show dialog box (shown in Figure 3.2) and immediately open the General Show Options window. Access it by choosing Show Options from the Show menu. It has fields to enter the aspect ratio and show title, plus additional settings that save time and ensure you don't overlook these options.

Figure 3.2
The New Slide Show dialog box is presented every time you choose New Slide Show from the File menu.

Adding a Show Thumbnail

The show thumbnail is used as the graphic for output menus and as an icon for the show. It will default to the first slide in your show and let you specify a different image for each slide using the General Show Options window. Click on the Select button in the Thumbnail section of the window. A dialog box will open to let you choose either a slide from the show or an image file of your choosing.

Determining the Correct Safe Zone

Standard CRT-based televisions and other viewing devices (that use the 4:3 ratio format) often clip the edges of images displayed on the screen during playback. If you place important parts of your show in that area, viewers won't see them. This can limit the visual impact of your design and render portions of captions unintelligible. ProShow lets you specify a safe zone, which acts as a safety margin. Look at the area below the Show Thumbnail pane in Figure 3.3. The gray border around the black rectangle shows the portion of the slide that may be cut off during playback based on the current safe zone settings. The black area shows where we can place important elements. The default settings provide 10 percent horizontal and 5 percent vertical margins based on the current aspect ratio settings. In general, the default settings (standard TV or widescreen) should work fine for most applications. Choose the one that will best suit your intended output device.

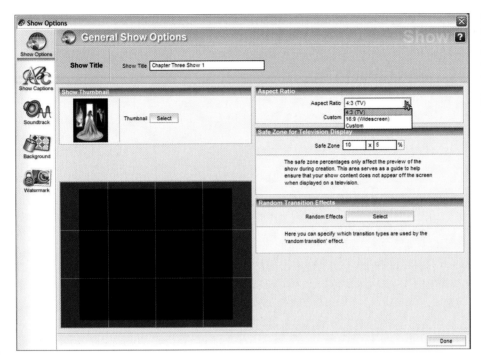

Figure 3.3
It's a good idea to set
all the General Show
Options when you
begin, even though
you can adjust them
later in the process.

Scaling Images within the Frame

There's one other set of global adjustments we should make before moving on. Open the Edit menu and choose the Preferences option. Now click on the Show Defaults icon, and you'll see a window like the one in Figure 3.4. Notice the Default Image Settings section, which is the fly-out menu opened in the figure. This setting will determine exactly how layers in the slide will be scaled to fit the area.

While it is possible to override these global settings for individual frames, you'll want to have this option set to match the desired setting for the majority of your images. Here is what each of the five options does.

Fill Frame forces the content of a layer to fill the entire frame (including the area defined as outside the safe zone). It can crop the edges of one side of an image. The setting is mostly used for backgrounds, where cropping doesn't really matter. It's generally not a good idea if you want to make sure that everything in a picture is visible.

Fit Frame resizes the entire image to make it fit within the frame, which may result in the background's being visible. It will resemble the letterbox effect seen when a widescreen movie plays on a regular 4:5 ratio TV set.

Figure 3.4
Make sure the Default Image Settings have the proper scale before beginning work on a new show.

Stretch to Frame stretches the image so it fills the entire slide. Unless the aspect ratio of the original image is exactly the same as that of the frame, the image will be distorted. This setting is generally useful only for abstract images and backgrounds.

Fill Safe Zone works much like Fill Frame but limits the workable area to what lies inside the defined safe zone. Once again, the image may be cropped.

Fit to Safe Zone ensures the entire image fits within the safe zone. Once again, part of the background may be visible in the display.

Determining the Proper Output Resolution

All shows are not created equal. Some are destined for really big screens; others will be seen online or on an mp3 player—much smaller venues. Many may play on both. Whenever possible, use the highest resolution source files. This gives ProShow the best possible image quality to work with in rendering the final output. Keep in mind that larger files require more storage space and will take longer to render and download and will use more computer resources. If you are making a large show or producing very large files (individual full format RAW and TIFF files from professional digital cameras often top over 25MB each), generating maximum quality jpegs for use in your production can streamline rendering, download, and playback times.

For optimal performance and output quality, consider the question at the top of the Create Output window before importing your images: "What Do You Want to Create?" Then make sure that the original images you imported have *at least* that much definition. For the Web and small-screen players, 800 x 600 dpi is often all that is required. For HDTV or a typical PC monitor, 1024 x 768 is generally acceptable.

Want to produce a show with great quality on screens large and small and that still provides optimal performance? Start by working with high-resolution files and use a third-party program to batch resize them to match the final requirements for each target device. I'll go over the steps and suggest software solutions when we cover outputting shows.

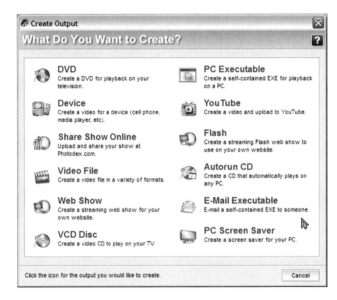

Figure 3.5
You won't be working with the Create Output window until the show is completed, but the target device should be part of your planning.

Working with Layers

Layers are one of ProShow's most powerful design features. You must have a firm understanding of how they work and how to use them to produce professional results. Open ProShow Producer and then load the FramesLayers01 Producer slide show file located in the Chapter 03 folder. Once the show loads, double-click on the first slide to open the Slide Options window. Make sure it is in Slide Images and Video mode, as shown in Figure 3.6. (Figure 3.6a shows the same window in Gold.)

Figure 3.6
Slide Images and
Video mode in the
Slide Options
window provides the
controls you need to
manage the visual
content in slides. This
is the Producer
version.

Figure 3.6a
The Gold version of
the Slide Options
window in Layers
mode. Notice that it
does not offer
masking, template,
actions, or water-
marking options. As
you can see in the
menu, Gold does not
offer a grid or display
a motion path.

The basic structure of the Slide Options window should be familiar by now. The left column in this mode lists all of the visual contents, with each element placed on its own layer. The current layer's label is highlighted in gray. We'll cover how to select and work with individual layers and the related tools shortly.

Below the Contents List is the Preview Area, showing the currently selected layer. Right-click on the image to open the Preview Settings menu, as shown in Figure 3.6. These options determine how previews appear in both this window and the larger Precision Preview window we are about to open and are basically self-explanatory. Toggle the check marks until your screen matches the ones in the figure. That will ensure that your screen shows the same details as we adjust layers and set up motion effects. Once they are set, close the menu and double-click on the image to bring up the Precision Preview window, as shown in Figure 3.7.

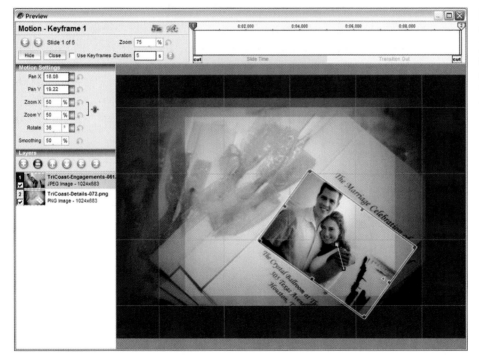

Figure 3.7
Changing a layer's position in the slide's stack order is as easy as a mouse click in the Precision Preview window.

This slide has two layers. Layers are stacked in the order they are added to the slide, and order is important. Layer 1 is an image of a wedding invitation. It is the topmost layer in the stack. Layer 2 is an engagement portrait of a young couple. The buttons just above the Layers List in the left-hand column are used to add, remove, hide, show, and reassign layers.

Notice how the picture of the couple is darkened. That's because we set the ProShow interface to render only the currently selected layer at full brightness.

Feel free to experiment with the options for the preview. Each setting offers advantages. Which one is "best" will depend on personal preference and the project at hand.

Above the Layers List are the controls for manually adjusting motion effects. We will return to those later. Above them on the left side are two buttons labeled Hide and Close. The Hide button closes the Layers and Motion Settings panes, increasing the size of the Preview Area. The two buttons above them let you navigate to other slides in the show.

The box to the right of the magnifying glass icon changes the size of the current layer on the slide. You can either enter a value (negative numbers shrink the image; positive ones enlarge it) or use the familiar drop-down slider bar. Below that are the Slide Timing box and a Preview button. The area in the upper-right corner of the Precision Preview window shows a graphic that details the slide's keyframes. We'll cover that tool later in the book.

The number to the left of each thumbnail shows the current order of each layer in the stack. The check box just below the number must be marked for a layer to be visible. Try it. Uncheck Layer 1. The content for that layer is now disabled. It will not be visible as long as it is unchecked, either when previewed or when the show is output in final format. Now all you can see is Layer 2, the picture of the couple.

Recheck the box for Layer 1 and uncheck Layer 2. Now the wedding invitation is visible, but the space for the other picture is black. That's the background showing through the transparent portion of Layer 1. (Remember that the background is a separate element of each slide and is not listed as a standard layer or considered in the numbering scheme.) Press the Preview button, and you'll see that only the first layer in the slide is displayed while the show plays. Go ahead and re-enable Layer 2.

Make sure Layer 2 is selected. It should be slightly grayed. (Click once on the thumbnail if it is not.) Then click on the third button from the left at the top of the layer stack, the one with the arrow pointing up. The Preview pane should look like the one in Figure 3.7. The button to the right moves the currently selected layer down. (The two buttons to the far right side of the row are used to add and remove layers from a mask—a more advanced topic we will cover later in the book.)

Now the slide should have the picture of the couple on top of the grayed-out invitation, as shown in Figure 3.7. The layer numbers have been changed to indicate their new positions in stacking order. Press the Preview button once more. The slide's design is radically altered, as the picture of the couple is now on top of the invitation. Once the preview has finished, place the layer with the couple back underneath the invitation. The slide is restored to its original form.

There is a green square outlined in red near the middle of the bride's gown in Figure 3.8 and a line running down to the right that ends at a red square. This is the motion path that the layer with the dress travels during the time the slide is visible in the show. I'll cover how to use motion effects later in this chapter. It is important to understand that having more than one layer in a slide, and the ability to move layers in relation to each other, is fundamental to producing advanced effects in your presentations. The neat thing about ProShow is how easy it is to incorporate layers.

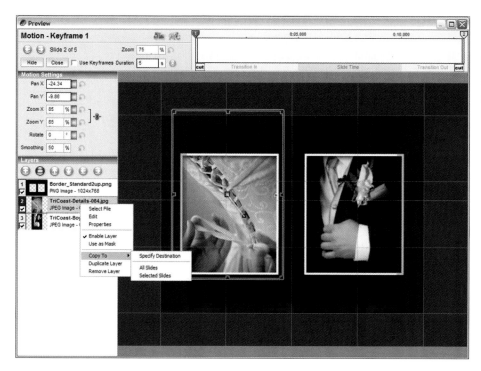

Figure 3.8
Right-click on a layer in the stack in the Precision Preview window to open the secondary content-sensitive Layers menu.

Change the active slide to slide 2 by clicking on the Next Slide button in the upper-left section of the Precision Preview window. This slide has three layers. The topmost layer has two transparent areas that frame the two pictures underneath and let us crop the underlying layers to show just the parts we want the viewer to focus on. Adding motion to the two lower layers lets them move in relation to both the frame and each other. That can be a very powerful visual tool for adding interest and creating relationships between the elements of a slide.

Right-click on the tab for Layer 2, as shown in Figure 3.8. This opens a handy flyout menu worthy of a formal introduction. The first option, Select File, lets you change the file (picture, movie clip, etc.) placed on the currently selected layer. The Edit option opens the selected layer's file in the external editor designated for that file type in the program's Preferences settings.

Choose the third option, Properties. A new child window will open, like the one shown in Figure 3.9, divided into two major areas. The top portion shows a thumbnail of the image in the layer next to a properties list. This information can be very handy during design. For example, knowing the length of a video clip lets you plan how to work it into a show. Knowing the size of your source files can be handy if you need to reduce the overall size of a production, both for playback and for archiving. I like using the Precision Preview window when making detailed adjustments to a layer because it offers a larger image size.

Figure 3.9
The Properties window provides a variety of facts about a layer's content.

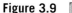

The second section of the menu lets you enable or disable the layer or define it as a mask. (Masks are a Producer-only feature you can use to hide or reveal only portions of the layers underneath.) We'll cover masking in more detail later in the book.

I've expanded the third section of the window in Figure 3.9 to show the options contained in the submenu. It provides a quick way to copy identical layer elements on other (or all) slides in the show, as well as to duplicate or remove layers within the current slide.

Use the Next Slide button to display the third slide in the show. Your screen should look like the one in Figure 3.10. Here the show's designer has used the Duplicate Layer command to generate a second copy of Layer 1 and made it Layer 2. Both copies have been sized to create the impression of a single tabletop with four frames and two candles. The picture frames have been made transparent in an external editor, just like the area in the invitation in slide 1 that revealed the engagement portrait of the couple on the lower layer.

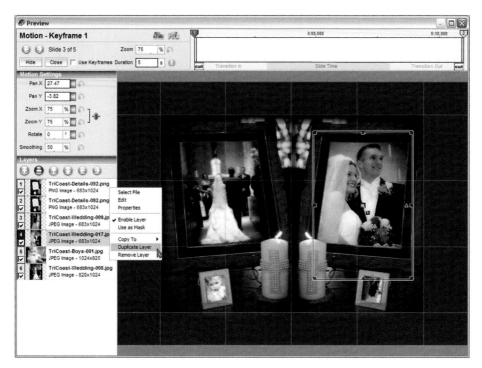

Figure 3.10
Slide 3 uses reversed
duplicates of one
picture on two
separate layers to
create mirrored sets of
frames and candles.
(Notice that the
Window Display
setting now has all
layers at full
brightness.)

Adding Content and Adjusting Layers

We are going to make a second version of this slide from scratch and work with
ProShow's layer adjustment controls and motion effects. If you already have the
show open, close any Slide Option and/or Precision Preview windows. The main
Producer window should have the Slide List enabled. If you have not been fol-
lowing along, please have ProShow open with the FrameLayers_01 show loaded
and the File List set to display the show's content.

The quickest way to duplicate would be to copy and paste slide 3 into the slide 5
position. But that wouldn't let you practice adjusting and manipulating layers, and
we are not going to make an exact copy. Instead, let's drag and drop the thumb-
nail of the picture with the lighted candle and two picture frames into the loca-
tion for slide 5.

Now we need to make a second copy of Layer 1 and reverse it. Left-click on the
green button with the plus sign and phrase "Add another layer" and choose
Duplicate Layer from the menu shown in Figure 3.11. (You could also accom-
plish the same task by holding down the Control key and dragging a second copy
onto slide 5.) We'll be adding some other layers soon, but we'll get the first two
arranged before doing that.

Figure 3.11
Adding a second copy
of the image using the
Duplicate Layer
command.

Figure 3.12
Using the mouse is
the easiest way to
quickly position and
scale layers within a
slide.

We now have two layers, one on top of the other in the center of the slide. Use your mouse to drag them into place, as shown in Figure 3.12. In that screenshot the layer on the right side is selected and being moved. We can tell because the layer information in the list is highlighted in gray and the number on the left of the listing is colored in blue.

See the hand-shaped cursor? It appears when the left mouse button is held down and indicates that any movement of the mouse will also move the layer. We want the slides to be side by side and the same size. The mouse wheel can be used to change the size of a layer and with it the size of that layer's image. You can also place the mouse cursor over the little boxes in the corners or midpoints of a layer's borders to resize it. When you do, the cursor will change into a line with pointers on each end. Drag the cursor to adjust the size. Another way to enlarge or reduce a layer is to use the Zoom slider in the Layer Settings portion of the window.

We can quickly position a layer within a frame using the mouse, and that method works fine when you don't need to be all that precise. Here we want to position the layers so that the candles and frames are vertically centered exactly the same. We can start with the mouse and then fine-tune the settings by pinpointing the placement using X and Y coordinates (yep, numbers). It's not hard to master.

Positioning Layers Precisely within the Frame

Position is the location of a layer vertically and horizontally relative to the center. A zero value places the image in the middle, on both axes. Move one of the layers with the mouse inside the Preview Area in the Slide Options window with the Layers tab active. This time watch the numbers in the Position entry located in the Layer Settings. The values will change as the layer moves. Move the image to the upper-left corner and the X and Y numbers both will show negative values. Drag the layer to the lower-right corner and they both become positive as the center of the layer passes through the middle of the frame. Figure 3.13 has an overlay showing the X-Y quadrants.

Use the mouse to adjust Layers 1 and 2 so that they look similar to the example in the figure, but not too similar. Now we are going to align the candles perfectly on the Y axis (the vertical axis). Choose Layer 1 and place a zero in the right-hand Position data entry box. (The mouse point in Figure 3.13 is just under it.) Now adjust the setting for Layer 2 the same way. With both values set at zero, they are aligned vertically.

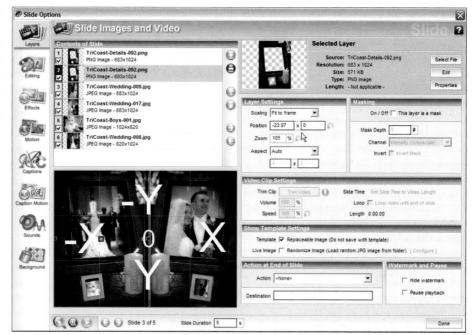

Adjusting the Position Coordinates

If we use the same values for both images on the X-axis (the horizontal axis), one layer will cover the other. Try it. Change the numbers for the other layer to zero as well. Instead, what we want is for both layers to have the same horizontal offset: the image on the left needs a negative value that exactly matches the positive number used for the one on the right and leaves very little space between them.

The easy way to do that is to use the mouse to adjust one layer and then enter the "opposite" value for the other (either positive or negative depending on which layer you adjusted first). That is what was done in Figure 3.13. My Position settings are 2397 and 0 for Layer 1 and -23.97 and 0 for Layer 2. Your settings may vary a bit because I slightly adjusted my Zoom value, our next point of discussion.

Adding and Ordering New Layers

Right-click in the Preview Area of the Slide Options window and set the menu option to darken the inactive layers. This makes it easier to see and adjust the active layer when there are several to be adjusted in a single slide. Now add four new layers to slide 5, as shown in Figure 3.14. Hold the Control key and drag the last four images in the Chapter 3 folder onto the slide, one at a time. The filenames all start with the letter *z* to make it easy to identify them.

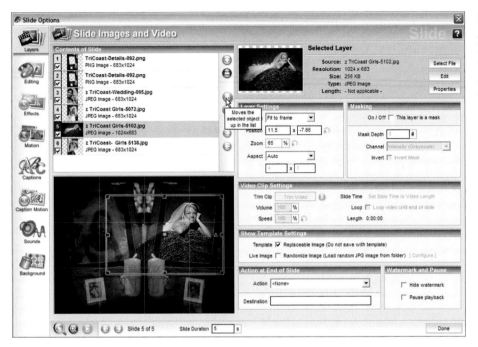

Figure 3.14
Adjusting the order of
layers is often the first
task after importing
new images into a
slide.

Once you've imported them, use the up and down arrows to place the layers in
the right order. (The up arrow is next to the mouse cursor and has a tooltip visi-
ble in Figure 3.14.) Place the image of the bride putting on an earring on Layer
3, the bride in front of the red wall on Layer 4, the bride resting on the hay on
Layer 5, and the bride with the bouquet on Layer 6.

Layer order becomes important when more than one object uses the same space
on a slide, when two objects have to move through the same space, or for special
effects involving masking and opacity. The reason the bride with the red wall is
on Layer 4 is so she won't hide the image on Layer 3, which is what would hap-
pen if their order were reversed. When you add motion, the placement has to work
the entire time the slide is displayed. You don't want part of one layer covering
another at the wrong time.

Adjusting Size and Rotation

When you drop an image onto a slide, the new arrival is automatically sized to fit
the available space based on the current scaling defaults and is assigned a Zoom
value of 100 (percent). Zooming changes the visual magnification of a layer. A
layer can be zoomed using the mouse wheel or by setting a percentage in the Zoom
box in the Layer Settings section. It can be entered as a number or adjusted using
the slider, accessed by left-clicking the marker beneath the number in the box.

Make the number larger than 100 and the image gets larger; a negative number shrinks the layer on the slide. We are going to do both using the mouse.

Planning for a Move

The four new layers are going to reside underneath the picture frames in Layers 1 and 2. We need to zoom and rotate them into their starting positions. We'll adjust the ending position and create the motion effects after all four are in place. Double-click on the Preview Area in the Slide Options window to open the Precision Preview window, shown in Figure 3.15.

Figure 3.15
Adjusting the zoom and rotation of a layer can be done quickly with the mouse or precisely by entering the coordinate values in the appropriate box.

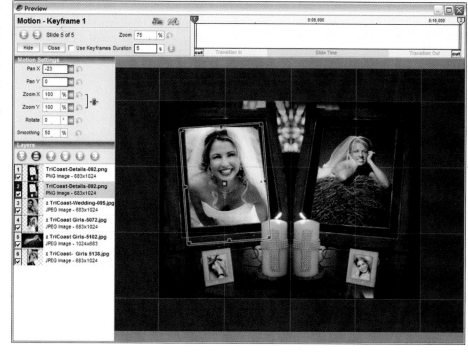

Select Layer 4, the bride in front of the red wall. Use the mouse wheel to zoom her to about 80 percent. See the triangle-shaped device just inside the box located at the middle of each side of the box around the layer in Figure 3.15? That's the handle for rotating a layer. Drag it so that our bride is in the same position as the example in the figure. The outer edge of this layer should be outside the picture frame in the layer above.

You may find it easier to set the display to "Show Inactive Layers" so that all are bright in the preview for this task. Now select the remaining layers and adjust the zoom and rotation so they look like the example in Figure 3.15.

Tip

Consider both source and output resolution when making an extreme zoom. The resolution at the largest zoom factor must still be sufficient to provide a good image at output on the most detailed display device.

Fine-Tuning the Design Is an Iterative Process

The basic design for the slide is complete. The four brides are framed by the top two layers' pictures. But there is still some work to do before we start adding motion effects. Depending on how we crop the brides, part of the red wall in Layer 4 and the gown in Layer 6 will be visible on the edges of the slide. I've already cropped Layer 5 in Figure 3.15 and left the distracting portion of Layer 6 showing. Use the Crop feature in the Editing tab to adjust your layers.

It's a good habit to run a full-screen preview of the preceding slide and transition as well as the slide you are working on once you have finished placing and adjusting the layers. It is easy to overlook something and takes more effort to correct after you add advanced effects like motion.

Why bother to look at the preceding slide and transition before moving to the next pair? They set the stage for the next slide. As the preview runs, watch how the contents (subject, placement, color, lines within the images, effects) work with each other. There are two useful concepts and techniques we can borrow from motion picture production when designing our slide shows: continuity and eye carriage.

Professional movie sets have one person, a very detail-oriented individual, assigned to maintain continuity between scenes. This person makes sure that between takes all the little things in the picture look exactly the same. If a glass of water was half-full when the camera stopped rolling, that person makes sure it has exactly the same amount of water when the director calls for action again. The same thing is true for the placement of chairs, the direction of lighting on the subjects, and every detail in the actors' clothing. The continuity person also makes sure that the actors enter and exit the scene as expected.

When we preview our slides, we want to watch for continuity, too. Although our viewers may not expect the same level of continuity found in motion pictures, we do want to ensure that the way one image changes into another is not a distraction or that the change in subject is not jarring—unless it's deliberate.

Eye carriage is a term used to refer to the way that a visual design of an image, or a series of images, draws and moves a viewer's eyes into the principal point of interest. Graphic design and artistic composition training programs spend a lot of time developing skills related to continuity and eye carriage. Many instructors start increasing students' skills by raising their awareness of what draws or distracts from their own attention and applying it to their work. That's a good habit for ProShow producers to develop, too.

Getting Things Moving

One of the most effective eye-carriage tools is movement. We see it all the time in movies and commercials. Now we are going to use it to enliven our show. First, a bit of background. Your monitor, a TV set (no matter what kind), and a motion picture all use a similar technique to present information to our eyes. A series of images is presented at a set pace, ranging from about 25 to 60 frames per second. This is called the refresh rate. Consider a word processor while you are typing. Unchanged words already on the page just keep getting redrawn on the monitor. The cursor and any new or changed items are drawn just as soon as the graphics adapter sends the new image to the display device.

In TV and movies—and yes, ProShow productions—the changes between frames produce the illusion of movement. The images are all just still images, and our brains are fooled into seeing them move. The faster the frame rate, the smoother the motion effect. If the frame rate is too slow, or if the image is not precisely aligned between frames, the illusion is lost and the picture will seem to "jitter" or jump on the screen.

Motion effects make use of four possible attributes, which can be combined to produce complex effects.

> **Panning** is when we shift the *position* of a layer within the frame as the slide is shown, adjusting the X and Y coordinates. The objects on the layer appear to move across the field of view. Panning is a technical term from the motion picture industry. It refers to the changing point of view as the camera follows the movement within the scene. Just as with a movie, the display device creates a fixed frame for our show, and the subject appears to move in relation to the boundaries. Each pan has fixed start and end positions that are described within ProShow using X and Y coordinates.
>
> Panning creates the illusion of motion, like the images of the airplanes "flying" in the shows we watched in the first chapter. We can also use it to show detail by slowly panning across a wide scene. Panning does not change the size of a layer.

Zooming adjusts the *magnification* ratio of the layer as the slide is being shown. Enlarging an object in size during playback increases its importance and focuses the audience's attention to that part of the image. Pulling back to show a wider area, or reducing the size of objects, adds perspective or diminishes the importance of a subject. For instance, the beginning of a slide might show the face of a single person and then zoom out to show the entire crowd gathered in Times Square for New Year's Eve.

Rotation is the third tool. It can be used as a simple design element, like making a caption spin into the frame. It can also be used to create the perception of "real" action. For example, we might make a propeller turn in front of an airplane or make the wheels turn on a car. Of course, such rotating elements must reside on layers stacked above the stationary parts of the slide.

Pace, the speed at which a motion effect occurs, is the fourth variable. In Gold, we are limited to the time the slide is on the screen, since each layer is linked to the display time for the entire slide. Producer lets us set multiple keyframes with their own display times for each layer in a slide and even within layers. With keyframes, we can force an action to happen faster than the total slide time allots. If we wish for an effect to last longer, we must either increase the total slide time or carry the effect to the next slide. (We will work with that technique when we deal with advanced motion effects and keyframing.)

Setting and coordinating motion effects attributes with the mouse is easier than describing them. ProShow does most of the work; all a user has to do is adjust a layer's appearance at the beginning and ending points of the display time. Experienced users tend to use the same techniques with adjusting motion as they do with layers. They develop a plan, get things started with the mouse, and then fine-tune the numbers as needed.

Beginnings and Ends: Motion Effects Demystified

Let's add some motion to slide 5 and explore ProShow's motion tools. Open it in the Slide Options window and choose the Motion tab. Your screen should look similar to the one in Figure 3.16 (or 3.16a, for Gold users). Use the Selected Layer drop-down menu in the upper left-hand corner of the window to make Layer 4 active.

Working with the Motion Effects Window

The Motion Effects window presents previews of the current slide at both the very beginning and the very end of its display within the show. The difference in the appearance of those two previews reveals the total change due to any motion

Figure 3.16

Panning, zooming, and rotating a layer can all be done quickly using Producer's Motion Effects window and your mouse.

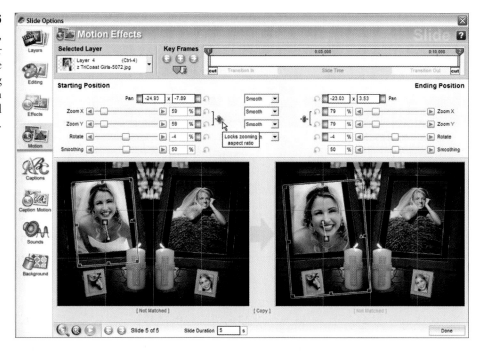

Figure 3.16a

Gold's Motion Effects window offers the same basic controls as the more elaborate Producer version (shown in Figure 3.16). Notice the single Zoom axis slider and that the Keyframe section is missing. Gold does not support editing keyframes.

effects. Adjust the layer using either the mouse or the controls directly above the previews. ProShow automatically generates variations of the image to match the playback framerate.

When starting out on a trip, it's a good idea to know where you are, where you're going, and how you'll reach your destination. That's a good habit to adopt with ProShow's motion effects, too. I tend to begin by adjusting all the layers in a slide (even the ones that won't move) on the starting position (left) side of the window before making any adjustments to the ending position, on the right side. We can use all the Layers, Editing, and Effects tools to get each layer looking just the way we want for the start of the slide. Then it's time to focus on the starting point.

Lining Up and Timing Layers

In Figure 3.16, the active layer has been given different Pan and Zoom settings for the start and end locations. As the slide plays, the image will grow larger and move so that the bride's face moves toward the middle of the picture frame. The line drawn over the active layer indicates the motion path during playback. See the two green boxes connected with a line on the selected layer in Figure 3.16? The line denotes the path of travel. The boxes mark the start and end points for the layer's center. (Producer can have multiple points thanks to the Keyframes feature; more on that later.) The box with the red frame shows the center position at that point in the playback.

Take another look at Figure 3.16. Notice how the blue rectangle showing the full area of the layer extends past the small picture frame underneath it for the end preview? That's why we have to place this layer below the one that shows in the smaller frame. If it were in front, it would zoom to cover the lower layer and show in the smaller picture frame.

The motion line lets us get a sense of the relative speed of an effect in relation to the amount of time a slide is displayed during the show. Consider our current example. This slide is set to run for five seconds. The movement line is mostly vertical and is about one-fifth the height of the slide. That pace will produce a relatively slow effect. A layer with a horizontal line going all the way across the slide would have to move much faster. We can slow down an effect by increasing the play time for the slide, or by shortening the line. A basic rule: The longer the line or slide time, the slower the apparent motion. The shorter the time or line, the faster the apparent motion.

Before working on the end point, make sure the desired layer is active and the starting point is exactly where you want it. Then drag the center of the layer to its new location, and use the mouse wheel to zoom the image to the proper size. Do that now with Layer 4.

The X and Y of Zooming

Producer offers a really neat Zoom feature, the ability to independently adjust X and Y values. That lets us stretch either the horizontal or the vertical aspect of a layer. The most common use is to adjust a background so it fills the frame. It can also come in handy for tweaking a foreground layer—especially a frame.

See the symbol the mouse cursor is pointing at in Figure 3.16? The X and Y settings are linked to hold the current aspect ratio when it looks like the example in the screenshot. Click on the symbol. Now the two axes are independent. Using it like this will distort the layer—not a good idea for most people pictures. I used it to stretch the picture frame layers to better cover the underlying layers.

Let's use that technique to adjust the pair of picture frames that are on Layer 1 of slide 2. (This will work only in Producer. Gold does not allow separating the X- and Y-axes.) Open the Slide Options window and select Layer 1. Now click on the symbol and disable the zoom aspect ratio link for the starting position, as shown in Figure 3.17. Adjust the frames to match the way they appear in the left-hand preview in the figure. Don't worry about the parts of the frames' white borders that are gray; they are just indicating that those portions of the layer are outside the safe zone. When you have finished, preview the effect.

The picture frames shrink as the slide plays. That's because we adjusted only the starting position. If that were the motion effect we wanted, fine. But what if we want to have Layer 1 stay exactly the same during the entire time the slide is on

Figure 3.17

Producer allows adjusting the X and Y Zoom axis of a layer independently as a motion effect. That can be a handy tool for stretching objects like frames and backgrounds—not to mention generating interesting motion effects.

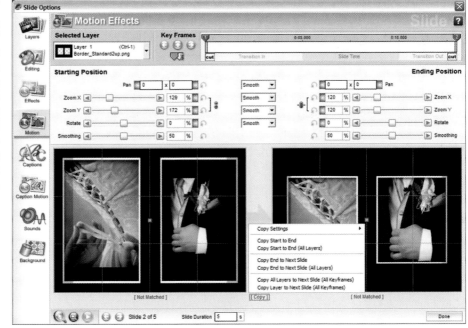

the screen? Then we must match the end position settings to the starting point. One way would be to disable the X-Y axis aspect ratio on the other side and then manually enter the numbers there. It's much easier to click on the word Copy at the bottom of the window and choose the Copy Start to End option from the menu that appears. Copying the start position to the end is also a quick way to undo end point adjustments.

Matchmaking and Moving Outside the Box

The menu we just used to copy settings between layers can also copy adjustments to the next slide, making it easy to create a very smooth transition and to extend an effect. If the transition between the slides is set to zero, the next slide becomes an extension of its predecessor in time. That opens up a world of creative possibilities, especially to Gold users, who don't have the ability to use keyframes to slice time and modify the impact of effects within a single slide. Keep in mind that this is a copy, and if you change the settings of either layer, they are no longer identical.

To make a permanent connection, one that will automatically update and maintain changes to the link, we have to use the Layer Matching function. Just under each preview (Starting and Ending Positions) are the words "Not Matched." Click on either one, and a dialog box opens like the one in Figure 3.17a. It offers two drop-down menus that contain links for each layer in the slides before and after the current one. Choose a layer and the layer's settings are forced to keep the

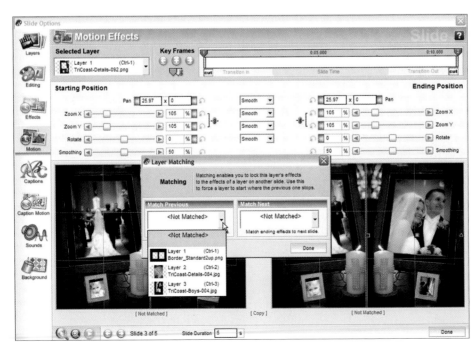

Figure 3.17a
Use Layer Matching to create a permanent duplication of layer effects between slides. When you change a setting on the source layer, ProShow automatically updates the target layer.

values of the one either before or after. If we change the settings for the matched-to layer, the settings are also copied to the link layer. This is a handy tool for carrying an effect across multiple slides.

Rotation

Think of clay centered on a potter's wheel. The clay rotates as the wheel turns, and the potter keeps the clay centered on the wheel. That is exactly the way the Rotation effect in ProShow works. The axis of rotation always passes directly through the center of the layer. If the layer is cropped, the rotation will be based on the center of the visible portion of the image.

You can rotate a layer using the mouse and the little triangle adjustment points located on either side of the layer. Pull them up or down to adjust the image. Figure 3.18 shows a layer being adjusted using the Rotate slider, and we can enter a value in the Rotate box.

Figure 3.18 shows Layer 4 literally turned upside-down. I moved the slider to the left to adjust the value in the box to -180 degrees. It would look exactly the same in the still screenshot if the number had been set to (+)180 by moving the slider the same distance to the right. In motion, positive and negative numbers make a big difference. Positive numbers always rotate the layer around the center to the right; negative values turn the layer to the left.

Figure 3.18
The point of rotation is always the center of the layer. Notice that inverting the active layer did not change the center in relation to the rest of the slide or the motion path.

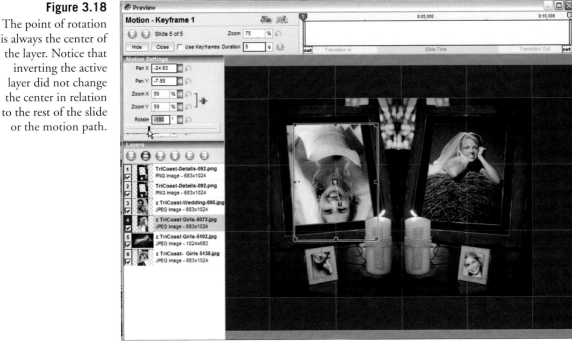

The Copy Layer to Next Slide function can be handy with rotation effects. Let's say we want to have a slowly rotating frame, and we want to have it change the picture inside with each of a series of new slides—no matter what the amount of rotation at the moment the new slide begins. Copy the settings and change the image for the underlying layer, and you are ready to move on to the next slide.

It's a good idea to preview the slide after setting up a rotation, especially if the slide has more than one layer. It's possible that the motion will cause part of the top layer to cover up a lower one in ways you didn't expect. Sometimes a minor modification to one layer is all that's needed to fix such a problem. It might require changing the layer order or adjusting a crop. It's also possible that the effect won't work with that combination of images.

Smooth Moves: ProShow's Acceleration Styles

There are times we want our motion effects slow and smooth and times we'd like a bit more punch. That's where ProShow's four motion styles come in handy. The drop-down menus between the starting position and ending position in Figure 3.19 have each been set to one of them. The styles adjust the way the effect is applied.

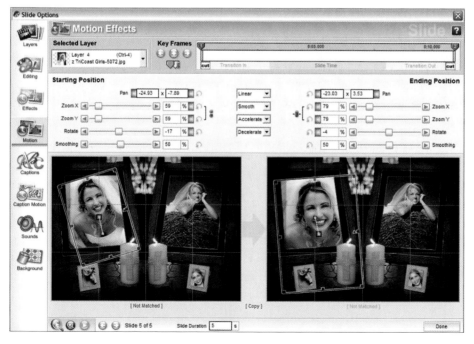

Figure 3.19
Motion styles let us adjust the way a motion effect starts, moves, and stops to fine-tune the way an effect operates during playback.

Linear

Use this setting (the default) when you want a constant rate of motion the entire time the layer is moving for the effect. The speed will not vary, and the rate is determined by the total time the slide is on the screen. This is like setting cruise control while driving and letting it maintain a constant speed.

Accelerate

This style starts slow and gains speed during the entire effect. The maximum speed is reached at the very end of the slide. Compare this to driving while slightly pressing more on the gas pedal to keep the speed increasing at a set rate.

Decelerate

As the name implies, this is the opposite of accelerate. The motion starts at full speed and immediately begins to slow. The breaking effect is increased during playback so that the layer is at rest just as the slide ends.

Smooth

This is a style that combines the other three. It accelerates up to the midpoint of the allotted time, peaks, and then decelerates for the remainder of the time, coming to a full stop at the end.

Don't confuse the Smooth setting with the Smoothing control located under the Rotate control. Smoothing works only in Producer and only when you have more than one set of keyframes in a slide. It sharpens or softens the angle of change when a motion effect applied to a layer changes direction. We are going to save working with it for the detailed discussion on motion effects with multiple keyframes.

Take a few minutes to experiment with slide 5 in this show. Try adding different motion effects to each of the layers under the picture frames. Use the Preview window to see how they change the way the composition works visually. Watch for any overlap in the layers. The two larger layers will be the most likely culprits. Change the design to accommodate as needed. As you work, consider how rotation draws the eye to that portion of the composition. When several layers are moving, it's easy to overdo motion effects. The entire slide must work visually. It's much like not overdoing the number of fonts or capital letters when designing a text layout.

Putting It All Together

We are going to watch and briefly examine another short show to review and refine our skills. In the folder for Chapter 3 on the companion CD-ROM is a file named All_together.psh. It was created using Gold, so you can open it using either Gold or Producer. (Don't worry about the version warning message if you are using Producer. The show will load properly.) It combines all the design elements and tools we have worked with so far. Once it is loaded, run the preview in Full-Screen mode. Then continue reading.

Two Slides, Two Backgrounds, Eight Layers, and a Disappearing Act

The basic way the show uses layers and motion should be obvious. All the layers are using a simple path to pass in front of the background. To the casual observer, that's about it. Let's look closer. There are some tricks of the trade you can learn.

Matching Motion Speed Between Layers

Look at the first slide. It begins with only the background visible, and then two pictures drop on either side of the frame as a third rises from the bottom. They all pass through the center at exactly the same time. Then all three pictures exit the viewing area. Figure 3.20 shows the slide in Producer's Preview window close to the midpoint of its 10-second playtime.

The exact timing isn't that hard to set if you follow a few basic principles. Remember that all movement in a slide is limited to the amount of time the slide is visible during play. All we need to do to get all three pictures to travel at exactly the same rate is to have them cover the same distance using the same motion styles. If the sizes of the images or the length of the motion path differed, then there would be some variance, but they are the same size.

Let's make a copy of the first slide and see how easy it is to create. Start by opening the Slide Options window and add the background (the filename is blur dot bkg.jpg). Then change to Layers mode and add the three pictures. The easy way to set up the motion effects in this slide is to place all three images alongside each other, as shown in Figure 3.20. Make any adjustments needed to fit them in the same space.

Now it's time to set the motion effects. Move one of the two images that start above the frame to the desired beginning location. Note the pan coordinates and adjust the other pictures accordingly. The other picture that starts above will keep its current X value and be given the same Y coordinate as the picture you just

Figure 3.20

Figure 3.20

The first slide in the show makes use of some basic rules to provide precise timing so that all three images pass vertically through the center of the frame at exactly the same time. At the beginning and ending points, none are visible on the screen. This screenshot shows the Producer interface, which provides a Keyframe Timeline in the upper right-hand area, a very handy tool.

moved. The picture that starts below the frame is given the negative value of the same number for the Y coordinate. Setting the ending point is even easier; copy the setting to the end of the slide, and then reverse the Y values by adding or removing a minus sign.

Producer users have a handy tool that Gold lacks when it comes to working with motion timing: the Keyframe Timeline. It's the bar in the top-right section of the Slide Options window in Figure 3.20. It's also available in Effects mode and in the Precision Preview window. This slide doesn't use keyframes, so the only ones present are the pair that mark the starting and ending points.

See the red triangle the mouse cursor is pointing at in Figure 3.20? Place your mouse at the very lower-left corner of the Keyframe Timeline, where it is colored light gray, and press the left button. Now drag the mouse to the right, and the arrow will follow your movement. The preview will show that precise point in the playback as you move the arrow back and forth. If your images aren't exactly lined up, it's easy to see which one needs a correction. Use the mouse or numbers as needed. When you press the Play button and preview in any window with a Keyframe Timeline, the red triangle will move as the slide plays to show the exact point being displayed.

We will be using the Keyframe Timeline a lot more in the following chapters. Right now it's just a handy preview tool. The darker shaded area on the top of the time-

line shows the entire time any part of the slide is visible during play, including the transitions. This is the first slide in the show, so the darker area starts all the way to the left of the timeline. That's because there is no transition before the slide. Notice the labels below the yellow bar, Slide Time and Transition Out. Those two areas are shaded in dark and light tones, respectively, and offer a visual reference.

Gold offers a simpler interface, with only thumbnails of the starting and ending points visible in the location of the Keyframe Timeline in the preview. The basic design of the slide is unchanged, but having the interactive preview visible in the same window with the layer and motion controls is a real timesaver.

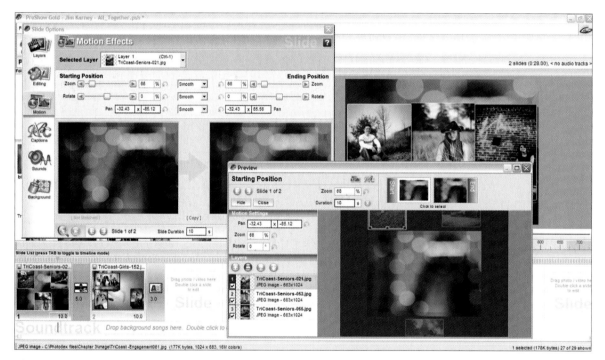

Figure 3.21 The same slide shown in Figure 3.20 open now in Gold with both the Motion Effects and Preview windows visible to demonstrate the differences between the user interfaces and features.

Who Says We Have to Start at the Beginning?

Slide 2 starts with only the background visible and then adds five pictures that slide into the middle of the frame, slowing into a pleasing collage as the frame begins the following transition. Watch this slide in full-screen preview (see Figure 3.22), and you'll notice that the pictures don't all move at the same rate. They do all slow to a stop at the same point during playback. Once again, the designer has let ProShow do most of the work. Follow along and see how easy it is to make a moving collage.

Figure 3.22

Sometimes it is easier to design the final appearance of a slide and then add motion effects to get the start of the slide. That's easy to do in the Motion Effects window and in this example.

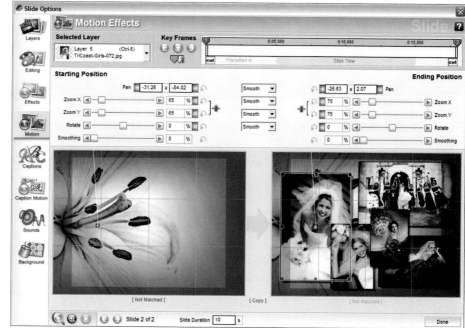

Start by adding the transition. It is named Open Vertical Soft Edge and is located at the top of the sixth column in the Transitions menu. Next, we need to add the background. The file is named Floral_01.jpg. (Since we have already covered how to add backgrounds, I'll skip the detailed instructions for that task from now on.)

Now for the fun part, adding and arranging the pictures. Notice how the pictures aren't visible in the Starting Position preview? How did the designer get them into their proper positions? It's simple: by working backward. Choose five or six pictures; don't worry about using the same ones as in the original example. Arrange them to form an interesting montage. Resize, crop, reorder layers, and rotate as desired. I find it easiest to do this part of the design in the Preview window.

Make any adjustments to the starting point, but arrange the design so that the pictures are positioned the way you want them looking at the *end* of the slide. Consider the way you want each image to move to that ending point and its speed relative to the other pictures, and choose the stacking order to allow for how one picture might hide another as they travel inward.

Once the design is finished, open the Copy menu and choose the Copy Start to End (All Layers) option. This makes sure that any accidental differences between the starting position and the ending position are neutralized. Now we have the layers in their proper ending positions, but without any movement.

Select one layer at a time and use the mouse to drag the pictures off the page to the appropriate starting position. If you want the picture to travel faster than average, move it farther outside the frame. For a slower effect, keep it shorter. Remember that the speed depends on the total length of the motion effect and the time the slide is visible.

When I'm setting up a motion effect, I choose a layer that has an average time, place it first, and use that as a reference. If a layer needs to move faster, it should get placed farther out than that. If the speed is to double, it needs to be twice as far away. If a layer should move a third slower, then it needs to move in by a third. Note that the travel is based from the center of the *layer* at the start of travel to the center of the *layer* at the end. Don't gauge the distance to the center of the frame *unless* the layer will end there.

As I work, I use the timeline to see how the elements fit together. Then, when all the layers are set, I preview the results in Full-Screen mode in real time. This gives me a good idea of the pace of the motion effect. To tweak, go back to the Slide Options or Preview window.

Have fun and experiment a bit with the design. Add some rotation, use different motion styles, and vary the slide playback time. We have only begun working with motion. When we add keyframes and combine them with adjustment effects, the basic concepts, and our understanding of how the design elements work together, mastering ProShow's more advanced tools will become that much easier.

Up Next

Movies are better with a sound track, and ProShow productions are no exception. Adding audio clips is easy, and ProShow provides tools that let us enhance our sound with effects like multiple tracks cross-fades and custom volume levels.

4

Adding and Editing Soundtracks

It's hard to imagine sitting through a movie without a soundtrack. Audio is a powerful component of any professional visual production, pacing the images as they are presented to the viewer and evoking an emotional response. ProShow provides exceptional tools for incorporating audio clips and quickly and precisely controlling their relationship to the visual elements of a show.

Just as with images, ProShow only borrows the data from audio source files. When you edit them inside the program, the originals are never modified. And just as with images, you can use an external editor to modify an image, a sound, or a video file. In those cases, the originals will be permanently changed. If you want to preserve the source content when using an external editor, be sure to make a new copy of the original file.

Working with Audio Files

You can import audio files into the body of your show and run them at full length, trim them to a segment, or limit them to a specific slide. It's even possible to have more than one audio file playing at the same time. A show must contain at least one slide before you can add any audio files. We'll start with an existing show, look at how to add content, and get familiar with interactive controls (the fun stuff). Then we'll build a new production and add both audio content and a video clip and explore the soundtrack menus.

Open the wasp gold01.psh show in the CD-ROM Chapter 4 directory in either Producer or Gold. (If you use Producer, ignore the warning about the version.) When the content has completely loaded (the green bar under the thumbnails in the File List will disappear), double-click on the soundtrack waveform just below the Slide List. The Show Options window will open in the Show Soundtrack mode, as shown in Figure 4.1. Let's start our discussion with how to add and remove soundtracks for shows.

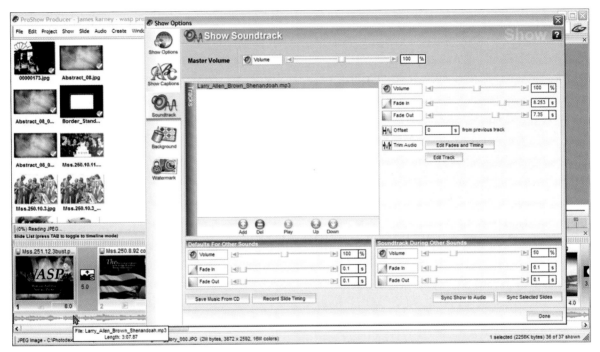

Figure 4.1 Double-clicking on a soundtrack is the easiest way to access the Show Soundtrack tools in the Show Options window. It provides easy access to the program's audio controls and lets you quickly load multiple audio tracks to a project.

Adding, Positioning, and Removing Audio Files

ProShow lets you add sound clips to a show in several ways. The quickest is to simply navigate to the folder containing the desired file and drag it to the Sound List area, located just below the Slide List. You can also open the Show Options window, choose Soundtracks, and add audio clips by browsing and selecting the desired files.

Clicking on the Add button in the Tracks section of the Show Soundtrack window lets you browse and add tracks using a dialog box. You can import both traditional audio files and Photodex MediaSource music this way.

The Delete button ("Del."), next to the Add button, will remove a selected track. Next to that is the Play button. Pressing it opens an applet that previews the clip. Soundtracks within a show play in the order they are displayed in the Tracks pane of the Show Soundtrack window (and, if left alone, will continue until the last clip finishes). You can use the Up and Down buttons to change the order of clips in the stack.

Audio clips appear as waveforms in the Sound List (located directly under the Slide List) once they are loaded and will play when we preview the show in ProShow. If you add more than one soundtrack to the list, they will appear in order under the slides and in alternating colors. That makes it easy to see how long clips will last and when a new one will begin. The waveform also provides a visual clue as to when the intensity of the sound rises and falls.

You can delete soundtracks by right-clicking on the waveform and choosing Remove Soundtrack from the content-sensitive menu. The waveform is handy for quickly seeing just how the audio tracks match up with the slides. Although it will be visible beyond the last slide in your show, the audio will not continue to play past that point. An exact fit requires synchronizing the slides to the soundtrack—and having a reasonable amount of audio for the number of slides in the show.

Figure 4.2

The controls located in the bottom of the Show Soundtrack window provide easy ways to synchronize slides to audio clips, adjust volume and fade times, and acquire music from audio CDs.

Simple Audio Synchronizing

See the file information displayed under slide 1 in Figure 4.1 where I placed the mouse arrow? This mp3 file will play for just under three minutes and eight seconds—unless we adjust the play time with edits. If we add another file after it, that file will start playing once the first track ends. We can keep adding as many audio clips as we want, but they will play only as long as there are slides left in the show.

Let's say we have a slide show that runs for three minutes and a soundtrack, like this one, that is a few seconds longer. At three minutes, the music stops with the show. If we add a blank slide, the clip will play until either it or the slide reaches the end of its allotted time—whichever comes first.

Adding a blank slide to let a music clip finish isn't a very elegant way to link audio to a production. Both Gold and Producer offer an easy way to synchronize ("sync")

a soundtrack to a show or a group of slides. In the lower right-hand corner of the Show Soundtrack window are two buttons:

- **Sync Show to Audio.** This option adjusts the timing of all the slides and transitions in a show so that the total time is exactly the same as the length of the available audio. This can be handy *if* the number of slides and the length of the soundtrack work well together. If the times are too short, you can add another sound clip—or add a second copy of the current file(s) and then click the button again. Each time you press "Sync Show to Audio," the times will be recalculated and reset. It is also possible to tweak the times manually after using this option.

- **Sync Selected Slides.** To use this option, you must first select the desired slides. The play time of the clip will determine the total time for the selected slides and transitions. You can manually adjust the times after using this option as well.

Going Interactive: Advanced Sound Controls

ProShow provides an elegant user interface with simple shortcuts for those who like easy solutions to common tasks. The simple sync buttons I just mentioned fall into that category. But fine-tuning a soundtrack requires hands-on editing. ProShow's well-designed and precise controls should satisfy more demanding users—who want professional results. Even novice audio engineers can make quick work of tasks like crossfades and matching a precise point in a soundtrack to a slide. One of the neatest tools (available in both Gold and Producer) has an unlikely name—Edit Fades and Timing.

Mastering the Audio Trimmer

The quickest way to master the Edit Fades and Timing window, which takes only a few minutes, is to use it on a soundtrack. To access the tool, also known as the Audio Trimmer, either choose a clip in the Tracks area of the Show Soundtrack window or right-click on the clip's waveform in the Sounds List and choose Edit Fades and Timing. Use either method now and open the Shenandoah soundtrack we used in the WASP show. The window will look like Figure 4.3.

Let's start with a few introductions. At the top of the window is the name of the selected audio clip, including the complete path to the file and the full, unedited running time. Just below that is the waveform, showing both the left (blue) and right (red) channels. You can enlarge it to show more detail. In Figure 4.3 it is compressed to fit the entire track in the window.

Figure 4.3 The Edit Fades and Timing window offers a powerful interactive array of soundtrack editing tools.

The slider just below the waveform allows you to scroll left or right when the entire waveform isn't visible in the window. You can zoom in on a certain section by adjusting the magnification slider. The first three buttons below the waveform are the familiar Play, Pause, and Stop. The last two, Start Here and End Here, let you precisely set the first and last points of the clip played in the show.

Notice the two flags with green numbers next to them, just above the left channel of the waveform? These mark the trimmed beginning and end of the clip. The clip shown in Figure 4.3 will start playing 31.310 seconds into the track and stop playing at the 3:39.186 mark. The black area to the left and right of the flags has been cut and will not play during the show. The white boxes below the buttons can be used to set timing manually. Most users never set the numbers since it is so easy to edit with the mouse.

Scaling and Positioning the Waveform

Expanding the waveform makes it easier to work precisely and see the shifts in tempo and volume. Move the magnification slider to the right to increase size and to the left to decrease it. (If you have a mouse with a wheel, you can use it to adjust

Figure 4.4
Use the two sliders to adjust the magnification of the waveform and position your desired section in the window for editing.

the magnification.) Hold down your left mouse button and the pointer becomes a hand you can use to scroll to a desired segment.

Setting the Start and End Points

Often we want to use only part of an audio file. The clip may start with silence, or the section we want is in the middle of the track. Setting the exact start and end points is easy with the Audio Trimmer. Try opening the Edit Fades and Timing window and pressing the Play button. The vertical bar with the equal triangles at both ends, shown in Figure 4.5 at the 0.45 second mark, will start moving once the track begins playing. This is the Current Location marker.

Figure 4.5
The Start Here and End Here buttons trim the clip so that only the desired portions of a soundtrack play in a show.

When the clip is at your desired starting point, press the Start Here button. The flag with the triangle on the top pointing to the right will automatically mark that location as the starting point. Let the track play until it reaches your desired ending location and click on the End Here button. The flag with the triangle pointing to the left will mark the end point. To fix the edits, press the OK button. Now only the portions inside the flags will be used as the soundtrack in your show. If you don't like the result, click the Cancel button.

You can also manually set the start and end points. Place the mouse pointer over the appropriate flag and drag it to the desired location. As you move the flags, the numbers in the white Start and End boxes will scroll. It is possible to enter the numbers, but most users find it easier to listen to the audio and click the buttons.

Adjusting Fade In and Fade Out Intervals

You may not always want a soundtrack to start or end at full volume but may rather have the sound levels fade in or fade out. This is especially useful when one clip follows another. Dropping the volume on the ending track and raising it on the new one is called a crossfade. The Audio Trimmer offers an easy way to "see" and adjust this type of effect.

The background's transition from black to yellow in Figure 4.6 denotes a fade in. Notice the position of the start flag. The gradient is shifting from black on the left to yellow on the right, signaling a fade in effect. The portion of the track with the black background is not played in the show. See the vertical dotted line as the background becomes solid yellow? That and the green Fade In box just below it mark the end of the fade in section.

Figure 4.6
Fade in and fade out effects are shown as a gradient-fill background in the waveform area of the Edit Fades and Timing window.

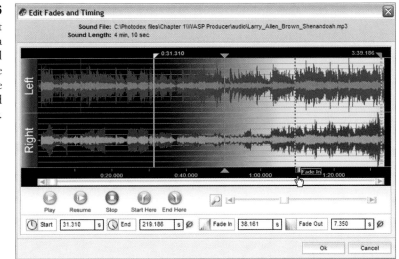

To set the fade, simply drag either the little box or the line with the mouse. The transparent tooltip displays as the adjustment is made. Just as with the start and end points of the track, you can manually enter fades in the appropriate box.

Adjusting and previewing effects inside the Audio Trimmer don't change the settings within the show until you click the OK button. Click the Cancel button to retain the current settings and exit the window.

Editing Soundtracks Using the Timeline

The Edit Fades and Timing window is a neat tool, but it works with only one audio file at a time. Creating really professional crossfades requires the ability to place one track over another while fading the new track in and the old track out. This can be done in the Timeline view of either Gold or Producer and allows direct editing of waveforms. The easiest way to access the Timeline is by simply pressing the Tab key or clicking on the Timeline button on the main toolbar. (Close any open child windows first.) Press Tab again to toggle back to the Slide List view. Another way to move back and forth is to right-click on the Slide List. A menu will appear like the one shown in Figure 4.7. Select Slide List Display and then the Show Timeline option. The Slide List area will then look similar to the one in the figure. (Note that the menu options will vary depending on where you place the mouse. Using the Tab key is the best method.)

Figure 4.7
Shifting from the Slide List to the Timeline interface in ProShow provides access to advanced interactive audio-editing tools.

When the Timeline is active, the timing points for the slides and transitions aren't visible. (You can still get that information by holding the mouse cursor over a slide or transition.) The slide thumbnails are smaller, and the audio waveform is larger. Holding the mouse cursor over the waveform and scrolling the wheel will expand or compress the waveform, similar to using the mouse with the magnification tool in the Audio Trimmer. If your mouse does not have a wheel, you can use the Zoom In and Zoom Out magnifying glass icons shown in the lower-right corner of Figure 4.8. They will appear when you hold the mouse cursor over the Timeline.

Figure 4.8

Holding the mouse
cursor over the
Timeline makes the
magnifying glass icons
and audio file name
visible. Dragging the
waveform and slides
lets you quickly
navigate to the desired
part of the show.

Figure 4.8

Holding the mouse cursor over the Timeline makes the magnifying glass icons and audio file name visible. Dragging the waveform and slides lets you quickly navigate to the desired part of the show.

The name of the audio clip will appear as seen in the upper-left corner of the figure, as well as in the tooltip seen in the center. The mouse cursor will look like a hand. You can use it to drag the waveform and the slide thumbnails to the desired portion of the show. It does not appear in Figure 4.8 due to limitations in the screen capture. I'll describe the mouse cursor's appearance in the figures where it is not visible.

The Timeline waveform makes it easy see how the tempo of an audio clip relates to a slide or transition. When the sound is peaking, the waveform "spikes" as the intensity increases. See how the clip in Figure 4.8 is very thin at the left edge of the Timeline? The sound is very soft, and the music is slowly fading in as the first slide begins. We can see that the clip does not really reach full intensity until midway through the first transition, right at the 10-second mark.

The raised-looking silver border around each slide matches the time on the Timeline during which the slide will be visible. The flat gray border around the transitions shows how long they will last.

Adjusting Offsets, Fades, and Volume Using the Timeline Tools

The Timeline does more that just depict the relationship between the images and the soundtrack. It provides the ability to adjust them using the mouse and the Control key. We'll start by shifting the offset of the audio to just under 2.3 seconds into the show. Hold your mouse pointer (which will look like a hand) over the waveform under the third slide and press the Control key. Now drag the waveform slightly to the right until the offset time (noted in the tooltip) is about 2.3 seconds. Figure 4.9 shows about how your Timeline should look, minus the hand-shaped pointer.

As you drag, the tooltip box will display the offset time, and the full length of the clip will be shown below. You can move the offset to the left to play the beginning of the slide show, or to the right to begin at a precise point within the show. Experiment a bit with the offset and also vary the magnification of the waveform to see how shifting the view helps when placing offsets and navigating in the show. Then place the waveform back in the original position.

Figure 4.9
Dragging the waveform to the right or left lets you adjust the offset time for the start of the audio.

Notice the vertical line with the square shape in the middle at the very left edge of the waveform. This is the beginning of the audio. The yellow triangle shape is the fade in. See how the triangle in Figure 4.10 is longer than the one in Figure 4.9? It is the same waveform, but it has been "stretched" to make the fade-in time longer.

Here's how to do it using the interactive waveform. Hold your mouse directly over the vertical yellow bar (next to the tooltip showing the current fade-in time in Figure 4.10). The cursor will change into a set of parallel vertical lines. Once the cursor changes, use it to drag the bar to the right or left. As you move it left, you shorten the fade-in time. Moving it to the right increases the time.

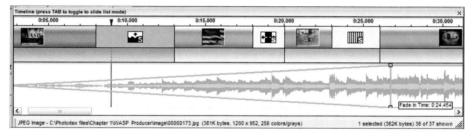

Figure 4.10
You can adjust the fade in by dragging the vertical yellow line to lengthen or shorten the triangle. The longer the triangle, the longer the fade-in time.

By now, you might have guessed that the width of the waveform denotes the relative volume of the audio clip. To the right of the triangle is a rectangle that stretches to the fade-out triangle at the end of the soundtrack.

You can also adjust the overall volume of the clip by making the rectangle narrow vertically. Place your mouse over the horizontal line above or below the main portion of the waveform (not in the fade-in section). The cursor will appear as a pair of horizontal lines once in place. You drag the line down to lower the volume and raise it to increase the volume. Figure 4.11 shows the clip adjusted to a volume level of 37 percent.

As you adjust the level, the tooltip will track the current volume and show the percentage. See how the box gets smaller? Keep in mind that your fade-in and fade-out levels will be reduced as well. Once you feel comfortable using the controls, use the Revert to Backup command in the File menu to restore the original settings before moving to the next part of the chapter.

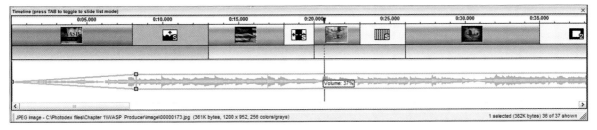

Figure 4.11 Using the mouse and the waveform to lower the volume of a soundtrack.

Creating a Crossfade Effect with the Timeline

Now for my favorite use of the interactive waveform: setting up a crossfade. This effect controls how one soundtrack blends into another. We need two audio clips for this exercise since you have to actually place one fade on top of the other. To keep things simple, we'll just load another copy of the existing track. Double-click on the waveform visible in the Timeline.

When the Show Soundtrack window opens, click on the Add button. Locate the Larry_Allen_Brown_Shenandoah.mp3 clip and then click OK in the browser window. You should now have two copies of the same clip in the Tracks pane. Click on the Sync Show to Audio button in the lower-right corner of the Show Soundtrack window, and then click on the Done button to return to the main Producer window.

Drag the waveform using the mouse cursor to the right until both the starting point of the second track and the end of the first track are visible. (The cursor will have the hand shape. Don't hold down the Control key; hold just the left mouse button while dragging.) The point you want is about 3 minutes 7 seconds into the show, as seen in Figure 4.12.

Now place the mouse cursor over the body of the second clip, press the Control key *and* the left mouse button, and drag the clip slightly to the right. This step is not essential to setting up a crossfade, but it is easier to see the effect while you are working.

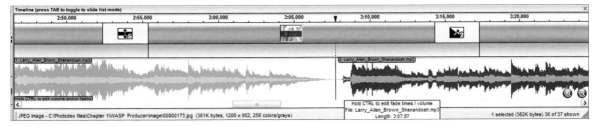

Figure 4.12 The Timeline with two copies of the clip visible, each shown in a separate color. The line between the two clips and the matching pointer above the slides note the current active point in the show. Dragging the pointer will shift the current active point.

When you click on the second soundtrack with the Control button pressed, the yellow lines will form a rectangle. That's because there is no fade in set yet. Holding down the Control key, drag the square at the top or bottom corner of the rectangle—not the ones in the middle. Drag in to the right and slightly down. The cursor will have the hand shape as you do this. (Be careful; if you let go of the Control key before releasing the left mouse button, the changes will be canceled.) As you drag the cursor in, the fade in will increase, and as you pull the line down, the volume will decrease (see Figure 4.13). It's possible to get the same result by dragging the lower-left corner in and up.

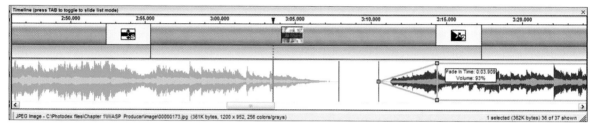

Figure 4.13 Drag one of the handles at the top or bottom corner of the rectangle to pull the fade and adjust the volume at the same time.

Since the first clip already had a fade out and we now have a fade in set for the second clip, all that is left to create the effect is to set the negative starting point on the second soundtrack. Place your mouse pointer over the body of the second clip. Hold down the left mouse button—no Control key this time—and drag the clip to the left so it slides over the top of the first soundtrack, as shown in Figure 4.14.

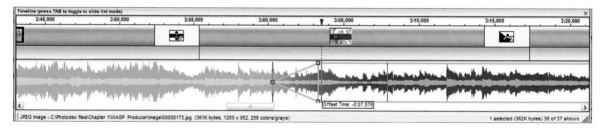

Figure 4.14 Creating a crossfade using the Timeline waveform is simply a matter of drag and drop.

As you drag the soundtrack, Producer will provide a tooltip noting the amount of offset time. This will be a negative value, since you are moving to the left. Once you have placed the offset, drag the Timeline pointer to a place before the fade, about 2 minutes 50 seconds into the show. Then use the preview to see and hear the result.

Crossfades are used to produce an audio transition so that the shift from one clip to another is easy on the listener's ear. If you want a fast shift in tempo, consider

a short crossfade or none at all. If the change is from a fast or loud track to a softer and/or slow piece of music, consider lowering the volume on the first clip and blending into the new track.

Of course, you can also precisely position a slide or transition and set how long it appears in the show in relation to the soundtrack. The tool of choice for that task, especially for fast tunes, is next on our list. Before proceeding, use the Revert to Backup command again in the File menu to restore the original version of the show.

Recording Slide Timings

Double-click on the waveform. When the Slide Options window opens, click on the Record Slide Timing button in the lower left-hand corner. A window similar to the one in Figure 4.15 will appear. Mine has already been set to slide 17. Yours should open with slide 1 enlarged and will not have the blue marks in the line above the image. The time in your window will be set to 00.00.00.

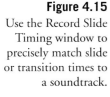

Figure 4.15
Use the Record Slide Timing window to precisely match slide or transition times to a soundtrack.

The basic concept of this tool is simple. As you preview the show, you can choose and hold down a button to set the start and end times for a desired transition. The preview and controls are different from the ones used in the Slide List or Timeline views, so a short anatomy lesson is in order.

The series of blue marks to the right of the word Soundtrack are the existing transition points. The wider the mark, the longer the time the effect takes to complete. White areas denote the time the corresponding slide is visible. The time listed to the right of the line is the current time in the show at the location of the black pointer (just to the right of the last blue marker in Figure 4.15). The larger slide in the middle of the window is the one that appears just after the last transition you placed.

To place and set a transition's time, press and hold the associated key or mouse button just below the related icon. Click on an existing transition icon, and the Transitions Chooser window will open. Selecting a new transition replaces the current icon in that position.

Move the slider just below the slides to quickly move through the show to find a specific location. The Start button activates the controls at the current location in the show, and the Stop button halts the action. No changes are made unless the Apply button is used, and the Close button closes the window.

The Record Slide Timing Window in Action

Using the Record Slide Timing window effectively takes a bit of practice. It really isn't designed as a primary timing interface. The Slide List is the best tool for that task. Instead, consider the Record Slide Timing when you want to exactly place the beginning and ends of one or more transitions or slides to match exact locations in a soundtrack.

To do this, use the positioning slider to locate the desired place in the show. As the point shifts, the larger slide in the center of the window will change, and the blue markers and time display will advance. When you have enlarged the slide before the desired transition point, press the Start button. When the soundtrack starts playing the requested audio, hold down the desired transition for the length of time the effect should last.

As the preview progresses, a blue mark will appear in the timeline. This indicates that the transition time is being recorded. Hold the key down for the amount of time you want the transition to run (or the place in the soundtrack) When the sound or time is at the point where you want the transition to close, release the button and set the accumulated time. The next slide will advance and be displayed in the larger, center position. If you let the show run, the time setting for the current slide will increase until you place the start of the next transition. Pressing the Stop button holds the current settings.

Using the Record Slide Timing window takes a little practice. I find it easiest to use for specific edits and make a list of the planned changes before opening the window and using the tools. After setting a transition, I go back to the Slide List, check the slide times that come after each edited transition, and make any tweaks. Often the next slide's time is not exactly what I wanted. Then I preview that portion of the show as a final check.

Menu-Based Volume, Fade, and Offset Controls

The program's interactive audio-editing tools are very powerful, but if you want to manually set number values for a production's soundtrack, ProShow is happy

to oblige. The Show Soundtrack window has several volume controls. The Master Volume slider at the top of the window adjusts the overall volume of the audio for the entire show. It will raise or lower the audio levels of all sounds at all points of the production.

Let's say you want to have a voice-over describing a set of instructions and a secondary sound still playing—but more softly—from a preceding slide or a global soundtrack. ProShow provides volume controls for balancing the relative values of multiple sounds.

The Volume slider directly to the right of the track list adjusts the relative volume for the currently selected clip. The Defaults for Other Sounds volume control lets you adjust the levels of slide sounds while a specific audio clip is playing. The Soundtrack During Other Sounds slider adjusts the relative volume of the primary soundtrack alongside a sound clip intended for a specific slide or slides.

The values in the Fade Out and Fade In boxes set the amount of time, in seconds, that a clip takes to rise to full volume or fade to silence. The Offset control is also set in seconds to allow for silence between a new audio file and the one played before it.

Adding Audio Tracks from a CD

A quick way to add an audio track to a slide show from a music CD is to open Windows Explorer from the CD drive and simply drag and drop the desired track into the show's Audio List. ProShow has a window that lets you save and use CD tracks. To access it, open the Show Options/Show Soundtrack window and click on the Save Music From CD button in the lower left-hand corner. The Save Audio Track window, shown in Figure 4.16, will appear. You should load the source CD in the drive before opening the window.

Figure 4.16
The Save Audio Track window is a convenient way to add CD tracks to a production.

Adding a track is straightforward. Choose the desired drive from the drop-down menu at the top of the window if it is not already visible. If you want to retrieve artist information from the Internet, check the box located below the drive. Highlight the desired file. If you are not adding the track to the show, uncheck the Add to Soundtrack box. Click the Save Track button, and ProShow will do the rest.

Adding Soundtracks and Voice-Overs to Individual Slides

So far, we have been working with sound that is added to the show soundtrack. We can also add a clip that is directly linked to one slide. This is especially useful for adding voice-overs to a demonstration or training slide show. We'll add a voice-over to the first slide in the WASP show as an exercise to explore the options and controls ProShow offers when adding clips to single slides.

You can use either Gold or Producer for this session. Make sure the Slide List, not the Timeline, is showing. Open the original copy of the WASP show. Double-click on the first slide in the show to open the Slide Options window, and then select the Sounds tab. The Slide Sounds dialog will open.

Click on the Browse button in the top portion of the window and navigate to the Chapter 3 folder in the companion CD-ROM. Select the 15.ogg file. This is a short voice-over audio file. At this point, your screen should look like the one in Figure 4.17, except the filename will not yet appear in the entry box next to the word "Sound" at the top of the window. Click the Open button.

The main soundtrack is now overlaid with the voice-over. The red-colored waveform under the slide is the new file, placed "on top of" the green show soundtrack. That was easy enough. But often a sound clip requires some editing to get the desired effect. See the Edit Fades and Timing button just above the Open Audio File window shown in Figure 4.17? It's identical to the one available in the Show Options/Show Soundtrack window.

When tweaking sounds for an individual slide, we have to consider the way the clip works with the slide, the neighboring transitions, and any other active sounds. ProShow makes all that easy by placing all the necessary tools in the Slide Sounds window. The Override Soundtrack During This Sound sliders let you adjust the main audio's fades and volume level only while the slide is being shown.

See the blank area before the voice-over in the Edit Fades and Timing window in Figure 4.18? You might be tempted to trim it and have the audio start right at the beginning, but will that give the viewer time to see the full slide and relate to what

is being said? You may want to even increase the offset. Each track should be trimmed to suit the specific situation. If you want the slide to display for exactly the amount of time the clip plays, click on the Set Slide Time to Sound Length in the Timing and Playback pane, and the job is done.

Consider whether the show's primary audio is distracting and adjust the volume to work well with the dedicated clip. Notice the two sets of volume controls on the right side of the Slide Sounds window. ProShow makes it easy to balance the audio levels. The Custom Slide Sound Settings pane lets you adjust both the volume and fades for the clip linked to the slide.

It's possible to actually record a voice-over inside ProShow. In the Slide Sounds window, click on Record Voice-Over, the second option from the top, and a Record Sound box like the one in Figure 4.19 opens. Type the proper filename in the Save field, and make sure you've specified an active sound device in the Device box and that a microphone is connected and properly adjusted for volume and audio quality. Click the Record button at the top of the window, and begin recording. The Record button will change to a Stop button. Click it when you are finished recording.

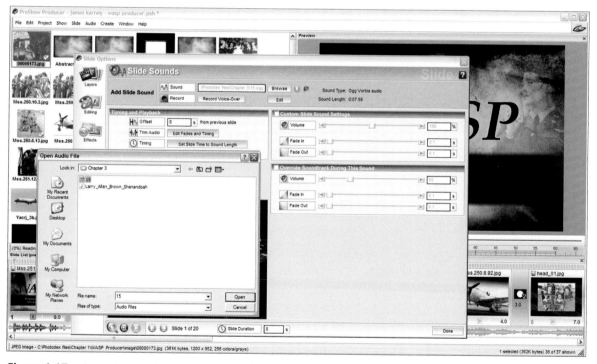

Figure 4.17 The Slide Sounds window (part of the Slide Options set) provides all the controls needed to attach and edit sound clips in individual slides.

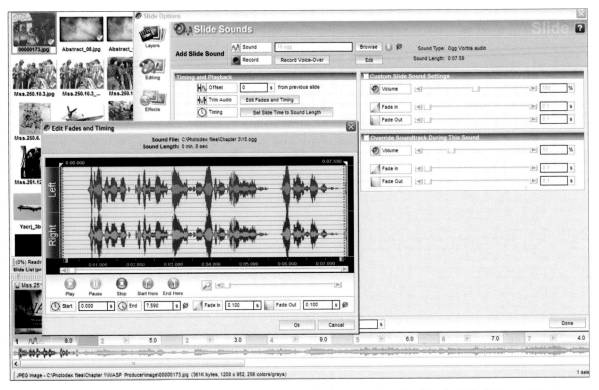

Figure 4.18 The same sound-editing tools that are available for show soundtracks, like the Edit Fades and Timing window, can be used with tracks linked to a single slide.

Figure 4.19
You can record voice-overs directly inside ProShow and linked to a specific slide.

Up Next

We've covered the basics of adding images and sound to our shows. Now it's time to look deeper into how using layers lets you really weave the story into your slides.

5

Caption Fundamentals: More Than Just a Way with Words

Pictures may be the stars of our slide shows, but captions are also important parts of the visual environment. Basic captions add explanations and details for the viewer. Well-crafted captions are design elements in their own right. Advanced captions incorporate sophisticated motion effects and can provide interactive options for the viewer like active links to Web sites and the ability to send e-mail requests for information or to view another show.

That's why the topic of captions is divided into two chapters. This one covers the fundamentals of caption design and explores in detail the text tools common to both Gold and Producer. The next chapter explores the advanced tools, special effects, and editing techniques available only in Producer.

Several of ProShow's text tools look and work very much like similar controls found in Windows-based word processors. It's important to understand that, although the alphabet and even the fonts may be the same, a caption in ProShow is not exactly like text in a word processor on a page, Web page, or even a graphics program. Captions can be made to move, change size, and be enhanced with special effects—things that their static, page-bound cousins can't do. ProShow text and caption tools are designed to do more than just put letters on a page, and so some controls work a bit differently from how you would expect.

We begin with a show that demonstrates effective use of captions and good design using the tools available in both the Gold and Producer versions of ProShow. There are two executable show files in the Chapter 5 directory on the CD-ROM. Please double-click on the one named Captions _Gold.exe to view it before proceeding.

This production has 16 slides, 14 of them with captions. The letters wiggle and wag, fade in and out, scroll, explode, and exhibit some most unlettered behavior—all using basic settings available in both versions of ProShow. That may be a higher density of text (and effects) than found in most slide shows, but they are designed to show the variety of effects that ProShow's basic caption tools produce.

Launch either version of ProShow and load the Captions_PSG.psh show. (Ignore any warnings about file type issues. The show will load and work fine in both versions of ProShow.) You may not see the same fonts in the slides if your system does not have the same ones used in the slides installed. Producer users will see a larger collection of tools in a slightly different arrangement from those in some screenshots, but the basic options, icons, menus, and controls will be the same.

Note

If you do not have any script fonts on your PC, there is a public domain TrueType font, CHOPS_.tff, included in the Chapter 4 folder on the CD-ROM. It can be added to your Windows font library. (Use the Font Utility in the Control Panel.) Feel free to substitute a different font for any exercise; just be aware that then your results, and the look of your slides, will be different than those in the screenshots.

A Special Type of Layer, with Its Own Special Effects

All ProShow captions share some common elements. They all use fonts present on the designer's Windows-based computer. They are all placed into the slide using either the Slide Options or the Show Options window. They all reside on a special Captions Layer that sits in front of all the other layers of a ProShow slide.

Those similarities should not blind you to the need to make a caption unique and well-suited to its slide and show. The pictures in this show are a collection of senior portraits taken by TriCoast photographers Mike Fulton and Cody Clinton. The show was specifically designed to show various examples of captions matched for the target audience: high school seniors and their parents. The typefaces and way the captions work with the design are important parts of giving the show an appropriate sense of style.

The title slide (slide 1) is designed with those attributes in mind. Figure 5.1 shows it slightly less than halfway through its screen time. The letters are all in motion, just about to swirl into the words *graduation wishes*. The font is definitely more decorative and suited to a poster than the kind you would find in a book report or a newspaper. *Decorative font* is actually a technical term. It indicates that the letters are designed more for headlines than for large bodies of text. It would be a challenge to typeset several pages of a book with all those stars buried within the text. The unusual shapes that make the letters a bit harder to read also make them more likely to be noticed. That's why you frequently see decorative type on advertisements and billboards.

Figure 5.1

Who says captions are just words? They are also part of the show's design. This example uses motion, varied intensity, and a decorative font to help set the mood and attract the eye.

Notice how the type has been laid over an out-of-focus background. The words are the primary element in this design. Consider word placement when planning the layout for title slide over a picture, much the way magazine editors do when planning a cover. Make sure the words don't get lost in the picture. In this case a designer used a Gaussian Blur effect to make part of the image indistinct. Most magazine and book covers use pictures that have blank or out-of-focus sections to accommodate title placement. The same types of layouts work well for title slides and any others that host captions.

Note

Some of the examples I've used in this chapter have fonts that do not come standard with the Windows operating system. That allowed me to demonstrate the range of fonts available and choose ones that would work well with other visual elements in the slides. However, it also means you might not be able to reproduce certain examples. If your configuration does not have a given font, the caption will load with the default font, which is unlikely to resemble the one in the example. If that's the case, pick another font. Your slide will look a bit different from the one in the book, but the functionality and the tools will work the same.

Adding more fonts to your collection is easy and might be free. A quick search of the Internet will produce a variety of fee-based fonts (like the Adobe Type Foundry), shareware fonts, and freeware fonts. (It's a good idea to check any software from an unknown source for malware before installing it.) Once you have obtained the font file, simply move it into the Windows/Fonts directory to make it available in ProShow and other programs on your PC that use the common system font library. The companion CD-ROM includes a public domain TrueType script font, CHOP_TTF. This can be added to your system using the Control Panel Fonts utility.

Blending Text and Motion in the Design

ProShow takes caption capability far beyond the way text elements are used in most business presentation slide shows. Captions add color, movement, and decorative elements to their slides. Before working with the tools, let's look a bit closer at several slides to understand how caption and text effects can be combined with images to enhance the overall design.

Use the Preview controls as shown in Figure 5.2 to "walk" slide 5. See how the layer with the girl enlarges as the caption appears to flow in from the left to the right? At the point captured in the figure, the second *i* in the word *beginning* is just about full size, as the next letter, *n*, is fading into view and about half size. Creating the movement of the picture was easy. All the designer did was to adjust the size and location of the picture layer's ending point with the mouse.

Setting up the caption's movement was simple, too. ProShow comes with an extensive library of caption motions called *text effects*. They are predefined motions set using drop-down menus. You can set one for how the caption appears (entrance transition), one for how the full caption displays, and a third for how the caption disappears (exit transition). In slide 5 the caption slowly grows, then sits still, and then fades out as the slide's ending transition begins.

There is a major difference between the layout of slide 8 and the earlier slides. Here the picture has been cropped and placed to provide an open area for the

Figure 5.2

Two simple motion effects combine in slide 5. The picture of the girl grows larger as it moves toward the viewer, while the caption grows in from the left side of the slide.

caption over the black background. Both the picture and the text drop in from the top of the frame, and as the slide plays, the text moves in a wavelike motion. Notice how the shorter lines of text are pushed to the right, bringing the visual center of the motion closer to the girl.

All three of these slides make effective use of captions within their design. ProShow did most of the work. Caption placement is just as easy as adjusting an image layer. The captions' motion was even simpler to accomplish thanks to ProShow's built-in tools.

To get the most from the examples, review the complete show before moving on to the next part of the chapter. Consider how the images, text, and motion effects all interact. As you examine each slide, notice how the picture's composition, open space in the slide, caption position, and text effects are combined in the design.

Good design requires planning where to place text in relation to all the other elements of a slide. It's important to actually view the slide in real time and make sure that the text not only is readable but also does not distract from other elements. Readability in a caption is more complex than on a page. In both cases the letters must be big enough to see easily, and they need to be displayed in a color that contrasts well against the background. In a caption, especially one that moves, the letters must also be clear enough—and visible long enough—to be read and understood by your audience.

Figure 5.3
The same opening text effect is used in slide 7. This time the picture swirls toward the viewer in a circular motion. The picture becomes larger as the caption becomes smaller and fades from view. This combination increases the perception of movement. The first text effect fades the words in from left to right, and the final one reduces the size and the opacity of the letters as they exit the frame.

Figure 5.4
Slide 8 uses the same basic concept as slide 7 (Figure 5.3) and slide 5 (Figure 5.2)—complementary motions of the picture and text—but here the text is given its own space and a bit of extra wave motion.

ProShow's Common Caption Toolkit and a Bit of Typography

The basic tools for creating and working with captions are the same in both Gold and Producer. Let's open a new show and add a blank slide using the keyboard shortcut. (Select the first slide position in the Slide List and then press Alt-I.) Now press the F5 key. That's the shortcut that opens the Slide Options window in Captions mode.

The top portion of the window has two boxes and a column with four buttons in between. On the left, the *Caption List* shows all the captions currently on the slide and shows as much of the text for each caption as will fit on the line, plus three boxes to the left of the text.

On the right-hand side of the Caption List are four colored, circular buttons. The green one on the top adds a new caption to the bottom of the list, the red one below it removes the currently selected caption, and the two blue ones underneath raise and lower (in that order) the current caption's position in the stack.

The *Selected Caption* box is in the upper right-hand side of the Captions window. This is where we enter and edit the actual letters that make up a caption. Click on the Add button. Now place your cursor inside the Selected Caption box on the top side of the Captions window. That activates it for entering and editing the text of the currently selected item in the Caption List. Type `Caption 1`.

Now let's add a second caption. Click on the Add button again and type `Global Caption` in the Selected Caption box. Your window should look similar to the one in Figure 5.5, allowing for the fact that your captions may be displayed in a different font and size. We'll fix that soon.

Selecting and Sizing Fonts

Directly under the label for the *Caption Format* section is a drop-down menu. This contains a complete list of all the fonts known to Windows that are currently installed on your system. (Special fonts designed to be used within programs that are not properly registered with Windows will not show up on this list.) Use the menu to set Caption 1 in Arial Black.

Immediately under the *Font menu* is the *Size menu.* You can use the drop-down menu, enter a number, or size your caption using the mouse to enlarge the bounding box just like with a picture layer. Values are set in points. One point is 1/72 of an inch. The print in most newspapers and books is 10 to 12 points. Set the caption to a size of 36 points.

Figure 5.5
Gold's Captions window contains all the primary tools needed to define, place, and add effects to captions. The font selection is limited to those fonts already installed in the computer's Windows/Fonts directory.

Now click on Caption 2 in the Preview Area of the Caption List. That makes it the active caption. Return to the Font menu and choose Times New Roman. (You can quickly move to a section of the menu by typing the first letter of the font's name when the menu is open.) The size should be set to 36 points.

Now add another caption to the slide using the menu. Right-click on Caption 1 in the Caption List. A menu like the one in Figure 5.6 will appear. (I've already

Figure 5.6
The context-sensitive Captions menu is handy for duplicating, copying, adjusting global settings, and removing captions.

added the new caption in the screenshot.) Choose the Duplicate Caption option. Change the new caption's text to read Caption 3 in the Selected Caption box, and then adjust the font to Wingdings and make sure the size is set to 36 points. Use three seconds for the slide duration.

All Fonts Are Not Created Equal

It's easy to see that our three examples don't look quite same, even though they are the same size and two of them even contain the same word followed by a single number. That's because each is set in a different font, and one of those fonts (Wingdings) is a symbol font that replaces the regular letters and numbers with special characters so that they can be typed into a document using a regular keyboard. Fonts set to the same size may not *look* the same size, and that requires a bit of typographical explaining.

Type is sized in points according to an arcane formula that is more than 400 years old. One point is 1/72 of an inch. Since the letters in a single font vary in size, typesetters decided to use the capital *M* as a reference point. That is the one letter in the set that is always scaled to match a 72 points-per-inch measure. (I told you it was arcane.) In a 36-point headline, a capital M will be half an inch tall. The other letters in the font might vary in size. We don't have to worry about the details, just how they apply to our shows.

That's a good thing, since font size in a ProShow caption is even more variable than it is on paper. A 72-point caption displayed on a handheld MP3 player will be a lot smaller than one projected onto a billboard-sized screen. Consider a very ornate font shown very small; the fancy swirls may degrade and make it hard to tell an *e* from an *o* or a *p* from a *q*. The effective point size is relative to the viewing device and the typeface used. As designers, we need to consider readability of text. With that in mind, let's quickly review a few facts about fonts.

A *type family* is a collection of *typefaces* that are similar in appearance and design. A *typeface* is a specific type style, irrespective of size and weight. A font is the complete set of letters, numbers, punctuation marks, and symbols available in one size and typeface.

Classes and Styles of Type

There are two basic classes of type: serif and sans serif. *Serif* is the word for the little flourishes on letters that add to the character (and readability) of a font. Times Roman and New Century Schoolbook are familiar examples of serif type. *Sans serif* means the font is designed with minimal ornamentation. Common examples of sans serif type include Helvetica and Switzerland. Most of the words we read are set in variations of these familiar families.

These two major classes are broken down further into categories by intended use: Text (used for general reading material as in textbooks and body text), Display (advertising, signs, and headlines), Decorative (invitations, posters, and seasonal and specialty items), and Symbol.

Symbol fonts often don't have a full set of alphabetical letters but rather offer an extended collection of special characters like business, mathematical, scientific, or musical symbols. These are usually type elements that are not found on traditional keyboards, including items like the copyright symbol and square root notations. Wingdings are a type of symbol font that includes items like heart shapes and astrological signs. Most common fonts offer a collection of common symbols, and ProShow offers an easy way to add them that we will work with later in the chapter. The following list shows examples of well-known members of the different font families.

Serif Font Examples:	Times Roman, Garamond, and New Century Schoolbook.
Sans Serif Font Examples:	**Helvetica Bold**, Arial, and Lucinda Sans.
Decorative Font Examples:	*Boulevard*, *Brush Script*, and Old English Text.
Symbol Font Examples:	Zapf Dingbats: ✳❀□❄ ❖✳■❊☺❀▼▲, Webdings: ⌇ 🎁 🚲 ♥ ⓘ ●■ ? .

Setting Bold and Italic Styles

Font styles refers to specific variations of the basic way a typeface looks. Not all fonts have all styles available. Body, **BOLD**, *italic*, and ***BOLD italic*** are the most common. Some typefaces come with several variations of the basic style, with names like Light and Narrow.

ProShow provides an easy way to set bold and italic styles. The **T** and *T* icons located right below the font size box in the Caption Format section of the window toggle a selected caption's text to bold and italic, respectively. The results vary with the caption's original font. We could go into a study of the true nature of bold and italic, but a demonstration is much more practical.

Double-click on your slide to open the Precision Preview window. Click on the Style T icon with each caption selected and notice the relative change in size. I've made duplicates of all three captions. The original is on the top, and the bold version right below it. See Figure 5.7.

Figure 5.7
Using the Bold command produces different results with different fonts. Those that are already bold, or that don't really have a bold style, will change very little or not at all. Standard text fonts will usually look thicker, and the line of text will become longer.

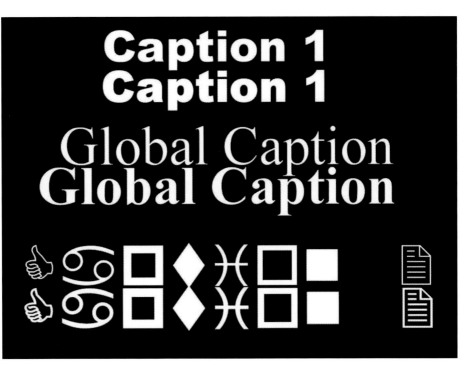

As you can see, only the middle caption looks different when set to bold. Fonts that are already formed in bold, like the Arial Black used with Caption 1, aren't affected by the style change. The same is true for most symbol fonts and many decorative fonts. Standard body text fonts, like Times Roman and plain Arial, will look thicker and expand horizontally when made bold.

You may need to allow for that factor if a caption needs to fit in a specific space in a slide. Notice that making the caption bold didn't make the letters taller, just longer. They are still set as 36 points, and the height of the capital M stays the same. Select each caption in turn and click on the Bold icon to toggle the font back to its normal state.

Adding Another Slide and Caption

It's time to add another slide to our show to experiment with, and review, the motion skills we used in the last chapter. Drag the file of the young man at the water's edge, named TriCoast b-003, into the second position on the Slide List.

Now hold down the Control key and drag the file with his close-up portrait (TriCoast b-066) on top of the first file. Set the transition between slides 1 and 2 to a crossfade linear. (That's the one with the AB side by side whose icon appears

raised next to the Cut transition in the top row on the lower-right corner of the Choose Transition window.)

Open the Slide Options window in Motion Effects mode. Use Figure 5.8 as a reference for the placement of the two layers at the starting and ending positions. Using the mouse is fine, or you can enter the values as follows.

Layer 1 starts with Zoom at 83 and Rotate set to -30, with position values of 32 and 41. It ends with Zoom at 113 and Rotate set to 32, with position values of 20 and 18.

Layer 2 starts with Zoom at 120 and Rotate set to 25, with position values of 27 and -69. It ends with Zoom at 153 and Rotate set to -15, with position values of -5 and 51.

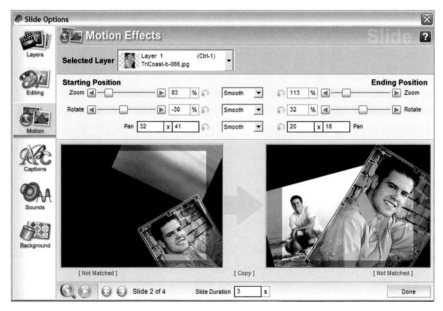

Figure 5.8
Which comes first, the pictures or the words? This time it's the images, but the choice often depends on the relative importance of each and which approach better helps the slide's creator see and work with the relationship between them.

I usually preview motion effects for images before adding any captions. That lets me identify areas that should not be obscured by the letters, or that might present a major distraction when trying to read the caption during the show. It's also a good time to look at the colors that are in the slide, and specifically areas that will be shared with the slide. Grass-green slides won't do well over a picture of a well-maintained golf course, and red may not be the ideal color for a caption with a fire truck behind it.

Click on the Captions icon to place the Slide Options window in Captions mode. Add a caption with the words "So Dream Your Dreams." Place a return between the words *Dream* and *Your*. Use the ***Script MS Bold font*** (or a similar script font

if that is not available on your system) and set the size as 30 points. Notice that the bold icon is active. Try turning it on and off. Since this is a bold font, it won't make a difference in the appearance of the letters.

Use the mouse to move the caption to the location shown in Figure 5.9. Exactly matching the location in the screenshot isn't critical. Just like picture layers, we can adjust the position, scale, and rotation of a caption using either the mouse or by entering numbers into the appropriate data box.

Figure 5.9

The new slide in place with its caption in color, and an outline and drop shadow defined.

The Caption Color tool should be familiar by now. Click on the Set Color button and the caption's color to match the example in Figure 5.9. The values for the three boxes are 245, 194, and 31. The Outline and Drop Shadow settings are active in the screenshot so they can be formally introduced. You have to click the check box in their upper left-hand corners to enable them. Then the Set Color button is used just like the one for caption color.

The primary use of an outline is to help separate an object, like a caption, from the objects behind it. Set the outline for the caption to white, as it is in the screenshot. Enable and disable it and move it over the darker and lighter areas of the two pictures a few times and watch what happens to the letters. They look a little larger and lighter with the outline active. Now set the outline color to black. The visual relationship between the caption and the pictures will be different. Drop shadows are an alternate way to provide visual separation between objects, often resulting in a more three-dimensional look.

Choosing a caption's color, and deciding on the use of outlines and drop shadows, can be very subjective. A lot depends on the size and font of a caption and the objects underneath it during its time on display. With the right combinations of drop shadow and outline, you can place white on white and make it readable—sometimes. The nature of the underlying layer, the relative contrast between them, and motion and text effects all are factors that can often be judged accurately only during previews and, sometimes (rarely, thankfully), during full-sized playback.

For our current caption, let's turn both the shadow and drop shadow off.

Making Captions Move Using Text Effects

The motion effects we watched in this chapter's opening slide show made use of very complicated special effects. Those effects required lots of planning. Fortunately, they are already built into ProShow's toolkit. There are more than 100 text effects in the collection, and they can be applied to any caption with the click of a mouse.

These are called text effects, and there are three types. Fly In text effects control how a caption enters the frame, Fly Out text effects determine how the letters disappear at the end of the slide, and normal text effects control text behavior in between Fly In and Fly Out. See Figure 5.10.

Text effects have descriptive names indicating the style and direction of the motion applied. For example, the zoom in Fly In effect makes the caption grow from small to full size, while captions given the fade-down Fly Out effect will become transparent as they scroll down and out of the frame.

Fly In categories include elastic, pan, fade, grow, spin, spring, and zoom. Normal categories include pan, grow, galactic scroll (this one looks like the opening credits in the Star Wars movies), shrink, pulse, rotate, strobe, slide, spin, warp, and wave. The Fly Out effects styles are Elastic, Explode, Fade, Pan, Shrink, Spin, and Zoom. See Figure 5.11.

The drop-down menus in the Captions window let you assign any of the text effects, but we are going to use an alternate approach right now. The best way to gain a quick working knowledge of text effects—and to sample them—is to use the Choose Caption Effects window (shown in Figure 5.11) to preview the different major styles.

Clicking on any of the Browse buttons, located behind each of the three Text Effects menus, opens the same Caption Effects window. Make sure slide 2 is selected and open the Caption Effects window now. At the top of the window is a drop-down menu to select the text effect you want to modify or observe. The

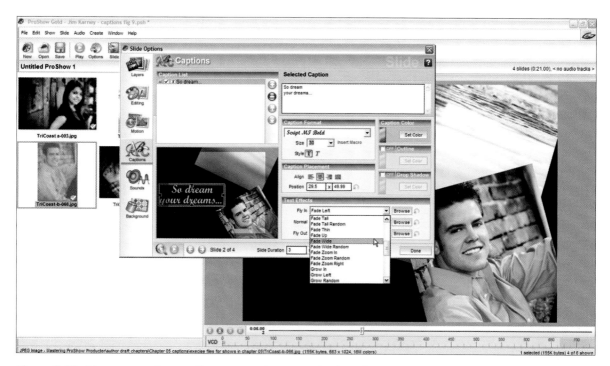

Figure 5.10 It's easy to apply text effects to a caption using the drop-down menus provided in the Slide Options/Captions window.

Figure 5.11
The Choose Caption Effects window is a handy way to preview and learn the variations of text effects' behavior while setting values for a new caption. Fly In and Fly Out effects are actually specially designed motion effects developed for use with captions.

list on the left-hand side of the window displays all of the available effects. The gray area on the right-hand side of the window plays a continuous preview of the selected effect(s). The screenshot shows a jumble of letters matching the curling Fly In effect that was previewing as it was captured.

In the lower left-hand corner of the window is a check box. When it is enabled, all the currently selected text effects for the slide are repeatedly displayed in the preview portion of the window. When it is disabled, only the text effect selected in the drop-down menu at the top of the window is previewed. Go ahead and place a check mark in the box by clicking on it with your mouse. When all of the text effects for the active slide are set to None (as is probably the case with your show), the Preview Area in the Choose Caption Effects window shows just a blank, solid-gray background.

Let's change that by adding some effects to our caption. Set the drop-down menu at the top of the window to Fly In effect. Choose Elastic Right from the list of available text effects. Change the drop-down menu to Normal Effect, and choose Shrink Slowly. Change the menu selection to Fly Out effect and set it to Elastic Right.

The only way to control the speed of text effects is by adjusting the running times for the slide and the transitions on either side of it. The longer a slide is displayed, the slower the speed of its text effects. The shorter the time, the faster the effect.

As we work, the preview changes to show the current settings. If you are curious about the different styles, experiment with different combinations. The right combination for a given slide will vary based on the overall design, the images used, the font, and the mood or message being conveyed to the viewer.

Using the Caption Effects window is an easy way to quickly become familiar with text effects and how to combine them into pleasing combinations. Take some time to experiment. Vary the slide times and notice how longer and shorter values modify the visual impact of the effects. After I introduce the rest of the common caption tools, we'll look at some more examples from the slide.

Alignment and Anchor Points

The same X-Y coordinate system we use for graphic layers works for captions, too. The first value sets the X-axis and the second value the Y-axis. That location is called the caption's *anchor point*. When a slide has only a single caption, critical positioning usually isn't necessary. But when several captions share space in the frame, and when you're working with caption motion effects in Producer, planning and precision become more important. Those require more understanding about how anchor points and alignment work.

> **Tip**
>
> Sometimes new captions that may be placed outside the Preview Area are in the Slide List and Slide Options window. In that case, open the Precision Preview window and zoom out to locate and position them.

There are four icons located to the right of the word *Align* in the first row of the *Caption Placement* section in the Captions window. They look like the text alignment icons found in word processors. They work a little differently in ProShow. Traditional Alignment is the way a line of text is set in relation to the "page." In ProShow, alignment determines how multiple lines of text are positioned inside a caption's bounding box and exactly how the bounding box is positioned over its anchor point.

If you change the Alignment setting for a caption, it may move. That's because the anchor point of a caption is relative to the Alignment setting. (Don't worry about the technical details.) Figure 5.12 shows examples of each of the four alignment styles with their X-axis lined up with the vertical center of the slide. They are in the same order from top to bottom as they are arranged in the Captions window and in the following list.

> **Left Alignment** places the caption so that the left side of the bounding box is vertically centered at the current position for the caption, and the text inside the caption's bounding box is shifted so that each line of text is aligned against the left side of the bounding box.

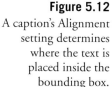

Figure 5.12

A caption's Alignment setting determines where the text is placed inside the bounding box.

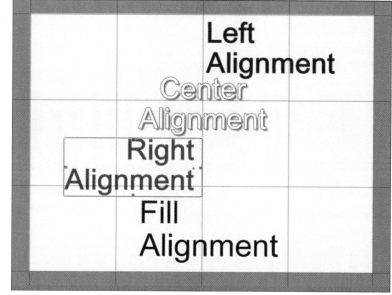

Center Alignment places the caption so that the center of the bounding box is centered at the current position for the caption, and the text inside the caption's bounding box is shifted so that each line of text is centered within the bounding box.

Right Alignment places the caption so that the right side of the bounding box is vertically centered at the current position for the caption, and the text inside the caption's bounding box is shifted so that each line of text is aligned against the right side of the bounding box.

Fill Alignment places the caption so that the left side of the bounding box is vertically centered at the current position for the caption, and the text inside the caption's bounding box is shifted so that each line of text is against the left side of the bounding box. (In some versions of Gold, the tooltip that displays for Fill Alignment uses the term *Fill Justification*.)

ProShow automatically positions the anchor point of the first caption added to a slide directly in the middle of the frame. If you add additional captions to a slide before the first one is moved, ProShow will put the new arrivals directly below the preceding ones and provide some vertical space between them based on the size of the font being used.

When you're placing a single simple caption, it's easy enough to adjust position and alignment by eye so that the result is visually pleasing. When more precision is needed, having a firm understanding of caption placement is essential. ProShow offers some really valuable tools that let us generate global captions and pull information from the files placed in the show's slides. We'll make use of the program's placement features (and some gain practical experience) as we add macros to our next slide.

"Automatic" Captions—the Power of Macros

There is a very powerful tool located just behind the Size menu in the Caption Format section of the Captions window. It can quickly add symbols and special characters to a caption. It can automatically create captions that show the filename of the picture in a slide, the complete path to its location, exposure data, and the date and time it was taken. And it can add that data to a single slide or to every slide in the show.

All that power is accessed by clicking on the words *Insert Macro* and taking advantage of ProShow's extensive collection of macros. To see them in action, we need a new slide. Drag the file named TriCoast a-003 (located in the Chapter 5 folder on the CD-ROM) into the show. Now open the Captions window with that slide selected. Add a caption to the slide that says "Working with Macros." Place a carriage return after the word *with* so that the word *Macros* is on a line by itself.

Set the font to Arial. (If you click on the drop-down menu and press the letter *a* on your keyboard, the list will move to that part of the alphabet.) Make the size for the new caption 30, and set the style to Bold. Make the caption color white, and set the alignment to Center. Leave the Outline and Drop Shadow fields disabled. Make the slide duration 6 seconds. Your slide and its caption should look like the example in Figure 5.13. ProShow will remember the settings we just applied and use them for any new captions until such time as we change them.

Figure 5.13
The first caption predictably appears in the exact center of the slide, thanks to ProShow's default placement configuration.

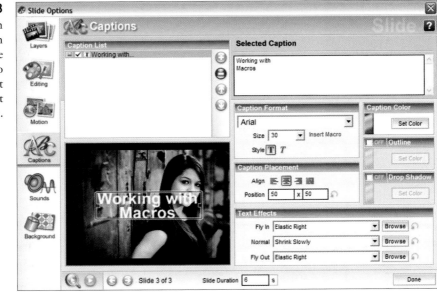

Inserting Special Characters into a Slide with Macros

Now click on the Insert Macro command. The Insert Macro window will open like the one in the foreground of Figure 5.14. Use the drop-down menu to choose the Symbol macros option located at the top of the list. There are a number of very useful symbols in most fonts that are not displayed on a standard computer keyboard. For example, the copyright symbol (©) is commonly used in slide shows to warn viewers that the content is owned and protected. It is part of almost every standard font.

There are three ways to enter these characters into a caption. The Insert Macro window contains a list of all of the symbols for the current font, along with the macro and the actual symbol. (The majority are the same for all common text fonts; symbol fonts may vary.) Click to select the desired item, and then choose the Add or the Add & Close button to place the symbol in the caption.

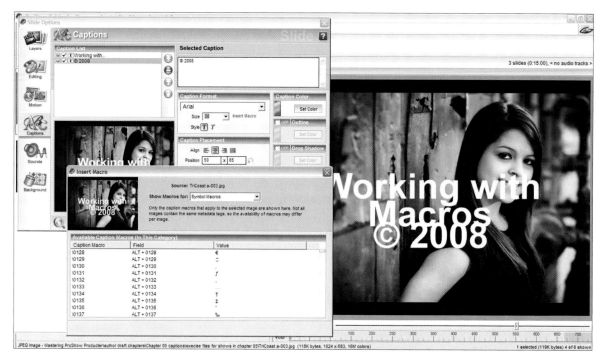

Figure 5.14 Special characters can be inserted into a caption using the Insert Macro window or by typing in the appropriate Alt-[number] combination.

Each of the symbols is assigned a number in the font table. If you know the number, you can place the cursor where you want the symbol to appear in the caption text for the Selected Caption box, hold down the Alt key, and type the number. I just entered the copyright symbol by typing Alt-0169. The symbol will actually appear in the box at that location and in the caption in all ProShow Preview windows. You can also enter a symbol (or any other macro value) by typing \macro code in the desired location in the caption text in the Selected Caption window.

Place your text-entry cursor behind the file size macro (/S). Add a space and then hold down the Alt key and type 0169. The © symbol appears. Now add a space and the number 2008. (Keep in mind that these files are actually copyrighted by the photographers that own them, and they are just on loan to you specifically for use with these exercises and not for any other use.)

There is an obvious issue with the location of the new caption. It's overlapping the bottom line of the first one. ProShow makes an allowance as it inserts additional captions into a slide. The first slide is always placed with its anchor point in the exact center of the frame (position 50x50). If you add a second caption, it will be placed a set number of points below the first one based on the size of the

font. Here the interval is 15 points (position 50x65). The next caption added will appear at 50x80, the next at 50x95, and so on.

If the first caption had only one line of text, the default space between the existing and new caption that ProShow automatically provides would have been enough. The insertion interval is set, so when we add multiline captions, some manual adjustment will be required. We'll wait until all of the captions for this slide are in place to correct this caption's position.

EXIF metadata macros read metadata information from the file currently on Layer 1 in a slide and place it in the caption. The available data will vary based on what was captured with the file as it was created and modified. This is one set of macros that is much easier to define using the Insert Macro window than typing it out. The syntax is a bit longer than for other types of macros.

Click on the Add Macro button and insert the macro that displays the date and time the file was last changed from the EXIF metadata macro menu, as shown in Figure 5.15. The mouse cursor is pointing at the macro to use. This caption should appear at position 50x80.

Figure 5.15 ProShow can insert information drawn from an image's EXIF metadata directly into a caption, like this example, which displays the date and time the picture was taken.

Show Captions, Globalization, and the Art of Invisibility

So far, we have been placing captions on individual slides. The Show Options/Captions window offers the ability to turn a macro into a database command that can be used to place slide-specific information in every slide in a show. Macros wouldn't save much time if we had to apply them to one slide at a time. They can also be used to exclude specific slides from such global operations.

Close any open windows other than the main ProShow program window. Press Control-F3 (or choose the Show Captions option from the Show Options menu). The Show Captions window will open. It looks almost identical to the Slide Options/Captions window. There are now Preview controls, and the only thing that shows in the Preview Area will be the caption. That's because this window sets up *global captions*, which are replicated for every caption in the show. (There is a way to hide a global caption or change its order and location on a specific slide; more about that soon.)

Adding a Global Caption

We are going to add a global caption that uses two macros to display the filename and file size of the image on Layer 1 that will appear in the upper right-hand corner of the frame. For this, we need to use predefined macros. They are available from the same menu, as shown in Figure 5.16. We are going to enter them using the keyboard.

Place the mouse cursor in the Selected Slide box. Type \f on the first line, add a second line by pressing the Enter key, and type \S. The \f adds the filename, and the \S the file's size. The macros will use the file information for the first content layer on each slide. It is not possible to set up a second caption to display information from another layer.

Adjust the settings for the new caption as follows. The font should be Arial, size 14 points, and alignment set to Left. Adjust the position to 83x16. The caption color is white. Make sure both the bold and italic styles are turned off. Add a white outline and a black drop shadow. Modify the text effects so that the Fly In field is set to Fade In and the Normal and Fly Out fields are set to None.

All Captions Are Not Created Equal

The new caption should now be visible in the upper-right corner of the second and third slides in our show and in the Preview Area of the Slide Options window when you open a slide. Try it now by double-clicking on slide 3. As you have seen,

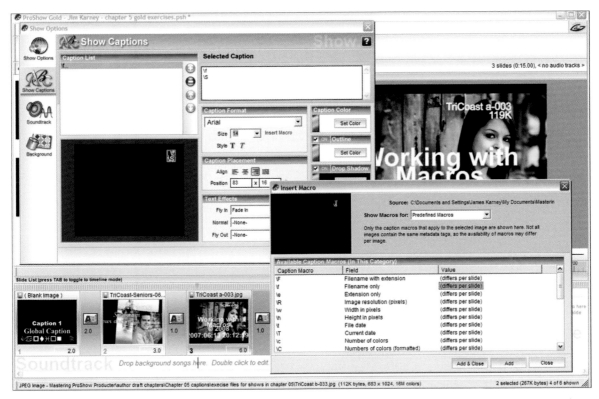

Figure 5.16 The Show Options/Captions controls work exactly like the ones in the Slide Options/Captions window. The captions created this way are added to every slide and Caption List in the show.

the tools for creating and adjusting global captions and captions with embedded macros are the same as the ones we use for working with standard captions, but there are some fine points of using macros and global captions that tend to confuse the uninitiated.

Double-click in the Slide Options Preview Area to open up the Precision Preview window. It should look like the screenshot in Figure 5.17. We now have a large preview of the slide. All four captions are present in the Caption List, but only Captions 1 and 2 are visible—the Preview window can't display information that is generated by the action of a macro.

The copyright symbol is not generated. Like the file information, it is a fixed element. That's why it can be seen. While we have the window open, let's move Caption 1 ("Working with Macros") up so that it does not encroach on the top of Caption 2. Change the Caption 1 position settings to 50x45.

Close all windows except the main program and slowly examine slide 2 using the control beneath the Preview Area. Watch the upper-right area as the global

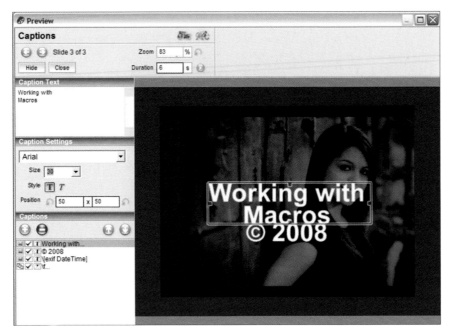

Figure 5.17
The Precision Preview window gives us a larger copy of the slide, making it easier to place captions.

caption with the file information is presented. The sky makes it difficult to see the information. Only the drop shadow provides any detail. Open the Slide Options/Captions window and selected the second caption in the Caption List. That is the global caption we want to edit. Set the outline color to black, as shown in Figure 5.18.

The contrasting outline makes the text easier to read without blocking up the white letters. My own workflow includes at least one viewing of the entire show that focuses on just the captions. Are they all easy to read? Do they move as planned? Do they sit on the screen long enough to be easily read by the viewer? Depending on the images in the slides, a different combination of colors or a change in font might be in order. The proof is in the seeing.

Since this caption is global, the change applies to every other slide in the show. Let's adjust the caption's position with the mouse. Shift it so that the text is just inside the safe zone. The screenshot already shows the change. Changes made to the appearance of a global slide will be seen in all the other slides in the show that share the modified element.

Let's look at slide 1 to see how this works in practice. The only text showing on the black background is the three local captions. The global slide isn't visible. Open the Slide Options window, double-click to see the Precision Preview, and check the contents of the Caption List. The global slide is there in the fourth position, as shown in Figure 5.19. The reason we don't see a caption is that there is no Layer 1, so there is no filename to list or file size to report.

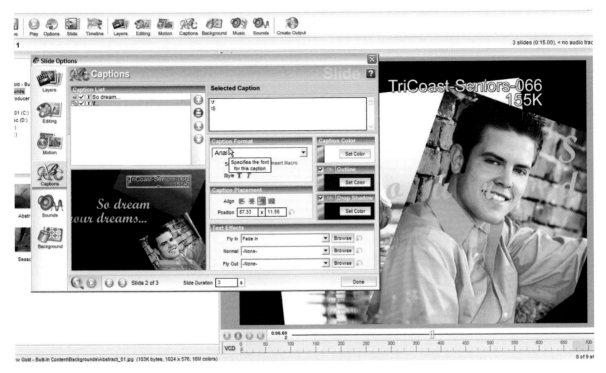

Figure 5.18 Changes made to the appearance of a global caption in any slide are instantly applied to every other instance of that caption in the show.

Figure 5.19
Slide 1 has only four captions visible. Global captions can be disabled on specific slides.

Modifying Caption Behavior Using the Caption List Options

The Caption List has three little boxes in front of each caption listing. Each has a switch to control how that caption is displayed. The Global/Slide box is the one on the far left. The default state is Slide, and the icon in the box looks like a single slide. The first three captions are set to Slide mode. The fourth caption's icon shows three slides in a diagonal row. That indicates a global caption.

We created that caption using the Show Options/Captions window. What if we wanted to make an existing slide global? All we have to do is click on the icon, and it will change state and the caption will appear on all the other slides in the show (with the same limitations I just mentioned concerning macro data).

Select the second caption on this slide, the one that says *Global Caption*. Click on its Global/Slide icon to toggle between modes. We have converted the caption. Change the active slide in the Precision Preview window to slide 2. Our new global caption is there, shown in Figure 5.20.

There are times when you won't want a global slide to be visible on every slide. Let's say you want to show the filename on all the slides but the title slide and the ending slide with contact information. ProShow lets you turn off global slides (or any local caption) on a specific slide by removing the check mark in the box just behind the Global/Slide icon.

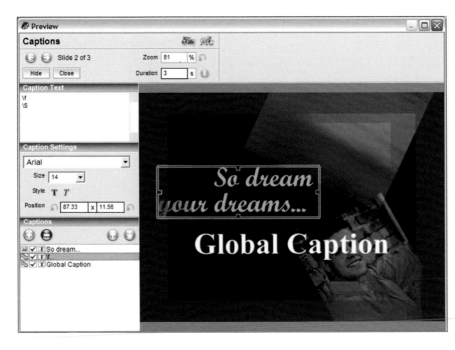

Figure 5.20
The global caption that displays filename and file size is absent from this slide because there is no file in the slide to report data to the caption's macro information.

When a caption's Visibility setting is disabled, it cannot be modified, is hidden from all previews, and will not be included in any output. This is how you prevent a global slide from showing up on specific slides in a show or hide a caption you use only occasionally. Go ahead and disable the Visibility setting on the global caption for this slide. Close the Precision Preview window and the caption will disappear.

In the Slide Options window, move to slide 3. Click on the Global/Slide icon. A box (as shown in Figure 5.21) will appear, letting you know that you are about to remove a global caption that is visible in two slides. Choose Yes to remove it.

Figure 5.21 Changing a global caption back to a slide caption removes it from other slides but leaves it visible on the current slide.

The caption is still shown in the Caption List and is displayed on this slide, but it has been completely removed from the other Caption Lists and is not displayed anywhere else in the show. We can still see it on slide 3 because we didn't delete it or make it invisible; we just demoted it from its global status.

Uncheck the Visibility box on this slide, and it will vanish from the frame but still remain in the Caption List. The process can be reversed as long as the caption remains in a single slide's set of captions. To completely eliminate a caption, use the red Delete button, or right-click on its listing and choose the Delete option from the context-sensitive menu that appears.

The Caption List also controls the order of captions in the slide. The topmost caption in the Caption List sits on top of all other layers in the slide. Any additional captions in the list sit "under" the first caption in their order in the list, and the captions are in front of all other objects in the slide.

The order can be very important when designing motion effects. The caption's position in the stack indicates its relationship to other captions on the slide. We will explore that in detail in the next chapter. When there is more than one caption on a slide, their order in the Caption List can help ensure that one caption does not interfere with the view of another during playback.

We will also make use of the final option box in front of a caption listing. The *Transitions* box sets the location of the caption in relation to the slide's transition effects. It toggles to place the caption above the transitions on either side of the slide or below them.

Basic Caption Design Considerations

It's a rare slide show that focuses on its text elements and captions rather than the images. There are some basic rules that are worth remembering (and which can be selectively, creatively—but not too frequently—bent or broken).

It's a good idea to make sure that the picture does not get lost or hidden in a forest of captions. If you have too much text for one slide, use another slide. A really good design blends captions and their design, including effects, with both the rest of the slide and the entire show. We will look closer at the examples in the shows designed for this chapter and use them to highlight specific design principles. There are some basics that apply to all captions.

In the days when fonts were actually carved in wood or set in hot metal, each font size of the same typeface was designed a bit differently to make them easier to read and to make the type better able to stand the stress of the printing press. Most modern computer fonts can be scaled (enlarged or reduced to the exact size needed) without changing the appearance of the letters. If you are making captions that will be displayed very large or very small, be sure to view the slide for readability on the target output device. Consider the amount of text involved and how long it takes to read and comprehend when planning slide length and choosing which font to use.

In traditional printing, sans serif fonts are used for headlines and serif fonts for body text. The opposite is generally true in the world of the Internet. The goal in both is readability and then pleasing design. If a font is hard to read, the reader may stop before finishing the text. If the design is unattractive or looks unprofessional, the reader's impression of the overall worth and quality of the material will be diminished.

Keep the number of typefaces on a single slide (and even within a show) to a minimum. The same is true for variations in the way captions enter, display in, and leave a slide. It's all too easy to create a multimedia version of a ransom note when we get too "innovative."

Early fonts were crafted to produce books, and typographic conventions were centered on making long passages of text—there were no photographs back then—readable. With slide shows, we can be a lot more creative in our use of text and add new special effects that the craftsmen of the ancient printing guilds never imagined. Still, we share the same goal: visually pleasing readers as we strive to make sure they understand what the words mean.

If there is too much text to fit comfortably in one slide, use two rather than resorting to smaller letters. Good design blends captions and their effects with the rest of the layers in the slide and considers the way text is used in the entire show. Limiting the number of fonts and effects makes it easier for viewers to identify and read captions.

A Closer Look...

Now that we have a good understanding of how ProShow's primary caption tools work, let's reload the Captions_PSG.psh show in ProShow and discuss how captions are used in the overall design of the show and are incorporated into individual slides.

This show uses a series of related captions, producing a running commentary that is matched to the selected pictures. The fonts are similar to those used on professional posters and underscore the high-quality and well-styled pictures. The quick pace of the show, the motion effects, and the caption text effects allow the viewer to read the caption and see the image but not dwell on them. Longer display of the slides and captions would change the mood of the show.

Slides 5 and 6, combined in Figure 5.22, are good examples of how design operates. The slides both have captions that are part of the same phrase: "for every memory, there's a dream ahead." The picture of the young man has a darkened tone, the portrait was taken with dramatic side lighting, and the subject has a quiet, almost pensive look. The picture and words indicate reflection-memories. The line break and text effects used with the caption give a little extra emphasis to the word *memory*. The pictures in both slides are presented with a circular motion effect. The one in slide 5 does not rotate as much and so is slower.

Slide 6 shows a young woman lying on her back looking at the camera. The motion effect quickly spins the face as the image grows in the frame. The caption fades in across the bottom. This image is bright, and so is the girl's smile. The

Figure 5.22 Slide 5 and slide 6 combine to make a statement that is reinforced by the pictures and motion effects.

visual impression, combined with the text, lets the viewer imagine a pleasant day-dream of the future.

The visual flow of the slides continues to match the words in the captions. Slides 7, 8, and 9 all work together by using slight variations and good eye carriage the way motion, text effects, and the pictures in each work individually and together.

Slide 7 shows a young woman on the right side of the frame, and the caption drops into the black area on the right side and wags as it reads, "The happy times you've had so far." The caption is aligned right to bring all the words close to the picture. Slides 8 and 9 are shown in Figure 5.23. The captions continue to alternate in the series from side to side, and so does their alignment. The pictures carry the visual

Figure 5.23 Alternating use of right and left open space and green and pink captions, along with "mirror-image" poses, complete the "matched" effect of slides 8 and 9.

theme, with young ladies facing the center of the frame. The text effects on both slides 8 and 9 drop in to pull the eye into the slide.

The designer wove slides 10, 11, and 12 visually into another caption triple play. The caption on slide 10 (shown on the left in Figure 5.24) enters from the left side using the elastic left text effect. The picture pans in from the right at the same time. All three captions are separated by the same two-pass, door open transition. The caption in slide 11 (not shown) starts a new phrase, but one that continues the overall statement of a changing time of life.

Figure 5.24 Slides 10, 11, and 12 combine transitions, text effects, and layout to maintain the viewer's attention.

The subject in slide 12 (shown on the right side of Figure 5.24) has the same direct gaze. The caption is displayed as a single horizontal line apart from the subject of the picture. Consider how the three slides (and, in fact, all the other slides in the entire show) use eye carriage, open space in the pictures, the actual words in the captions, and the movement of text effects to convey a visual theme and keep both the eye and the mind of the viewer engaged.

The final caption in the show is on the next-to-last slide (shown on the right side of Figure 5.25). It opens using a slide open-corners effect that reveals the text as the preceding picture of the teenager walking (on the left half of the figure) is divided into four sections that pull out and away to the corners of the frame. The designer uses the same decorative font that graced the title slide at the beginning. The title slide's picture included an out-of-focus student in the background. The final slide has the same girl, on a slide without a caption, in her graduation cap and gown. The balance at the beginning imparts a subtle symmetry to the overall design of the show. In this example, the text, and what it says, is a major element in the design. All the other components were tuned to the words. In many shows, the captions play a secondary role. The nature of the design and the way text is used have to be adjusted accordingly.

Figure 5.25 The closing statement takes center stage, as the transition opens directly onto the center of the frame and the caption by itself.

Up Next

The basic caption toolkit is only the starting point when it comes to working with text in Producer. Advanced typographic control and keyframes let us create sophisticated motion effects and precisely adjust the appearance of text on slides. The next chapter offers a first detailed look at how keyframes expand your ability to fine-tune every aspect of a show and move each caption within the frame. We'll also work with interactive captions that allow the user to use the captions to branch into variations of a show and let the designer link the show to Web sites and obtain e-mail responses from viewers.

Getting Fancy: Keyframing Basics and Advanced Caption Tools

This is where the fun really begins. We've covered ProShow's basic tools and concepts. Now it's time to shift into the program's high-performance mode and meet Producer's powerful keyframing tools. Combining them with Producer's advanced graphics capabilities and interactive caption toolkit lets us create really professional multimedia text effects. This chapter serves as the foundation for exploring sophisticated motion and special effects techniques in the following chapters.

We'll start with a short slide show demonstrating how Producer's keyframes, caption motion effects, and interactivity dramatically expand our ability to control text in our shows. Then we'll dissect the slides, see how they were made, and build some of our own. You will need Producer to follow along and work with the examples. The latest version can be downloaded from the Photodex Web site if you don't have a copy already.

In the Chapter 6 folder of the CD-ROM is an executable show file named Chapter_06.exe. It contains nine slides and 24 captions. Please watch it by double-clicking on its icon. (You can first move it to your hard drive for better performance if you prefer.)

During play, pay particular attention to how the captions enter and leave the frame in relation to each other. In Gold all captions (and all layers) share the same timing as the slide. That restriction is lifted in Producer. This is a major improvement. As you will soon see, with the help of keyframes and interactive control, we can make our captions do some amazing things.

Keyframes Defined, Captions Redefined

Traditional captions, like the ones we created in the last chapter, may move around, but we have no real control over their predefined actions. Their time onscreen is totally determined by the slide's time in the show. Those limitations are gone when we use keyframing to control special effects. Before we can work with keyframes, we have to understand what they are and how they work.

Keyframes are points of reference that tell Producer how to build an effect. They are like the landmarks and turning instructions we use when giving travel directions to a friend: "Turn right at the gas station and go three miles to the city high school, and then turn left at the next intersection." The friend will handle the mechanics of getting between the landmarks and making two turns.

Keyframes mark the change points in an effect. They always work in pairs: a "from" and a "to." Let's say we want to move a caption halfway across a frame over a period of two seconds; we also want the caption to change in color from dark blue to light blue as it travels across the frame. If the frame rate during play is 30 frames per second, that's 60 frames (each with slightly different locations and colors) that have to be created.

All we have to do is set two keyframes, one adjusted with the desired starting location and color settings and the other set to the final position and appearance. Producer generates all the frames in between automatically. Change the display times or frame rate, and Producer will regenerate the appropriate number of new frames with the required settings for the effect.

Before delving into the mechanics of using keyframes, let's see what they let us do when working with captions. That makes it easier to understand how to apply them with more advanced controls in the following chapters. Figure 6.1 shows the third slide in the show most of the way through its five-second play time.

There are two captions in slide 3, shown in Figure 6.1. Both use keyframes to create precise motion effects. First to appear is the word *Wedding*, replete with a gold-toned gradient fill (another Producer feature not available in other versions of ProShow) and drop shadow. It moves from the right side of the frame to the left and fades out and back into full opacity. The word *Gallery*, set in a script font, becomes visible from left to right as if someone were writing it with a pen, just as the Wedding caption fades back into view.

Figure 6.1

Two captions, one with a gradient fill and the other with a motion effect resembling a hand-drawn word, let us know this slide was created using Producer's advanced caption toolkit.

If this slide had been created without keyframes, each caption would have appeared—and ended—at the same time. Independent keyframes let us control exactly what each caption (or a layer) will do as a slide is displayed. Add interactivity to a caption and keyframes become tools the viewer can use to control the show and even expand its domain to the Internet and e-mail.

There are four captions in slide 4, shown in Figure 6.2. Once again, the designer has used keyframes and a script font to make the letters appear as if they are being written as the slide plays. Hold the mouse cursor over a caption and it will pulse, denoting an interactive function. In this case, the captions link to a specific slide in the show; click one and the program jumps to that location and continues playing.

The next four slides, including slide 5, shown in Figure 6.3, are the destinations linked to the captions in slide 4. They could have been at any point in the show, in another show, on the Web, or even in a command to launch another program. We'll look more closely at these interactivity options and how to use them shortly.

There are three captions on each of these slides. The titles ("The Engagement," "The Formals," etc.) use the now-familiar left-to-right scroll. A Shakespeare sonnet scrolls up the right side of the slide, and an interactive link to slide 4 is in the upper-right corner. That caption and the ones on slide 4 provide a user interface, allowing the viewer to easily navigate the show at will. With only nine slides, that

Figure 6.2
The four captions on this slide are interactive links, allowing the viewer to jump to a different point in the show.

Figure 6.3
The Slide List makes it easy to step through a transition of special effects to preview and tweak settings for maximum impact. This image was made using Producer's built-in capture feature.

isn't really necessary but is useful for the sake of demonstration. Consider a complete set of wedding proofs with more than 300 images. Some viewers will want to watch every minute. Others will want to go right to a particular section.

ProShow makes it easy to give viewers the access they desire, or what we want them to use, with well-designed captions. The timing of the caption motions relative to images used in the slide, the Fly In and Fly Out effects, and the chosen fonts are all elements that can be used to create an overall design. Captions are more than words.

The closing slide in this show has five captions. (See Figure 6.4.) The large "Contact" caption uses an image for a fill to give it a unique appearance. Adding "Contact Us" as a separate caption underscores the point of the slide. Interactive links to the Web site and e-mail address make it easy for the viewer to follow up without delay or the need to manually launch a browser or an e-mail program. This slide show quickly demonstrates Producer's advanced abilities with words. Now let's see how they work.

Figure 6.4
The last slide in the show features an interactive caption linked to a Web site. Clicking on it will open a Web browser and load the page.

Producer's Captions Window

Open the Caption_PSP show in Producer, select slide 4, and press the F5 key. The Captions window will appear, as shown in Figure 6.5. The basic features found in Gold are the same, but the locations are a bit different, and we have some new tools. The Caption List, Selected Captions, and Preview Areas are identical in both versions. So are the Text Effects, Caption Color, Outline, and Drop Shadow controls. Before getting into the details, let's take a quick tour of the expanded interface.

Figure 6.5
The Captions window in Producer provides more tools than in the Gold version, including additional placement adjustments, interactivity, and the option to use texture effects as fills.

Caption Styles

Producer's Caption Format section has a Style button not found in Gold. A style is a collection of caption settings that can be saved and applied to a new caption. Almost every setting except the actual location on the slide can be defined and applied with a couple of mouse clicks. Not only is this a great time-saver but it also ensures a consistent appearance within a show.

Setting up and applying styles is easy. Choose a caption on a slide in the Captions window, and then click on the Style button. The Caption Styles window will open. There are several predefined styles available in the column on the left side of the window. Choose one and all its settings will be applied to the currently active caption.

You can use the Add and Update buttons to define a new style based on the current caption. Figure 6.6 shows the Caption Styles window and New Caption Style window arrayed over the Captions window. Name a new caption if desired, and check the attributes to be included.

Figure 6.6
Styles are a quick way to apply text effects and formatting attributes to a caption.

Caption Placement (with Style)

Placement controls in Producer are extensive. You can adjust character and line spacing as well as opacity, and you can skew and rotate both the caption and the characters in it. Even neater, many can be modified while the slide is playing, adding to your collection of special effects.

Let's add a caption to slide 5 and experiment with the caption placement controls. Choose the slide and press the F5 key to open the Captions window. Add a new caption that says "Turning Around." In the Caption Format area, set the font to Arial and the size to 30. Double-click on the Preview to access the Precision Preview mode.

Now adjust the following values in the caption placement section: Rotate to 43, Character Rotate to -43, and Character Spacing to 140. Figure 6.7 shows the Precision Preview window after applying the settings and positioning the new caption in the center of the slide.

Figure 6.7
Producer's caption
placement controls
can be combined to
create a wide range of
special effects.

We now have a diagonal caption. Fine-tuning Spacing, Rotation, and Skew settings provides almost total control over the letters in the caption. Let's save this one for future use. Press the Style button and then click on the Add button. Name it "Diagonal." Uncheck all but the Spacing, Alignment, and Position options.

It's a good idea to consider what settings need to be included (and excluded) when we create and save captions. Generally speaking, it's best to limit the options to those needed for a specific effect or action. Once the settings are adjusted, click Done to save the style. Then delete the caption we just made and exit the Precision Preview window. Leave the Captions window open with slide 5 selected.

Using Interactive Captions

The caption that says "Back to Gallery" in the upper-right corner is an interactive element. Select it and notice the settings in the Caption Interactivity area of the window. There are two boxes in the section: Action and Destination. The Action setting determines what happens when the viewer clicks on the slide during playback. (This works only when the show is being played in ProShow Presenter.) The Destination setting defines how the action works. With this caption, when a viewer clicks on "Return to Gallery," the show jumps to slide 4.

Actions fall into several categories. Some let the user control the operation of ProShow Presenter. Captions can be set to pause or resume playback, open another show, jump to a specific point in the show, and exit Presenter. They also allow the viewer to shift between Full Screen mode and a smaller display size. The caption can launch another program and return the user to the show when the other application is closed.

An active Internet connection expands the possibilities. Actions can let the viewer visit a Web site and send an e-mail to a specific address. These tools let the user provide feedback, request information, and even visit an online shopping cart to purchase items featured or described in the show.

Placing Captions on Multiple Slides

It's easy to see how you might use some captions several times in the same show that you nevertheless don't want to set as a global caption. The Copy Captions commands make quick work of that task. To add a single caption to another slide (or group of slides), select the target(s) and open the Captions window. Then right-click on the caption you want to copy and use the context-sensitive menu to copy your selected caption to other slides (see Figure 6.8).

Figure 6.8

Use the context-sensitive caption menu to copy a single caption to a slide or group of slides in the same show.

There is a better way to broadcast captions if you have several to place. Open the same context-sensitive menu and choose the Specify Destination option. The window shown in Figure 6.9 will appear. The left side of the window has a thumbnail of all the slides. In front of the thumbnail is a box used to show or hide the captions for that slide. Figure 6.9 displays the list for this show with Slide 5 expanded and the rest closed. Choose the captions you want to copy to other slides in the show. I've placed a check mark in the listing for the "Back to Gallery" caption.

Figure 6.9
The Copy Captions window makes short work of copy operations, letting you set up complex copy commands for an entire show.

The right-hand list is used to set the target slides where the selected captions will be added. The example in the figure has slides 6, 7, and 8 marked to receive the active captions. Choose Copy if you want to add captions and set up another copy command. Choose Copy and Close when you are running the last set of copies. This window is a great one-stop copy center.

Producer offers the ability to fine-tune space between lines of type as well as individual characters, set opacity, and define the exact placement of each caption individually. Suppose we have a caption that runs across two slides or that appears in several slides. Sudden changes in position or color as a new slide comes in distracts the viewer. We usually don't want parts of our design to radically change from one slide to the next. Copying lets us place a caption on multiple slides using the same settings.

Keyframing, Motion Effects, and the Magic of Timing

The built-in Fly In and Fly Out text effects add motion to a caption but lack the ability to control the timing and direction of the movement beyond the predefined menu options. To produce custom motion effects, you have to be able to control the direction of movement, the speed, and how long an object travels along a path. That's where keyframes come in. They precisely place and adjust the attributes of any object or effect at specific points in time and space *within* the slide, and to change those settings during the time the slide is on the screen.

The easiest way to understand how they work is by using the keyframe controls. Select slide 8 and open the Caption Motion window. (The keyboard shortcut is Control-F9.) Your window should look like the one in Figure 6.10. The basic window layout should be familiar by now.

Figure 6.10

The Caption Motion window lets you control every aspect of a caption's behavior during playback and use keyframes to precisely adjust the timing of special effects.

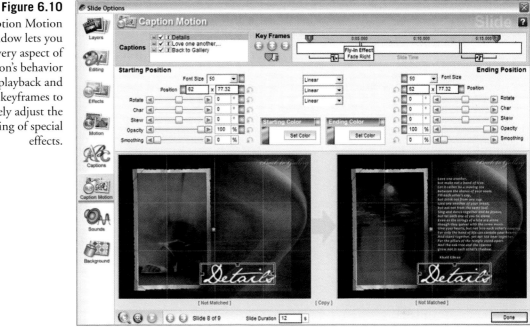

This slide has three captions. They are listed in the captions area on the upper-right side of the window. One is visible the entire time, one fades into view and remains, and one fades into view and then scrolls up the right side of the slide. The controls and preview on the left side of the window show the slide and setting at the beginning of playback; the right side shows the slide and values at the end of playback for the currently selected keyframe.

Up until now, we've created only slides and captions with one pair of keyframes. So our start and end settings applied to the entire slide, since those two points marked the beginning and end of the slide. Keyframes always work in pairs. Adding and adjusting keyframes is how you gain more control points to tweak the timing of the slide and special effects. First you set the points, and then you adjust the attributes to create the desired effect. Producer creates all the intermediate frames to yield the desired results.

The basic controls in the Caption Motion window (already shown in Figure 6.10) are similar to the ones in the Motion Effects window. At the top left of the window is the list of captions, and to the right is the Keyframe Timeline. The lower

portion of the window has two tool panels. The panel on the left controls the starting position, and the one on the right controls the ending position. We can adjust the font size and the X-Y position by entering values into data boxes located above the column of sliders.

The Rotate setting rotates the entire caption, the Character setting rotates the letters inside the caption, and the Skew setting tilts the letters along the caption's baseline. Opacity adjusts how transparent the caption is. Smoothing adjusts the level of jerkiness during a shift in the path of a motion effect.

Working with the Keyframe Timeline

The Keyframe Timeline is where we create and manipulate keyframes. Let's examine the keyframes on slide 9 and see how the Keyframe Timeline works. Figure 6.11 shows the keyframes for Caption 1, which has only two keyframes. The bar (the horizontal rectangle in the center of the area) indicates the entire length of the time that any portion of the slide can be seen on the screen: that is, from the midpoint of the preceding transition to the midpoint of the following transition.

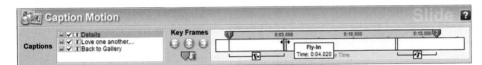

Figure 6.11
The Keyframe Timeline for the first caption on slide 8 with its Fly In selected.

On the top of the bar are the two icons, Keyframe Markers, each with that keyframe's number in the center. The colored area between them shows the length of time these two keyframes control. Along the top of the bar are tick marks and numbers denoting the amount of time used at each point. A light-yellow gradient fill shows how the transition effects blend in and out and is solid when the slide is being shown at full intensity.

Underneath the bar are two icons representing the caption's Fly In and Fly Out text effects. The arms in front and behind each icon show the points on the timeline where they begin and end. I've placed my mouse cursor over the end point of the Fly In, and my cursor has changed into adjusting handles. The tooltip shows exactly how long the effect will last. Placing the cursor over the beginning point of the Fly Out provides the same type of adjustment of the Fly Out text effect. The colored space in between indicates the total slide time.

Between the Caption List and the Keyframe Timeline are three round buttons above two icons that look like Keyframe Markers. Clicking on the green button with the plus sign in the middle will add a new keyframe. The blue buttons

with the arrows let you change the active keyframe set. Click on the icons below the buttons and a dialog box opens that lets you adjust the time location of the currently selected keyframe. Enter a positive number to shift the keyframe to the right. A negative number moves it to the left.

Adjusting Keyframes and Text Effects

Let's have some fun and see how moving the objects on the Keyframe Timeline changes how the caption works. First, save the show (press Control-S) so you can revert to the current version when you finish. Preview the slide so you'll know how it played before the adjustment. Now place your mouse cursor over the first keyframe so that a tooltip showing the time appears next to the cursor. Now drag the keyframe to the right until the position is similar to the one in Figure 6.12. Don't worry about the exact time interval; just be sure that it is about the same distance inside the slide's playing time.

The preview is changing as you move the keyframe. Adjust the icon so the result is similar to the one in Figure 6.12. Now run the preview. The slide still starts at the same point, but the word *Details* starts fading in much later. That's because we shifted its location on the timeline. The text effects still work the same, but the entry point is retarded.

Figure 6.12

Moving a keyframe is simply a matter of drag and drop. As the keyframe is moved, the appearance of the slide in the Preview Area will change.

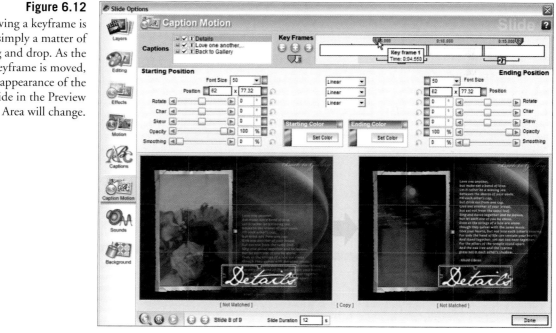

Now place the mouse cursor over the Fly In so that you can see the red box and the adjusting handles. Drag the rear of the box to the left until the time is reduced to zero. The tooltip will change. Note that the Fly In effect is set to None, as shown in Figure 6.13.

Figure 6.13
Reducing the Fly In time to zero by dragging the icon eliminates the effect without removing it.

Now preview the slide again. The caption no longer fades in—the word *Details* appears all at once. The slide plays for the same amount of time and fades out normally. The changes we are making apply only to the selected caption and only to the section of the time for that caption that we manipulated.

Now place the cursor over the first keyframe and drag it all the way to the far left of the Keyframe Timeline. That brings it into the area of the transition effect between slide 7 and slide 8. Close the Caption Motion window and preview the show from the start of slide 7. The word *Details* now appears as slide 7 transitions and stays at full opacity until the point where the Fly Out makes it fade.

Open the File menu and choose the Revert to Backup command to restore the show to its original condition. Select slide 8 and open the Caption Motion window. Now that you understand how keyframes operate, it's time to see what happens when an object has more than two keyframes.

Working with Multiple Keyframes

Select the second caption. This is the block of text that scrolls up the right-hand side of the slide. It has three keyframes. Remember that no matter how many (or few) keyframes an object has, they always work in pairs. Only two keyframes can be active, whether in the editing window or when the slide is being played. The left-hand slide is the starting point, and the one on the right the ending point. When the timeline reaches the ending point, it becomes the beginning point of a new time slice, and the next keyframe becomes its ending point. The very first keyframe is still the technical starting point, and the very last keyframe is the ending point. See how the left column in Figure 6.14 is labeled Keyframe 1 (starting point) and the right is labeled Keyframe 2?

Let's examine the effects set for each position and what these two keyframes are doing in the design. Hold your mouse cursor over the Fly In icon on Keyframe 1. It is set to None. Now examine the Fly Out icon. It is set to Fade Out. The first

Figure 6.14

This slide has three keyframes. Each pair of keyframes allows you to create a new set of effects within the slide.

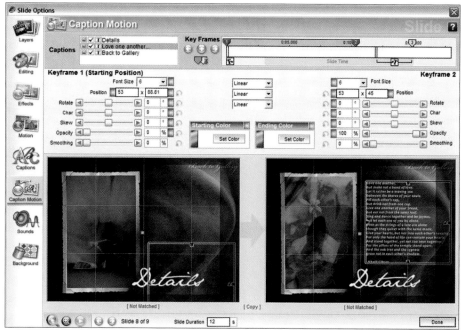

keyframe is all the way at the left edge of the slide's timeline. So the effect begins at the midpoint of the preceding transition.

But what is the designer doing? There is no Fly In, yet the Preview Area shows that the text is invisible as the slide starts and gradually becomes solid. Look at the opacity settings for the two keyframes. The first is set to zero and the second to 100 percent. That's what is producing the fade in effect, not the text effect. Now notice the Position settings. They begin at 53x88.61 and move up to 53x45. That is what is causing the block of text to scroll up.

The second set of keyframes is designed to have a time when the text is opaque and then let the Fly Out text effect fade the text until it is invisible, all *before* the transition begins. Figure 6.15 shows the Keyframe Timeline just at the point where the following transition begins. (The red marker indicates the point on the timeline when I made the screenshot.) See how the text in the second caption has disappeared in the Preview Area on the left?

Playing the show into the next slide reveals why the caption was completely removed before the start of the next transition. The next slide has a black background, and the designer wanted to have only pictures visible as it came into view. Allowing the caption to play during the transition would have interfered with that effect.

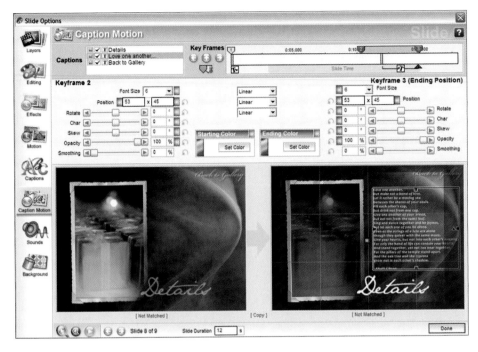

Figure 6.15
The second set of keyframes holds the text in position and then uses the Fly Out text effect to let the caption completely disappear before the start of the following transition.

Adding and Adjusting Keyframes

We can add keyframes to an object (remember that the basics of keyframe manipulation are the same for both layers and captions) by clicking on the green button with the plus sign between the Keyframe Timeline and the Caption List. An easier way is to use your mouse. Let's do that now. With Keyframes 2 and 3 selected, place the cursor midway between them and double-click.

Voilà! Now we have four keyframes. The new member is number three, and the old number three is now four and designated as the ending point. The settings for the new keyframe are the ones the program had already calculated to produce the effect for that object's appearance for that moment in the show. (Producer automatically generates the intermediate frames, so the new keyframe is pulled from that array and fixed as a point on the Keyframe Timeline.)

With Keyframes 3 and 4 selected, adjust the Skew setting for Keyframe 3 to -360. Leave all the other settings the same. Double-click on the preview to open the slide in the Precision Preview window. Select the second caption and the Play button. Figure 6.16 shows the change as the new Skew setting takes hold. Notice how the keyframe position is inside the text effect area. Keyframes can be placed anywhere on the timeline.

Figure 6.16
The effects of a single setting in a single keyframe can be quite dramatic. Here just shifting the Skew setting makes the caption look like it was caught in an earthquake.

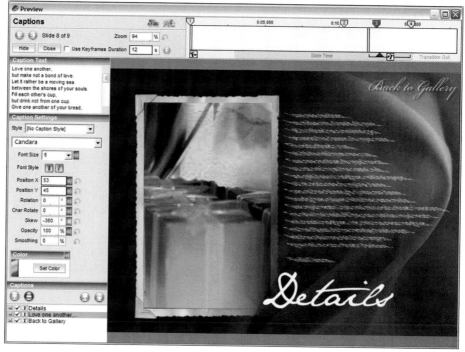

We can make a wide range of keyframe and caption adjustments in the Precision Preview window, but there are some differences in the way it works compared with the Caption Motion window and Motion Effects window. Look at the Keyframe Markers. In the Precision Preview window, only one has turned dark, and there is not shading in the space between the active keyframes. That's because we can only adjust one keyframe at a time. If you want to add, remove, or adjust the time for a keyframe in the Precision Preview window, right-click on its Keyframe Marker and choose the appropriate option from the context-sensitive menu.

Now look at the colored boxes behind the Adjust settings on the left side of the window. All but the one for skew is green. Its box is amber-colored. A green box indicates that the setting is in Auto mode. That means that Producer is calculating the settings between the keyframe before and after this one and that the current value is the result. Amber boxes appear when we set values for a keyframe and override the generated values.

So, when you want to create an effect, determine where you want the action to peak. Place a keyframe there and make your adjustments. Producer will make the needed adjustments to the surrounding keyframes and generate the intermediate frames to produce the desired result. You can then tweak the effect by adjusting the settings or the location of the keyframes.

Keyframes Move More Than Words

So far we have limited our discussion of keyframes to captions. Keyframes operate exactly the same with any type of object in a show. They control action: when it occurs and for how long. The Effect settings define what the action is and its degree or intensity. We are going to use the Captions window and Adjustments Effects window along with keyframes to make a simple yet sophisticated ending title slide for the current show.

Our new slide will scroll three captions in one at a time from left to right, just as if someone was writing them with a pen over a picture of gift boxes. Then we will fade the background image so that slide ends with three white captions against a totally black backdrop.

Setting Adjustments Effects and Keyframes

First, let's add a blank slide behind slide 8. Set the time for both the new slide and the preceding transition to zero. The Images folder contains an image of gift boxes and lit candles named Tricoast-Details-012.jpg. Drag it into the Slide Timeline to make a new slide at the very end of the show. This image will serve as the background for the slide, which will also have three white captions. Set the time for this slide to eight seconds.

Now add another blank slide at the very end of the show and set its time to three seconds. The blank slides on either side of the final title slide add a smooth black backdrop that is independent of the title slide. I usually add one at the end of a show and trail just a little of the soundtrack into its playing time. It's a way to control the end of a show, rather than have it end abruptly.

Select the new slide 11 and press F8. This shortcut opens the Adjustments Effects window. We are going to make several adjustments so that your window will look like the one in Figure 6.17. This window, and the Keyframe Timeline and the Keyframe controls, works just like the one in the Caption Motion window. The slide has only one layer, so there is no layer list on the top left. (If we added a second layer, the list would appear and we would have to select the layer we wanted to adjust.)

Right now, the ending point looks just like the starting point. Let's set the desired adjustments first and then work with the keyframes. That way the changes will be shown in the ending point preview. Leave the starting opacity at 100 percent and set the ending opacity at 32 percent. Shift the ending contrast to -25 percent.

Your window is not quite the same yet. Use the mouse to drag Keyframe 2 in until the tooltip reads 8.3 seconds. (If your timeline doesn't seem to have the right amount of time, make sure the time for this slide is set to 8 seconds and that the following transition is set to play for 3 seconds.)

Figure 6.17
Keyframes let us adjust setting values as a slide is played. Here we use opacity to fade a layer almost to black before the start of the ending transition.

Now place the cursor over the left end of the ending transition and drag it to the left so the tooltip shows 0.01.360. We're almost done, but we want a different transition. Place your mouse pointer on the ending transition icon on the Keyframe Timeline and left-click. The Choose Transition window will open. Select the Crossfade (Blend) transition, as shown in Figure 6.18.

Figure 6.18
We can set transitions for a layer by clicking on the appropriate transition on the Keyframe Timeline and then selecting the desired transition affecting the Choose Transition window.

Adding and Adjusting the Captions

Click on the Captions icon on the left side of the window and add three captions
to the slide. I've used a script font and adjusted the sizes to fit the design. Feel free
to use any font you like and adjust the size as needed. The first caption reads
"Congratulations" (without the quotes, of course) and is set to 48 points. The sec-
ond caption says "Lynn & Mike" and is set to 48 points also. The third is the
date—"October 22, 2008"—set in 30-point type.

Adjust the placement and size of the captions to match the example in Figure 6.19.
We want the top caption near (but not touching) the upper-left corner of the safe
area. The name of the couple is in the middle of the slide and starts a little to the
right of the left side of the first caption. The date is below and to the right of the
middle caption, mostly over the tablecloth.

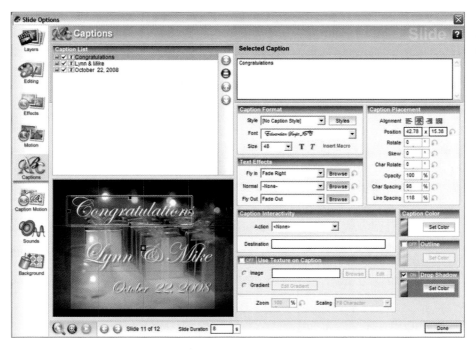

Figure 6.19
Setting the captions
for the new title slide.

Now we are going to add a drop shadow to all three captions. The image in the
background contains a wide range of tones, and it can be hard to make out the
white letters over the brighter portions of the picture. Select each caption in turn
and enable the Drop Shadow option. Then click on the Set Color button and use
the eyedropper tool to pick a color in the picture that offers a clean shadow that
adds to the caption's readability. I found that the top caption required a lighter
color and the bottom one a darker color to contrast with the portions of the pic-
ture underneath.

Once the captions are in position with the drop shadows added, change to the Precision Preview window. We are ready to adjust the keyframe timing and text effects. Using your mouse, set the first caption as follows: Keyframe 1 at 0.5 second, the Fly In at 1.0 second, and the type to Fade Right. (Click on the Fly In icon and use the Choose Caption Effects window to set text effects.) Figure 6.20 shows what the Precision Preview window should look like after making adjustments to the first caption.

Figure 6.20

The Precision Preview window after adjusting the first caption.

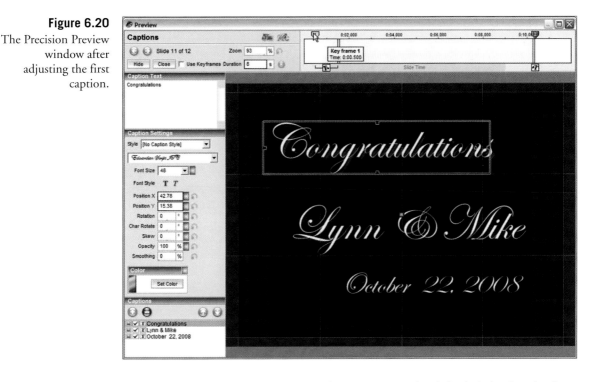

We want an effect that has the second caption enter the slide slightly after the first, with a left-to-right fade in. By setting the start time for the first keyframe of Caption 2 slightly behind the first keyframe of Caption 1 and about the same amount before the beginning of Caption 3, we obtain that result. We are going to set the second keyframe of all three slides so that they exit at the same time.

Select Caption 2 and adjust the settings using your mouse and the Keyframe Timeline as follows: Keyframe 1 to 2.290 seconds (the box will show 0.02.290), the Fly In to 1.0 second, and the type to Fade Right. The Fly Out value is set to None. The Fly In times, types, and the final keyframe for all three captions will be the same in order to synchronize the exit effect. Figure 6.21 shows the Keyframe Timeline for Caption 2.

Figure 6.21
The Keyframe
Timeline values for
Caption 2.

The third caption is set to start after the second caption. The values: Keyframe 1 set to 4.0590 seconds, the Fly In set to Fade Right for 1.0 second, and the second keyframe set to 10.360 seconds with the Fly Out set to None. Figure 6.22 shows the way the Keyframe Timeline should look after making the adjustments to Caption 3.

Figure 6.22
The Keyframe
Timeline values for
Caption 3.

Press the Play button to see the result. Adjust the starting point of the first keyframe as needed to get the effect of a line starting to appear as the preceding one is completely visible. The exact time will vary depending on the typeface and the length of the caption. Keyframe timing is part art, part science. The slide show is a visual experience, and so the way the viewer sees an effect is the true test.

Figure 6.23 shows the final result of the slide just as the last caption is entering. Shifting the starting point, adjusting the playback time for the slide, adjusting the

Figure 6.23
The final result as the
third caption enters
the slide.

font size, and even using the smoothing function to reduce jerkiness are all variables you can use to tweak the captions. The opacity amount and timing offer additional tools for fine-tuning the effect.

Up Next

Keyframes are one of the most powerful tools Producer offers. Combined with the various settings and special effects, they offer incredible creative possibilities. This chapter was only an introduction to their use. Now we turn to advanced adjustments that you can combine with keyframes to produce stunning professional effects.

Advanced Motion Effects Using Keyframes

Keyframes add a new dimension to ProShow's motion effects. We can make multiple layers dance across the frame independently of each other, each with its own timing. They can enter and exit at will, and each layer can have its own transitions, adding to the creative special-effects possibilities.

This is a Producer-only chapter because it is the only edition of the program that supports keyframes. Before working on the following exercises, you should already know how to use the Keyframe Timeline and understand the basics of how to manipulate layers and apply basic motion effects.

A Traffic Control Lesson

Keyframes are powerful and fun once you get to know them. As with any high-performance technology worthy of those adjectives, it's best to understand how it works—and how to control it—before doing anything serious. Trying to track the effects of several keyframes with several layers going in multiple directions can be confusing to the uninitiated. Once you understand the basic concepts and controls, creating fancy motion effects is much easier. So, before we start making multiple layers do all sorts of fancy movements, a test drive is in order.

Power up Producer, and then create a new slide by dragging the file named TriCoast-Girls-002.jpg from the Chapter 7 Images folder on the CD-ROM. Give the slide a 10-second play time and a three-second transition. Now press the F4

key to open the Motion Effects window. Your screen won't look quite like the one in Figure 7.1. That's because I've already added a third keyframe and made some adjustments for the demonstration. If you don't see the motion path on your screen, right-click on the Preview window and enable its context-sensitive menu option.

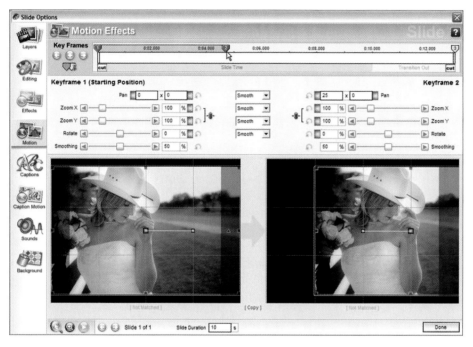

Figure 7.1
The Motion Effects window open with the slide's first and second keyframes selected.

Place your mouse cursor at same point on the Keyframe Timeline as the one in Figure 7.1, one second into the play time, and click to set a new keyframe. Make sure the first and second keyframes are selected by clicking in between them on the Keyframe Timeline. The space between them will now be a darker shade than the space between Keyframes 2 and 3. Now change the pan value for the X-axis of Keyframes 2 to 25. (The pan value is the top entry in the right column. I have already changed it in Figure 7.1. Now your window should look just like the screenshot.)

We just created a motion effect that moves the image one-quarter of the way across the screen to the right during the first keyframe. The motion path tells the story. See the green square with a red border in the center of the Keyframe 1 preview? That symbol, the Current Keyframe Marker, notes the center position of the layer at the point for the current keyframe. It has moved to the point for Keyframe 2 in the right-hand preview.

Now click between the second and third keyframes on the Keyframe Timeline. You should see Keyframe 2 listed above the left side's controls and Keyframe 3 (the ending position) noted above the right side's controls. Adjust the pan values for Keyframes 3 to 25. That will push the layer directly down. Your window should now look like the one in Figure 7.2.

Figure 7.2
The Motion Effects window with the second and third keyframes selected.

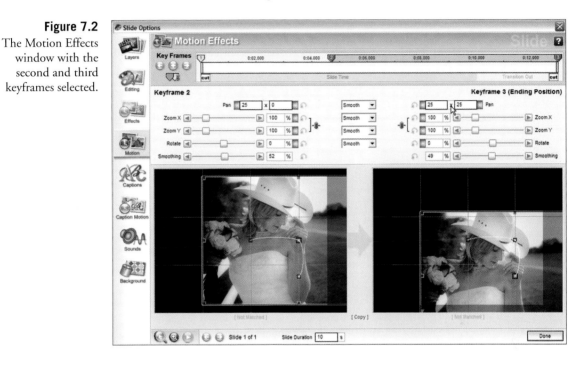

Now we have a motion path that runs through three squares on the screen. The Current Keyframe Marker marks the center of the layer at the start of Keyframe 1. In the left-hand preview, it notes the starting point in the path, and in the right, it notes the ending point. That's because the active keyframe is different in each window. The other green marker, the one without the board, notes the center position. The red marker notes the center position of a keyframe that is not a member of the currently selected pair. Now click the Play button to run the preview.

It will take a few moments for the playback to begin. That's because ProShow has to gather resources and render all of the images to produce the video stream. For a 10-second slide at a rate of 30 frames per second, that's 300 images at the working resolution. That means it also has to calculate how each frame will look based on the desired motion effects. Any captions, soundtracks, or adjustments effects add to the workload and have to be calculated for each frame.

The Smoothing Effect

When we added the Pan effect to the third keyframe, the shape of the motion path changed from a straight line to a curved one. A sharp turn in a motion path can look jerky during playback, as the picture quickly changes direction. Consider how it feels when you are in a car during a turn. If the change is very fast, the shift in direction feels sharper. A more curved path results in a gentler turn. The same is true in motion effects. The default Smoothing setting is 50 percent. A value of zero produces a straight line and a fast break in the line of travel. A value of 100 will generate an even larger curve. See Figure 7.3.

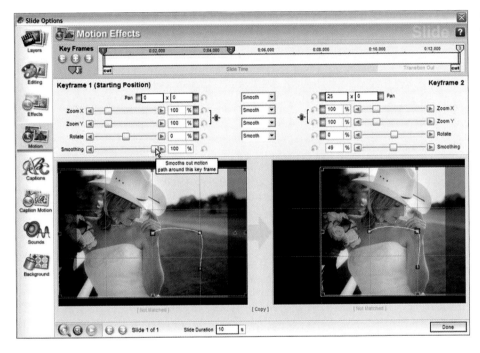

Figure 7.3
The straightness of the motion path line shifts depending on the amount of smoothing applied to each keyframe.

A higher Smoothing setting also avoids the visual appearance of a pause or slowing of motion when a very sharp change in direction (over 90 degrees) occurs. Adjust all the keyframes to a Smoothing setting of zero. Then drag the third keyframe over to the right, as shown in Figure 7.4. Play the preview and watch how the image moves as it makes the sharp turn.

Adjust the Smoothing settings for all three keyframes to 100 percent. Play the preview again and observe the change. There is no hard-and-fast rule for applying this setting. The "best" value varies based on the image, the motion path, the nature of the effect, and the desired result. Take some time to experiment with settings as we work with different layers and keyframes in this chapter to get a better appreciation of how it can improve your results.

Figure 7.4

The Smoothing
setting changes the
shape of the motion
path and how a layer
behaves as it moves
around a keyframe.

Notice that the first and third keyframes have icons underneath the timeline for transitions. For this slide there is no preceding transition for the slide itself. Each layer can have its own beginning and ending transition that is totally independent of the settings for the slide. Click on an icon and the Choose Transition window. The beginning transition for Layer 2 starts at the beginning of the play time for the slide. The last transition actually starts after the following transition for the slide has already begun. The motion effects have already been introduced, so they should be familiar.

Getting Things in Proper Order

Before we start really playing with keyframes, it's important to understand a few quirks in their behavior. Let's add another slide to our show; it's easier to demonstrate with a fresh example. Drag the image TriCoast-Girls-004.jpg into the second slide position on the Slide List. Click at the five-second point on the Keyframe Timeline and add a new keyframe. Click between the first and second keyframes to select them. Now in the Keyframe 2 preview, drag the layer straight down until the Y-axis has a value of about 25 (the exact amount isn't critical, but make sure the motion path is a vertical line). Your Motion Effects window should look like the example in Figure 7.5.

Figure 7.5
The new slide ready
for preview in the
Motion Effects
window.

Now press the Play button and see the results. The layer moves down as expected. Did you expect it to move back up? Understanding why it did and how to control such "unexpected" behavior is a critical skill for anyone wanting to create fancy motion effects.

The reason is simple. We added our new keyframe in the middle of the Keyframe Timeline. The program had already calculated the position for the ending point (that is now Keyframe 3). Select the second and third keyframes and you can see the reason. When we moved the middle keyframe, the program calculated the new position for Keyframe 2 but left Keyframe 3 with the original settings that were assigned when the slide was first created. The settings and motion path are shown in Figure 7.6.

Make sure that Keyframes 2 and 3 are selected. Click on the Copy menu, located at the bottom of the Preview Area between the two views. Choose the Copy Start to End option that is highlighted in the example shown in Figure 7.6.

This is one of the handiest menu items when working with keyframes. "Start" is the start of the current beginning keyframe. In this case, that is Keyframe 2. "End" is the end of the slide. So all of the settings for Keyframe 2 are now applied to Keyframe 3 and to any keyframes that follow in *this* slide. We'll play with this concept some more in a minute.

Figure 7.6
The settings for Keyframe 3 are the same as the settings for Keyframe 1 because they were set when the layer was added to the slide.

Run the preview again. Now the layer travels down and then stays in place until the end of the slide. Make sure Keyframes 2 and 3 are selected. Now look at the motion path, shown in Figure 7.7. It is the same in both windows! What happened to the second green dot, the one without the border that denotes the other active part of the current keyframe pair?

Figure 7.7
The motion path looks a bit different when no motion occurs during a keyframe segment. The second green dot is hidden under the Current Keyframe Marker.

The second green dot is hidden under the Current Keyframe Marker. The red dot is the marker for Keyframe 1. We will see both Keyframe Markers for a given pair only once the layer moves during the pair's active playback period.

Simple Keyframe Effects: There and Back Again

Let's exit the current show and create a new one to practice what we've just covered. In your new show, drag TriCoast Girls-002 into the first position on the Slide List. Set the slide time to 10 seconds and the transition to zero. We want just 10 seconds on the Keyframe Timeline and all 10 included in the slide time.

Adjusting Keyframe Timing and Position

Press the F4 key to open the Motion Effects window. Now add four keyframes to the Keyframe Timeline to make a total of six. (Two were created when the layer was added.) Right-click on Keyframes 2, 3, 4, and 5 in order and choose Set Time from the context-sensitive menu. Set the times to a two-second interval: Keyframe 2 at two seconds, Keyframe 3 at four seconds, Keyframe 4 at six seconds, and Keyframe 5 at eight seconds (as shown in Figure 7.8). Keyframe 1 is already set to zero. Keyframe 6 is set to 10 seconds since it is the last keyframe and automatically matches the end time for the slide.

Click between Keyframes 1 and 2 on the Keyframe Timeline and adjust the Pan X-axis for Keyframes 2 to 25. (That is the left side entry box for the Pan setting.) This is just what we did in the very first slide we created in this chapter. As you enter the numbers, the layer will move to the right. Click between Keyframes 2 and 3 and adjust both the X and Y Pan values for Keyframes 3 to 25 (25 x 25).

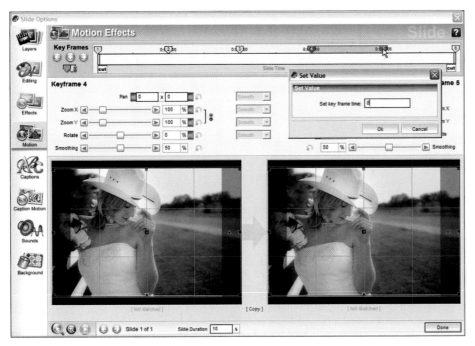

Figure 7.8

Using the Set Value dialog box is the quickest way to set exact times for a series of keyframes.

Now click between Keyframes 3 and 4. Look at the motion path and the values for Keyframe 4. The program has already entered values for the remaining keyframes, and the resulting motion path has a somewhat rounded triangular shape, as shown in Figure 7.9. The Pan settings for Keyframe 6 are 0 x 0. Of course, that is because the settings for Keyframe 6 were set by Producer when you first dropped the image onto the Slide List and the keyframe was the original ending point.

Figure 7.9
The triangle-shaped motion path at this point in our design is due to the way Producer automatically adjusts later keyframes when a user modifies one earlier in the sequence.

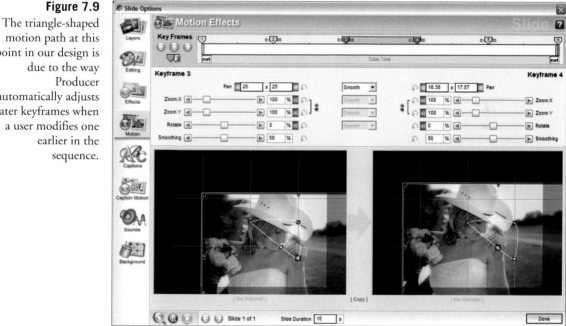

If you plan for a design to end at the same point, the current motion path is just part of the process, as long as you properly line up the intermediate keyframes. Since that's our current plan, the existing settings will work fine.

Just as when we worked with simple motion effects without keyframes, it's sometimes easier to start at the end of an effect and work forward. That's how we are going to make our next adjustment. Make sure that Keyframes 3 and 4 are selected. Drag the Current Keyframe Marker in the Keyframe 4 preview so that it is positioned under Keyframe 1 and to the left of Keyframe 3 to form a square motion path, as shown in Figure 7.10.

Sometimes the motion path can hide a marker behind another. If you can't see the Current Keyframe Marker for Keyframe 4 in the Keyframe 4 preview, it may be behind the marker for the end point. The green markers will be in the same location on the motion path if the starting and ending Pan settings are the same. Try

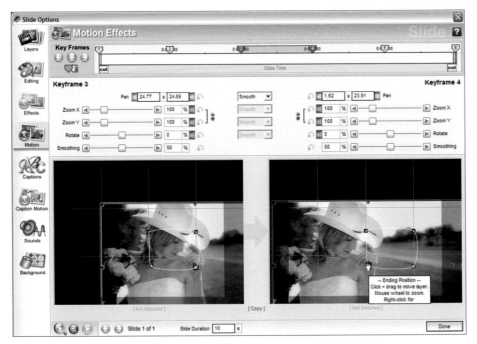

Figure 7.10
Keyframe adjustments can be made in either preview when using the motion effects. When you drag the layer in the left-hand preview, only the starting position will move. In the right-hand preview, only the ending point will move.

clicking on that location, and the Current Keyframe Marker will become visible. Only the Current Keyframe Marker will move when you drag in either preview. That's because you are moving the active layer, not the marker. The marker just shows how you are changing the layer's position.

You can always use the Pan settings to place the values. For this step, the Pan values for Keyframe 4 should be 0 x 25. If you are dragging the marker, the numbers don't have to be precise: ±3 is good enough for this exercise. As Producer recalculates the show, the actual numbers shown in the settings may vary while you work.

Tip

Your window may look somewhat different as you work. Both the motion path display and the exact values for a keyframe are dynamic during the design process. As you move a keyframe, ProShow adjusts the values for other parts of the effect, and the motion path and values for the related keyframes are updated. Producer may generate slightly different final position numbers for intermediate keyframes because it applies a smoothing factor to the slide. Don't be surprised if the numbers change a bit.

Once all the elements are in place, both the preview and the effect should be the same. The trick is to work in an orderly fashion and have a plan in mind for the effect. Always keep an eye on the motion path as you work and preview an effect when you are finished setting values. If you set the wrong value, the entire motion path can be changed. If that happens, locate the problem keyframe and correct the setting. That will be a lot easier than trying to redesign the effect.

Closing the Square

To the uninitiated, it looks like the motion path is complete and the picture will simply move in a complete square to the original position in one even motion. Not quite. Right now the Keyframe Marker at the top left is red, not green. Play the preview, and the picture will traverse back to the starting point, but it will stop and hold still for two seconds during the period controlled by Keyframes 4 and 5. Try it if you like.

We have to actually move the appropriate markers until we have positioned all the keyframes. So, select Keyframes 4 and 5 and move the marker for Keyframe 5 so that it sits right on top of the first keyframe, as shown in Figure 7.11. Play the slide now, and it will move at an even pace from the top left in a clockwise square all the way back without a pause.

Figure 7.11
Closing the square to produce a smooth movement along the motion path without a pause.

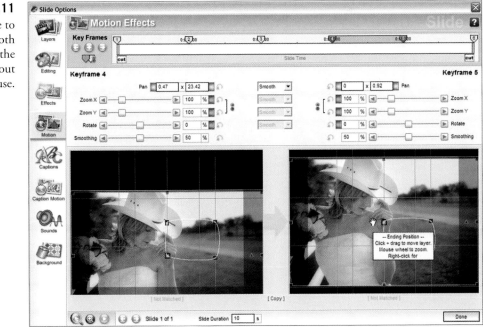

Zooming in for a Closer Look

So far, we have only changed the Pan values when adjusting the keyframes. Now we are going to use both the Pan and Zoom controls to enlarge the picture and center the girl's face in the frame. This is a fairly simple effect, but there is a trick to making sure that the adjustment does not alter the preceding keyframes and make the picture enlarge slightly throughout the entire motion path.

Manual and Automatic Modes

Next to each data entry box for the Pan, Zoom, and Rotate controls are colored boxes. When they are shaded green, Producer is calculating the value. That's what produces the varied numbers that allow for smoothing as you work with keyframe positions. When you manually set a value, the color changes to amber (though it may look more like gray on some monitors).

We are going to change the Zoom settings for the last keyframe. We want the image to grow in the screen, but only in the last two seconds of play (between Keyframes 5 and 6). When we make an adjustment, any keyframes affected by the change that are in Automatic mode will be changed to create the effect along the entire path. So we need to limit the action to just the time between the desired keyframes.

Use your mouse to click on both the Zoom X and Zoom Y Automatic/Manual Mode buttons so that they are amber. (Figure 7.12 shows how they should look

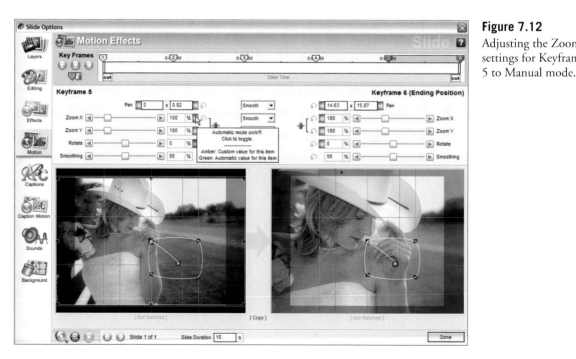

Figure 7.12

Adjusting the Zoom settings for Keyframe 5 to Manual mode.

and the mouse pointer is over the Zoom X box for Keyframe 5.) Now we can create our effect within the desired part of the timeline.

Adding the Zoom Effect

Now it's time to enlarge the layer. You can rotate the mouse wheel to enlarge (and reduce) the Zoom settings or enter the values in the appropriate data boxes. If you enter the numbers manually, only the ones for Keyframe 6 have to be changed. A setting of 180 for both the X-axis and Y-axis will do the trick.

Working with Precision Preview

Double-click on either preview to open the Precision Preview window. This is a handy interface for fine-tuning layer placement and adjusting individual keyframes. There are some differences in the way the Keyframe Timeline works in this window.

Look at the top of the Keyframe Timeline in Figure 7.13. The mouse pointer is selecting Keyframe 6, but there is no darkened area between it and the paired keyframe. That's because we can adjust only one keyframe at a time in Precision Preview.

Make sure Keyframe 6 is active, and then adjust the image and the motion path so that it looks like the example in Figure 7.13. Press the Play button and examine the effect. Take a few minutes to experiment. Enable the auto function for the

Figure 7.13

Adjusting Keyframe 6 using the Precision Preview window.

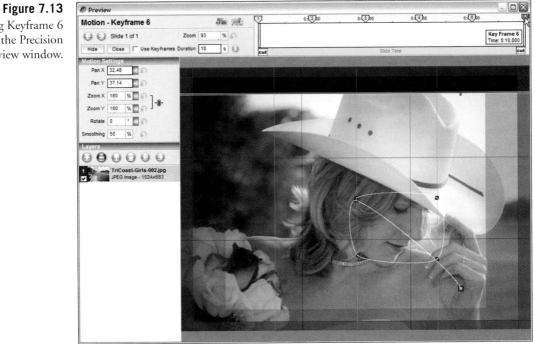
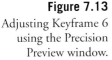

Zoom on Keyframe 5. See how that alters the entire motion path. Reset it, and then unlink the Zoom X- and Y-axes. Increase just the X-axis value and play the slide again. Now the image grows but is distorted.

Adjust the time and move markers, and become comfortable with the controls we have used so far. You can also add a soundtrack to the slide and view it in the Precision Preview. The audio clip will be displayed in the center of the Keyframe Timeline. That view can be handy for tweaking a precise point in the motion path to a peak or valley in the soundtrack.

Motion Keyframing with Multiple Layers

In the Chapter 7 folder on the CD-ROM is the MotionKeyframin1.psh Producer file. Open it and use the Preview to see it in motion. There is only one slide in this show, and it has only two image layers and a plain black background. The two pictures cross over each other, and then one zooms while the other shrinks and rotates. As they do, one image appears to grow darker to make a new background for the one that is now smaller and rotated.

Once the preview is finished open the show's single slide in the Motion Effects window. Make sure Layer 1 is selected. The images are the same two pictures we've already been using in this chapter. We have already worked with all the tools used to create this show. We are going to apply keyframe-controlled motion effects to multiple layers in the same slide.

Managing the Preview Area

Working with motion effects on multiple layers in a single slide offers real creative potential. (Some designers create complex shows lasting several minutes with only a few slides and sometimes just one.) When there are lots of layers in the frame, the Preview Area can get pretty crowded.

To move layers and apply effects, you have to be able to see and manipulate the objects, establish relationships between layers over time, and organize the visual content. That can be hard when there are six or seven images on a slide, all stacked on top of each other and visible during only part of the playback time. Customizing the Preview Area display and making full use of the motion path (along with a little practice) make that easier.

Right-click in the Preview Area and open the context-sensitive menu. We've already used this menu. While working with multiple layers, you quickly learn to rely on its options to reduce clutter and highlight what's important. Figure 7.14 shows the first slide with Layer 1 and the first and second keyframes selected.

Adjust the context-sensitive menu so that the Show Composition Lines, Show Safe Zone, and Darken Inactive Layers options are enabled. We also want to have the options Activate Layer With Mouse Click, Show Layer Outlines, Show Motion Path, and Show Grid checked, as shown in Figure 7.14.

Figure 7.14

Adjusting the custom settings for the Preview Area makes it much easier to work with motion effects in slides with multiple layers.

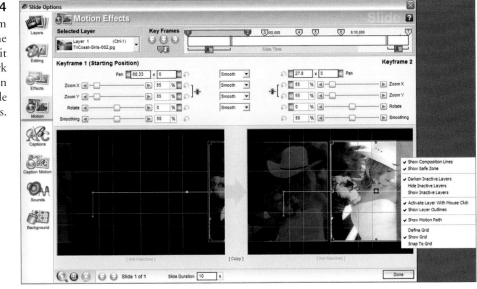

Darkening the inactive layers makes it easier to see which layer is selected. Hiding inactive layers lets you see and work on a layer that is "underneath" other layers during playback. Showing inactive layers makes it easier to position two layers in relation to each other. Keep these options in mind as you work, and use the settings that best meet the needs of the moment. I find the current settings to be the ones I use the most.

Can you interpret what the motion path and the preview are telling you about the way this keyframe operates and how the layers move in the slide? Both Layers 1 and 2 start the slide sitting out of view and then move into the frame and pause side by side. So why don't we see a starting point in the starting point preview for Layer 1? Only the ending point of the first keyframe and two red Keyframe Markers are visible. The preview for the ending point does show the Current Keyframe Marker for Keyframe 2.

The reason is simple. The Preview Area shows markers only inside the viewable area. The Current Keyframe Marker for Keyframe 1 would be outside the zone. So will most of both layers, since the view in the Motion Effects window extends only slightly beyond the area that will be visible in the slide as it is played.

Double-click on the Preview Area and open the Precision Preview window. The same situation with the motion path display applies here, too. Only the markers inside the active rendering area will be shown. Figure 7.15 shows the Precision Preview window. As you can see, it provides the same display options via an identical context-sensitive menu.

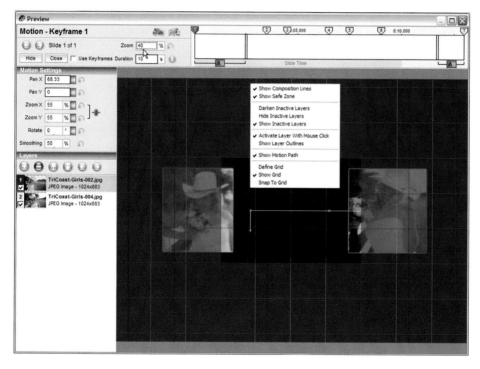

Figure 7.15
Adjusting options in the Precision Preview window with the imaging area zoomed out to show a wide point of view.

See how the viewing area is much larger? The Zoom control (located in the upper portion of the window to the left of the Keyframe Timeline) lets us change the magnification to widen or narrow the work area. Here I have used the slider to set the zoom to 40 percent and bring both layers well inside the window.

Multilayer Motion Effects Workflow

There are no hard-and-fast workflow rules for motion effects in Producer. It is a process. For simple effects, an interactive approach often works well: moving and adjusting layers, tweaking effects and settings until things look right. More complex designs, demanding precise placement, often require using a numbers-based approach. It's often helpful to draw a simple storyboard sketch before actually importing your files into the slide when creating complex motion effects with multiple layers.

The slide we are about to create (or rather duplicate) is a basic design, and both layers have the same number of keyframes with exactly the same timing. We could complexly set out one layer and then duplicate it and replace the image. We could also step through both layers one keyframe at a time. While the second method is more cumbersome, it lets you see each stage of the process as the design develops. Let's use a hybrid of the two for purposes of this discussion.

Placing and Adjusting the Images

It's usually a good idea to crop images before applying motion effects. In some cases, you'll want to bring all the images into the slide first and see how they work together. If you have layers that will have identical keyframes, you may want to wait. That way you can duplicate the layer and then add the image later. We are going to bring both images into the slide at the same time so that we can gauge the size and amount of movement needed for our effect.

In simple designs, the actual layer order may not be that important. If you create a storyboard or have slides enter in a sequence, assigning layer numbers to match the way the layers work within the design helps you avoid confusion. It's easy to adjust the layer sequence (along with the layer numbers) in ProShow after you have imported the images. See Figure 7.16.

Figure 7.16
Adjusting the order of the layers to help coordinate motion effects.

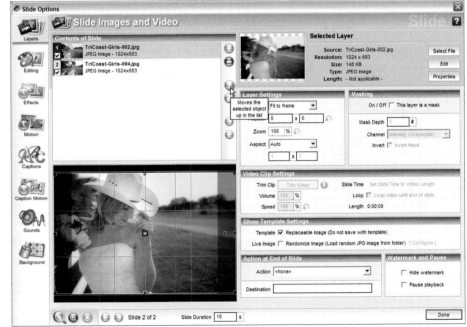

Drag the image of the girl touching her hat and the one with the girl looking at the bouquet into slide 2. Hold down the Control key as you drag. Once they are placed, make sure that the one where she is touching her hat is on Layer 1. In the Layer Settings section, set the Scaling option to Fill to Frame for both layers.

Now we need to crop them to the right size and adjust the zoom. We want the girl's face to be larger in both pictures than it is in the original composition. They need to fit side by side in the safe zone. Change to Editing mode by clicking on the icon on the left side of the Slide Options window. Click on the Crop button in the Editing Tools section. If I were designing this slide alone, using the mouse to crop the images would work well. A precise crop ensures that your results will look the same as the example's, so let's enter the values.

When the Crop window opens, adjust Layer 1's image using the following settings: Left to 4, Right to 633, Top to 0, and Bottom to 683. Now the Size boxes in the lower right-hand corner of the window should read 629 x 683. The results should match those shown in Figure 7.17. (Remember that Producer does not make any modifications to the source image file.) Click the OK button to set the crop.

Stay in the Edit window, change the active layer to Layer 2, and repeat the cropping process. The same goal applies. You want the images to be basically the same size and have similar aspect ratios. That way they will look balanced in the slide when they are side by side.

Figure 7.17
Cropping Layer 1 to fit the design.

Use the example in Figure 7.18 as a model and enter the following values: Left to 63, Right to 640, Top to 0, and Bottom to 683. Now the Size boxes in the lower right-hand corner of the window should read 577 x 683. Click OK when you're finished.

Figure 7.18
Layer 2 being cropped.

The crop gives us the desired composition for the effect, but the pictures need to be sized to fill one side of the safe area when they're placed side by side. Place Layer 1 on the right side of the safe area and Layer 2 on the left. Select Layer 1 and double-click on the preview to open the Precision Preview window. Make sure Keyframe 1 is active, and use the Zoom Y control to adjust the image to properly fill the frame. Select Layer 2 and adjust it to be close to the same size. (The slight difference in their dimensions won't let them be exactly the same size.)

Setting the First Keyframes

Before working with any keyframes, make sure that the slide duration is set to 10 seconds and that the preceding and following slide transitions are set to zero. Now we'll set up the keyframes for Layer 1. When they are all in place, we will copy the settings to Layer 2. Right-click on the Keyframe 2 marker and set the time to 3.5 seconds. This segment is when the two pictures slide toward each other from opposite sides and pause.

Double-click on the top of the Keyframe Timeline to add a third keyframe, and set its time to 4.5 seconds. This is the first one-second pause when the pictures sit side by side. Your current transition defaults may be different from the ones you used to create the show, so let's make sure everything is the same. Set both the before and after transitions for Layer 1 to a crossfade (blend).

Drag the time for the preceding transition to 2.5 seconds and the ending transition to 1.25 seconds. When this step is completed, your Keyframe Timeline (but not the Preview Area) should look like the example in Figure 7.19. Make sure Keyframe 1 is selected. It should be the one that is darker than the others are, as shown in the figure.

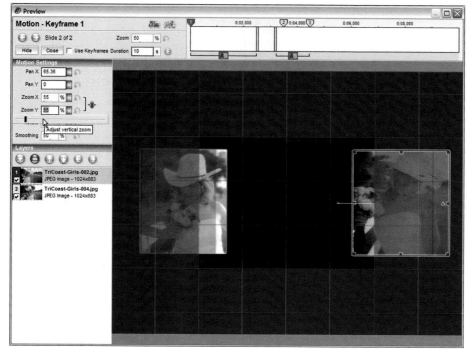

Figure 7.19
The Precision Preview window showing the new keyframe timing and the picture zoomed and placed in the starting position for Keyframe 1.

Matching the Layer's Position to the Keyframe Timing

We are going to set the motion for each keyframe in the order it appears on the Keyframe Timeline. That will eliminate the tendency layers have to move around when you adjust the motion path. Set the Precision Preview Zoom function to about 50 percent. (That is the zoom near the top of the window, not the Zoom X or Zoom Y adjustments.)

With Keyframe 1 and Layer 1 selected, adjust the position of Layer 1 so that the picture is mostly outside the safe area, as shown in Figure 7.19. You can use the mouse or use 30 for the Pan X setting. Keep the Pan Y setting at zero. As you move Layer 1 to the right, the motion path will display with a Keyframe Marker at the original center point of the layer. All markers except the Current Keyframe Marker are red in the Precision Preview window. Since the Current Keyframe Marker for Keyframe 1 is outside the viewable area, you won't be able to see it.

Select Keyframe 2 and, with Layer 1 still selected, bring the image into the right portion of the safe area, as shown in Figure 7.20. Keep the Pan Y at zero. We are not actually adjusting Layer 2 at this point. Its keyframes and motion path will be set after we finish with Layer 1. I've positioned it just to see how the two images will fit in the center of the slide. If you wish to do the same, select Layer 2 and move it. Then select Layer 1 again.

Figure 7.20
Setting Keyframe 2 for Layer 1.

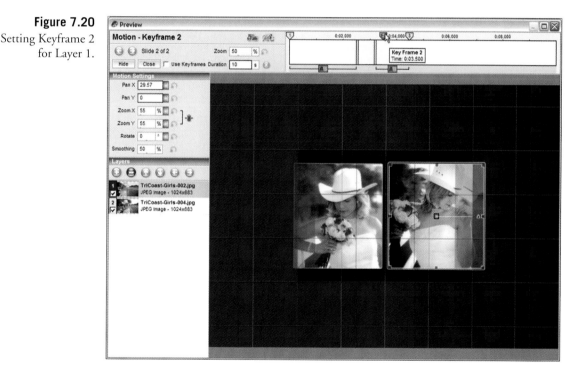

Your window should look like the one in Figure 7.20. The Current Keyframe Marker for Layer 1 notes the ending point of this segment of the motion path. Note the numbers for the Pan X and Y settings. Make sure Pan Y is set to zero. Click on Keyframe 3 and make sure the values do not change. If they do, enter the same values for Keyframe 3 as those for Keyframe 2. We want the layer to stay in this position for the one-second interval between Keyframes 2 and 3.

Adding Keyframes 4 and 5

Close the Precision Preview window and return to the Motion Effects window. We will add the next keyframes and adjust their motion path there. Now the ending Keyframe Marker should be green. Double-click on the Keyframe Timeline behind Keyframe 3 and add two new keyframes. Right-click on the new Keyframe 4 and set its time to 6.5 seconds. Set Keyframe 5 to 7.5 seconds. The interval between Keyframes 3 and 4 is when the pictures will cross over each other and switch positions. The layers will sit still between Keyframes 4 and 5.

Let's modify the Preview Area display. Open the context-sensitive menu and choose the Darken Inactive Layers option. That makes it easier to see which layer is selected. Disable the Show Layer Outline option. With inactive layers darkened, we don't really need that option, and it will be easier to see the exact edge of the layers without it.

Make sure the motion path is straight for the Pan Y setting (zero). Click between Keyframes 3 and 4. Now bring Layer 1 across to the left side of the slide. Keep Pan Y set to zero. When properly positioned, your Preview Area should look like the example in Figure 7.21.

Notice how the ending transition for the layer is moving with us as we work. We can fine-tune it after we finish placing all the keyframes. If you want to check the placement with both images in position, you can select Layer 2 and move it to the

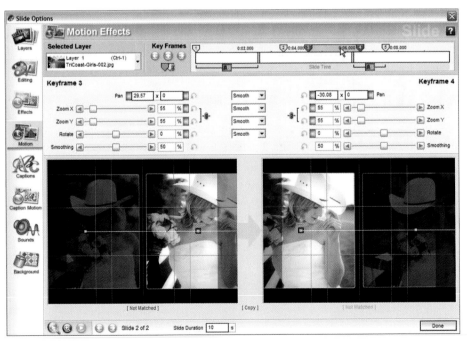

Figure 7.21
Setting Keyframes 3 and 4 for Layer 1.

other side. Don't forget that we are not actually setting up Layer 2 yet; be sure to re-select Layer 1 before moving on to the next step in the design process.

The layers are supposed to stay in place for one second between Keyframes 4 and 5. Select that pair by clicking between their markers on the Keyframe Timeline. If everything is set properly, your preview should match that in Figure 7.22. The motion path appears as a straight horizontal line with a red marker on the right side of the safe area and the Current Keyframe Marker over the center of Layer 1 on the left side.

Figure 7.22
Checking the motion path for Keyframes 4 and 5.

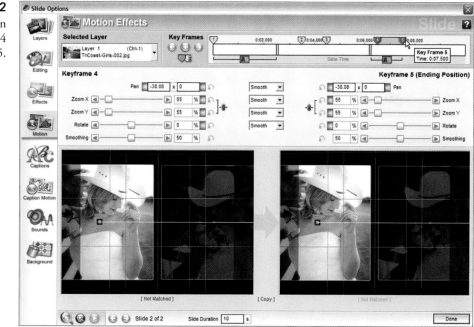

That's because the entire duration of the current keyframe is all taking place in one spot—directly under the Current Keyframe Marker. If there is any deviation, adjust the layer as needed before moving on to the next step. When possible, it's best to work one keyframe pair at a time in order.

Adding a Little Spin

Now it's time to add the rotation movement to Layer 1 and complete this portion of the slide. Once again we have a keyframe pair with movement, followed by another with a pause. Add Keyframes 5 and 6 to the Keyframe Timeline. Adjust the duration so that Keyframe 6 is placed at nine seconds and Keyframe 7 at 10 seconds.

Make sure that Layer 1 and Keyframes 5 and 6 are active. Bring Layer 1 down and reduce its size, as shown in Figure 7.23. Make sure that the vertical motion path (the X-axis) keeps the same value for both keyframes in the pair. I've adjusted and resized Layer 2 for reference. You don't need to make any changes to it right now. We will come back to it after we finish the complete motion path for Layer 1.

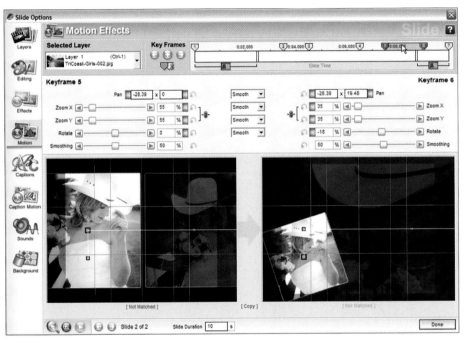

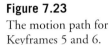

Figure 7.23
The motion path for Keyframes 5 and 6.

Now select the Keyframe 6 and 7 pair. Place your mouse cursor over the ending transition and adjust the time to about 1.25 seconds. Finally, check the motion path for this segment of the slide. It should look like the example in Figure 7.24.

We can tell that the layer is stationary because the Current Keyframe Marker is at exactly the same location in both the starting and ending position previews. The respective values for the Pan, Zoom, and Rotation settings are identical, too. If there is any variation in these on your slide, adjust Keyframe 7 to be the same as Keyframe 6.

Layer 1 is ready, and we are almost finished. Check the design by playing the show. The behavior of Layer 1 in both slides should be the same. Now we are ready to complete the design of Layer 2. We are going to duplicate Layer 2, swap out its image file, and adjust the motion path.

Figure 7.24
The motion path for Keyframes 6 and 7. Layer 1 should not be moving during this portion of playback.

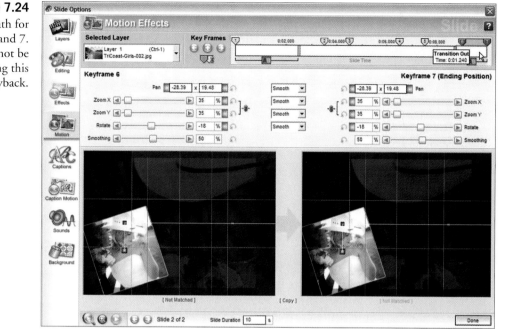

Revisiting the Copy Commands

ProShow offers a wide range of copy commands, making it easy to reuse resources and settings in a show or project. One approach is to copy each keyframe individually between layers. The Copy menu, located between the previews, has an option titled Copy Settings Between Layer Keyframes, which opens a window like the one shown in Figure 7.25.

This window can copy virtually any attribute of one layer to another or from one slide to another. You select the source slide and keyframe in the left column and then choose the attributes you wish to copy from the menu in the center column. Then identify the destination slide, layer, and keyframe in the right column. Click on the Copy button, and ProShow will make the desired modifications.

This menu would be great if we had only one or two keyframes to copy, but this layer has seven. So, let's just replace Layer 2 with a copy of Layer 1, replace the image, and then adjust the motion path. It's not as involved as it sounds. Select slide 2 on the Slide List and press the F2 key to open the Slide Images and Video window.

Right-click on Layer 1, located in the Contents of Slide list on the left side of the window. Choose Duplicate Layer, as shown in Figure 7.26. You should now have three layers. Keep the two layers with the girl holding the brim of her hat. Delete the one with her looking at the bouquet.

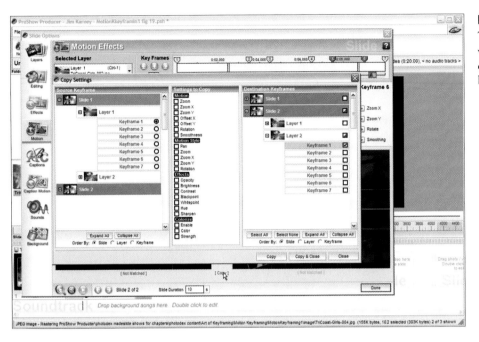

Figure 7.25
The Copy Settings window opened to copy a keyframe between layers.

Figure 7.26
Duplicating Layer 1 in the Slide Images and Video window.

Now we have two identical layers. They have the same keyframes, timing, image, and motion path. The next step is to get the right image on the layer. Then all we'll have to do is adjust the new motion path.

Make sure that Layer 2 is selected in the Layers List. Click on the Select File button in the upper right of the Slide Images and Video window. The Open Image File dialog box will open, as shown in Figure 7.27. Navigate (if needed) to the folder containing the TriCoast-Girls-004.jpg file. Select it and click OK.

Figure 7.27
Replacing the Layer 2 image file.

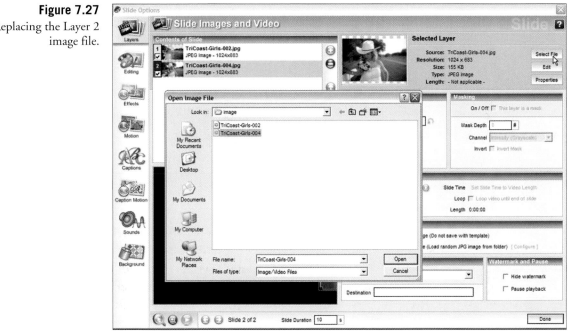

Before moving on, we need to repeat the Cropping and Zoom adjustments to this image that we made before. Click on the Edit icon and then the Crop button. Adjust the settings so that they read Left 63, Right 640, Top 0, and Bottom 683. Click OK. Go to the Motion Effects window and set the Zoom X and Zoom Y fields to 50.

Right now the only difference between these two layers is the picture that each contains. Click on the Motion icon to change over to the Motion Effects window. Make sure that Layer 2 is selected. Check the context-sensitive menu to be sure that your Preview Area is set to Darken Inactive Layers and to display the motion path. That way your display will look the same as the examples in the screenshots.

Click between Keyframes 1 and 2 in the Keyframe Timeline. Your window should look like the example in Figure 7.28. We can't see Layer 1's image at all. That is because the two layers are identical and Layer 2 is selected. The motion may not be the correct motion passed for the layer, but it provides an excellent guide for positioning the initial keyframes.

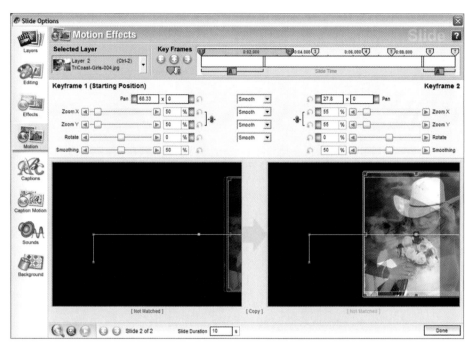

Figure 7.28
The "new" Layer 2 before adjusting the motion path.

Adjusting Keyframes 1 through 3 for Layer 2

The image needs to be off to the left side of the safe area at the beginning of play—Keyframe 1. The existing motion path shown in the starting position preview has red and green Keyframe Markers on the horizontal line. The red Keyframe Marker is in exactly the position we want the center of Layer 2 to be in for Keyframes 2 and 3.

Remember how that worked when we made the rectangular motion effect earlier in this chapter? The motion path would look distorted until all of the keyframes had been properly placed. It is important to remember that this layer already has a complete motion path that needs to be reset as adjustments are made. Don't worry if you have some unwanted lines while you're defining a position as long as you like the final result.

Click between Keyframes 1 and 2 in the Keyframe Timeline. Use your mouse to move the image in the Keyframe 1 (starting position) preview to the same position shown in Figure 7.29. As you make the adjustment, the motion path will be pulled along with the image. Once the image is where you want it, make sure that the horizontal line is perfectly straight. Both of the Pan X values should be zero.

Figure 7.29
Setting the motion path for Keyframes 1 and 2.

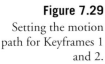

Now click on the Copy menu located between the previews and choose the Copy Start to End option, as shown in Figure 7.29. This sets all the values for the second keyframe in a pair to the same values as the first member of the set. The image in the right window will move to the same position as the one in the starting position keyframe.

This command does not change any values for later keyframes. It simply resets the motion path for the second keyframe in the segment to match the first. That keeps the effect free of strange motions due to the existing settings from the original Layer 1. All we want is the appropriate timing and transitions.

Use the mouse to drag the image in the Keyframe 2 preview (on the right) so that the center of the layer is positioned right at the top of the short vertical line on the left side of the safe area. Use the position shown in Figure 7.29 as a reference.

Now Keyframes 1 and 2 are set properly. Select Keyframes 2 and 3 on the Keyframe Timeline. Click on the Copy menu and repeat the Copy Start to End command. This sets everything correctly for the one-second pause that occurs between Keyframes 2 and 3.

The next segment is where the two layers trade places left and right. That's really easy. Select Keyframes 3 and 4. Copy the keyframes beginning to end. In the Keyframe 4 preview (on the right side), swap the centers of the images. Make sure the horizontal line is perfectly straight and adjust it if needed. Now select Keyframes 4 and 5 and repeat the Copy Start to End command to create the one-second rest. Your window should look like the example in Figure 7.30.

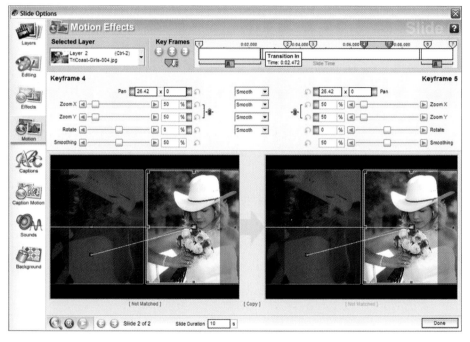

Figure 7.30
Adjusting Keyframes 4 and 5.

By now, the basic procedures for manipulating the motion path and working with keyframes should be familiar. It takes practice and experimentation to really master the skills. Use the Keyframe Timeline to preview the slide by "scrubbing" below it with your mouse. When the playback reaches Keyframe 5, both layers will rotate and shrink. That's because they both are on the same motion path we originally set for Layer 1.

Each time we match the beginning to the end of the keyframe for Layer 2, we clear out the old settings. Remember that this applies only to the current keyframe pair. It's also important to make sure you have the correct layer selected. If you used the command on Layer 1, it could remove part of the effect.

Adjusting Keyframes 5, 6, and 7

We only have one more set of adjustments to make to complete the design. The Layer 2 image needs to grow and shift position to fill the background as Layer 1 shrinks and rotates. Make sure Layer 2 is active. Select Keyframes 5 and 6 and then Keyframes 6 and 7, and copy the keyframe settings start to end to both pairs. Now the image should be sitting on the right side of the safe area with a single horizontal line running from the left to the Current Keyframe Marker. The diagonal line going back down to the left in both previews is the remainder of the motion path. (See Figure 7.31.)

Figure 7.31
Setting Keyframes 6 and 7 on Layer 2.

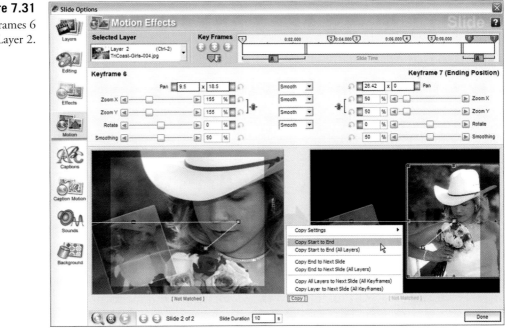

Select Keyframes 5 and 6. For Keyframe 6 set the Pan values to 9.5 x 18.5 and the Zoom to 155. Then select Keyframes 6 and 7. Copy the settings from start to end. That's it. Now play the show. The two slides should work the same.

Designing Complex Motion Effects: The Real Deal

You have now been formally introduced to Producer's keyframing and motion effects tools and practiced using them to build a multilayered design. Let's examine a more complex show that uses multiple layers and multiple motion paths. The goal in this portion of the chapter is to learn to "see" motion and develop a

better sense of how to create motion effects using Producer. Developing this skill is the key to mastering the advanced features of the program and being able to create professional-quality shows with the least amount of effort.

The complete show with its images is in the Chapter 7 folder on the companion CD-ROM, so you can open it in Producer and follow along. We won't re-create it step by step, but you have everything you need to study and experiment with the design.

The show is named realdeal.psh. It contains just one slide with nine layers and lasts 20 seconds. It was designed specifically for this chapter so we could delve deeper into using motion keyframing. The images are provided by TriCoast photographers Mike Fulton and Cody Clinton strictly for use within this exercise.

Before we get into the discussion, preview the show. Watch how the different elements interact. Can you determine the motion path? How would you plan this show yourself? The Photodex Web site showcases shows with excellent design. Using the understanding you developed in this chapter to analyze those productions is a good way to increase your design skills and get ideas for improving your shows.

A Quick Shuffle and Laying Down the Cards

When you're designing or analyzing a motion sequence, breaking it down into segments is a useful technique. It's a bit like giving directions. There are landmarks and turns. Once you have described the segments, it's a lot easier to determine the motions required and then set up the keyframes and timing.

There are three primary elements to any motion: speed, direction, and duration. In other words, which way does it move (and does it involve any turns), how long and how far does it move, and how fast does it move? I often vary the Preview Area display when examining a slide. Showing all the layers and then selecting keyframe pairs is a good way to see the relationships between the elements of a slide at each point in the playback. Turning off all but one layer makes it much easier to track the actions of a single component.

Let's look at the show again. Figure 7.32 shows the slide just as all of the layers become visible. Eight images appear like cards quickly dealt onto a playing table. They appear to be in a random collage and then separate. The backdrop for these images is a picture of a blackjack table complete with cards and chips. The table is not visible as the slide begins. Late in the slide's playback, it grows lighter and fades back to almost black with a dark circle effect as the slide enters its ending transition.

Figure 7.32
The beginning of the
Real Deal slide show
has nine layers
arranged in a collage
against a dark
background.

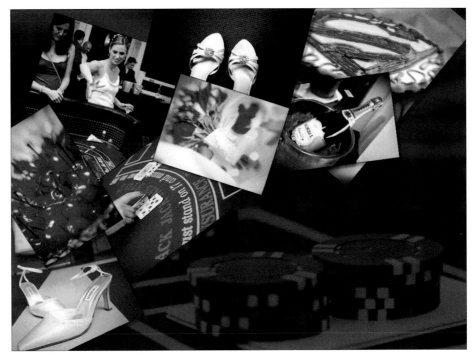

Examining the Table

Take a closer look at the slide and you'll see that the table has been added as Layer 9, not as an image used as a background. If it were a simple background, the designer could not use keyframes or apply transitions to it. Open the Motion Effects window and select Layer 9.

The blackjack table does not move during the slide, so there are no motion effects. Figure 7.32a shows the slide just after the midpoint of the beginning transition for Layer 9. The table looks very dark—darker than the crossfade transition would make it. The designer wanted it dark to make the bright colors in the other images dramatic and then have the viewer notice the cards and chips. Toward the end of play, a circle out two-pass transition was used to create the growing dark circle over the table. (You can scrub the Keyframe Timeline to see just how the table blooms into color and then fades.)

The darkened effect was generated by adjusting the black point of the layer between keyframes. This is a type of adjustments effect, and we'll work with those in the next chapter. Adjustments effects use the same Keyframe Timeline and controls and can be easily combined with motion.

Figure 7.32a
The blackjack table,
Layer 9, uses four
keyframes to create its
darkened background
effect.

The Second Collage

Make sure that all of the layers in the slide are active in the Slide Images and Video window (click on the Layers tab or press Control-2). Then change to the Motion Effects window and scrub the Keyframe Timeline between Keyframes 3 and 4. Your preview should look like the example in Figure 7.33.

Now the design shows an organized collage with Layers 1 through 8 arranged in rows and columns above Layer 9. This shows a common point on the timeline for all nine layers, since they all have to meet at the same time. It's even possible that the designer started the process with this layout and then arranged each layer's position before and after.

Remember how we adjusted the motion effects for the last slide? By carefully working in a precise order and choosing which Preview Area to adjust layers in, we could correct the motion path by adjusting either the starting or ending position. That means that by moving "backward" (adjusting the starting point of a pair after setting the ending point), you can change the earlier portion of the motion path. By adjusting the ending point after setting the starting point, you move forward along the motion path.

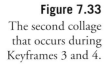

Figure 7.33
The second collage that occurs during Keyframes 3 and 4.

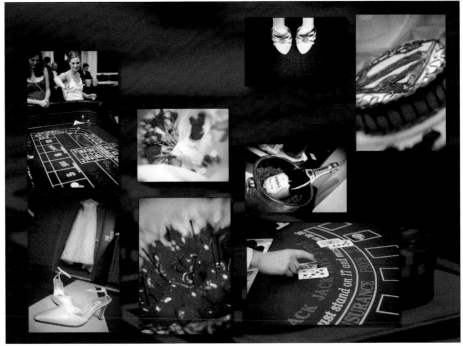

Let's use the traveling directions analogy again and consider working out the motion paths for this slide. The second collage is like a central location, and we want to describe how to get to it from one point and then move to a second location. We backtrack from the central point to give the instructions to the first point and then describe the directions to get from the central location to the final destination.

Examine the motion path for Keyframe 7 as shown in Figure 7.33a. The Current Keyframe Marker in both previews is in the exact same location, just as when we copied the settings from start to end when working on the last project.

Scrub the Keyframe Timeline backward and forward, and it's easy to see just how this motion effect is constructed and how each keyframe works. Right now, I'll just concentrate on the preceding keyframes, since we are dissecting this slide in chronological order.

The motion path is an open triangle shape. The layer begins by appearing at the lower left Keyframe Marker, rotated about 45 degrees from the ending position in the figure in the lower-right corner of the viewing area. Let's detail each of its keyframes to the current point in time.

Figure 7.33a
The second collage
with Layer 7 selected
at Keyframes 3 and 4.

Keyframes 1 and 2

The first keyframe is offset from the beginning of the slide and has a Cut transition. This explains how the layer pops into view after Layer 8 (the image with the women playing craps) is already visible. During this keyframe pair, the layer stays still.

Keyframes 2 and 3

This is the segment when Layer 7 rotates and moves from the original position near the center of the viewing area to its resting point in the lower right-hand quadrant of the slide. We can see the motion path and confirm our analysis by checking the Pan and Rotate settings. The layer stays the same size, as we can see from the constant value for the Zoom settings.

Keyframes 3 and 4

This is a keyframe pair with no motion effect. All of the layers sit still. We can verify this by checking the settings, but it's just as obvious when scrubbing the Keyframe Timeline.

Examine the other layers and you'll find that they all have a similar design (except for Layer 9, which we have already discussed). They enter with a Cut transition, and each is slightly offset from the precise entrance time of the others. Look a little closer, and you can see that they all have very common keyframe structures, with minor variations.

Blow-Up and Drop-Out

The third and final act of this one-slide drama has the eight active layers enlarging to fill the screen as they move to the center of the slide. Then they shrink and disappear one at a time. Figure 7.34 shows Layer 7 shrinking above frame-filling Layer 8. We can see how this was accomplished by examining the Keyframe Timeline and observing the motion path in the Motion Effects window. Let's follow Layer 7 as it journeys through its gyrations.

Figure 7.34
Layer 7 shrinking over Layer 8 just before disappearing during Keyframes 6 and 7.

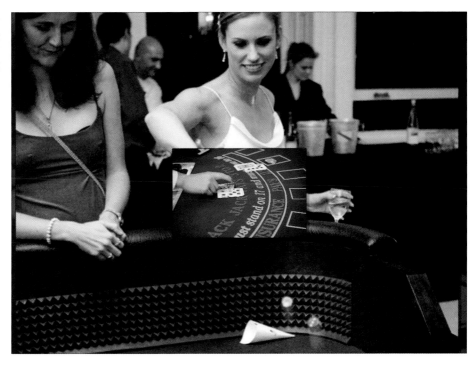

Select Layer 7 in the Motion Effects window and then click between Keyframes 4 and 5 to select the pair. Your window should now look like the one in Figure 7.34a. Use your mouse to scrub the Keyframe Timeline between this keyframe pair.

As the segment begins, all of the active layers pull in to the center of the slide. Notice how all of them stay the same size during this part of the slide. The Zoom settings have not been modified. Only the Pan settings change. They are also moving to a common point. They are not all arriving there at the same time.

Staying in the Motion Effects window, change the active layer and see how the keyframes during this portion of the slide change position. You'll also notice that they all have seven keyframes. The basic keyframe motion could be created once

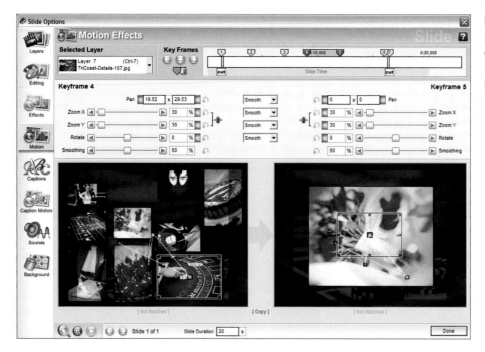

Figure 7.34a
Layer 7's motion
effects for the
Keyframe 4 and 5
pair.

and then duplicated, and the images assigned as we did before. Then each layer will be positioned and tuned to play its part.

Now it's easy to see how starting work from the second collage makes setting up the design simpler than working from the first keyframe to the last. Just as we adjusted the entry of the captions in Chapter 6 with slight adjustments to the starting point of the first keyframe in the timeline, this design staggers the beginning of each layer here.

Take the time to compare the intervals of the same keyframe in different layers. What does the shift tell you about how the timing and settings alter the way the layer moves? As we begin working with both keyframes and motion, the controls are not very intuitive, and slight mistakes can be very confusing. Looking at designs that work and figuring out how they do their magic is a shortcut to the day when understanding becomes skill.

With Keyframes 5 and 6 selected (Figure 7.34b), you can see how Layer 7 grows to fill the frame. At the starting point, the preceding frame is still not filling the view. Also note how Layer 7 not only zooms but also pans as it grows larger. Once again, you can examine the settings for these effects to see just how much movement and enlargement was used there.

Figure 7.34b

The Motion Effects
window for
Keyframes 5 and 6 of
Layer 7.

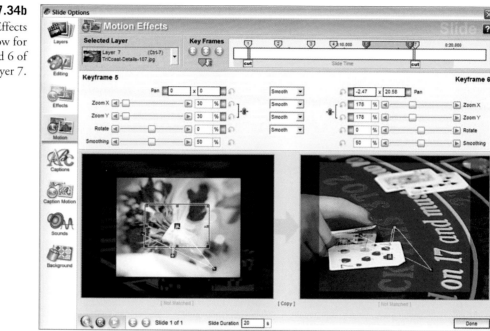

One of the nice things about this show's design as a learning tool is how several layers use slightly different motion paths and timing with almost identical effects. Comparing the variations is a good way to learn how different settings produce different visual results.

There and Back Again: Keyframes 6 and 7

There is only one keyframe pair left: 6 and 7. They are close together, lasting a half-second. The Cut transition that ends the layer adds to shortened visual effect, and the image shrinks and disappears quickly. Study the other active layers; they all do the same thing. The starting position times on the Keyframe Timeline vary just enough to stagger the effect to allow the preceding layer to vanish immediately before the next layer starts to shrink. See Figure 7.34c.

Turn your attention to the motion path and how the layer shifts its position as well as moves back to the center of the slide to disappear. Scrub the Keyframe Timeline for this pair, and you will see that Layer 7 starts to move just as the preceding layer vanishes with its cut transition.

As it moves, the Zoom setting drops from 178 percent (the program allows zoom factors up to 500 percent) down to zero. The exact percentage of beginning zoom varies for each layer. That's because the source image size is different and so requires more or less magnification to fill the slide. They all drop to zero to disappear.

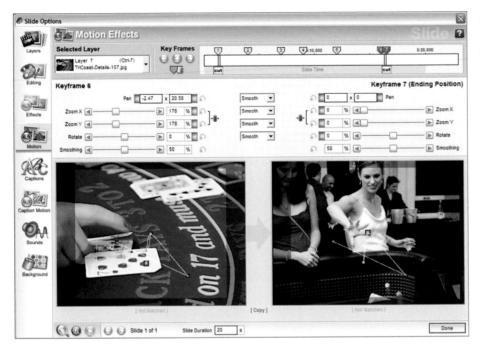

Figure 7.34c
Layer 7 disappears
from the scene.

That raises an interesting design consideration. If the amount of time allowed for a keyframe pair is the same but the zoom ratio (beginning to end settings) is different, then the speed at which the effect, executes will not be the same. In some cases, that may not matter. In others, the relative change might be visually disconcerting. That can be true of Pan effects too.

View the slide again and watch the end of each layer. Are they the same? Try adjusting the duration of the Keyframe 6 and 7 pair for some but not others. What difference does it make? How much difference does it take to be noticeable? Try the same experiment with the sections of the motion path and see how it looks. The key to mastering keyframes and motion is playback and comparison.

Up Next

Now that you have a good grasp of keyframing, it's time to apply these skills to adjustments effects. These tools let us transform the appearance of a layer during the course of playback. Alone or combined with motion effects, they offer astounding creative tools.

Advanced Motion Keyframing with Editing and Adjustments Effects

There's more to working with ProShow Producer's keyframes than just motion effects and captions. Adjustments effects and advanced editing tools let us control (and change) how a layer looks as a slide is played. They can make images change color, fade, grow in intensity, and become transparent. We can combine keyframes with adjustments effects to control the timing of an effect within a layer. And multiple tools can be combined in the same keyframe pair for even more control. This chapter assumes that you already know the basics of working with keyframes and the Keyframe Timeline. If not, you might want to read Chapter 7 before continuing.

We will be examining three shows in Producer; all required files are in the Chapter 8 folder on the CD-ROM. Let's start by opening the show file adjustment 01.psh. Once it's running, select slide 1 and press F8. That launches the Adjustments Effects window. (All images used in these three shows were taken by TriCoast photographers Mike Fulton and Cody Clinton. They are provided only for use with these projects.)

The timeline has been slightly advanced in Figure 8.1, so your preview won't look quite the same as the one in the screenshot. I moved it for purposes of discussion. The top section of the window should be familiar. The Selected Layer and Keyframe Timeline tools are exactly the same as the ones we have used in the preceding chapters. So are the Preview areas and the Copy menu between them.

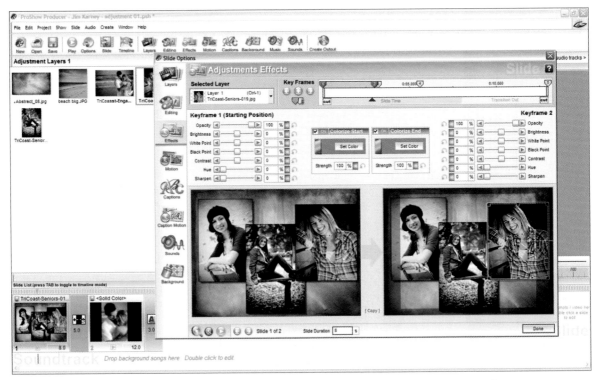

Figure 8.1 The Adjustments Effects window open with slide 1 selected over Producer's main window.

The center portion of the window offers a collection of image-adjustment controls, hence the name adjustments effects. Modifying a control setting only changes the appearance of a file within ProShow. Just as with the tools in the Editing window, the source file is not actually modified.

These controls work in conjunction with keyframes, just like motion effects. Set the starting values with the bank on the left and the values for the second keyframe in the pair on the right side. Producer will generate the points in between. I won't bother with a detailed discussion of keyframing, which we covered in Chapters 6 and 7. Here is what each control does.

- **Opacity.** This slider specifies how opaque or transparent the current layer appears. A value of zero makes it disappear, while a setting of 100 shows it at full opacity. This is a handy tool for fading a layer in or out.

- **Brightness.** Moving the slider lightens or darkens the appearance of the selected layer. Increase the value to lighten the object and decrease it to darken.

- **White point and black point.** The possible tones in an image range from total black to total white. In between are the middle tones. Adjusting the white point changes the point at which the tones are forced to appear white, hence

the name. Changing the black point does the same thing from the other end of the tonal range. These two controls set the lightest and the darkest point in the image.

- **Contrast.** This slider adjusts the overall difference between the light and dark areas of the image. A bright, sunny day has higher contrast than an overcast day.

- **Hue.** Hue is the dominance or wavelength of a color. Adjusting this control changes the shades of the colors within an image.

- **Sharpen.** This control allows you to make edges in the large areas of an image more clearly defined, increasing how well-focused the objects look. Over-sharpening will make objects look posterized.

- **Colorize.** This control produces a toned image effect by adding an overall selected color. Shifting the color to gray produces a black-and-white effect that can be adjusted with the slider settings.

Use your mouse to scrub the Keyframe Timeline for slide 1. The slide has three layers and a background. The three layers begin as black and white and then move into the center of the screen and blossom into color. About four seconds into play, the slide should look like the one in Figure 8.2.

Figure 8.2
The first slide, about four seconds into its playback.

Working with the Colorize Controls

The Colorize controls are simple to use and powerful in their effect. We can use them to vary both the color of a layer and its intensity. We can easily generate a wide range of special effects by combining various Colorize settings with keyframes. Set the keyframes long to produce a slow transition where the layer shifts gently from one color to another. Place several keyframes close together with dramatically different settings, and you get what looks like the layer being bathed in flashing colored lights.

The Oz Effect: Black and White to Color

This first slide uses Colorize to shift quickly from black and white to color, like the gray Kansas landscape gave way to bright color in the movie *The Wizard of Oz*. The movie used two different kinds of film to produce its magic. In ProShow, it's done using the Colorize controls. The image has regained most of its color by the four-second mark. Let's follow Layer 2 through the slide's keyframes, see how the effect was produced, and learn more about the control and how the window operates.

The first keyframe pair opens with just the background visible. Then the three pictures enter the frame in black and white and pause in a triangular arrangement, as shown in Figure 8.3. Both the adjustments effects and motion effects are shown in the previews.

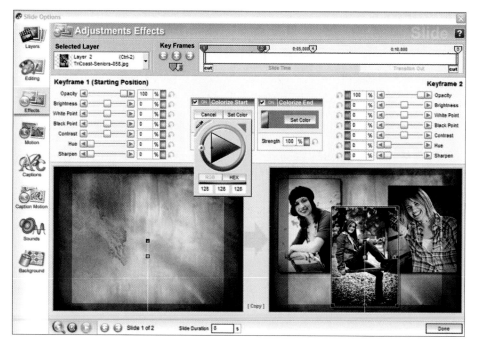

Figure 8.3
The first keyframe pair for slide 1 shows the Colorize settings, including the Set Color values.

Note that only the active layer's effect is displayed. The other layers are shown in color, even though they have been colorized to a black-and-white version at that point in the show. If you change the active layer, it will become the only one in black and white. Scrub the Keyframe Timeline and they will be displayed with the adjustments.

I've opened the Set Color control for the first keyframe. The basic interface should already be familiar from the preceding chapters. The Strength control determines how strongly the effect modifies the colorization. (There is a matching control hidden under the Colorize Start: Set Color control.) Both controls are set to 100 percent, so the controls are fully active.

Without making any other change to the slide, turn the Colorize Start off and on for the active layer. What happens? Do the same for the Colorize End. As we tour the various controls, modify them to see what effect changing the values has on the current layer. Then revert to the original settings and rejoin the discussion. The variations possible with adjustments effects are incredible, and the best way to learn them is by experimenting.

The basic controls have all been introduced, and these shows reveal how to use them to create interesting effects. We won't be doing a lot of directed step-by-steps. Instead, I'll show how the effects were created and offer suggestions for additional experiments.

The interval between Keyframes 2 and 3 has exactly the same Adjustments Effects settings as the first pair. Its sole purpose is to halt all layer movement and only lasts one-tenth of a second, as you can see in Figure 8.4.

There is an important fact to consider about workflow when combining motion effects and adjustments effects. Both windows share the same keyframes. You can actually use the Preview Areas to change a motion setting in the Adjustments Effects window. If you drag a layer, the position (and hence the motion path) will change. That's not the way I recommend you do it.

That also means that if you add a new keyframe in either the Adjustments Effects or Motion Effects window, it will be active in the other window the next time it is opened. Consider this: you want a slide to change from one color to another during the course of a six-second playback, *and* you want it to have a motion path with two segments (and so need three keyframes). The color effect calls for only one keyframe pair.

If there are three keyframes on the timeline when you create the color effect, it will have to be designed in two segments. That's because the program calculates the intermediate frames from one keyframe to the next. If you set up the color shift first (when there are only two keyframes), then the program will calculate

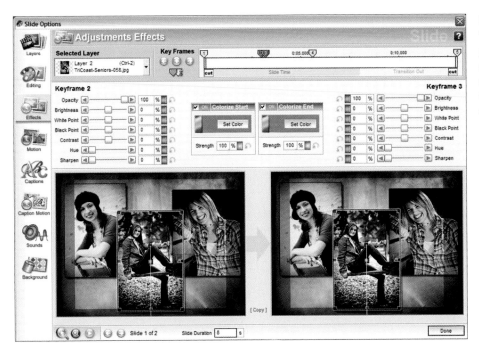

Figure 8.4
The second keyframe pair for slide 1. This segment halts all layer motion, maintaining the same adjustment effect.

the entire run and save you the extra work. Then you shift to the Motion Effects window, add the keyframe, and adjust the motion path.

When possible, create the types of effects with the fewest number of keyframes first; then shift to the other window and add those keyframes and settings. In this case, the best approach is to create the adjustments effects first and then add a keyframe to control the pause in movement.

The third pair of keyframes demonstrates the easy way to eliminate a colorization: just turn it off. Keyframe 3 has the same Colorize settings as Keyframes 1 and 2. The check box has been disabled in the Colorize End box. That automatically changes the value to zero and neutralizes the effect.

Scrub the Keyframe Timeline from the beginning of the slide to the Keyframe 4 marker. Watch how the three layers shift into color as they move between Keyframes 3 and 4, as shown in Figure 8.5. The transition is smooth; the program is rendering the frames with a constant reduction in the colorize effect so that it is removed just as the three layers reach their side-by-side position along the motion path.

The perfect timing was easy. All that was required was to be sure that the arrivals of all the layers at that point along the motion path were linked to the same keyframe that was assigned to the zero point for the adjustment effect. What happens if you create a new motion path segment and offset the colorize effect from that point in the Keyframe Timeline?

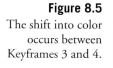

Figure 8.5

The shift into color occurs between Keyframes 3 and 4.

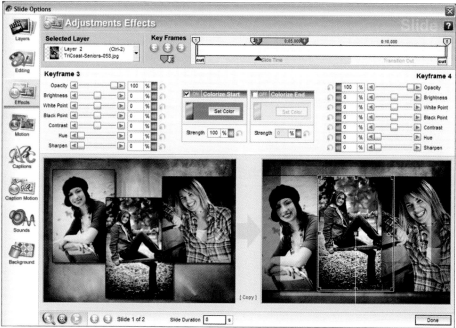

The preview in Figure 8.6 shows the slide during the following transition. Notice how Keyframe 6 is placed all the way at the end of that portion of playback. That's part of the reason we see the beginning of the next slide appearing in the middle of the screen as the first slide ends.

The first keyframes for slide 2's layers are placed at the start of the same transition. The layers in both slides are cuts, so they reveal the images as soon as that point in the Keyframe Timeline is reached. The Slide Timeline transition between slides 1 and 2 is a doors open–soft edge effect that lasts for five seconds.

Select Layer 1 on slide 1 in the Adjustments Effects window. Move Keyframe 6 for that layer so it is just at the end of the slide time on the Keyframe Timeline. Now scrub the Keyframe Timeline and watch how that layer disappears before the next slide starts to grow in the center of the frame.

What happens if you also move the first keyframe for slide 2's Layer 3 (the picture of the couple) from its position on the far left of that slide's Keyframe Timeline into the Slide Time? (That's where the scrub pointer is in Figure 8.7.)

Slide 2 has three layers, plus a picture of a beach scene used as a background. It opens to reveal a black-and-white image of a couple hugging on the edge of the surf. Scrub the slide, beginning at the far left of the Keyframe Timeline in the Adjustments Effects window, with Layer 3 selected. The door-opening effect during the very first part of the slide is the preceding transition. Just past that, the

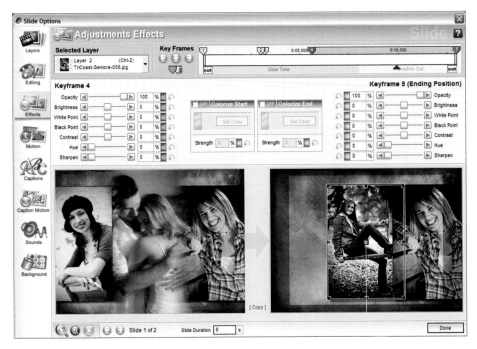

Figure 8.6
Scrubbing the preview shows how slide 1's final pair of keyframes' play time runs through the following transition.

Figure 8.7
Slide 2 makes use of two solid black layers and colorization to create a compound effect.

doors seem to shut and reopen very quickly. Now the image is in color. Finally, the picture of the couple shrinks and moves to the center of the frame, revealing the background as the frame fades to black.

There is a bit of sleight-of-hand at work here, a combination of adjustments effects and motion effects. The fast shift from black and white to color is managed with a short colorize effect lasting a half-second. The Preview Area in Figure 8.8 shows the slide just before playback reaches the second keyframe for Layer 3. We can see how the black-and-white version was produced using a colorize effect. It is at 100 percent for Keyframe 2 and disabled for Keyframe 3.

Figure 8.8

The Adjustments Effects window showing slide 2, with Keyframes 2 and 3 selected.

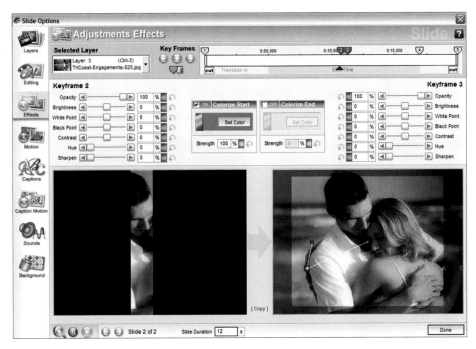

We can see the motion path for Layer 3 in Keyframe 3's Preview Area, but not all of the markers. The layer is expanded to fill the frame at the beginning of Keyframe 2 and does not move between Keyframes 2 and 3. The reason for this pair of keyframes is to provide the timing for the shift into color.

Move Layer 3's Keyframe 3, placing it midway between Keyframes 2 and 4. That will add about two seconds to the segment. Now run the preview. The color flows more slowly into the couple, but the timing of the doors does not change and the effect is altered.

Reverse the timing. Replace Keyframe 3, and move Keyframe 2 to the start of the Slide Time. That will advance it about six seconds, to the end of the preceding transition. Now the image slowly gains color before the shutters cross the frame. Restore the keyframes to their original positions and see how the shutter effect is produced.

The two solid black layers (Layers 1 and 2) form the shuttering door. Select Layer 1 and then Keyframes 2 and 3 on the Keyframe Timeline (see Figure 8.9). The two solid layers were already partly covering Layer 3; while this keyframe pair plays, they completely close and then rapidly reopen during the interval controlled by Keyframes 3 and 4.

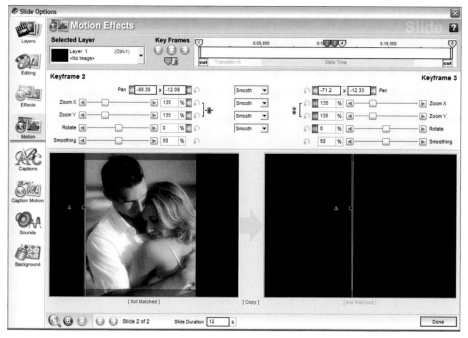

Figure 8.9
The motion effects assigned to the second keyframe pairs for Layers 1 and 2 create the shutter-style transition matched to the shift from black and white to color.

The only difference in the settings for Layers 1 and 2 is the motion path. The timing and layer properties are identical. Just as we saw in the exercises in the last chapter, copying the keyframe settings from one layer to another makes it easy to map precise timing like this, without having to painstakingly set timing values individually.

This slide makes straightforward use of two black layers by combining a set of keyframes and the Colorize control applied on a third layer to produce its result. The next show opens with a slide that uses the same basic elements to produce a darker, more subtle result.

Opacity: It's Not Just an Adjustment Control

Real mastery of Producer's power comes as we see how the program's tools can be combined to gain total control over every aspect of a layer's appearance with fraction-of-a-second precision. That requires thinking creatively. See if you can figure out how the designer produced the transparent effects in our second show. Open Adjustments 02.psh (in the Chapter 8 folder) and run the show as a full-screen preview before examining the slides to see their components or effects settings.

The first slide in this show starts out dark with muted color. Then there are two shifts as the picture brightens and a speckled pattern plays across the image (see Figure 8.10). It stays bright for only a couple of seconds as the next slide transitions to cover it up once more.

Figure 8.10
The first slide, five and a half seconds into its eight-second play.

Did the designer use the Adjustments Effects Opacity control to darken a layer over the picture of the young woman? Let's see how the slide is constructed and then see how the effect was created. Select the first slide and open the Slide Images and Video window (commonly called the Layers window; F2 is the shortcut).

This slide has three layers. Layers 1 and 2 are solid black, and the picture is Layer 3. Select Layer 1, and shift to the Adjustments Effects window, shown in Figure 8.11. There is no transition before this slide. (Remember that each layer has its

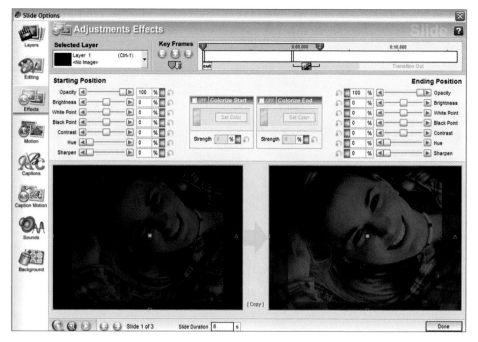

Figure 8.11
The Adjustments
Effects window for
slide 1 with Layer 1
selected.

own transition on the Keyframe Timeline that is separate from transitions placed on the Slide Timeline.)

The cut at the start of Layer 1 makes it fully visible as soon as the show starts. The layer's ending transition is a Big Dots pattern with a soft edge that moves from the lower right to the upper left. That accounts for the pattern over the picture, but not the level of opacity.

Scrub the Keyframe Timeline and watch how the action in the Preview Area matches the information. This layer is the one that produces the second big dots transition, because the first occurred before the ending transition for this layer, and the first big dots transition moved from the lower-left part of the screen to the upper right.

Stay in the Adjustments Effects window and select Layer 2. The Keyframe Timeline (shown with the Adjustments Effects settings in Figure 8.12) confirms that this layer ends before Layer 1. Once again, the Adjustments Effects settings are unchanged.

Choose Layer 3. It is present from the very beginning of the show and runs right through the slide's ending transition. Once again, the layer is free of any adjustments effects. Of course, we didn't expect any on this layer.

Figure 8.12

The Keyframe
Timeline and
Adjustments Effects
settings for Layer 2.

If there are no adjustments effects applied to any layer on this slide, how were the changes made, from dark to not so dark to bright? We know that the two solid-black layers are involved. That is obvious from their transitions. But what caused the change in opacity, and why wasn't it done using the Adjustments Effects window?

There is another place in the Slide Options toolset that allows the user to change a layer's opacity: the Editing window. Open it and select Layer 1, as shown in Figure 8.13. Normally the Opacity setting is 100 percent. Here it is 55 percent. The before and after samples in the middle of the left column show the relative strength of the adjustment.

Figure 8.13

The Editing window
with Layer 1 of slide 1
selected.

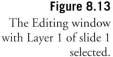

Select Layer 2 as the active layer. It has an Opacity setting of 30 percent. So why wasn't the opacity modified in the Adjustments Effects window? Because the layer needed to be active at that opacity setting throughout the entire keyframe, and the Edit window was the easiest way to get the desired result.

You can get the same effect by setting the starting and ending positions' opacity to the same number. That's a little more work. The same is true for any of the other common tools found in both the Editing and Adjustments Effects windows.

Smooth Moves: Creating a Composition with Opacity and Transitions

Slide 2 has three layers, all photographs. Layer 1 is a flower, Layer 2 is a mirrored disco ball, and Layer 3 shows a couple dancing at their wedding reception. All three images were black and white before being imported into the show, so they have not been colorized in ProShow.

Open slide 2 in the Adjustments Effects window and use the context-sensitive menu in the preview to turn off the inactive layers. Let's examine the composition a bit closer before looking at the technical aspects. This slide is an excellent example of how to combine the composition of an image with ProShow effects to create mood and a visual statement. Check out the romantic mood evoked in the second slide, shown in Figure 8.14.

Figure 8.14
The second slide in the show uses a combination of timing and effects to blend three layers into a romantic composition.

The primary image is the one with the couple dancing. The other two are simple details of the event. The photographer placed the couple in sharp focus on the right side of the frame. That side is much brighter than the left, and the audience in the background is slightly out of focus. This composition sets the stage for the design.

Use your mouse to scrub the Keyframe Timeline. Pay attention to the way the different elements and the brightness of the scene work during the preview. The beginning of the slide has the disco ball on the left. The couple moves slightly as the slide plays but remains on the right side of the frame. At the midpoint in the playback, the disco ball disappears and the couple looks to be bathed in a moving spotlight. From that point on, the flower blends into the left side of the scene from the middle to the left and then the image fades into the next slide.

Figure 8.15 shows the midpoint of the slide. We can see there is a short motion path and that Layer 3 (the couple) has cut transitions at either end. It extends the complete length of the timeline, from the start of the preceding transition to the end of the following transition. There are no adjustments effects applied to this layer.

Layer 3 is the central element of the composition. Its slight motion enhances the visual effect of the couple dancing. Scrub the Slide Time portion of the Keyframe Timeline. Can you see how the spotlight effect was created? It relies on the ending transitions of the slide's other two layers and their placement on the Keyframe Timeline.

Figure 8.15

The second slide midway through its playback.

Let's look at Layer 2, the disco ball. It enters the frame with the couple at the very beginning of the starting transition. Figure 8.16 shows the Adjustments Effects window with Layer 2 selected.

Figure 8.16

Layer 2 in the Adjustments Effects window, just as the disco ball begins its ending transition.

Layer 2 has an Opacity setting of 50 percent, applied in the Editing window, so it lasts the entire time the image is visible on the screen. This layer has a very short motion path, which pulls the ball away from the couple toward the upper-left corner of the frame. This movement adds just a hint of rotation and makes the highlights on the dance floor, on the layer below, look like they are glittering from light reflected on the mirrors.

The ending transition for Layer 2 is a circular wipe, left to right. The last part of the layer to dissolve is the right side, reducing the amount of time that the couple will be darkened by the empty area on Layer 2 to the right of the ball. The total transition time is 1.3 seconds.

Now select Layer 1, which contains the flower. It has an Opacity setting of 50 percent, defined in the Editing window. Originally, the flower was on the right side of the layer. Look in the Editing window under the Editing Tools section, and you'll find that it's been flipped horizontally.

Figure 8.17 shows Layer 1 as it enters its ending transition. You can't see the marker underneath the Keyframe Timeline because it's hidden underneath the transition icon. This layer stays in the same position during the entire play of the slide. Compare the beginning of the frame and opening transition of this layer with the keyframe position and transition of Layer 2.

Figure 8.17

The flower (Layer 1) as it enters into view. The Keyframe Timeline pointer is hidden under the transition icon.

The ending transition for Layer 1 and the beginning transition for Layer 2 are both circular wipes. For Layer 1 the transition moves from left to right, while Layer 2 reverses the direction. The ending keyframes are offset slightly. The combination of timing and alternating flow creates the spotlight effect as the upper two layers are both off-screen. That leaves an unobstructed Layer 3. The spotlight was already present in the source image. The rest of the time, Layer 3 is darkened because of the semitransparent layers above it.

Before moving on to the discussion of the next slide, experiment with the transition timing of these layers and see how it modifies the way the spotlight effect works. Subtle designs often use very simple (but not always obvious) settings to accomplish their results. This is a good example. It didn't require shifting white points or adding multiple versions of the image after retouching in a program like Photoshop. It was simply a creative use of keyframes and transitions.

Creating an Overlay with Opacity

The third slide in this show reverses the technique used in the last example to create an interesting effect, shown in Figure 8.18. The topmost layer (Layer 1) is a picture with a graduation cap with its tassel position on the right side of the frame. Its Editing window Opacity is set to 50 percent.

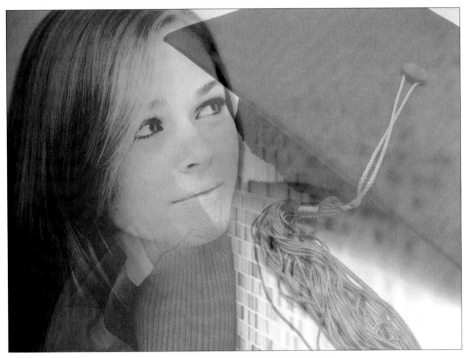

Figure 8.18
The third slide in the show, midway through play.

The layer is visible the entire time the slide is on the screen, from the start of the slide's opening transition to the close of the ending transition. The transitions are both cuts. It does not have any other adjustments effects or motion effects. In short, it acts as a semi-transparent overlay.

The other two layers on this slide are both senior portraits, each with a young woman positioned on the left side of the frame. These layers are both at 100 percent opacity and lie underneath Layer 1. Figure 8.19 shows Layer 2. The only adjustment is a slight zoom. There are no adjustments effects applied to this layer.

This layer is visible when the slide begins, and it ends with a wipe transition that runs from the lower-right corner to the upper-left corner of the frame. Its complete opacity keeps Layer 3 hidden until the transition begins. Then it reveals the lower image as the transition runs its course. You can see how it works by scrubbing the Keyframe Timeline.

Figure 8.19
Layer 2, the first
senior portrait.

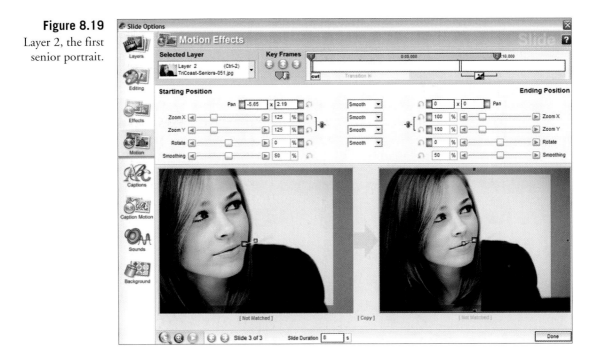

The last portion of the design shows the cap and tassel still in place and the Layer 3 picture in the position that just held Layer 2. This layer remains on the screen until the end of the show and exits with the crossfade transition that follows the slide.

The Keyframe Timeline for Layer 3 (see Figure 8.20) shows that the layer is present during the entire duration of the slide. We can't see it until Layer 2 is solid. It is visible under Layer 1 because of the 50 percent Opacity setting. To learn more about using transparency, experiment before moving on to the next show. Open the Editing window and modify the Opacity values for both Layers 1 and 2. Now adjust the duration and timing of the ending transition for Layer 2.

Hue Adjustments: Playing with Color on the Move

The three slides in this chapter's final show focus on using color as an effect. Open the adjustments 03.psh file and play the show. The first slide in the collection is a collage consisting of several duplicate images that shuffle like cards, move into a diagonal set of three variations with changing colors, and then expand and merge as this slide dissolves into the next one. Figure 8.21 shows the slide early in its sequence.

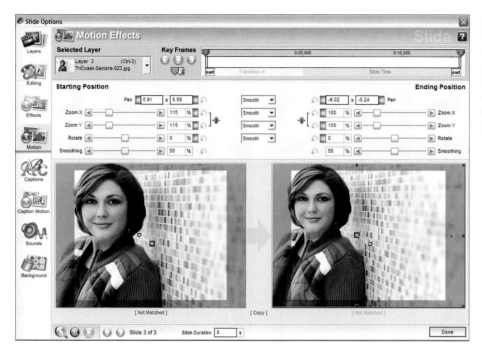

Figure 8.20
Layer 3 is present during the entire playback for the slide but can be seen only after the Layer 2 ending transition reveals it.

Figure 8.21
The first slide just as all three images have extended and changed color.

This slide offers the opportunity to see the results of blending several controls at once. We'll tour the four windows that were used to create this design. The starting point is the Slide Images and Video window.

Setting Up the Layers

In the Slide Images and Video window, select Slide 1 and press the F2 key so we can examine the layers used in the composition. The first step in creating a slide like this one is to assemble and prepare the layers for the motion effects and adjustments effects. This discussion will not walk through every detail of the design and duplicate it. Feel free to experiment with both the design and the settings.

Figure 8.22 shows the Slide Images and Video window open with Layer 1 selected. There are four layers in this slide but only two files. Both are variations on the same picture. Layers 1, 2, and 3 are the same image as Layer 4 but slightly cropped: you can tell by looking at the layer information displayed next to the listing and in the Selected Layer area at the top right of the window. (I'll explain the reason for the crop shortly.)

The basic settings for all four layers are the same in this window. Remember when designing a slide that the images are like the ingredients of a recipe. Just as with cooking, some ingredients need special preparation before being added to the mix. The basic sepia tone is one example. It was set before the image was imported.

Figure 8.22

Layer 1 selected in the Slide Images and Video window.

Now look at the image dimensions. Layer 4 is larger than the rest. It is sized at 1024×683 pixels, cropped to cover the background area of the slide. This layer has also been zoomed slightly, to 115 percent. That ensures it covers the entire frame. If it were 100 percent, you would still be able to see the top and bottom edges of the background.

The other copies are all 821×587 pixels. The crop allows the smaller versions to sit inside the area covered by Layer 4 and make them look like one picture with a section set off in a frame. Run the preview again and watch how this framed section appears to shrink and replicate. The larger copy sits directly underneath the smaller versions.

Click on the Editing tab to see what Editing settings are applied. Figure 8.23 shows the Editing window with Layer 2 selected. Layers 1, 2, and 3 have all been given white outlines and black drop shadows. These enhancements help separate them from Layer 4 and add depth to the composition. Try replacing the drop shadow with a contrasting color and see what difference that makes to the look and feel of the slide. (Be sure to revert to the original settings before moving on.)

While we can add multiple copies of the same file into a slide by repeatedly dragging one of them while holding the Control key, it's quicker to duplicate when there are common modifications to be made. In this case, the drop shadow and

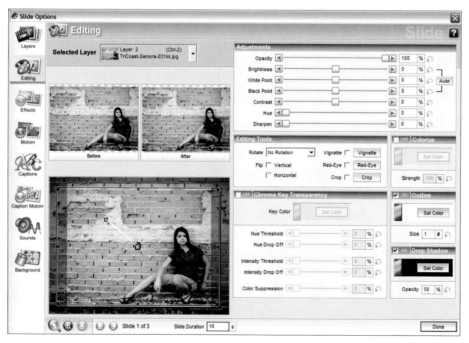

Figure 8.23
The Editing window shows how the upper three layers have been spruced up with outlines and drop shadows.

outline can be added in the Editing window and then the layer duplicated in the Slide Images and Video window. But it's not time to duplicate Layer 1 yet—we have more modifications to make first.

Motion and Adjustments Effects: An Intricate Dance, with Some Sleight of Hand

Now we get to the keyframing. This is the more challenging part of this slide, but this sophisticated effect is not too difficult with a bit of planning. It looks like one layer gets duplicated and moves to the upper-left corner. Then copies are made that slide diagonally down the frame, changing colors as they go.

The reality is a bit different and easier to create. A look at the keyframe structure and motion path tells the tale. The most complicated part of the design is the movement of the layers. Shift to the Motion Effects window and choose Layer 4. Here we see the larger version of the picture filling the frame (shown in Figure 8.24).

There are only two keyframes associated with this layer. This is the base of the design. It just stays in the back. The designer cropped this image and then placed the smaller copy on top. Then the motion effects and hue were added.

Figure 8.24

Layer 4 serves as the backdrop for the moving layers in slide 1.

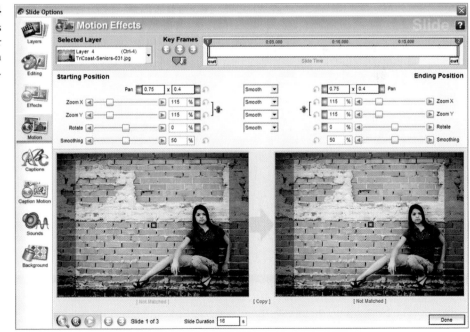

A Closer Look at Layer 1

Select Layer 1, the workhorse of this slide. As you can see in Figure 8.25, it has eight keyframes assigned. Check the number for the remaining layers. Layer 2 has six keyframes, and Layer 3 only four. What does this tell you about how the slide's design was set up?

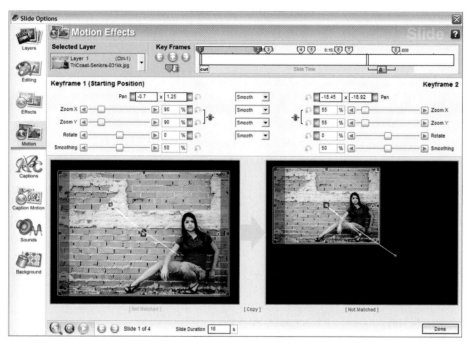

Figure 8.25
Layer 1 is the cornerstone of the design and contains the most keyframes. They encompass the entire motion path.

Layer 1 is actually the only layer that travels the entire motion path. Scrub the Keyframe Timeline and watch how it moves. The image shrinks into the upper-left corner. It changes color and moves to the center, leaving behind a copy in the new color. It moves down to the lower, repeating the process of changing color and leaving a copy. Then all three copies enlarge and blend back into Layer 4.

Use your mouse to select each of Layer 1's keyframe pairs and examine both the Adjustments Effects and Motion Effects windows. During the four seconds of the first pair, the zoom changes from 90 percent to 55 percent and the pan shifts from -0.7 × 1.25 to 10.45 × 18.92. The next pair lasts one second, and the only change is a shift in hue from 0 to 17.

The third pair is used to move the layer to the center of the frame in just under two seconds. Another second of rest during the fourth pair (Keyframes 4 and 5) brings another change in hue. The fifth pair moves the layer to the lower corner of the frame. That is followed by another color change between Keyframes 6 and 7.

The final keyframe pair is when the hue is restored to the original settings. That lets the color of the image blend to match Layer 4. The Zoom and Pan settings are adjusted to enlarge the image and make it appear to fade into the larger picture.

Some sleight of hand and the use of motion make this slide easier to create. The moving layers do not have to line up precisely with Layer 4 at the start and end. Look closely and you can see that the designer used the lines of the brick wall with the drop shadow and outline, and a little experimentation with the zoom and preview, to create the illusion of a perfect fit.

Cloning the Effects and Adjusting the Keyframe Timeline

Select Layer 2 and compare the Keyframe Timeline with that for Layer 1. While Layer 2 has fewer keyframes, they are arranged with the same timing and functions. The designer duplicated Layer 1 to make a template, replaced the image, and then adjusted the settings.

Let's look a little closer. The basic structure is the same until the last keyframe pair. (See Figure 8.26.) This layer starts full frame and shrinks into the upper-left corner of the slide. Then it changes hues and moves to the center of the slide. The timing and settings are the same as those for Layer 1. This frame is hidden until Layer 1 moves to the lower-right corner, leaving Layer 2 exposed in the center of the frame.

Figure 8.26

A copy of Layer 1 was used to set up the keyframes and controls for Layer 2.

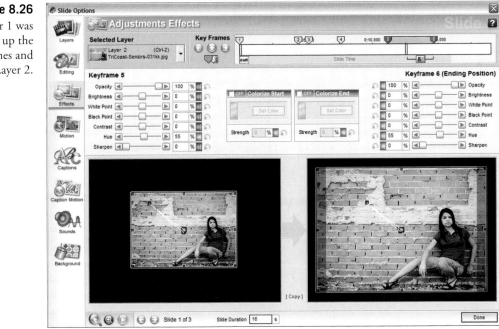

In short, the Layer 1 keyframes that move it to the lower-right corner were removed so that Layer 2 stops in the center position and then grows larger at the same time as Layer 1. The final keyframe pair's Pan and Zoom settings had to be aligned to the timing of the last pair for Layer 1.

Now select Layer 3. We can see that the same technique was used here. This layer is a copy of the first portion of the first layer. It simply shrinks and travels to the upper-left corner of the frame. Then it waits for the other layers to move into position and join in the final enlargement and fade out at the end of play. See Figure 8.27.

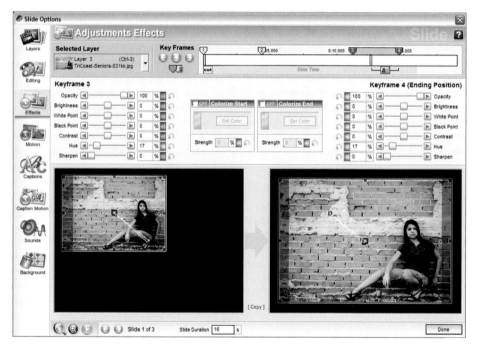

Figure 8.27
Layer 3 has also been copied from Layer 1 and then adjusted to map a shorter motion path.

The slides in these shows are excellent examples of how to combine effects and use efficient workflow. The techniques you are using to discover the way these slides were built can be used with all of the shows on the companion CD-ROM. We'll continue to use it with the rest of the lessons. Individual slides can be copied from one show to another inside a ProShow project. That makes it easy to bring the effects covered in this book into your productions. (Keep in mind that slides that use features found only in Producer can't be used in the Gold version of the software.)

Variations on a Theme

The second slide in this show employs a thematic design that works well in digital picture frames or trade show display panels. (See Figure 8.28.) The bottom layer is a generic detail picture composed within the frame as a setting with open space for placing pictures. Above it, images are displayed using a combination of motion effects, layer transition, and hue adjustments to attract the eye and add interest. Right now there are only two other layers, but you could add more to extend this slide into a show in its own right.

Figure 8.28
The second slide in the show midway through its playback.

We aren't going to examine this slide in full detail, but will just focus on the elements I mentioned and see how they work within the design. Preview the show, and then open the Adjustments Effects window. Select Layer 1. This layer has six keyframes. It opens with a cut and ends with a close vertical transition. (See Figure 8.29.) Use the context-sensitive Preview menu to hide the inactive layers. Now scrub the Keyframe Timeline and pay close attention as the closing transition occurs.

The direct placement and cropping of Layer 1 (the three-quarter-length bridal pose) and Layer 2 (fitting the earring) over each other creates an activity zone inside the frame—a frame within a frame. Layer 3 is static throughout the slide. The vertical transition adds to the effect in the way it reveals the layer underneath.

Figure 8.29
Layer 1 being replaced by Layer 2 using the close vertical transition (the Keyframe Timeline Marker is hidden underneath the transition).

In this slide the bottom layer is not the primary focus; it is a backdrop. So we are free to move and zoom in on an object as desired. Scrub the Keyframe Timeline again and pay attention to the motion path of Layers 1 and 2. Both layers cover the entire frame and change position when they are at their smallest.

Each layer's relationship to the other elements of a design determines how a layer can be positioned and moved. First, there is the visual composition of the frame area itself. Remember how the flower and disco ball were used in the slide with the dancing couple? They had to be placed in the left half of the frame to avoid covering the bride and groom. Even though they constituted the "background," they were the primary focus of interest.

Change the active layer to Layer 2, and change the menu setting to Darken Inactive Layers. Select each keyframe pair in order. Layer 2 actually sits under Layer 1 through the first part of the slide. Mimicking the path and sitting below the top layer were an easy way to keep the second layer out of sight and properly positioned for the transition point. As long as the lower layer was either the same size or slightly smaller, there were no problems with it showing on the screen before its proper entrance.

Open the Adjustments Effects window and move through the keyframe pairs again. Observe how (and when) the design uses hue to add emphasis. Examine the shift that happens in Keyframes 4 to 5 during a short interval without motion. (See Figure 8.30.) Experiment with alternate settings to get a sense of visual flow

and impact. Alter the white and black points as well as the hue. There are no pre-
cise rules, and different images may look better with different combinations. (See
Figure 8.31.) The nature of the background, the preceding and following layers

Figure 8.30
Layer 2 uses a hue to
add another element
of contrast to the
composition.

Figure 8.31
The final slide in the
show uses hue and
two layers with an
alternating motion
path to show
variations on a theme.

and slides, and the desired effect and personal taste can all be factors in choosing the final combination.

Digital photography makes it easy to experiment with various processing options for an image. Producer makes it easy to display these variations, assemble proofs for a client, create a sample collection, or just design something for artistic pleasure. The final slide offers an example of how this can be done and combines several techniques we have been using in this chapter and the last one. We won't examine all the fine points; rather, we will use them to expand on our discussion and do a quick review.

Play the slide, and then open it in the Motion Effects window. In the preceding slide, the bottom layer was an integral part of the design. This slide uses an image as a designated background layer. It is simply an attractive backdrop pattern that is covered during much of the playback. There are also two layers that both contain the same image file.

Figure 8.32 shows the slide with Layer 1 selected. Change to Layer 2 and the keyframes don't change; only the direction of the motion path changes. Just as with the slide of the bride in the cowboy hat in Chapter 7, this design is a natural for creating one layer, setting the keyframes, duplicating it, and then changing the assigned image file. With the Chapter 7 slide, all we had to do then was reassign the motion path to the new layer.

Figure 8.32
Layer 1 of slide 3, showing the motion path with Keyframes 3 and 4 selected.

There is still additional work to do here. The images change hue three times each. You could do it to one layer before the duplication and then adjust the hue for the second, or you could set both during another design step together.

This is a matter of personal preference. I tend to do both at the same time. It's easier to judge which colors work best side by side that way. If one is already set, it tends to limit the options or require changing both sides to complement each other.

Figure 8.33

Layer 2 in the Adjustments Effects window.

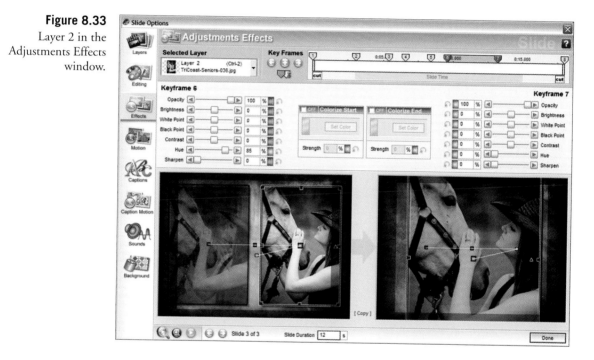

That brings up another issue. Any changes in the Adjustments Effects controls alter the way the image looks on the screen. In some cases the new look may clash with the other layers in a slide. It may be possible to tweak the design and keep the new look. Sometimes it requires paring or altering the design.

Producer offers an extensive array of design tools, multimedia effects, and image controls. The interface offers a very flexible workflow and the ability to change and extend a show at any time. It lets us use the same show file to generate a wide variety of output formats. When working on the design, we have to keep the final goal for each project in mind.

Up Next

We have covered most, but not all, of the design tools in ProShow. The next chapter explores some of the program's most advanced layer controls: masking, vignetting, and Chroma Key. These tools offer powerful ways to add depth to a slide and link the way layers relate visually to each other.

9

Advanced Layer Techniques: Masks, Vignettes, and Chroma Key

Get ready—in this chapter we'll combine what you have already learned with Producer's advanced layer tools to generate incredible effects. Masking lets you use one layer to hide or reveal portions of selected layers beneath it. So you can isolate, highlight, and spotlight portions of a slide in very creative and subtle ways.

Vignetting controls the shape and transparency of a layer's edges, giving you the tools to frame and blend one layer with another. Chroma Key makes one color in a layer transparent. Best of all, you can pair these tools with motion and adjustments effects and keyframing.

You should already be familiar with the material presented earlier in the book. This chapter is about Producer only, and the material assumes a reasonable knowledge of motion and adjustments effects, keyframing, and the ProShow user interface. Also, be aware that many of the slides shown here use complex effects, and they may take longer to render previews than those in the preceding chapters. (That won't, however, slow down previews you do by scrubbing the Slide List or Keyframe Timelines.)

The best way to master these advanced topics is to follow along with the lesson files in Producer. All of the files related to the examples are available on the companion CD-ROM. I will explain how the slides work but won't give step-by-step instructions. By now, I assume you are familiar with the Producer user interface and know how to use the necessary controls to duplicate the design. I will point out any innovative or unusual design techniques. Keep in mind that you always have the actual settings for each effect in the sample show itself.

Let's start with a quick example of masking and motion. Run the automatically executing show file Jump for Joy.exe, which is in the Chapter 9 folder on the CD-ROM. It uses a single image, albeit a very active one, of a groom and groomsmen jumping in the air. Figure 9.1 shows a segment of the show.

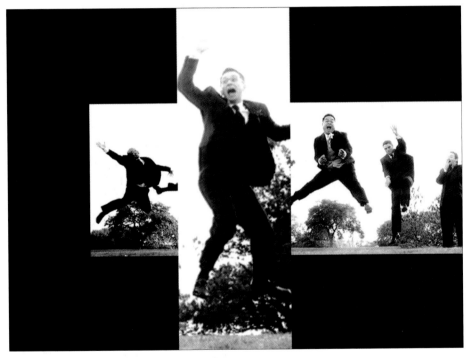

Figure 9.1
This zany portrait of a groom and groomsmen by TriCoast Photography really comes to life with a bit of masking magic and motion effects in Producer.

We'll look closely at how it was created later in the chapter. For now, just examine how the vertical slit in the center works. It looks like a pair of black frames was placed on either side of the frame, leaving the center section free. Not so. In fact, the center is covered by a black layer! In this case, the black layer is really a mask—so we can see through it!

Masking is a very sophisticated technology, but Producer provides all the tools you need to make use of its creative potential. Masking may be a bit confusing at first glance: things like solids being transparent, for example. We'll take things steps by

step, with plenty of examples. Before you go into your first hands-on session, let's look at how Producer sets up a mask.

This slide has three layers: a solid-black one on top and two copies of the same picture of the groom's party. There is also a solid-black background. Figure 9.2 shows the Slide Images and Video window for the show with Layer 1 selected. The deep black you can see in the Preview Area is the background. The actual layer is the gray area in the center.

Figure 9.2

Defining masks is done in the Slide Images and Video window.

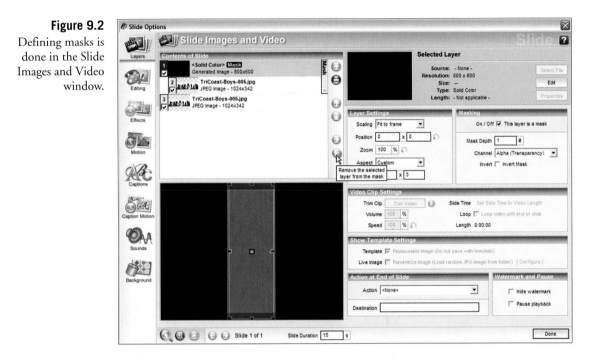

On the right side of the window is the Masking section. Notice that the check box that reads, "This layer is a mask" is checked. The depth is 1, which means that the mask is applied to the first layer *below* it. If the number were 3, then the mask would control the first three layers below it. Any deeper layers would not be affected by the mask.

The channel type determines the mask's behaviors. This one is set to Alpha (Transparency). The black layer is really a transparent mask. In any layers controlled by the mask, the portion of the frame where the mask is placed will appear transparent, and the rest of the frame will not. The color of the mask makes no difference when it is a transparent mask (also called an alpha channel mask).

Grayscale is the other type of masking. When a layer is used as a grayscale mask, the dark areas of the image hide the layers below, and the light areas are shown. We'll work with this type of mask later in the chapter.

Examine the Layers List. See how Layer 1 is designated a mask (the black label with the word "Mask" in the layer's first line)? Layer 2 is indented, indicating that Layer 1 is masking it. The Mask bar on the far right of the list also shows which layers the mask affects. The mask determines what portion of the layers underneath is seen in the show.

The Alpha Channel and a Spotlight on Masking

One of the most common (and easiest to master) masking effects is the moving spotlight. I am going to use it to introduce the basics of both transparent masking and Producer's Vignetting controls. They complement each other, and the combination makes it easy to see exactly how alpha channel masking (transparency masking) works.

Creating a Simple Transparency Mask

Open the file Mask1.psh in Producer. This show has one slide with a single image layer, underneath a transparency mask, and a solid black background. As the show plays, the mask's motion path creates a spotlight that focuses on the bridesmaids' flowers and then enlarges to reveal the entire picture.

Open the Motion Effects window and select Layer 1. The Preview Area in Figure 9.3 shows the slide at a point midway between Keyframes 5 and 6. Layer 1, with its motion path, is shown on the right. The large area of black is the background, not the Layer 1 mask. It is the area defined inside the layer outline. If your layer does not have the outline, enable it using the context-sensitive menu. It really helps when working with solid masks.

We are going to add another slide to this show and create a similar effect. That's the quickest way to learn basic masking. Drag the image file TriCoast-Girls-113.jpg to the second slide position on the Slide Timeline. Adjust the transitions before and after this slide to zero seconds.

Open the Slide Images and Video window. Click on the green "Add another layer" button and choose the "Add Solid Color" option. Use the Color controls to make the new layer a dark blue. Click the Set Color button once you do. Figure 9.4 shows my screen just as I finished this step.

The Preview Area should show a solid-blue fill. The picture of the jumping bridal party is now Layer 2, covered by the new Layer 1. If your layers are not in this order, please adjust them. Click on the On/Off box labeled "This layer is a mask" in the Masking section of the window. As soon as the box is checked, you'll be able to see Layer 2 grayed out underneath the mask.

Figure 9.3
Masking and motion combine to create a spotlight effect.

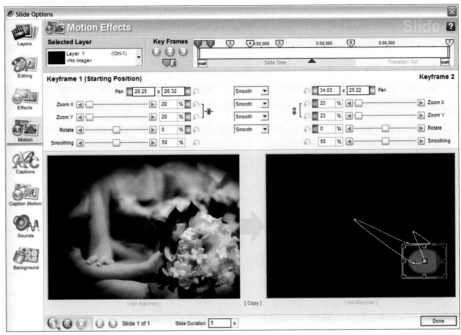

Figure 9.4
Setting up the color for the new Layer 1, to be converted into a mask.

Now look at the Layers List in the Contents of Slide section of the window. Layer 1 is designated a mask, and the second layer has been indented in the list. We could have obtained the same result by clicking on the second blue button from the bottom (with the arrow pointing right), located to the right of the Layers List. It indents the currently selected layer. The arrow pointing to the left undoes the indent and removes the layer from the masked stack.

Change to the Motion Effects window and zoom Layer 1 to 50 percent. Copy the zoom setting to the end of the slide. Drag the Keyframe Timeline to the middle of the slide's play time. Figure 9.5 shows how your window should look. There is no motion effect; we simply used the Zoom control to set the size of the mask in the frame. The black area that borders the group is the slide's black background. The mask keeps any portion of Layer 2 not under the mask from being seen.

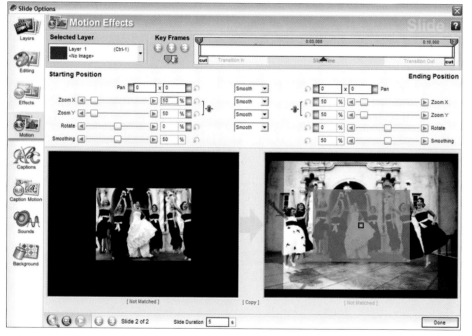

Figure 9.5
The mask, zoomed to 50 percent midway through playback.

Notice that our mask is not black. We set it to dark blue. The color of the mask has no bearing on how the slide looks. A transparency mask does one thing—it blocks portions of any layer beneath it (that are indented and made part of its stack) from being seen. This is *not* the same thing as placing a transparent layer that is not a mask on top of other layers, even though the results may look similar in some cases. Masks offer a lot more control.

Combining Transparent Masks with Vignettes

Sharp-edged squares don't look much like a spotlight. Let's make the shape round and feather the edges before we add a motion path to our mask. That's easy with Producer's Vignette controls. Open the Editing window with Layer 1 selected. Click on the Vignette button, in the Editing Tools section. A dialog box like the one in Figure 9.6 will open. For the Shape option, choose an ellipse, and set the Type to transparent.

Figure 9.6

Designing a transparent ellipse vignette for Layer 1.

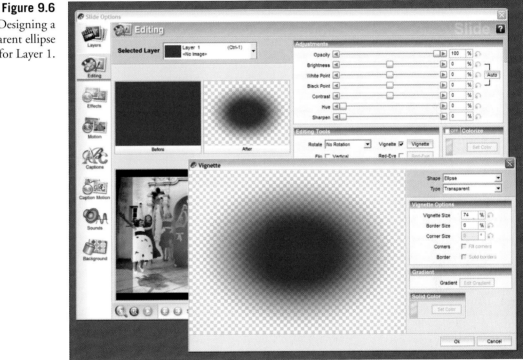

This type of vignette has two controls. Vignette Size adjusts how big the soft edges of the layer are, and the Border Size sets the diameter of the ellipse. Set both to zero, and the result is an oval shape with sharp edges. Change both to 50 percent, and you get a mid-sized oval with a soft, feathered border. Play with both controls to get a good idea of how they operate, and then set the Vignette Size to 75 and the Border Size to 25.

Now the mask produces more of a spotlight effect. It's time to make it move and light up the ladies. Change to the Motion Effects window, and make sure Layer 1 is still selected. We're going to add keyframes to this layer so that the spotlight

moves from the junior bridesmaid on the far left across to the far right and then comes back to the bride and zooms out. Along the way, we'll add a bit of rotation.

The easiest way to define a motion path from beginning to end is to set the first pair, adjust the interval, and then add one keyframe at a time. Set the Zoom to 55 and the Rotate to 56. Use the Copy Start to End command (in the Copy menu between the two Preview Areas) to match the values for both keyframes. Move the center of Layer 1 just between the faces of the two women on the far left.

Move the second keyframe to about .65 seconds on the Keyframe Timeline. (You can drag its Keyframe Marker or right-click on it and use the Set Time command.) Move the second Keyframe Marker over the face of the third woman from the left. Repeat the process to add new keyframes to set up a motion path similar to the one shown in Figure 9.7.

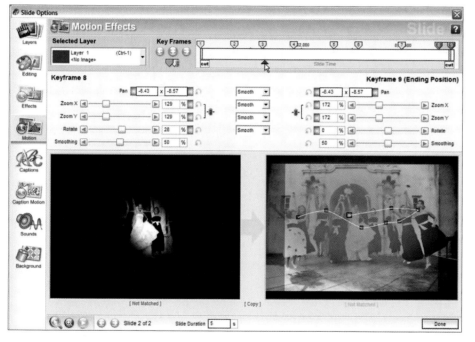

Figure 9.7
Scrubbing the Keyframe Timeline with the finished motion path, shown in the Preview Area on the right.

I've made a low pass in front of the bride and the women on the right and then crossed back across to the bride's face. The last pair of keyframes holds the position over her, and the spotlight effect zooms and rotates to light the entire group. This is just an exercise in using a transparent mask with motion, so feel free to experiment with the motion path, rotation, and keyframe interval.

Isolating Portions of the Frame with Transparent Masks

Static masks are used to set off a portion of the frame during play. Of course, they mask only the layers nested underneath them. Layers above are not affected, and neither are those below that are not part of the mask's stack.

Let's look more closely at the slide with the groom's party and see how it works. Open the Mask2.psh file in Producer, and then open the Slide Images and Video window. Select Layer 1. Your window should look like the one shown in Figure 9.8.

Figure 9.8

The Slide Images and Video window open, with Layer 1 selected.

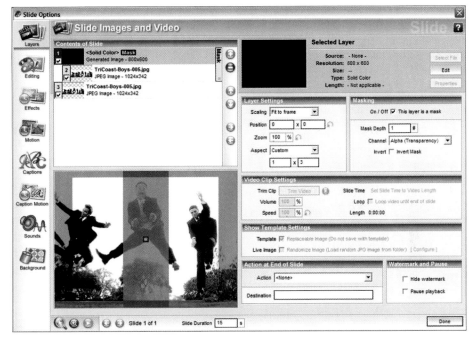

It has three layers: the mask, a nested image in the mask's stack, and a copy of the image that is not masked. Let's look at how the layer was created. The layer information shows that it is a solid-color fill and that the Scaling field is set to have the layer fit within the frame. So why does it appear as a narrow vertical rectangle? Notice the aspect ratio in the Layer Settings section: Custom, with a value of 1×3. Change it to 3×3, and the rectangle becomes a square. (If you try it, change it back before you go on.)

Since Layer 1 is an alpha channel mask, only portions of a layer underneath the masked area will show if they are included in the stack. In this case, Layer 2 is affected, but Layer 3 is not. This is another example of how ProShow does not

actually modify an external file; rather, it just "borrows" the data and renders it in a video stream.

Click the check box in the Masking section that says "Invert Mask." Now look at the preview in Producer's main window. There is a black vertical line in the center of the frame, and the rest of the picture that was hidden before is now visible. Uncheck the box to return to the original setting.

Open the Motion Effects window. The mask has only one keyframe pair, and it runs from the beginning of the show to the end of the following transition. (There is no transition before the slide.) That means that it is present on the screen for the entire playback. You can see it in both Preview Areas. It is the transparent, gray, vertical panel in the center of the frame.

Change the selected layer to Layer 2. Now you can see the mask in place with part of the underlying layer and its motion path visible (see Figure 9.9). The black on either side is the underlying background. To prove that, switch to the Background pane and change the selected color. The areas on the sides will then show that color.

Run the preview and watch how fast the segments change. Now examine the Keyframe Timeline for this layer. See how Keyframes 2 to 14 have sets, with one keyframe sitting on top of another? Then the interval for the final keyframe pair increases to allow the underlying layer to slide into the frame and zoom toward the viewer.

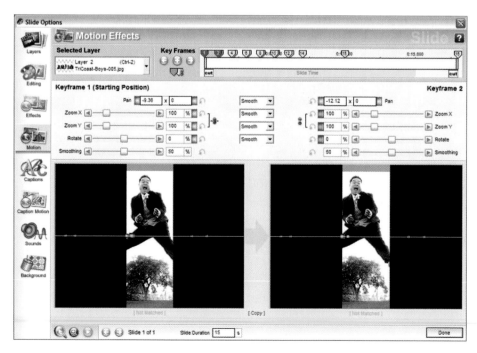

Figure 9.9
Layer 2 in the Motion Effects window with Keyframes 1 and 2 selected.

This design really fits the mood of the subjects and their zany poses. The first part of the playback, with its fast shifts in the masked region, matches the acrobatics of the groom and his friends. The viewer is drawn into the action, but it doesn't give the full picture.

Then the entire images scrolls in from the right. The viewer can focus on the way the men are all in the air at the same time. Can you figure out what happened to make the masked area and Layer 2 disappear to the left as Layer 3 passed beneath it? It's the same reason that the color of the mask makes no difference. Understanding the way it works will help you understand how masks and the layers they control operate.

Figure 9.10 shows the playback as the masked area is starting to close. It's not really moving all, but the vertical rectangle that makes up the mask is getting narrower. The mask isn't there as an object in the slide. It is simply a regional effect defined by the shape of the mask. That's how a mask differs from a transparent file used as a frame.

Layer 2 is moving to the left at this point in the slide. As the right side of the picture reaches the right side of the mask, more of the background is revealed. That's what makes the mask "disappear." Layer 3 first slides behind Layer 2, unaffected by the mask. The part of Layer 2 that you can see hides that portion of Layer 3.

Figure 9.10

Layer 3 entering the slide as the masked image "narrows" and disappears.

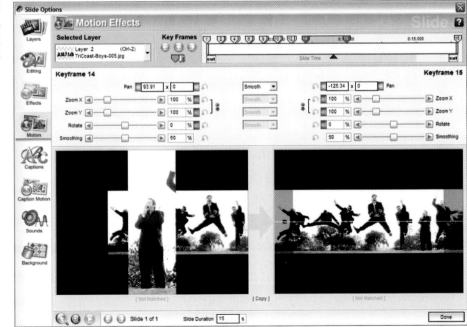

Compare the keyframes for Layers 2 and 3. (Layer 3 is shown in Figure 9.11.) As Layer 3 starts to move into the right side of the frame, Layer 1 stops moving back and forth and pans to the left in its exit pass. The difference in zoom means that Layer 3 travels faster and so passes partially beneath Layer 2 before it can fully leave the frame. Finally, Layer 3 zooms during the segment controlled by Keyframes 2 and 3.

Figure 9.11
Layer 3 enters the frame as Layer 2 scrolls off to the left.

These examples give a good introduction into the realm of transparency masks: how to use them in your productions and how to combine them with motion effects. Keep in mind that you can have multiple layers and that a mask has control only over the layers in its stack. Lower layers that are not in the stack are not masked. You'll see more of how that affects the view of a slide next, when we use intensity masking.

Intensity Masking: White Reveals while Black Conceals

Intensity masking (also called grayscale masking) is based on the grayscale intensity of the masking layer. The basic rule is, "white reveals while black conceals." Choose the Invert option, and white will conceal while black will reveal. Portions of a mask that are not pure black or white will pass through the mask's layer stack

based on density. A 50 percent gray will be 50 percent transparent. We can use images, gradient fills, and even video clips as masks. Of course, we have to choose the mask carefully to match the desired effect.

Slide 1: A Simple Stencil

Launch Producer and open the Mask3.psh show file. This show has three slides, and all make use of intensity masks. The first slide isn't designed to be a show-stopper. I created it to demonstrate the basic principles of grayscale masking using a gradient layer. The other two slides are designed to show what you can accomplish with this style of masking and a little imagination.

Select slide 1 and press the F2 key. The Slide Images and Video window should appear, looking like Figure 9.12. This slide has four layers. Layer 1 is a gradient created in ProShow and designated as a grayscale mask. Layer 2 is an Adobe Photoshop file with black letters and a transparent background. Layer 3 is a solid color generated in ProShow, and Layer 4 is a JPEG-textured background that comes with Producer. Layers 2 and 3 are masked by Layer 1.

Layer 1 is a linear gradient fill divided into three zones. It is pure white on the left side and pure black on the right side and has a middle that compresses the rest of the grayscale. As a result, the mask will show the left side of the layers beneath, hide the right side, and provide a graduated opacity in the middle.

Figure 9.12
A gradient layer used as an intensity mask.

The first step in setting up an intensity mask is to add a new layer and choose the Add Gradient option. Then the new layer is fine-tuned by clicking on the Edit button and configuring your settings in the Create Gradient dialog box. You can see the Create Gradient box I used to generate Layer 1 in Figure 9.13. It is accessed by clicking on the "Add another layer button" in the upper-left section of the window and choosing the Add Gradient option from the context-sensitive menu.

Notice the five markers on the Colors bar, to the right of the Preview Area in the center section of the window. They look a lot like Keyframe Markers. The plus and minus buttons on the right of the bar are used to add and remove markers as needed to get the desired effect.

Figure 9.13
The Create Gradient dialog box used to generate Layer 1.

In this case, I adjusted the two markers on the left to create the pure white zone. The two on the far right control the width of the black region. By adjusting the grayscale density, you control the effect of the layer as a mask. See the line with the mouse cursor at its right end in the preview? Placing the mouse pointer on the preview and dragging lets you adjust the angle of the gradient fill. This window offers an interactive and intuitive way to create a complex gradient mask with very little work.

Underneath the preview are six icons that show the types of gradient styles available. Set the desired type using the drop-down menu above the preview. If you want to practice with this window before moving on with the discussion, add a new layer and experiment. (Just don't forget to delete it before continuing with the exercise.)

You can see the complete design, and the result of the mask, in Figure 9.14. Most of the words in the PostScript file ("Masking Magic"), and the red layer underneath, are visible, but both begin to fade as you move from left to right because of the mask—near the letter *s* in the word *masking* and the letter *a* in *magic*. Most of the letter *g* in masking is not visible at all. The pattern of Layer 4 starts to become visible near the middle of the slide and is the only thing you can see in the frame on the far right.

Figure 9.14

The appearance of the complete slide just before the end of Layer 1's display time.

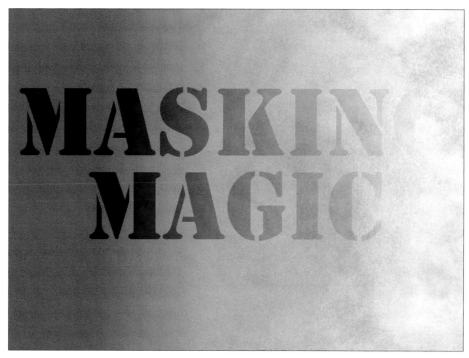

Close the Create Gradient dialog box and open the Motion Effects window with Slide 1, Layer 2 selected. Now scrub the Keyframe Timeline as shown in Figure 9.15. Just after the 4.2-second point, everything but Layer 4 vanishes! You can see that the ending position for this layer is all the way at the end of the following transition. Shouldn't you be able to see Layer 2? Layer 3 also extends to the end of the following transition, and it is gone as well.

Select Layer 1. It has only two keyframes, and the second one is placed at the precise time that the lower layers vanish during playback. That's why only Layer 4 is visible. To gain a better understanding of how this works and what kind of control you can achieve, take some time and add different ending transitions to Layers 1, 2, and 3. Modify the type and direction of the gradient for Layer 1.

Figure 9.15
Layer 2 vanishes from the slide midway through playback, even though its ending keyframe has not been reached, due to the timing of the mask in Layer 1.

Then add some motion. Make Layer 1 rotate. That will change the placement of the light and dark areas within the frame and so change what is visible at any given time. What happens if you add motion effects to the layers in the mask's stack?

Try variations in the Adjustments Effects settings for Layers 1, 2, and 3. Then invert the mask. This type of exploration not only shows more about how intensity masks are controlled and about their effects on other layers; it also tends to spark new ideas for special effects and creative slide design. When you're ready to continue, remove slide 1 from the show. You want slide 2 to appear without slide 1 playing first.

Slide 2: A Role Reversal

Let's look at the layer structure and the masking configuration for this slide. There are four layers. One image is used twice (Layers 1 and 4), another image (Layer 2) appears once, and Layer 4 is solid black. The slide also has a solid-black background that is not on this list since it is defined in the Background window.

Make sure Layer 1 is selected. See the marker noting the center of the mask layer in Figure 9.16? It shows that the layer is positioned on the left side of the frame (the gray area). There is no image visible because the mask is not an image—just a mask. The Preview Area in this window defaults to the slide's starting point on the Keyframe Timeline.

Figure 9.16

The Slide Images and Video window showing the layer and mask assignments for the second slide.

The black area we see to the right of the mask is the portion of Layer 3 that is not covered by the mask. If you want to test this, use the mouse to drag the mask to one side or the other. You can see Layer 4 because the black portion of Layer 3 on its left side is masked.

Layers 1 and 4 are identical. Making Layer 4 an inverted intensity mask allows Layer 4 to show through any layer inside Layer 1's stack. You can prove this by unchecking the box in front of Layers 1 and 3 and previewing the slide. The black area on the left side of Layer 2 now hides Layer 4 when it slides into place (see Figure 9.17).

If you want to explore how the elements work together and expand your understanding of masking, convert Layer 3 into a solid-white fill. (Select the layer, choose Edit, and then set the color to white.) Now run the preview and see what happens. The masking alters the appearance of Layer 4 because of the shift in the underlying tones in the masking stack. What happened to the dark areas of the bride, like her hair? What happened to the light areas, like the gown? Be sure to restore Layer 3 to solid black before moving on.

Figure 9.17
This screenshot shows
the slide at the peak
of action, as Layer 2
nestles into place.

Combining Adjustments Effects with Intensity Masking

Shift to the Adjustments Effects window, with Layer 1 selected. Figure 9.18 shows the left Preview Area two-thirds of the way through the slide time. This is the point where Layer 3 has completed its motion and is nestled "under" the bride on the left. I used quotation marks around the word *under* because the bride on the left is really under the mask stack.

We can see that Layer 1 has a single keyframe pair, so any adjustment settings shown in Figure 9.18 apply to the entire play time for this layer. The Brightness and White Point values have been adjusted from their default values to 80 and 40 percent, respectively. That alters the appearance of Layer 4 in the slide because it adjusts the intensity values for the mask.

Shift the starting point's brightness to -100 and the white point to 100 percent, and then scrub the Keyframe Timeline to see the change in the slide. The bride on the left is now missing at the beginning of play but slowly brightens because we changed the tonality of Layer 1's grayscale range. The original settings changed the tonal range just slightly to enhance the detail in the gown against the backdrop of Layer 2.

Figure 9.18
You can fine-tune the
way an intensity mask
alters the rest of the
slide by changing the
mask's Adjustments
Effects settings.

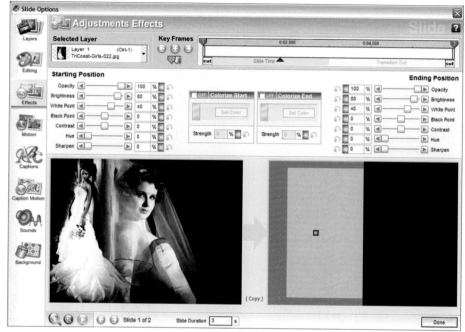

Restore the starting position's original values to Layer 1 and select Layer 4. Adjust the black point to -100 and the brightness to -22. Repeat the preview, paying attention to the way the edges of the white gown and highlights in Layer 4 are darkened during the beginning of playback.

This exercise shows how any variation in the gradient of an intensity mask can change the way the slide appears during playback. When you blend images using gradients, consider making a second pass to fine-tune the settings in the Adjustments Effects window. You can adjust the appearance of the non-masking layers as an additional detail control.

Alpha Channel Masks and a Selective Bit of Color

Our next show uses an alpha channel mask to create a moving band of color over a black-and-white image. Open the Mask4.psh file in Producer. Once the show has loaded, open its single slide in the Slide Images and Video window.

This slide has three layers. Layer 1 is the mask. It has an aspect ratio of 6 × 1, making it appear as a horizontal rectangle. Layers 2 and 3 are both the same file, TriCoast Girls-045. These are a copy of a bride in front of a desk and a wall-sized world map. Layer 2 is stacked under the mask.

Figure 9.19
This slide has three
layers. Layer 1 is an
alpha channel mask.

Play the slide, and you'll see how the mask moves over the frame. Only the portion of Layer 2 under the mask will be shown in color, as Layer 1 moves and reveals it. The rest of the frame will show the black-and-white, colorized version of Layer 3, as shown in Figure 9.20.

This same technique can be used to "paint" virtually any variation you create in Producer over another copy of the same image. Try colorizing Layer 3 and play the slide again. Now the slide shows the contrasting color as the mask moves over the frame.

The variation can be made to change over time through the use of keyframes. Alter the color during the course of a keyframe pair, and the mask will reveal the changes as they occur. You could also have additional layers in the mask stack and have them enter and exit the mask's path by using the Keyframe Timeline to adjust when they become visible. That concept can be taken even further by allowing the beginning or ending transition of a layer to be revealed by the mask.

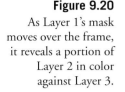

Figure 9.20
As Layer 1's mask moves over the frame, it reveals a portion of Layer 2 in color against Layer 3.

Working with Multiple Masks

It's possible to use multiple masks in the same slide and have a single mask control several stacked layers. You can combine both grayscale and transparency masks in the same slide, but only one mask can control a single layer. (You can't have two masks controlling the same layer.)

Open the Mask5.psh file and then examine slide 1 in the Slide Images and Video window. There are 10 layers in this slide, and half of them are transparency masks. The other half are image files, with one mask matched to each image layer, as shown in Figure 9.21. The number of layers might lead you to think that the design is complicated. It's not, as you will soon see.

Run the preview for this slide. The basic design is obvious. The images have no effects at all. They sit centered in the frame without any variation in their appearance. All of the action in the slide is created by the movement of the masks over their respective layers.

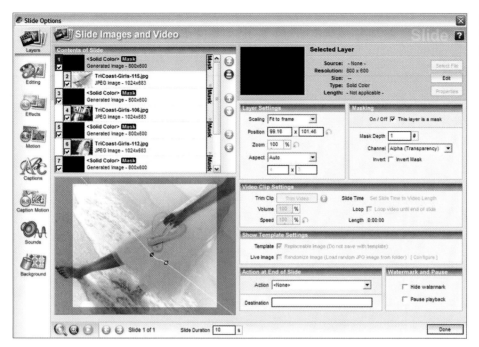

Figure 9.21
This slide has 10 layers; five are transparency masks.

The slide has a black background, so as each mask/image pair is played, the portion of the image under the transparent portion of the mask is shown, and the rest of the frame is filled with black. We can see the motion path for the Layer 1 mask superimposed over the layer it controls. During play the slide looks as if a black frame were being slid over the picture. The frame moves from the lower-right corner to the upper-left corner of the frame.

Then the image of the bride on the beach is replaced by a picture of a bride holding her bouquet. A black frame pans from the upper right to the lower left. As the other images come into view, the motions of the masks become more varied.

Open the slide in the Motion Effects window and select Layer 9, the final mask in the slide. The Preview Area in Figure 9.22 shows the slide at the midpoint of the first keyframe pair for this layer. We can see in the Keyframe Timeline that its action takes place late in the slide. It's not surprising. Each of the other pairs has already played. The images are rendered invisible as the end of their mask's final keyframe is reached.

Figure 9.22
The final mask and its layer being played in the preview. The motion path is visible on the right side.

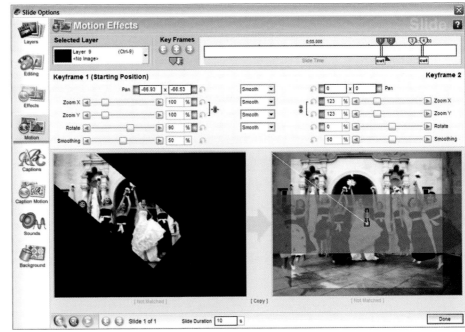

Vignetting Reconsidered

It's easy to see how powerful masking is as a tool for adding professional effects to shows. Let's look at how vignetting, a Producer feature, can play a role in refining how layers and masks are used (and appear) in a production.

Layers normally have sharply defined edges and are either square or rectangular. Vignetting lets you soften edges and adjust the outer shape of a layer to suit the needs of a design and produce subtle variations. There are two basic outer shapes to a vignetted layer: a rounded rectangle and an ellipse. These are the starting points for the outer shape, and you can adjust them dramatically with the other controls.

Vignettes let you quickly create masks with custom shapes and edges when they're combined with a solid or gradient layer. You can also use vignettes to produce an incredible array of borders, ranging from simple feathered edges to psychedelic rainbows.

Vignettes can soften the edges of images in a slide, allowing them to blend in with the other elements of a design. That's their primary purpose in this show. The top two layers both have vignetted borders. Open the Vignette1.psh show file. Run the preview and notice the edges.

Select its single slide. Then press the F3 key to launch the Editing window. Select Layers 1 and 2 in turn and disable their vignettes by unchecking the box next to the Vignette button located in the Editing Tools section of the window. Replay the Preview, and pay close attention to the edges of the layers. This is not a dramatic difference in the show, but it does improve the appearance of the slide. When finished, reenable the vignettes on both layers by rechecking the box.

Select Layer 2 and click on the Vignette button. Figure 9.23 shows the Vignette controls in front of the Editing pane. My example is going to look different from the one on your screen. I've made some adjustments to the settings to produce a rather colorful gradient border.

We've already covered the purpose of the Vignette controls, so I won't repeat them here. The best way to learn how these controls affect a layer is by experimenting with them. Take a few minutes to play with both the image and a solid fill layer. Use a variety of settings. Different combinations produce dramatically different results. Be sure and try some complex gradients.

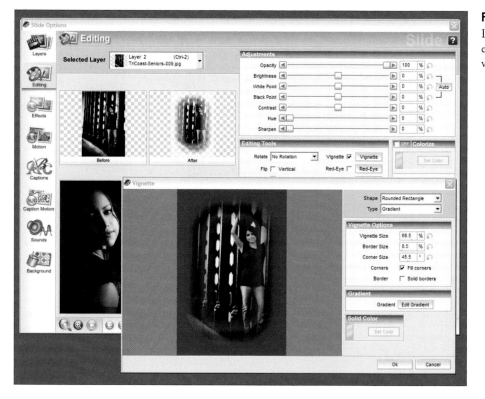

Figure 9.23
Layer 2 with an elaborately bordered vignette.

It's Not a Mask, It's a Vignette

Vignettes can be used to create some interesting effects all by themselves. Our next show has a good example. Open Vignette2.psh and play its single slide in full-screen preview. The portrait of the young woman has edges that darken into a kind of spotlight effect as the picture zooms slightly larger.

At first glance, this looks like a slide that has a mask applied. Examine the layers in the Slide Images and Video window. No masks at all. There are two copies of the same image file. Layer 1 has been vignetted into an oval with transparent edges, as shown in Figure 9.24.

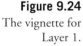

Figure 9.24

The vignette for Layer 1.

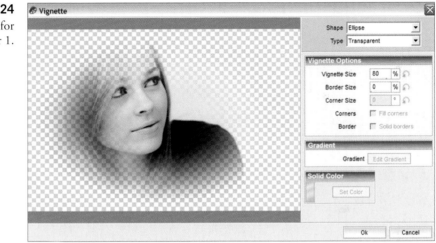

The vignette leaves only the woman's face without some degree of transparency and reduces the outline to an oval. This is accomplished simply by setting the shape to an ellipse and the type to transparent and adjusting the vignette size to 80 percent.

With these settings, the areas that are shown as transparent will let Layer 2 show through during playback. Instead of a mask, we have an overlay. Shift to the Adjustments Effects window and examine the Keyframe Timeline for both layers.

Layer 1 has only the original default pair of keyframes. We can see that no motion effects are applied to this layer, because no motion path is showing in the Preview Area. All of the Adjustments Effects settings for this layer are still set to their default values.

Now scrub the Keyframe Timeline with Layer 1 selected. At the very beginning of play, the corners of the image look bright, but they quickly become dark. Select Layer 2, and then select the first keyframe pair (1 and 2) on the Keyframe Timeline. The picture has a normal brightness with bright corners.

Make sure that the Preview Area is set to "Hide Inactive Layers" using the context-sensitive menu. Select the second pair of keyframes (2 and 3). Your screen should look like the one shown in Figure 9.25.

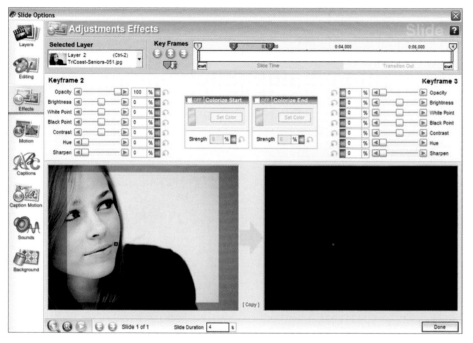

Figure 9.25
The slide with the second pair of keyframes (2 and 3) selected in the Adjustments Effects window.

Note the Opacity settings for this pair of keyframes. The starting point is set to 100 percent, and Keyframe 2 is set to zero. That accounts for the black frame in the right Preview Area. Enable the Show Inactive Layers option in the context-sensitive menu. Layer 1 now floats on top of the black slide background, and Layer 2 is invisible. The crossfade (A/B) transition that follows the slide causes it to fade as time runs out.

A Final Spotlight on Vignettes and Masking

Our next show combines two vignetting effects in one slide: the transparent mask spotlight in one layer and edge softening in another layer. Open Vignette3.psh in Producer. Play the slide in full-screen preview.

There are nine layers in this slide. Layer 1 is an alpha channel (transparency) mask. Layers 2 through 8 are image files, and all are included in its stack. Layer 9 is another image file. Layers 2 through 7 are carefully placed on the left side of the frame. They do not move or have any adjustments applied during their entire time on the screen.

Layers 8 and 9 zoom slightly. Layer 8 is on the left side of the frame, and Layer 9 on the right. Layer 1 creates a spotlight effect over the left side of the frame during the entire playback time.

Open the Slide Images and Video window and select Layer 1, and you can see the masking stack. Scroll down to make Layer 9 visible and select it. Change to the Editing pane, and click on the Vignette button to access the controls (shown in Figure 9.26).

Figure 9.26
Vignetting applied to Layer 9.

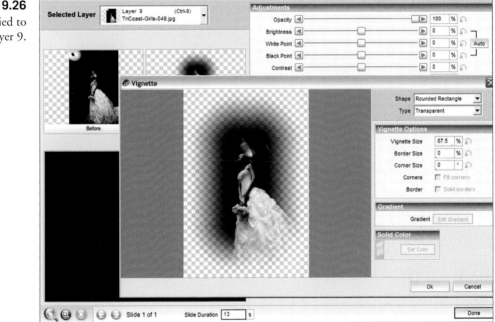

Compare the before and after appearance of Layer 9. Turn off the vignetting and see what that does to the composition. Change to the Motion Effects window. Scrub the Keyframe Timeline. Now the overhead lighting that was obscured in the vignette is a major distraction, and the left side of the picture overlaps the other layers as they are shown during playback. Reenable the vignette and replay the slide. Less can be more with a properly designed vignette.

Now select Layer 1. This has more keyframes defined (a total of 22) than any other layer we have seen so far. All but the last three are placed to make the spotlight travel back and forth over the left side of the frame. The last three deploy a bit of zoom and place the transparent layer over more of the frame.

Figure 9.27 shows the appearance of the window as the Keyframe Timeline is being scrubbed between Keyframes 2 and 3. We can see how the size of Layer 1's vignette's transparency softens the edge of the spotlight effect and Layer 9's allows the two images on the screen to properly blend with each other in the frame.

Figure 9.27
The Motion Effects window, with Layer 1 selected, showing the 22 keyframes defined for the masking spotlight effect.

Take a few moments to examine how the keyframes for the other layers have been arranged and matched to the actions of the mask. Once the basic design was figured out, assigning the keyframes was not that difficult a task. The Copy menu's options are very useful when creating effects that call for a number of repetitive keyframe pairs.

All of the files required to duplicate this slide are included in the collected show files. For more practice with both masking and vignettes, try duplicating the basic design with a different arrangement. One way to gain experience would be to place a different image on the left and rebuild the spotlight effect. Experiment with various borders and work them into a new design.

Chroma Key: More Than Just a Green Screen

Chroma Key is a popular video and motion picture tool that most of us see every day. A portion of a set is painted in a special blue or green color. That color is then made into a transparency mask, and a second scene is dropped behind it as

a second layer. It places the daily weather map behind the reporter and lets computer-generated graphics and actors inhabit the same reality in movies.

Producer lets you define any color on a layer as the Chroma Key index and make that color transparent. That allows you to create a useful mask in two ways: You can locate an existing area of an image that has a single color and define that color as the Chroma Key index. Or you can use a program like Adobe Photoshop, paint the desired portion of the image in a single color, and define that color in Producer as the Chroma Key index.

We are going to use both methods (the Photoshop editing is already completed) in two shows to create several drop-in effects, including a video-clip sky with moving clouds. To save time and effort, most of the design already has been completed. All we have to do is set up the Chroma Key elements. I'll point out some other interesting design elements as we work.

Figure 9.28
This composite image uses Producer's Chroma Key technology to make the right side of the first layer transparent, allowing the right side of the frame to display several images.

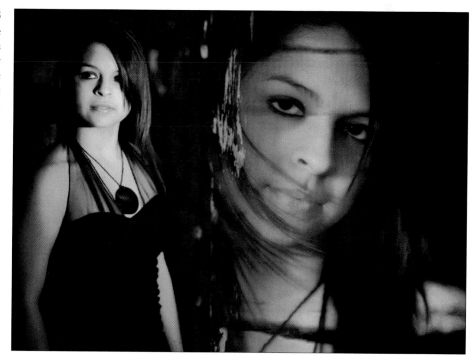

Open the show Chromakey_01.psh in Producer. This show has three slides, each using a Chroma Key effect as part of the design. Open slide 1 in the Slide Images and Video window.

Layer 1 is a high school senior portrait. The young woman is posed on the left side of the image, and the majority of the frame is filled with the blue background behind her. Most of the background is a single shade, with some darker area where

the material is folded. The blue color will be the Chroma Key index. The image is colorized in the Adjustments Effects window. That will not make any difference in the Chroma Key definition. Producer uses the original color values in the source file as the reference point.

Layers 2, 3, and 4 are also senior portraits. These have all been vignetted to blend easily into the composition. You can learn more about this technique by examining the settings used for each in the Editing pane. Timing and motion effects were combined to bring Layers 2, 3, and 4 into the right side of the frame behind the transparent area during playback.

Setting the Chroma Key Index on an Existing Color

Open the Editing pane and select Layer 1. Right now the Preview Area shows the colorized rendition of the image, and the before and after views are about identical and in color. Locate the Key Color option in the Chroma Key Transparency section of the window. Place a check mark in the upper-left corner of the area to enable the feature, and then click its Set Color button. The color that is selected here will be the shade that becomes transparent in the layer.

Click on the Eyedropper tool, located in the upper-left corner of the Set Color dialog box (as shown in Figure 9.29). Before setting the final color, try experimenting a bit. Place the tool on a very dark, even black, portion of the image and

Figure 9.29
Setting the Chroma Key index using the Set Color dialog box's Eyedropper tool.

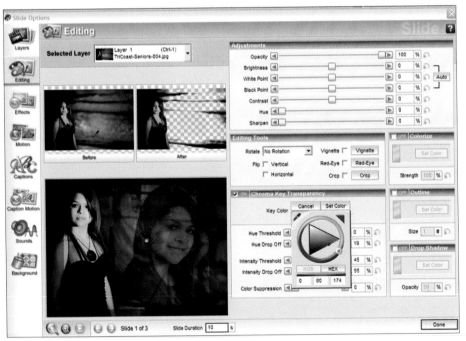

click. Notice the result. Choose the eyedropper again and choose a very light-blue area. Observe how that changes the result. When you choose black, all the true black is removed from the entire image. Chroma Key does not limit its actions to a portion of the layer.

There are no hard-and-fast rules for selecting an index color when you're working with an existing dominant color in a layer. I usually set it by using the Eyedropper and trying several locations. You can't always tell just how the transparency will work, due to slight variations in hue.

In this case, values from about 0, 80, 175 (as shown in Figure 9.29) to 0, 130, 225 will produce an acceptable result. It's also possible to index by using the Eyedropper to get a reasonable amount of transparency and then tweaking the result by adjusting numerical values in the Set Color dialog box.

Adjusting the Effect

Behind the Set Color box are five sensitivity adjustments. Each of these can be used to alter the amount of transparency. (The values were already set for this example.) Let's examine how each operates on this image. The exact results will vary based on the color composition of the image.

You can use these tools on all the other examples in this discussion, but I won't give detailed instructions or settings for the other Chroma Key effects. As you work through the description, move each slider to both ends of the scale. Watch how the remaining bluish tint in the mostly transparent right side of Layer 1 changes. That should give you a good working knowledge of what each control does.

Keep in mind that the relationship between colors and their visual appearance can be complex. The "correct" settings for these controls are the ones that produce the desired results. Also, if the Chroma Key color is set to pure black or white, only the Intensity Threshold and Intensity Drop Off controls will be active. The others would have no effect and so are disabled.

Hue Threshold determines the range of the selected color that will become transparent. Move the slider to 100 percent, and almost all of that shade of blue in the image will be removed. Shift the level to zero, and there will still be notable areas of bluish tones. Once you are finished, set the value back to zero.

Hue Drop Off controls how the edges of a color area are included in the hue threshold effect. The higher the number, the less color is retained. Once you are finished, set the value back to 19.

Intensity Threshold forces very dark areas and very bright areas to become opaque. Set the value back to 45 before continuing.

> **Intensity Drop Off** controls how the edges of an area are included in the intensity threshold effect. Reset the value to 55.

> **Color Suppression** adjustment removes the key color (index color) from the edges of the image. Reset the value to zero when finished.

The purpose of using Chroma Key in a layer is to selectively reveal objects in the layers beneath it. Once you have the index set and have adjusted the other controls, it's a good idea to examine the results in the Slide Images and Video window. Set the preview to Show Inactive Layers. With the Chroma Key Layer enabled, make only one other layer active and see how they work together. Repeat the process for each layer in the show with the Chroma Key Layer in turn.

Try that with this slide. You'll see that portions of the background that had black and white areas that did not match the index color will still be visible. Do they distract from the design? What if a band of black masks the subjects' eyes? You may not have to re-index the Chroma Key: just reposition the layer to show the eyes.

Employing a Traditional Green-Screen Chroma Key

There are two traditional Chroma Key colors in photography and video production that date back to the days of film. They are even named Chroma Key Blue and Chroma Key Green. You can buy backgrounds and paint in the precise hue of each. That's because the colors were engineered to be slightly different from the shades of blue and green generally found in clothing, room décor, and, to a lesser extent, nature.

Open slide 2 in the Editing pane, and select Layer 1. This slide also has a dominant color in the first layer's background, Chroma Key Green. Right now, your slide has Chroma Key Transparency turned on for this layer, but it is set to black. You can see that there is also a vignette defined. The result is a washed-out oval image of a young man sitting on driftwood with a muted green background. In the preview, you can see the sunny beach, the slide's background.

Figure 9.30 shows the Editing and Vignette panes after I adjusted the Chroma Key index. (The vignette is added to help blend the layer with the rest of the design.) Open the Chroma Key Transparency tool's Set Color dialog box and click the Eyedropper anywhere on Layer 1's green background. The result will be immediate.

This image was prepared in Photoshop. The original background did not offer a suitably solid expanse of color for indexing. There are two ways to enable a transparent area with Chroma Key (and you don't have to use a specific color): (1) identify a color that is not present in any area you want to be solid in the slide; and (2) use that color to paint the area in the image that you want to be transparent using a third-party editor like Adobe Photoshop.

Figure 9.30
Layer 1 after adjusting the Chroma Key index to the green color of its background.

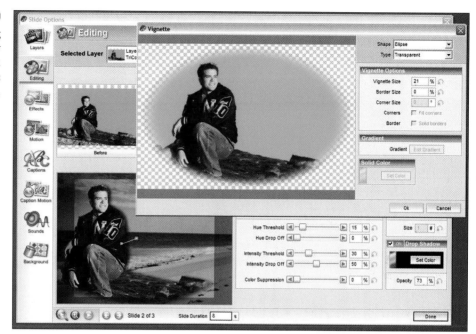

Consider the blue area in Layer 1 in the first slide. We could have obtained a completely transparent area on the right side by painting that portion of the image medium blue in Photoshop, if we wanted to eliminate the bit of existing background left when using a color already in the layer.

Before moving on to the next slide, take a minute to consider the other design elements. How do the motion effects, crops, vignettes, and transitions add to the overall composition? Is there another masking effect that could have given the same result? The best way to master slide show design, as well as the powerful tools in ProShow, is by watching examples and considering both how the design works visually and how you could produce similar results.

Fade to Black Reconsidered

Our third slide demonstrates how our eyes can be fooled by color and shows the benefits of experimentation. Open slide 3 in the Editing pane and select Layer 1. It is an image we have used before, of a young woman posed with her back resting against a wall. This time the picture has been rendered as a blue-toned version in an external editor. An expanse of black has been added to the left of the picture.

If you experimented with black as an index color for the first slide in this show, you might think that using black on this layer would result in a faint, ghostly image as all the dark colors in a dark image are removed. In fact, there is a lot of

blue and a bit of green in this picture. Make sure Layer 1 is selected. Enable Chroma Key Transparency. We don't need the Eyedropper. Set the color to pure black: 0, 0, 0.

The result should look like the example in Figure 9.31. I've enabled the Darken Inactive Layers option in the preview. Notice in the after area how the black area to the left is gone and it looks like there's a vignette around the woman. It's all due to the black around her: there is no vignette defined for this layer.

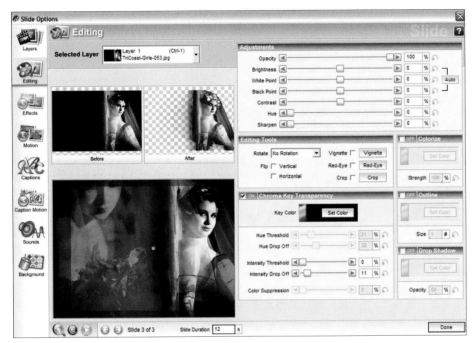

Figure 9.31
Layer 1 after applying the Chroma Key Transparency.

Play the slide and there will be black in the background areas. It is generated by the slide's background. Once again, take time to explore the overall design and note how the different effects are blended together to create the overall result. Consider changing the Chroma Key index color for Layer 1 to white (255, 255, 255) and see what kind of change that makes to the design.

Fast-Moving Clouds: Using Video Clips with Chroma Key

Open the file Chromakey_02.psh. This may take a little longer than average to open because you're loading the video clip used as the second layer in the show's two slides. The clip shows a sky with fast-moving clouds that appear thanks to Chroma Key Transparency.

The first layer in both slides is a picture of a couple sitting close together, with an open sky as part of the background. The shade of blue sky and area covered by clouds is not the same in the two images. That called for different approaches in setting up the Chroma Key.

Working with Video Clips in ProShow

Supported video file formats (see the Photodex Web site for a complete and current listing of file types) are imported as a layer. Drag the file into the Slide List, and the program will do the rest. Keep in mind that large video files use significant system and storage resources.

Open slide 1 in the Slide Images and Video window and select Layer 2. Your screen should look like the one in Figure 9.32. As you can see in the Selected Layer Information at the top-right corner of the window, this layer contains clouds.mov. This is a 13-second video clip with a screen resolution of 640×480. It's also 14MB.

ProShow provides several dedicated tools for tuning a video clip for use in the program, in addition to the regular Editing and Adjustments Effects controls. These changes only affect the way the layer looks in ProShow, in that specific layer. The original source file and the appearance of the file as another layer—even in the same show—are not affected.

Figure 9.32
Layer 2 selected in the Slide Images and Video window.

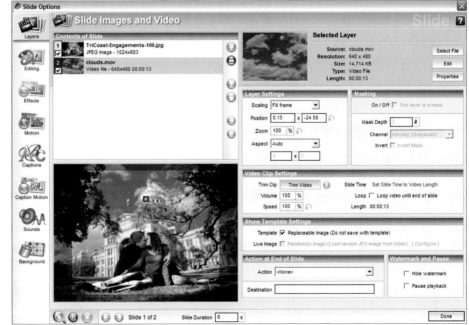

We can position a video clip just like any other layer. This one has been placed in the upper half of the frame. Notice the center marker is about one-fourth of the way down from the top of the frame.

Examine the Video Clip Settings section of the window. Sliders let us adjust the volume of any sound during playback and adjust the speed at which the clip is played. If you click on Set Slide Time to Video Length, the slide time will be adjusted to match the run time of the clip. You can also loop a short clip so that it repeats until the slide has finished its full playback.

Click on the Trim Video button, and the Trim Video Clip window shown in Figure 9.33 opens. We are not going to make any edits; just examine the controls. This is not a full-fledged video editor.

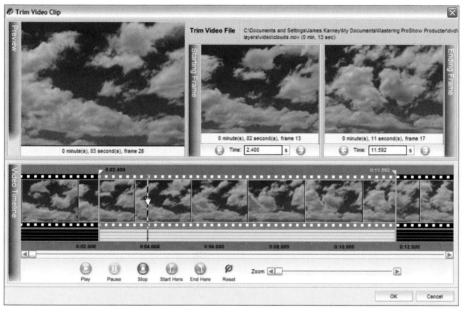

Figure 9.33
The video clip trimmer.

The Trim Video Clip window lets you examine a clip, adjust the length, and set precise starting and ending points. The interface works like the Edit Fades and Timing window. In the figure, the start and end segments have been trimmed by dragging the markers in from the sides, just like we did when working with soundtracks. The clip is not actually trimmed in this show, so your window won't show the edits you see in the figure.

Setting Up Slide 1's Chroma Key Transparency

Close the trimmer. Scrub the Slide List and preview slide 1. The sky in this layer has been made transparent using the Chroma Key tool's Set Color eyedropper. The Layer 1 image sky is mostly blue, so indexing this way works very well. The way the couple is framed by the trees and the motion effect help draw the eye to them. The movement of the clouds adds impact without detracting from the man and woman as the center of attention.

Did you notice the two objects that did not completely disappear in the sky area to the left of the Capitol Dome? They are the U.S. flag and the state flag of Texas. Only the blue portions of their designs were made transparent, so they are still visible. Scrub the slide again and pay attention to the skylight on the left side of the building under the tree and the windows of the dome and main portion of the building. The blue areas have been made transparent.

Such artifacts are common with Chroma Key effects. Photographers and motion picture crews have to be very careful when lighting with Chroma Key backgrounds and make sure that the color is not reflected onto actors, clothing, or the set in a way that would reflect enough of the index color to cause telltale fringing.

Open slide 1 in the Editing pane and select Layer 1 (shown in Figure 9.34). You can see how effective the Chroma Key is by comparing the before and after samples. For a closer look, switch between the Show Inactive Layers and Hide Inactive Layers options in the Preview window.

Figure 9.34
Fine-tuning the Chroma Key settings.

This slide offers a good opportunity to see how you can use the Chroma Key Transparency's fine-tuning controls to modify an image. They have been tweaked to improve the effect. (Keep in mind that each image and color combination is different.) Let's push them a bit and see what happens. Set the preview to Hide Inactive Layers so we can focus on the changes in just this layer.

There is a very faint light-blue cast in the sky, and there is some blue visible in the girl's shirt and the jeans both people are wearing. The hue threshold is set at zero. Move its slider from the current zero up to 51 percent. The faint blue in the sky disappears. So does most of the color in her shirt—and part of the tree above them and the top portions of the building are gone! Return the value to zero.

The hue drop off is set at 10 percent. Move it down to zero, note the changes, and then run it up to 45 and then 100 percent. Dropping the value quickly eliminated the transparency. Raising the level to 45 percent gives just about the same result as increasing the hue threshold to 51 percent. Set the slider back to 10 percent.

The intensity threshold is at 35 percent. Drop it to zero, and the dark blues get very dark. Raise it to 100 percent, and the jeans become white and his shirt takes on a patterned appearance. Return this slider to 35 percent.

Move the Intensity Drop Off control back and forth and pay attention to the change in the color of the jeans. Move the Color Suppression slider back and forth and observe how the color of the woman's shirt changes.

Slide 2: The Same Clouds, but Not the Same Sky

Slide 2 uses the same video file, and the clouds look almost the same. The first layer is another couple seated on a bench. It's tempting to think the design uses the same blue-indexed Chroma Key. It doesn't. Open the Editing pane. The color has been set to pure white (shown in Figure 9.35).

Play the preview and pay attention to the clouds low in the sky, on the left side of the bush. There is a portion of the sky that does not move. The sky in Layer 1 is washed out to pure white in the upper third of the picture. The sky gets denser lower down. There is also some color in the woman's white coat, but it is not pure white.

All of the adjustments for the Chroma Key, except the intensity threshold and drop off, are disabled. That's because all of the others are related to the attributes of the index color. Pure white and pure black have no color values, so only the intensity-related values can be modified.

Adjust the intensity threshold to 100 percent, and the layer will shift in intensity until it becomes white. Adjust the intensity drop off, and you can see how the control shifts intensity at the edges of the effect.

Figure 9.35
This slide didn't have a blue sky before the designer added one using Chroma Key Transparency.

Masking, vignettes, and Chroma Key Transparency are three tools that offer the ability to link and blend layers and bring a three-dimensional quality to your shows and motion effects.

Up Next

Producer's advanced toolkit gives you the ability to create show templates complete with all the effects you might want to use. Though they initially contain empty layers, you can easily populate the templates with new images. Producer also can create shows automatically using files stored in a designated folder. Use a camera with either a wireless or tethered connection to fill the folder, and the software will add new slides to the show as you make pictures.

10

Templates and Live Shows

Producer templates and live shows are two features that let you speed up workflow and add a new dimension to your productions. Templates are shows that have been saved with all their slides, soundtracks, layers, and special effects, but the template files' layers have been converted to placeholders. If you repopulate the layers with new images, you have a new show. Live shows automatically populate the slides in a show with content from a "hot folder." When you add new supported images to the designated folder, they are automatically added to the show.

Both features are available only in Producer, so that's the version we'll be using in this chapter. All of the files needed for the hands-on exercises are in the Chapter 10 folder on the companion CD-ROM. The content in this chapter requires a working knowledge of the ProShow user interface as well as the ability to work with slides and layers.

Working with Templates

A template is a Producer file that has been converted to a template file. The basic process is simple and handled by the program. Open the Show menu and choose the Show Templates/Save as Template option. Producer removes all the existing files from the slide layers, leaving special placeholder-type layers. You can repopulate these layers by dragging new files onto the placeholders.

To save you time, I've already assembled a simple show to explore template technology. Open show_for_template01.psh in Producer. It has four copies of a slide we used in Chapter 8. Slide 2 still has both the adjustments and motion effects unchanged. The other three have only the motion effects. The color of the background has been set to a different hue for each one, so it will be easy to see when the slide changes.

Once the show is loaded, open the Slide Images and Video window. The first step in converting a show into a template is to let Producer know what layers have content that needs to be removed and which ones should keep the referenced source file. That's done by checking the Replaceable Image option in the Show Template Settings section of the window. See Figure 10.1.

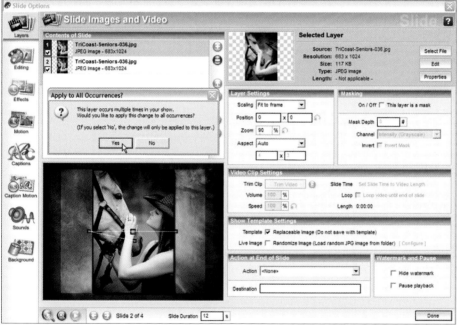

Figure 10.1
Marking the reusable layers in the Slide Images and Video window.

Locate the Show Template Settings section, the second section up from the bottom-right corner of the window. Place a check mark in the top listing. It says "Replaceable Image (Do not save with template)." A dialog box will open asking if you want to apply this to all layers in the show. Click the Yes button. Now open slide 2 in the same window and uncheck Layer 2 as a reusable image. Do not choose to apply this setting to all layers. We want all of the layers—except Layer 2 on slide 2—to be empty in the template.

> **Tip**
>
> Setting all layers as replaceable and then unchecking that option for the layers with content you want to keep in the show is usually the quickest approach when tagging layers for a template.

Creating and Saving and Templates

Now it's time to create the template file. A template is not just another PSH show file. It is a special Photodex file type that is saved in the program's Templates folder. We use special file-management tools built into Producer to manage templates. Open the Show menu and place your mouse cursor over the Show Templates option. Now click on the Save as Template option in the secondary menu, as shown in Figure 10.2.

Figure 10.2
Saving the current show as a template.

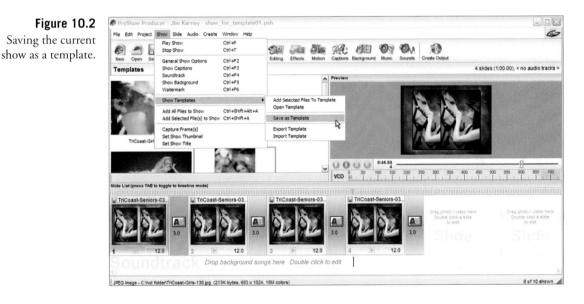

If you have not yet saved a show when you choose this option, a warning will appear asking you to save the file as a PSH file first. If the file has been saved, a dialog box will open notifying you that all show content will be removed during the process. You should see that warning now. Click OK.

This opens the Save Show Template dialog box, like the one in Figure 10.3. There are already several templates listed in the Available Templates column on the left side of the window. All but Template 1 are included with Producer and come installed. Template 1 is new, the one we are saving now. I already have added it to my collection of templates.

Figure 10.3
Adding a description
in the Save Show
Template dialog box.

You can give a template a meaningful name; include spaces to make the title more readable. Then you can add a description with notes on its use and any reminders about tips on customization. Add any remarks you wish, and then click on the Save button. The new file will be created and added to the list.

A quick glance at the ProShow title bar at the top of the program window and the Slide List shows that the operation was a success. The title bar lists "Templates*" where the name of the show file is usually displayed. The majority of the layers in the Slide List are now medium-gray boxes. Notice that they are no longer cropped to the original dimensions. They are now placeholders and will be resized to fit a new file whenever it is added.

Slide 2, shown in Figure 10.4, still has one picture visible in Layer 2, on the right side of the frame underneath Layer 1. That's because the check box for making it a reusable layer was not enabled when we saved the template.

Adding Content to Template Layers

Gray template layers are a special type of content container. You can drag and drop a file directly onto such a layer, even if another file is already there. The layer will be sized to match the aspect ratio of the new arrival. Take care where you drop a file if there is more than one layer on a slide. If your dragged file is hovering over one layer more than another when you drop it, the file will end up on the layer with more shared real estate. That may not be the intended destination.

Open the Folder window and navigate to the hot folder—labeled "Hot Folder." (It is in the Chapter 10 folder on the CD-ROM. Place it on your hard drive for faster performance.) There are eight image files in that folder. These are the ones you see as thumbnails in Figure 10.4. Drop in the first seven to populate the open layers in the template. Layer 2 on slide 2 already has an image in place.

Figure 10.4 The Producer window with the template loaded.

When you're finished, all but the image of the woman in front of the brick wall, TriCoast-Seniors-055.jpg, should have green check marks in front of their thumbnails and be included in the show. All of the layers have been adjusted to show the entire image and all keyframes. Motion and adjustments effects are assigned.

You can also populate a template by selecting thumbnails or filenames from a list of files and then choosing the Add Selected Files option in the Show Templates menu.

Template Planning and Workflow

Scrub the Slide List and preview the show. The bride lying on the haystack in slide 3 has less than ideal color during playback, which becomes obvious in the preview shown in Figure 10.5. That's because the slide's adjustments were originally set to make colorized images look toned. The other layer in this slide has its original image still in place.

I constructed this slide to illustrate a point. When designing slides for templates, be careful to plan effects that will work with the files you will use in the future. It's usually easier to add a few effects once the new images are placed than to rework the victims of bad settings.

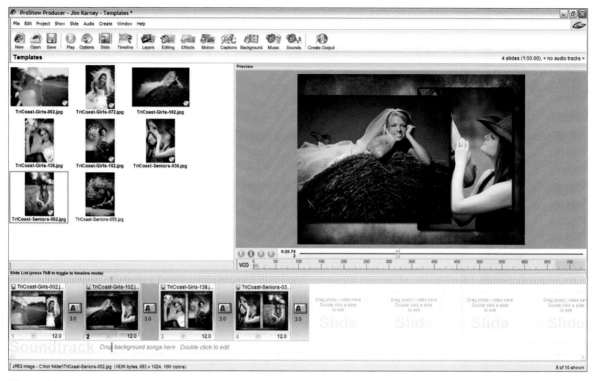

Figure 10.5 This bride's skin tone demonstrates why it's usually best to limit effects in template slides to ones that will work with the images you plan to use in future shows.

When creating the show for the template, I removed the adjustments effects and then copied the modified slide three times. I made the unchanged version slide 2. Over the years, I've created a Producer project with shows that have my best slides in categories. When it's time to design a new template, it's easy for me to build a new show by copying the ones I want into a new show and then saving it as a template.

Importing and Exporting Templates

A show file can't be used as a template until it has been converted. (The original show will still be preserved.) To have it show up in the list of available templates, you have to export it, and to use it on another computer, you have to import it into that copy of Producer. Until you export them, templates are stored in a temporary folder.

Exporting and importing are easy. Both commands are located in the Show/Show Templates menu. The Export window looks just like the Save Show Template window but with a different label. Select the template to be exported. Make any

desired modifications in the Name and Description sections and click on the Export button.

The act of exporting makes a registered copy in the Program Files\Photodex\ ProShowProducer directory on your hard drive. Template files have a .pst extension. They may display an Outlook icon in Windows Explorer if you have a copy of Microsoft Outlook on your computer.

Windows Explorer will open when you choose to import a template. Navigate to the folder that contains the desired file and select it. Click on the Open button, and the template will be added to the Template List and can be used with that copy of Producer.

Modifying and Using Templates

An open template works almost exactly like a regular Producer show. You have access to all of the program tools and special effects. The only functional difference is your ability to drop a new file onto a layer that already has a file and have the new item replace the old one.

Open slide 1 in the Motion Effects window. Scrub the Keyframe Timeline and watch how the layers work together and fit within the frame. Layer 1's image is too wide, covering up too much of the other layer during play and not fitting well in the frame. See Figure 10.6.

Figure 10.6

You have access to all of Producer's editing and effects tools when editing a template to design a new show.

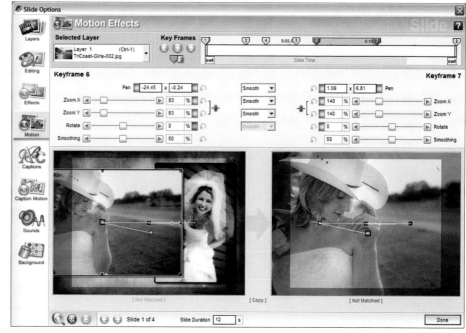

All you have to do to fix this slide is crop and size the layer. It is actually the same one we used in the original show earlier in the book. Templates are a speedy way to assemble a show. The more complex an individual slide, the more tweaking it will require. Planning your content will streamline the process. When you have the new show the way you want it, output it and save it just like any other show. The original template is untouched and available to use again.

Now let's look at another way to use templates. You can combine them with Producer's live show capabilities to automatically generate shows containing all the files in a folder—even adding new ones as they are saved in the target location.

Producing Live Shows

Live shows are Producer's premier party trick, letting guests see almost real-time images taken during an event. They are a natural fit for occasions like wedding receptions, proms, and awards banquets. Photographers with a wireless or tethered camera can transmit images right to the folder for automatic addition to the show as it is running.

Setting Up a Basic Live Show

Simple live shows can consist of a single slide and still show every image in the target folder. Live shows can also have mixed content, including slides with both regular and live layers. Any layer in a slide can be designated as a Live Image layer. Let's start by creating a show with a single slide and the same eight images we used in the template exercise.

Launch Producer. In the Folder window, navigate to the hot folder. Drag the first image into the slide 1 position in the Slide List. Now we have to enable some settings so that the program will play the show properly. As it is now, only this one image will play before the show stops.

Open the Slide Images and Video window. In the Show Template Settings section, click and enable the Live Image option. This designates the layer as a container, similar to the way a layer works in a template. The content isn't fixed to show a specific file, but you still have to tell it when to find the files to be included.

Notice I didn't say *which* files, just where to find them. When a live show plays, the slides in the show will fill any layer marked as a live image with the next file in the designated folder. Here we have one slide with one layer.

We have to tell Producer where to get the image for this layer. This is always a folder that is accessible from the host computer that will run the show. We also have to define how the show operates and the sequence in which the files are displayed. Click on the word *Configure* and open the Random Image Settings dialog box (shown in Figure 10.7). This is where you set the options.

Figure 10.7
The Slide Images and Video window with the Random Image Settings dialog box on top.

Preview or Executable?

Live show layers can draw files from any storage device that displays folders on the host PC. There are two ways to run the show. You can load it into ProShow and play it from within the program in Preview mode. Or you can save it as an executable file and play it on any Windows PC capable of running Photodex Presenter.

If you have a computer with Producer loaded, then you can use either method. To run the show on any other Windows PC, you'll have to go the executable route. Keep in mind that these shows are actually played through Photodex Presenter.

Any folder can be used as a hot folder, and it can be empty when you select it. But there must be files in it at the time the show is run for it to work. If you have not already copied the hot folder in the CD-ROM's Chapter 10 folder to your hard drive, do so now. Click on the Browse button for the Preview option. When Windows Explorer opens, navigate to the hot folder, select it, and then click OK. Use the same process for the executable option.

You only have to set a location for the mode you actually plan to use. These do not have to be set to the same folder. Setting both and using a consistent folder name makes it easier to set up a show file to handle both the preview and exported, executable live shows. You can create a special folder for a specific show or have one folder that you repopulate with images for each live show.

Playback Options

Use the Order option to choose the sequence in which the files in the hot folder will be added to the show. "Play in random order" will add them in no set order, "Newest" will select files based on the time and date the file was created, and "In order they were added" will display them based on the time they were added to the hot folder. Choose "Play in random order" for this show.

With the Orientation setting enabled, Producer will check for EXIF data to determine whether a file should be displayed with landscape or portrait orientation for that layer. Leave this option unchecked.

You can use the Include setting to add only newer files, excluding files that were created before the cutoff point. Leave this option unchecked. Click the OK button once you have all the options set.

Creating a Loop Condition and Playing the Show in Preview Mode

Live shows have layers with variable content. The name of the associated file is set (and the file added to the show) as the slide is rendered. Right now, we have only one slide, so our show will be one slide long. We want the show to play every file in the folder and repeat the process until we tell it to stop. In effect, we are setting up an endless loop. If new files are added to the folder, they will be added to the show based on the conditions named in the Order and the Include option settings.

Now we need to have the slide repeat and load a new file each time it plays to get the desired result. That's easy to do in Producer by setting an action. Open the Action drop-down menu in the Action at End of Slide section of the Slide Images and Video window. Choose the Jump to Slide option and then type the number 1 in the Destination field located immediately below the Action menu. Click the window's Done button when finished.

Press Control-P to run the show as a preview. If it opens inside ProShow, right-click in the Preview Area and choose the Full Screen option from the context-sensitive menu. All of the images will play in random order until you press the Escape key to exit the preview.

Creating an Executable Live Show

The preview method is simple to operate and great for testing a live show or running it under direct supervision. It also requires that you have a copy of Producer running. That means, unfortunately, that you can't share it and that you'll need more system resources than if you were just running Photodex Presenter.

When working with an executable live show, all you need is the executable file and a hot folder with the same name and drive location as the images for the show. The executable has a built-in run-time copy of Presenter and all the proper settings for running the show.

The process is simple and the same as for creating any other executable with ProShow. Select the Executable option from the Create menu. Enable any branding, menu, and desired output options. (These are covered in detail in the next two chapters.) Then click on the Create button. When the rendering process is complete, the new file will be available in the location you specified during creation.

You can play executable live shows anytime by simply making sure the hot folder is in the proper location and double-clicking on the file icon.

Creating Advanced Live Shows with Templates

Our first live show was a very simple production with a single slide. Live show technology can be used to create complex productions, and templates can speed the process. Still, you have to take into consideration the types of images you'll play in the show. Live shows play any image placed in the hot folder. We've already seen the need to be careful when a slide contains adjustments effects. Layout and motion effects have to be planned, too. Let's build a more complex show and look more closely at the fine points of live show design.

In Producer, use the Show/Template/Import Template menu and import the Template LS template from the Chapter 10 folder. There are four slides in this template. The first is a basic title slide. There are two slides with a pair of template layers, and one has a single template layer.

Setting Fixed Slides and Content

The basic design workflow for a full-fledged live show is very much like the one for any other production. A template design isn't a polished product. It is the starting point in a customization process. The captions are generic. They have to be edited to match the needs of this specific show. The slides may not be in the proper order or right quantity and may need adjustments to effects or layout.

Live shows often include slides that have layers with set images—ones that don't change each time the show is played. These need to be configured with the proper files and settings. Normally, at this point in the process, I arrange the fixed content for the show. Since we aren't actually designing a complete production, keep the existing design as is and move on to the next step.

Adjusting for Vertical and Horizontal Composition

The template's slides containing image layers are the foundation of our show. Right now, two of these slides are designed to work best with horizontally cropped images. Most of the pictures in the collection are vertical. That may cause problems, depending on the layout and the Fill/Fit to Frame settings. To see what I mean, drag a vertical image into each available frame in slides 2, 3, and 4. Each one will produce a slightly different result because of the Layout and Layer settings.

Slide 2, shown in Figure 10.8, looks fine. The title and image areas are well proportioned and balanced. The result looks professional. Double-click on the slide in the Slide List and examine the Slide Images and Video window. Layer 2, the one with the image, is set to scale to Fit the Frame.

Open slide 3 in the same window (Figure 10.9). Here the result is not as pleasing. Layer 3 (the one on the top) fills too much of the frame, and part of it is

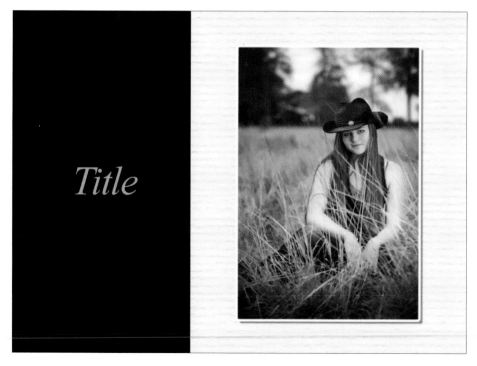

Figure 10.8
The layout for slide 2 is well suited to displaying vertical images.

Figure 10.9

The two vertical images in Layer 3 don't fit as well as the single image in Figure 10.8 did.

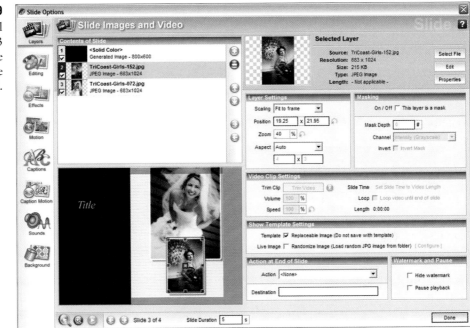

covered by Layer 2 (the one on the bottom), which is too small. Layer 2 is set to Fit to Frame. The smaller size was generated by Producer so that it would fit vertically in its portion of the frame. Layer 3 is larger because it has been scaled to Fill to Frame.

Close the window and replace the vertical images with the two horizontal images. Since this is a template, we can just drag an image over an existing layer to replace the contents. Figure 10.10 shows the results of the completed revision.

The pictures aren't exactly the same size, but they fill the frame better. Open the Slide Images and Video window and set the Scaling option for Layer 3 to Fit to Frame. That makes both layers the same size and forces the pictures to stay fully within the safe zone. Now repopulate both layers with vertical images. They are a bit smaller, but they fit the slide and do not overlap.

Drag one of the horizontal pictures into slide 2. See how it looks too small? This is the same problem we had with the lower vertical image in slide 3. Simple full-frame slides like the one in the first live show work fine with both horizontal and vertical pictures. Slides with multiple or constrained layers often will not.

It's a good idea to test and preview slides with a mix of horizontal and vertical images since we can designate only one folder for a working live show. Layers and slides that don't work well with both should be redesigned or removed before running the show. The same is true for any motion and adjustments effects used in the production.

Figure 10.10
Slide 3 after replacing
the layers with
horizontal images.

Setting the Live Show Options and Placing the Content

Once all the slides are tested, it's time to set (or double-check) the Live Show options and arrange the content. Open the first slide in the Slide Images and Video window. Check the scale and Live Show options. Select each slide in turn and check/set each layer. Make sure the last slide has been set to jump back to slide 2—the first slide after the title slide.

Close the window and return to the main program. Make sure that an image has been added to each image layer. Live shows will display only layers that have been "primed" with an image file.

At this stage, we have what I call a working template. Everything is loaded and ready to run. Now it's time to extend the design and add a soundtrack. Copy and paste slides with images to create a show that has a bit more variety than just three slides that repeat in the same order. (Normally my designs have more than three slides. This is just an exercise example.) Figure 10.11 shows the finished product with its 12 slides.

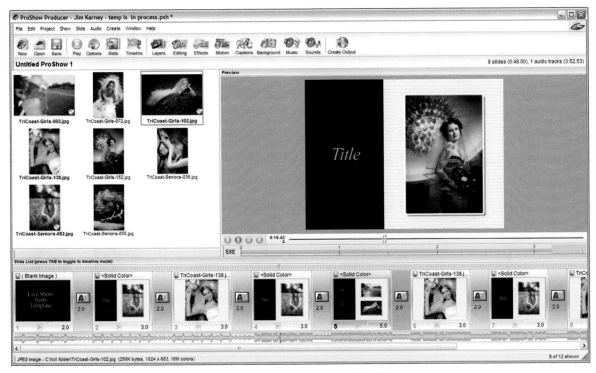

Figure 10.11 The live show ready for preview or export to an executable file.

Now it's time to test the show. Run it as a preview and pay attention to how the slides progress. Watch for any effects that don't work well and for images that tend to repeat too often. Correct any problems and repeat the preview. Once everything is in order, save the show. If you are making an executable version, it's ready to be rendered and exported.

The Camera Connection

If your camera can write files directly to a computer, you can add images to a live show in real time. Advanced digital SLR cameras like the Nikon D3 and D300 (shown in Figure 10.12) offer both wireless and tethered connections. A wireless adapter and a live show let a photographer work a crowd, where using a cord would be dangerous. Add a projector or big-screen TV, and your production will be a real attraction.

It's a good idea to field-test the entire process before promising a client a real-time show at a major event. I even advise clients that we can't promise a wireless connection until the actual day. There might be interference from other electronics at the site. Even with those concerns, this is a really neat feature.

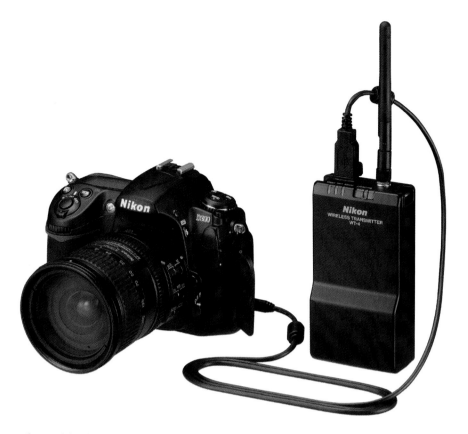

If possible, have an assistant monitoring the pictures as they are captured. The photographer might need to test a setting and produce a wonderful picture of his show, or a guest might decide to do something untoward just as the shutter is released.

The best insurance is a trained pair of eyes and a holding folder. The images go there first to be checked, and then the ones that pass inspection are added to the hot folder for the show. The software that works with the camera to provide remote control usually allows you to set options for the storage location, processing of the image file, and the action the computer should take when a file is written to the target folder. (See Figure 10.13.)

It is important to double-check the camera-control software before running a live show that depends on transmitted pictures. I make sure that the White Balance adjustment renders clean whites and pleasing skin tones. Make sure that no image editors are set to open with each new file. The memory and CPU resources they use would slow down the live show.

Figure 10.13

Nikon Camera
Control Pro software
connecting a Nikon
D300 for use with a
live show.

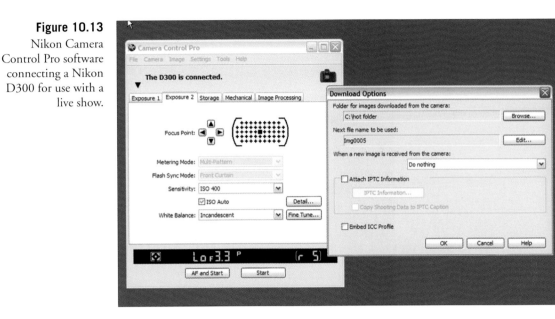

Once the camera is connected and the software is running, take a few pictures to test the lighting conditions and the show itself. Watch for good exposures, smooth play, and proper layout with any effects and cropping. If you don't always enable the Orientation option for live shows (which uses EXIF data to determine each picture's proper orientation), be sure to turn it on before running or exporting the show.

Up Next

Adding a professional interface and branding increases ease of use and the professional appearance of a production. The next chapter shows how to design a user interface that does both, from the screen design and options to video clips and credits that mark the show's beginning and end.

Creating Menus and Branding Shows

It's time to turn our attention to the final product. ProShow lets us create shows in a variety of output formats. Most formats let us use menus, icons, thumbnails, and "About This Show" clips to provide information and a user interface to the viewer. Setting up the menu is one of the first steps in the output process. ProShow provides a complete menu-authoring system with an extensive array of customization features to polish our shows and provide a professional user interface for viewers.

The tools are broken into two major groups: menu authoring and branding. The menu tools include features for designing layouts and themes, combining several shows on one disc, and adding interactivity. ProShow's branding capability lets you personalize a production with logos, custom icons, and loading announcements. It also includes options for copy protection and watermarking.

We'll explore each in turn. Some options are available only in Producer. (See the detailed comparison of features in ProShow's versions in Appendix A.) Adding multiple show files to a menu means working in Project mode. To keep things simple, I've created a project with two shows in Producer to work with in these exercises. (We'll be using Producer throughout this chapter.) Please launch it. Then open the Project menu, choose Load Project, and select the file named, appropriately, Menu Project. It is in the Chapter 11 folder on the CD-ROM. Place that folder on your C drive for the best performance and to make sure ProShow can locate all the files used in the examples.

Designing Professional Menus and Adding Interactivity

The menu system included with a multimedia show is a user interface that allows the user to select the program, choose options, and view information about the title and its author. A good-looking and well-organized user interface is part of a professional slide show. The Photodex development team has worked hard to provide an easy way for ProShow users to create attractive and functional menus for productions.

That includes collections of generic menus, backgrounds, and themes you can customize for your projects. Some come with the program; others are available online from ProShow. The collections are updated and expanded periodically.

To obtain bonus content, open the Create menu and choose the Create DVD option. This opens the Create DVD Disc dialog box. Clicking on the blue Download More Menus text launches the Download Content dialog box, shown in Figure 11.1. (You will need an Internet connection to actually download the materials, but you can continue this exercise without them.) Select the items you like, and then click on the Install Selected button. When the process is complete,

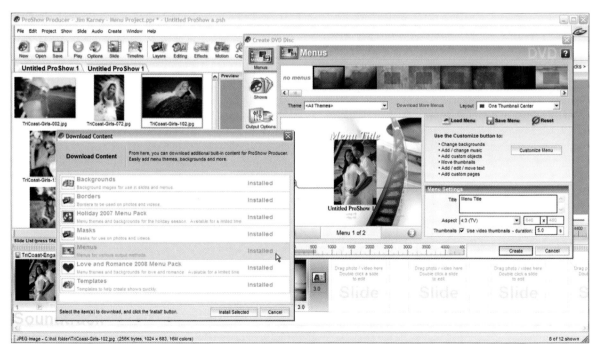

Figure 11.1 Producer with the Create DVD Disc and Download Content dialog boxes open.

the listing will be labeled as installed, as you see in the figure. Click the OK button to close the window once the operation is complete.

The Create DVD Disc window (one of several Create Output windows) should still be open if you have been following along. It has seven icons on the left side. Clicking on one reveals a different set of tools. We'll focus on the Menus and Branding sections in this chapter; these sections are basically the same for all output formats that support these features. Not all output types support all options, such as full menus. In these cases, some options will be disabled.

Make sure the Menus tab is selected and that the word *Menus* is listed as the window's title. I'll refer to this mode as the Menus window from now on. The Theme drop-down menu under the row of thumbnails should be set to <All Themes>, and the Layout drop-down to One Thumbnail Center, as shown in Figure 11.2. Click on the Load Menu option underneath the Layout drop-down menu. Then navigate to the Chapter 11 folder and select the menuBL.mnu file. We are going to build a custom menu as we tour the options and controls.

Figure 11.2
The Menus window
in Producer.

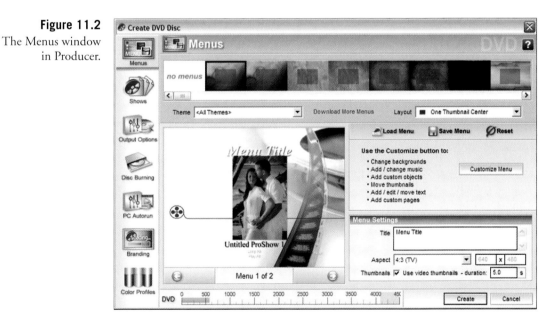

The Menus Window

Menus can contain more than one page, and they are divided into two components: a layout and a theme. ProShow allows users to save and reuse menus, layouts, and themes. The layout details the positions of show icons and any navigation objects on menu pages. The theme controls the options for adjusting

the appearance of the menu, including colors, captions settings, images, music, and the pages themselves. You can save themes, layouts, and menus independently of each other within ProShow. The Menus window is where you choose a predefined basic menu or load an existing custom menu. It can also be used to set the menu title or a menu's aspect ratio and enable or disable video thumbnails.

The row of thumbnails just under the window's title shows an array of predefined menus. The two drop-down menus just beneath the thumbnails can be used to sort the array to show specific combinations of themes and layouts. Below the Layout drop-down menu are buttons for loading a custom menu, as well as for saving and resetting the current menu.

Each menu page has a background and can contain captions (both static and interactive), images, and video clips and make use of layers. You can use the same editing tools found in the main program to adjust the appearance of layers. Keyframes are supports, so you can't use adjustments or motion effects. All of the elements can be moved or scaled, and all but the background layer can be given interactive assignments like loading a show, jumping to a slide, or opening a remote Web site.

Menus with Multiple Shows

If you want to create output that contains more than one show, you have to create a project. You can do that in the Project menu or use the features of the Shows window. (If you exit ProShow without saving the resulting project, the additional show information, and its related menu options, will be lost. ProShow will prompt you to save the project when you try to exit.)

Click on the Shows icon on the left panel. This shifts you into a different mode; the window label now reads "Shows," and you can see a new set of tools, shown in Figure 11.3. There are two shows listed in the Included Shows section. These are drawn from the current project's shows. You have to have a project open to create menus and output with multiple shows, and the shows you want to use have to be in the project.

You can use the Add and Delete buttons at the bottom of the list of shows to add and remove shows from the current project. Add one, and the show's title will appear in the tabbed list in the main ProShow window. Delete it, and the title will disappear. Use the up and down arrow keys to change the order of the shows. The principal show should be first on the list.

This window also lets you change the show title and thumbnail and set up an intro show to play before the menu for the main show appears. We'll cover intro shows with branding later in this chapter. The next chapter will cover details for the output options and disc burning.

Figure 11.3
The Shows window displays the shows contained in the current project and is used to set thumbnails and define an intro show.

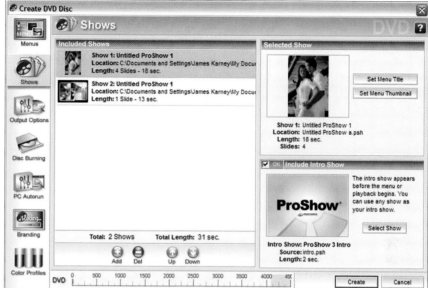

Customizing ProShow Menus

Return to the Menus window by clicking on the Menus icon, and then click on the Customize Menu button on the right side of the Menus window. If you didn't load the menu file, your button may be inactive. To access the menu-customization features, you must have a theme or menu enabled. We already did that by loading a menu file.

The Customize Menu window is where you create and modify menus, themes, and layers. Our tour (and menu-design exercise) starts with the Pages tab. If it is not open, click on the Pages icon. This opens the Menu Pages pane (see Figure 11.4). We'll just refer to it as the Pages pane. You should be familiar with the basic ProShow interface and buttons by now, so I won't give detailed instructions on how to open and close items, access common program features, or operate basic tool controls. Your screen may differ slightly from Figure 11.4. I've worked ahead a bit.

This menu design calls for a single page for each show. I have a project loaded with two shows, so there are two pages. If you added another show to the project, ProShow would generate a new page with the same background layer and caption structure. If you look closely in the lower right-hand corner of the Preview Area, you'll notice a small caption that says "Next." This lets the viewer navigate between the windows. Click on the second page's thumbnail at the top of the window. The second page has a caption reading "Previous" linked to this page in the lower-left corner.

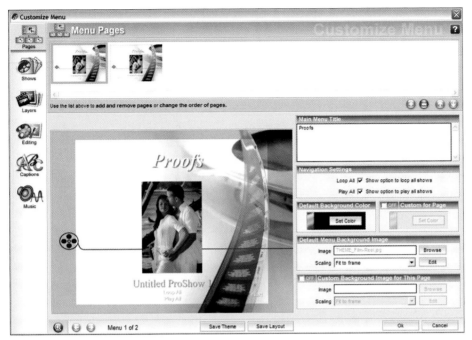

Figure 11.4
The Menu Pages pane
open in the
Customize Menu
window.

Below the display list of pages, on the right, is the Main Menu Title section. Select the text in the box and change it to read "Proofs" (without the quotation marks). As you type, the main caption on both pages shows the new title.

The Navigation Settings section of the window has two check boxes. These enable the two interactive captions shown at the bottom center of each page. Uncheck both. We are going to convert this menu to a single-page format during this exercise. These are global settings. Click on the second page to remove them there as well.

Beneath the Navigation settings are the Default Background Color section and Custom for Page sections. Use these when a theme or page does not have a background layer to set the color.

We do have a Default Menu Background Image defined, the most common procedure for ProShow menus. Checking the box beside Custom Background Image for This Page lets you override the global default.

There are two important buttons in the bottom center of the window to save the current layout and theme for future use. They add the names to the list of designs available on the Menus page.

Select the second page and click on the red Remove button on the right side of the window under the page thumbnails. You won't need it in this design.

Setting the Show Titles and Thumbnails

You may have noticed that both the shows in our project are called Untitled ProShow 1. That's because both had that name set in the show options. It's not very functional as a menu option. Click on the Shows icon to open the Shows for Menu pane (see Figure 11.5). You can use the Add and Delete buttons and the Up and Down buttons to change the shows in your project, just as you can in the Shows window, which you can access in the various Create Output windows. Being able to change the show order either way is merely a convenience. The Shows for Menu pane is not a duplication of that the Create window. The Shows for Menu window has the controls for managing the appearance of the show title and thumbnail for the menus.

Figure 11.5
The Shows for Menu pane after the adjustments were made to the show titles (with the Title dialog box still showing).

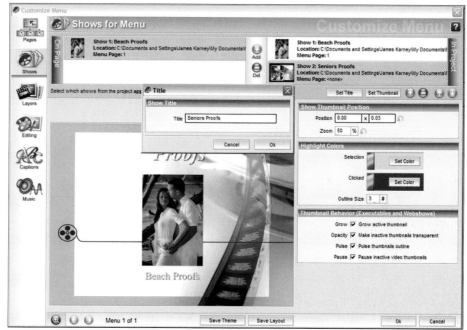

Click on the first show listing on the upper-right side of the window, the one with the couple on the beach. Now click on the Set Title button. A dialog box will open. Change the text in the entry area to read "Beach Proofs," and click OK. Select the second show and repeat the process, changing the text to read "Seniors Proofs," as shown in the figure. The caption under the thumbnail now reads "Beach Proofs." That is the show title. The other show does not have a title on the menu yet.

The show thumbnail can be either a slide from the show or an image file. The first show here uses a file, and the second uses a slide. Click on the Set Thumbnail button to access the dialog box shown in Figure 11.6. Choose the Image from File

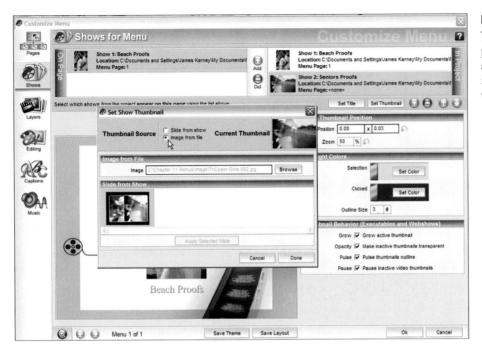

Figure 11.6
The Shows for Menu pane after the adjustments were made in the Menus window.

option. Navigate to the Images subfolder in your Chapter 11 folder on the CD-ROM. Locate TriCoast Seniors-002 and select it. Click OK.

You can use the Zoom and Position controls to adjust the selected image in the Preview Area. We will save that task for later (and use a different window). You can make the show titles and other text elements on a page interactive, like links on a Web page. When the user hovers a mouse over an active caption, the caption gets an outline colored to match the Selection setting in the Highlight Colors section. An already-used caption will be outlined in the Clicked section. You can adjust the outline width with the Outline Size slider. These effects don't show up in the preview and are visible only on a live menu. For the majority of menus, the default settings work fine.

Adjusting and Enabling the Images

Click on the Layers tab to open the Menu Images and Videos window (see Figure 11.7). The list under the Layers on This Page heading, in the upper left-hand corner, should have three entries. The Layer controls here work almost exactly like the Layers tab in the Slide Options window, but there is one difference in their overall operation. Notice Layer 1: the Select File, Edit, and Properties buttons are inactive. They do work, however, for Layers 2 and 3. Bonus points if you noticed that Layer 1 has a .psh extension and that the other two are JPEGs. Layer 1 is a show thumbnail. If you want to edit a file in the external image editor, it has to be an image format that Producer supports.

Figure 11.7

The Menu Images and Videos window.

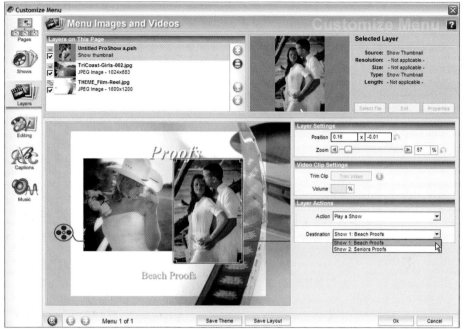

Select Layers 1 and 2 in turn and use the Zoom slider to make the layers approximately the same size as the ones in the figure. Use your mouse to position them. Set the layer actions for Layer 1 to play Show 1 and Layer 2 to play Show 2.

Editing the Image Layers

The images fit well on the page, but the picture on the left lacks the contrast seen in the one on the right. Click on the Editing tab and open the Menu Image Adjustments pane (see Figure 11.8). These controls should all be familiar by now. Select Layer 2 and move the Contrast slider to the right slightly. Don't let the light tones in the hat and gown become completely white. You can adjust Layer 1 here, even though it has a .psh extension.

Add a white outline to Layer 1. That will visually separate the two images where they overlap. The default setting of 1 works fine. The Colorize tool next to the Outline section is the same one as in the main program. We won't use it for this menu.

Next, enable the check box in the bottom section of the window to add a drop shadow to both images. This window also has tools for rotating and flipping images. We can't crop images in this window; files have to be trimmed using an image editor. This may require substituting an image file for a show template.

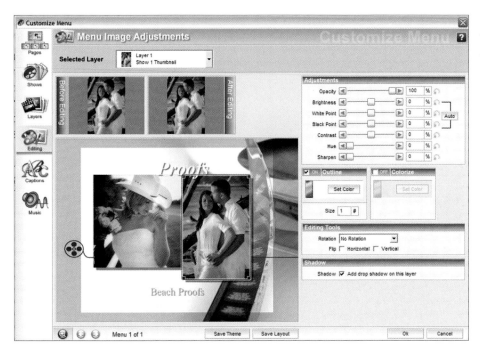

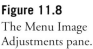

Figure 11.8
The Menu Image Adjustments pane.

Working with Menu Captions

Text elements are a major component of any menu, so captions require planning. We want to make sure the viewer knows what options are available, how to use them, and how to select and play a desired show. Click on the Captions button to set the text for this menu.

The screenshot in Figure 11.9 shows the Menu Captions pane with the completed captions. The basic controls are all familiar from the Slide Options tools. Let's look at the details of the menu's user interface and discuss the settings. The Caption List has eight items, and three are disabled. That's because they are standard controls that were part of the original menu. The Previous and Next options are not needed in a one-page menu, and not adding the Loop All option was a design decision.

We have a main title ("Proofs") and an information item ("Click on a Picture to See a Show") that are not interactive. They let the user know the main topic and tell how to choose an individual show. The "Play All," "Seniors Proofs," and "Beach Proofs" captions are all self-explanatory.

Figure 11.9

The completed design
in the Menu Captions
pane.

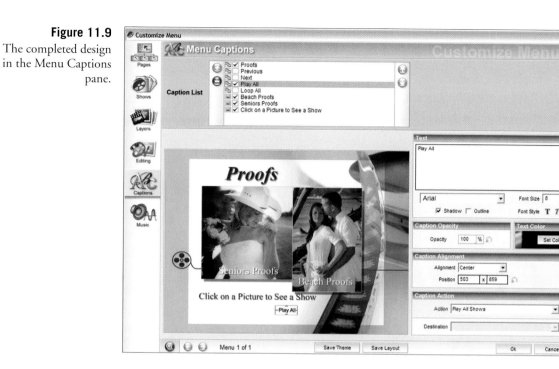

Adding Menu Soundtracks

ProShow lets you add audio to your menus. You can choose to use one global soundtrack and use a custom clip for selected pages. Click on the Music tab to open the Menu Music pane. We won't actually add one as part of the exercise. My sample has a global clip selected and a custom clip defined and disabled (see Figure 11.10). Placing a check mark in the Custom Music for This Page box would override the global setting—even though this is the only page in the menu.

Once again, the program offers familiar tools. You can use the Edit Fades and Timing window to adjust an audio clip. There are also sliders to manage volume levels and tweak fade out and fade in times.

Saving Menu Designs

All of the panes in the Customize Menu window have buttons on the bottom to save the current layout and theme. If you often create shows and projects for similar purposes, then both components and complete menus offer easy ways to streamline your workflow.

It's a good idea to give layouts names that relate to their design, and themes and menus ones that indicate the type of use. Menu files can be transferred to new locations. If they require special background layer files that are not part of ProShow's regular collection, copies of those files should be placed within the same directory.

Figure 11.10
The Menu Music
pane.

Personalizing Shows with Branding

One thing we didn't place on the menu was an item that is almost always on mine: a logo. It's easy to do. Just add a layer with your logo and mark it as your production. Branding is a buzz word in marketing for a good reason. It builds public awareness and fosters customer loyalty. ProShow offers a variety of opportunities to brand shows. The options vary with the type of output, and Producer (once again) has more features.

Announcing Your Work with an Intro Show

We'll keep using our menu project for the rest of the chapter. If need be, open it in Producer. Choose the Create DVD option from the Create menu and click on the Shows icon. The lower-right portion of the Shows pane is where you set up an intro show (see Figure 11.11).

If the check box is enabled, the selected show will play before the actual show begins. If the show has a menu, the intro show will appear before the menu does. Unless you already changed it, your screen shows the standard ProShow intro show. Its logo and color scheme let everyone know you used ProShow.

Figure 11.11
The Shows pane with
a custom intro show
selected.

The intro show selected in Figure 11.11 is one I produced in a couple of minutes to promote the book. It's a simple one-slide show that zooms and rotates the cover of the book as the caption fades from view. This kind of intro show is perfect for production and output formats that don't need a menu and increases brand awareness for all formats.

Setting up an intro show process is simple. Any PSH file can be used as the source. It is read and rendered into the final file with the rest of your project or show. Normally, you want it to last no more than a few seconds. My standard intro show uses one of the theme backgrounds with an image of a projector. My logo and a copyright notice move into the center of the screen during the three-second show.

Using the Branding Tab Options

The mother lode of branding options is available when your show format is—or includes—a PC autorun or executable file. Click on the Branding tab, and a pane like the one in Figure 11.12 opens. It shows the default options for Producer. Any or all of these settings can be changed and saved for repeat use by clicking on the buttons in the lower-right portion of the pane. If you want to change any of these options, and later restore the defaults, click on the Save Brand button and name the new file default.

Figure 11.12
Producer's default branding options in the PC Autorun Branding pane.

The left side of the PC Autorun Branding pane configures the startup screen displayed when an autorun or executable show is played on a compatible computer. You can generate both types of output independently or put them on a variety of output media, including CDs and DVDs. (A full discussion of output types and formats is included in the next chapter.)

ProShow comes with a default startup screen with the Photodex logo and a Progress bar that moves as the show file is loaded for playback. The logo is actually a background image, and the bar an animation on a layer in front. Click on the Select Image button to change the file used as the logo layer.

Just beneath the Select Image button is the check box that enables/disables the Progress bar. Click on it to toggle the bar on and off. The circular arrow on the right edge of the startup screen area is a shortcut that resets the screen's default appearance.

Just below the check box is a text box. You can change the "Loading Presentation" caption here. The check box below the text area toggles the Animation bar from a narrow strip to a wide bar. Test it to see the difference. The two color-selection tools to the right of this area change the color of the text and bar animation.

Customizing the Startup Screen

Figure 11.13 shows my window after customizing the options. Notice the location of the Progress bar. It's moved to the upper-left corner, and I've changed the colors to show up against the next image. The startup screen is basically a splash page, and the program makes it easy to modify. I selected a JPEG of the book

Figure 11.13
The same PC
Autorun Branding
pane shown in Figure
11.12, with the
options customized.

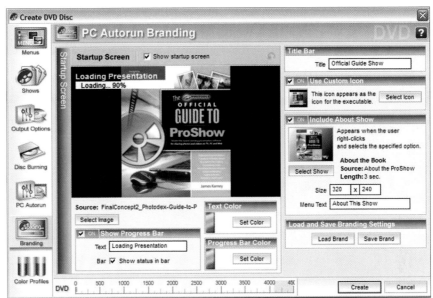

cover. At 1125x1350 pixels, it was larger than the maximum allowed size of 320x240. The program automatically resized the image to fit the page. You can move the Status bar using the mouse; here I shifted it to the upper left of the design. The text remains the same as the default.

Relabeling the Title Bar and Setting a Custom Icon

PC-based playback requires the Photodex Presenter viewer. This application has a Title bar on the top of its window. The text comes from the Title text-entry box on the top of the window's right side. Whatever is listed here will display on the Title bar during the show. This setting does not modify any other title setting for the show or the output.

The Windows operating system displays an icon for files in folders and on the desktop. ProShow has a default icon for executable and autorun files that is normally used for this purpose. Figure 11.12 uses the standard icon. In Figure 11.13, I've checked the box and replaced the default icon with a JPEG for this show.

Adding a Custom About Show

The final branding option in this window is Include About Show. This show will play if the viewer right-clicks on the show in Photodex Presenter and chooses to see it from the list on the context-sensitive menu. Check on the check box and click on the Select Show button. Then choose any PSH show. While there are no limitations on the length of the About Show, it's usually a good idea to make it short and to the point.

The play size of the About Show will be limited to the dimensions in the Size settings, and the menu listing will match what you entered in the box.

Setting a Disc Label Before Writing to the Media

Click on the Disc Burning tab to change modes (see Figure 11.14). We'll cover the output options in the next chapter, but I want to note one useful branding option here. The last entry on the left side lets you change the label for the final disc. This is what will appear in Windows folders as the label for the drive content when the DCD (or CD or VCD) is loaded and available for play.

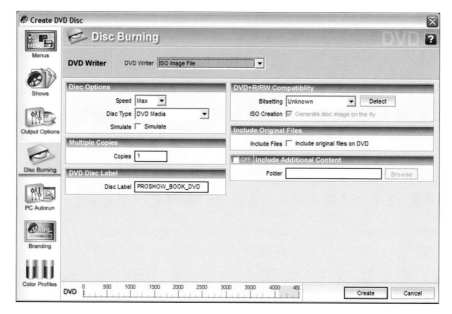

Figure 11.14
The Disc Burning pane.

Setting the label with the name of the show, or some other meaningful title, makes it easy to identify the disc without having to open the drive, launch the menu, or launch Presenter.

Adding a Watermark to the Slides

Copyright protection is an issue for many ProShow users concerned that viewers might use proprietary images captured from slides. Producer lets you add a global layer that's laid over each slide in the show, called a watermark.

To access this feature, open the Show menu and choose General Show Options. Then click on the Watermark tab to access the Watermark controls. A watermark layer most often contains an image of a logo, sometimes with a copyright notice. Figure 11.15 shows both the Watermark pane and the main Producer window in the background. The slide in the preview is watermarked.

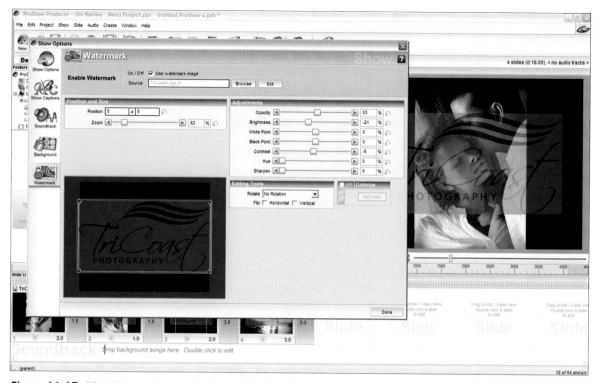

Figure 11.15 The Watermark pane in front of Producer's main window. The watermarked slide is visible in the Preview Area.

You won't see the slide in the Watermark window Preview Area since the layer is globally applied to all the slides in the show. Positioning the window as shown in Figure 11.15 makes it easy to see just how the result will look. Choose a representative slide in the main program window's preview before opening the Show Options window. Use the controls to tweak the appearance of the watermark. These controls work just like their Editing window counterparts.

Up Next

With designs down and menus ready, the only steps left in the workflow are rendering the output and testing the result. The next chapter covers the various supported file formats and actually outputting the final show.

12

Getting the Story Out

ProShow is really two programs in one: a multimedia editing platform and a rendering engine. The rendering engine provides a full range of output options, from optical media to video formats that support iPods and YouTube to high-resolution streaming Web content and even HDTV. This chapter is a guide to the delivery process and the options you have for getting your ProShow creation to its audience. We'll also look at the different types of files the program uses to produce a show and how to use them to maintain your work.

The supported formats vary slightly with the version of ProShow you use. Both Gold and Producer let you create DVDs, video CDs, Web-ready content, and PC-executable video shows. But only Producer supports compressed and uncompressed AVI output. The complete output process includes designing any menus you need (see Chapter 11) and then choosing output options, rendering the file, and placing it on the target media (covered in this chapter). If you want to play the show online, the file will need a Web host. That's a topic of the next chapter, which will cover Flash, YouTube, e-mail, and Web-sharing formats.

Let's start our discussion with an overview of the output process and the ProShow output interface. Then we'll turn to choosing the proper format and, finally, the details of each major category one by one.

Show-Creation Basics

Rendering a show is really a two-step conversion process. The rendering software "borrows" your slide show design and the source content. They are not modified. All that data is used to produce a file that complies with published standards for

the desired output media. The options available, like using menus, including certain branding features, and adding a PC autorun file, vary by format.

Once you have a file ready to go, the data is written to the target device and verified. In addition to having ProShow software, you'll need the appropriate media and hardware before you can generate the output. For example, to create a DVD, you'll need a DVD burner and blank disc. Playing the show will require a compatible DVD player and a TV or monitor.

The exact process depends on the target device. You can divide the formats into categories based on the output media: optical discs, hard drives, memory devices like iPods, and the Internet. You can create multiple versions of the same show for different target devices. All you have to do is choose the appropriate output options in ProShow, and it will do the rest.

Choosing an Output Format and Understanding Common Setting Options

The Create menu is the starting point for generating output. Figure 12.1 shows the Create Output dialog box. It serves as a gateway, organizing the various formats into categories and offering a short explanation of each type. Click on an option, and the window for the specific format opens. You can also access a specific window directly by choosing that option from the Create menu. Most follow the same design as the Slide Options window, with a row of tabs on the left side that lets you choose a specific set of tools.

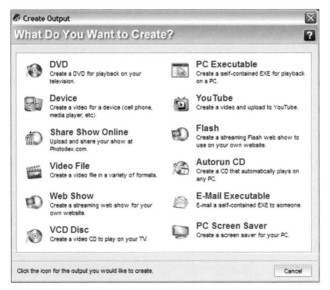

Figure 12.1
Producer's Create Output dialog box showing the available categories. ProShow Gold supports the same file formats, except for compressed and uncompressed AVI.

Launch ProShow (preferably Producer), and open any show. You must have at least one show open and saved before choosing any Create option. As you saw in the last chapter, you can add shows to a project and the output during the creation process.

Press the Control, Alt, and D keys at the same time. This opens the Create DVD Disc dialog box (see Figure 12.2). Most but not all of the output windows will be similar to this. Some will have fewer tabs, and some won't have tabs at all. Later in the chapter, we'll go through each output type and its options. Right now, we are just covering the basics and common rendering and output tasks to clarify the process.

Figure 12.2
The projected file size of many formats is displayed on a bar at the bottom of the Create DVD Disc dialog box for easy reference.

All of the optical output windows look very much like this one. The Menu, Shows, and Branding tabs should be familiar from the last chapter. I'll cover adding shows to a Web page and sharing shows over the Internet in Chapter 13.

The Output Options Window

Click on the Output Options tab, and your window will look like the one in Figure 12.2. These options control the quality and technical details of the primary output. If there are different varieties of a format available, choose the most appropriate one first. It may change the available options. Most windows offer an explanation of the format and its options in the right-hand column. Change the DVD type in the drop-down menu at the top of the window, and the information will change.

Video Standard

Formats that are designed for playing on a television set will have an option for setting the video standard. In North America, the NSTC format is used. In Europe, PAL is the standard. Many formats have a quality setting that will adjust the resolution. Keep in mind that in video technology, higher quality usually results in larger file sizes.

File Size Considerations

ProShow doesn't limit the size of a show or the size of the files you place in a design. That's not true for the physical output media itself. The size of the target disc and hard drive and the restrictions of the output standard and operating system must be considered to ensure a workable result. In general, limits are determined by output type and available space on the output medium.

DVD- and CD-based shows are restricted by the amount of playing time and the capacity of the disc. Video CD still shows cannot exceed 99 images due to limits defined by the format. The other supported formats don't have defined size limits, but it's important to keep storage and file-loading times in mind. For example, a Web-based show has to be downloaded, and a show intended for a hard drive or flash drive must fit in the available space.

The projected file size for many formats is readily available in a bar displayed in the main program and on the bottom of the various output windows. (See Figure 12.2.) The limit for executable files on some operating systems is capped at 2.1GB. This varies based on the operating system, so it's a good idea to stay within reasonable limits. Keep in mind that high-definition files can get quite large, so watch the size of the bar and trim as needed.

One way to conserve space is by limiting the output resolution and image-quality settings when including a PC autorun file in a project. These settings have a noticeable effect on the final file size. Click on the PC Autorun tab. This tab is available in many formats and is an output type in its own right. (See Figure 12.3.) This is a PC file that includes an embedded runtime version of Photodex Presenter. The resulting show boasts outstanding quality and can be burned to an optical disc for play on any Windows-based PC. The format supports all branding and menu options. We'll cover the details of setting options later in the chapter.

Color Profiling

Color profiling (see Figure 12.4) is a process that adjusts the appearance of a display device (like a monitor or HDTV) to match as closely as possible standard colors, white balance, and contrast values. This tab lets you set the show to take advantage of a color profile. Use this option only if you know that the target viewing device supports color profiling and is properly calibrated. Mismatching a profile can result in some very unusual colors.

Figure 12.3
The PC Autorun
window.

Figure 12.4
The Color Profiles
window.

Use ICC Color Profiles enables and disables a selected color profile when you're generating video for the PC executable.

Color Profile Settings for PC Playback/Use Default sets the color profile for the PC executable to be the default profile of the machine that it is being played on. **Use Installed** selects a color profile from those installed on your computer.

Use Custom allows you to use a color profile that may not be installed on your machine.

The **Browse** button allows you to browse for the color profile you would like to use to generate the video for the PC executable.

Output Formats and Files Demystified

Now that we've covered the basics of the output process, let's look more closely at the file formats and then go into specific options for each. If you are already familiar with video file formats, feel free to skip this section. If it's new territory, here is a quick primer. All ProShow output (except for single-slide captures of previews in Producer) is video. The program renders many frames for each slide and transition in a PSH file based on the framerate. Each type of media has its own special format.

There is a lot of technology behind a video file format, all precisely specified—usually in serious geek-speak—by an international standards association. ProShow deals with all of that. We need to know how the show will be seen and on what kind of device. Figure 12.1 shows the master Create Output dialog box. It is the first option on the Create menu. Click on an option, and the appropriate window for setting options for that type of output will be presented.

You can also directly choose the format by using one of the other options on the Create menu. The following list highlights uses for the different output options and formats.

- **DVD Creation** is the best option for playback on a DVD player. **Video CD Creation** is a good option if you don't have a DVD burner or DVD media. Video CDs will play on most DVD players. Both formats let you include an optional PC Autorun executable file for hassle-free PC playback.

- **Device** allows you to create your show using preconfigured profiles for many viewing devices, including cell phones, media players, and game consoles. It also includes the ability to create your own profile.

- **Video File Creation** lets you choose from a wide variety of video file formats, including AVI, WMV, MPEG 1 and 2, and HD Video.

- **Web Show Creation** outputs your show and generates the HTML code for your Web site. Show playback is controlled by Photodex Presenter, a free Web plug-in. **Share Show Online** creates your show output and uploads it to Photodex's online sharing service (http://www.photodex.com/sharing) so you can share your shows for free. **YouTube Output** allows you to automatically

upload your slide show to your YouTube account with no additional steps. **Flash Show Creation** outputs your show for Web playback to FLV for easy integration into your Web site. No Flash experience required!

- **PC Executable Creation** makes a stand-alone slide show that will play on any Windows PC without additional software. **Autorun CD Creation** creates a disc that runs your show automatically when loaded into a Windows PC. It requires no additional software to replay shows. **E-Mail Executable** creates an executable file and then e-mails it from within Producer using your preconfigured e-mail preferences.

- **PC Screen Saver Creation** creates a screen saver of your show that will play when your computer is idle.

Supported Output File Formats and Media Types

Occasionally, you need to know the specific type of disc and file formats available to ensure device compatibility. Use only those that are certain to work with a target device. Keep in mind that while ProShow may be able to write files in a given format and to a certain type of media, your system must have the proper hardware and operating system capability to complete the task. It's a good idea to make sure that you have the latest updates to both ProShow and your system drivers before starting an output session and that you use high-quality optical media. Bargain media often costs more in the long run because of failed burns and poor read rates.

ProShow supports the following file and media formats:

- Video disc formats: DVD, VCD, SVCD, XSVCD, CVC, and MiniDVD

- Video file formats: AVI (compressed and uncompressed, Producer only), Video CD CUE/Bin Image (CUE), Windows Executable (EXE), Adobe Flash (FLV), CD/DVD Image File (ISO), QuickTime (MOV), MPEG 1 and 2 (MPG), Streaming Web Show (PX), Windows Screen Saver (SCR), Windows Media Video (WMV), High-Definition Video in 480p, 720p, 720i, 720p, 1080i, and 1080p

- Disc media: Recordable CD (CD-R), Rewritable Recordable CD (CD-RW), Recordable DVD (DVD-R), Recordable DVD (DVD+R), Rewritable Recordable DVD (DVD-RW), Rewritable Recordable DVD (DVD+RW), Recordable Dual Layer DVD (DVD+R DL), and Recordable Dual Layer DVD (DVD-R DL)

Photodex Presenter Files and Plug-In

Photodex Presenter is a free plug-in that allows users to view streaming ProShow presentations on the Web or a PC. It provides outstanding playback quality and performance superior to other streaming Web formats, and it supports all the effects created in ProShow, including menu and branding features. As a bonus, the resulting file size is a lot smaller than for shows saved in traditional video formats.

You must install the plug-in before viewing Presenter shows. Photodex Presenter is automatically installed with Producer and Gold. A runtime version is included in all executable and autorun output. When users attempt to view a Presenter-based show without a plug-in, they are offered the ability to connect, download, and install it automatically. Every copy of Photodex Presenter is digitally signed to ensure its authenticity, safety, and security.

Presenter can run in its own window or in a Web browser in full-screen mode. It offers a variety of user controls during playback. You can access them via the tool at the bottom in window mode or using the right-click menu in full-screen playback.

Pause/Play temporarily pauses or resumes playback of the show. The current slide will display until show playback is resumed. **Stop** ends show playback and returns either to the menu or to the beginning of the show, if there is no menu. **Previous Slide** returns to the previous slide in the show. **Next Slide** advances to the next slide in the show. **Sound On/Off** enables and disables sound for the show. The **Volume Control** sets the volume level for show sound.

Selecting Options for Different Output Formats

Each output format works a bit differently and so offers its own set of options. In most cases, the ProShow defaults work well, but knowing how to tweak settings and match the output specifications to take full advantage of the target player will let your viewers see the show in its full glory.

This section gives an overview of the settings and shows the windows for each type of output. (When one window is very similar to another, I will show only the first one in a figure. For example, DVD and VCD are almost identical windows, so I've used only the DVD output windows. The various autorun/executable formats are all grouped as one. Photodex is constantly updating the program's support for output and new hardware devices, so be sure to keep your copy up to date.

DVD/VCD/CD Production

There are a range of DVD and VCD disc types, but all make use of the same basic options, and all support the addition of a PC Autorun file, menus, and branding. You can also include the original show source files and add additional content.

DVD Output Options

The DVD Output Options window (see Figure 12.5) controls the settings for video quality. **DVD Type** specifies the quality for the DVD. Choose from the drop-down menu to view related information, including capacity, in the DVD Type Information section. The **Video Standard** sets the television standard to be used on the DVD. The **Audio Type** specifies audio encoding format for the DVD.

Figure 12.5
The DVD Output Options window.

Anti-Flicker enables and disables the anti-flicker filter during rendering. Anti-flicker prevents the flickering effects that you sometimes see in the DVD format. There is a small loss of sharpness, so enable this only if you really need to. **Desaturation** desaturates the video by a specified percentage, keeping colors from becoming extreme and resulting in an unnatural-looking video. The default value usually works well. **Video Clip Output Options**: The Encoding Quality option sets the encoding quality of video clips used in slides in your show.

DVD Disc-Burning Options

The Disc Burning window (see Figure 12.6) lets you control the way the files are written to the media and the operation of the drive used in the process. **Writer** selects the drive that will be used to burn the DVD. The drop-down menu lists

Figure 12.6
The DVD Disc Burning window.

the available drives installed on the computer. You can also create an ISO image file for use by third-party DVD-/CD-authoring programs.

Speed sets the speed at which the DVD is written. The default is the maximum speed for your DVD burner. Lower speeds may improve compatibility with older DVD players. **Disc Type** specifies whether you are burning to a DVD or a CD. **Simulate** enables and disables testing the burning process without actually burning a disc. This feature works only for the CD Media (MiniDVD) disc type. **Copies** specifies the number of DVD copies to be burned.

Disc Label sets the label that appears when you browse for the disc on your computer. **Bitsetting** specifies the bitsetting method used for the DVD. Bitsetting reconfigures DVD+R/RW media to make it more compatible with stand-alone DVD players. Bitsetting works only with +R/RW media. In addition, not all writers support bitsetting.

Detect determines whether your DVD writer supports bitsetting. Do not use bitsetting if your DVD writer does not support it. **ISO Creation** instructs the program to write data directly to the disc or to finish creating the image prior to disc writing.

Include original files on DVD specifies whether the original files used in your show will be included on the DVD. Users can then access these files. The **Include Additional Content Folder** displays the location of a folder containing additional content that may be added to the DVD. **Browse** lets you browse for the folder you want to include on the DVD.

VCD Output Options

Video CDs work like DVDs, but they are created on a CD-R or CD-RW. They are less expensive to produce, but Video CDs do have lower quality and compatibility than DVDs. There are two types of shows that you can create using the Video CD output format: video shows and still shows.

Video Shows are complete productions complete with motion effects and transitions. They are limited in length based on the amount of space available on your CD. They support Video menus, which can have video thumbnails and background music. **Still Shows** display higher-resolution images but do not have motion effects or transitions. Still shows are limited to 99 images and can contain a Still menu (a solid, still image).

The Output Options window for VCD works basically the same as the one for DVDs. **Video CD Type** is the drop-down menu used to set the quality for the Video CD. As you choose an option, the details of the format are explained on the right side of the window.

Show Types sets the type of show. Video shows include motion effects and transitions, while still shows display higher-resolution images without motion effects or transitions. **Default Show** specifies which show will open by default in Video CD playback. You can choose between video shows and still shows.

The **Video Standard/TV System** option selects the television standard to be used on the Video CD. **Audio Type** specifies audio encoding format for the Video CD.

Anti-Flicker enables and disables the anti-flicker filter during rendering. Anti-flicker prevents the flickering effects that you sometimes see in the DVD format. There is a small loss of sharpness, so enable this only if you really need it. **Desaturation** desaturates the video by a specified percentage, keeping colors from becoming extreme and resulting in an unnatural-looking video. The default value usually works well. **Video Clip Output Options**: The Encoding Quality option sets the encoding quality of video clips used in slides in your show.

Menu Type enables and disables the use of Still menus. Still menus are solid, still images, while default menus are, or can be, Video menus. Some players support only Still menus, and some support only Video menus. **Encoding Quality** sets the encoding quality of video clips used in slides in your show.

VCD Burning Options

Writer selects the drive used to burn the CD. In addition to the available drives on your machine, you may want to write to a CUE/BIN image file, which you can import into other CD-authoring programs.

Disc Options/Speed sets the speed at which the CD is written. The default is the maximum speed for your CD burner. Slower speeds may improve compatibility with older disc drives and players. **Simulate** enables and disables testing the burning process without wasting a disc. **Copies** specifies the number of CD copies to be burned. **Disc Label** sets the label that appears when you browse for the disc on your computer.

Include original files on Video CD specifies whether the original files used in your show will be included on the Video CD. Users can then access these files. **Include Additional Content/Folder** displays the location of a folder containing additional content to be added to the Video CD. **Browse** lets you select the folder to include on the disc.

Autorun CD and Executable Files

Autoexec CDs, PC Autorun files, and PC executable shows are all versions of a self-contained Photodex Presenter show. They all offer full menus, high-quality output, branding, and color profiles. Autorun CDs work very much like a DVD or VCD, but since they are actually a special form of PC Autorun, you can add that format's copy protection to the disc itself. The other windows are the same as for VCD, so I won't detail them here.

Figure 12.7
The Autorun CD Output Options window.

This format can be rendered as a stand-alone file, included on DVDs or CDs, and loaded on media devices that support Windows executable media. Here are details of the available options. **Executable Startup/Window Size** specifies the startup size of the executable. **Image Size** determines the largest size at which images in the show will be stored in the show file. **Monitor** specifies which monitor the show will play on when it launches. **Loop Show** enables and disables show looping. A show menu will override this feature.

There are several **Quality/Performance Settings. Rendering** sets the maximum size for your show during internal rendering. It does not affect the display size of your show. **Resizing** specifies how your photos are resized before they're rendered. This eliminates the need to resize your images before bringing them into Producer. A smaller value yields smaller images that take up less space but also reduce image quality.

Image Quality determines the quality setting used for image compression. Video Output Quality/Resolution allows you to specify the video resolution. **Quality** sets the general quality level used to encode your video clips for the show. **Audio Output Quality/Quality** sets the general quality level used to encode your audio for the show.

The **Protection** option limits how long or how many times the show can be seen, or it can require an unlock key to view the show. **By Days** limits the usage of the executable to a specified number of days. **By Runs** limits the usage of the executable to a specified number of runs. **Registration Key** allows you to specify a registration key or password that will unlock the executable for unlimited use. **Info URL** specifies a Web site for the user to visit for more information about the show. **Info Link Text** specifies the text that represents the link to the Info URL.

Screen Savers

A screen saver is a great way to share images and promote your skills. Producer allows you to create a screen saver from any show you make so that it will be displayed anytime the computer is idle. This format does not support menus. Since it is a simple file, there is no Disc Burning window. You can include multiple shows, add branding, and set a color profile.

The Output Options window is shown in Figure 12.8. **Audio Playback/Enable Audio** enables and disables audio in the screen saver. **Quality/Performance Settings/Rendering** sets the maximum size for a show during internal rendering. This does not affect the display size of the show. **Resizing** specifies how the photos are resized before being rendered. **Image Quality** determines the quality setting used for image compression.

Figure 12.8
The Output Options
window for creating
screen savers.

Video Output Quality/Resolution specifies the video resolution of any video clips used in the show. **Quality** sets the general quality level used to encode the video clips.

Protection/By Days limits the usage of the screen saver to a specified number of days. **By Runs** limits the usage of the screen saver to a specified number of runs. **Registration Key** allows you to specify a registration key or password to unlock the screen saver for unlimited use. **Info URL** specifies a Web site for the user to visit for more information about the show. **Info Link Text** specifies the text that represents the link to the Info URL.

Portable Device Output

ProShow can generate output in a form that is ready to use with a wide range of multimedia devices, including iPods, cell phones, and game consoles. The program is configured with profiles for many popular devices to provide output with maximum quality and compatibility. You can also customize a profile. Open the Create menu and choose the Video for Device option to open the interface. ProShow will check for an updated list of device profiles and then present the screen shown in Figure 12.9.

Figure 12.9
The Device Output window ready to create an HD show for Sony PlayStation 3.

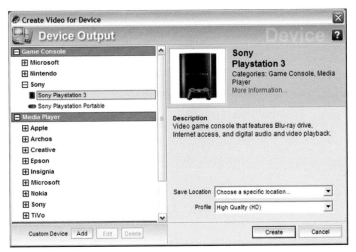

Creating Device Output Using an Existing Profile

Generating a show for a defined device is very simple. Use the Profile Selection menu, choose the manufacturer, and then select the appropriate device from the list. Once a device is selected, the Save Location drop-down menu and Profile drop-down menu are enabled. If a supported device is attached to the computer, it will be listed on the Save Location drop-down menu. If Producer cannot detect a device attached to your system, Save Location will not have any options.

Select the profile that you would like to use and click on the Create button. If you didn't specify a location in the Save Location menu, ProShow will ask you where you would like to save your output video. Once that's complete, consult your device documentation for methods to transfer the video to your device.

Creating a Custom Device Profile

You can create your own profile with the manufacturer and device name to access it again in the future. Click on the Add button in the Create Video for Device window. A dialog box like the one shown in Figure 12.10 will appear.

Enter the name of the manufacturer of your device and the model number in the **Device Information** area. Enter the name of the new profile and choose the desired format from the drop-down menu in the **Profile Settings** section. Only Producer supports AVI (compressed and uncompressed). You can also choose the file extension for the finished file.

Now it's time to configure the **Video Settings**. Compression is the encoding method that ProShow will use to create the video. **Resolution** is the resolution that will be used for the completed video. **Framerate** determines the framerate that ProShow will use when rendering the video. **Aspect Ratio** specifies the default aspect ratio for the device. **Bitrate** allows you to manually determine the overall quality of the video.

The final section controls the file's **Audio Settings**. **Audio Format** determines the method ProShow will use to create the audio portion of your slide show. **Channels** specifies whether ProShow will create mono or stereo audio. **Sampling Rate** determines the playback quality of the audio in the show. **Bitrate** determines the encoding quality of the audio in the show.

Once you've adjusted the settings, click the Save button to register the new profile and add it to the list. This type of profile is listed under the Custom Profiles option by the manufacturer and model name. Remember that many devices require very specific settings for their media files. When you're creating a custom device profile, consult the device documentation or the manufacturer's Web site to make sure that the settings will function properly on the target device.

ProShow File Types and File Management

Gold and Producer create a number of different files for various uses, including backup file caching and customizing your workspace. There are four main categories. **Show Files** are the various components that make up your show, and they can be used to recover your work in the event of a system crash. **Menu Files** save

menus, themes, and/or layouts created in the authoring stage of show creation. **Output Files** relate to certain aspects of the output functions in Producer. **Workspace Files** consist of custom window layout files you can use to load custom workspace settings and configurations. The following sections detail the files by category.

Show Files

PSH File (Photodex Slide Show File) is the main file for your show. This file contains all the settings and options Producer needs to load, create, and play your show. *This file does not contain any of your show content. Producer simply links to your files; it does not alter or move them.* The PSH file is what you would save in order to save a show. If the file is deleted, your show no longer exists, but the content included in the show remains in its original location.

The PSH file contains a list of all the other files used in your show. If you move the PSH file, ProShow may not be able to link to your content properly. If you attempt to load a show and the content cannot be found, Producer will prompt you to locate the files in order to load the show properly. If you wish to back up your show, you must backup both the PSH file and the original content used in your show. The Collect Show Files feature will automate this process and ensure that all content is copied correctly.

Backup Show Files are created by Producer to automatically back up your show file each time you save your show. This allows you to revert to previous versions of your show at any time. These backup files are stored in the same folder as your show. The files have the same name as your show, but extensions like .bak, .bk1, and .bk2. Do not delete these files if you would like to revert to them while working on your show.

Show Content Files (Images, Music, and Video) are the files used in your show. When you add content to your show, Producer does not copy or modify the file. ProShow simply notes where the original content is saved on your computer and links to the files when they are used in the show. If your original content moves, your show will not be able to link to those files. The Collect Show Files function copies all your content into a single folder, allowing you to move your original files as desired.

PXC Files (Photodex Cache File) are created when you load a Producer slide show. The PXC file is a cache file, which means that Producer can access it very quickly to load the show you are working on. This file is generated automatically while you work on your show, and it can be deleted at any time. You cannot load a show or recover lost content from a PXC file.

PST Files (Show Templates) are saved show templates. Producer's template feature lets you create reusable show templates from any show. When you save a template, it is stored as a PST file in the Templates folder in Producer's installation folder.

Autosave Files are automatically created by Producer every five minutes in case of a system crash. When Producer autosaves, it places a copy of the current show in its program folder as autosave.psh. This file is cleared when you save the show. Do not delete these files if you would like to revert to them in the event that your system crashes.

Temporary Files are created and removed by Producer as you use the application. These files are stored in your Windows temporary folder and will usually be named px*.tmp or _px*.tmp. Producer will delete these files when the application no longer needs them. Do not delete these files while Producer is running.

Menu Files

MNU Files (Menus) are saved menus. With Producer's advanced menu-authoring system, you can save completed menu designs for later use. These files can be saved in any location.

LAY Files (Menu Layouts) are saved menu layouts. With Producer's advanced menu-authoring system, you can save layouts that can be matched with saved themes to create menus. These files are saved under Application Data/Photodex/ ProShow Producer/Menu Layouts.

THM Files (Menu Themes) are saved menu themes. With Producer's advanced menu-authoring system, you can save themes that can be matched with saved layouts to create menus. These files are saved under Application Data/Photodex/ ProShow Producer/Menu Themes.

Output Files

ISO and CUE/BIN Files are disc images used to burn DVDs and CDs. These files include all information and data necessary to write a disc. These files are created during authoring of a DVD, a VCD, or an Autorun CD. You have the option of saving these files rather than writing a disc. Most CD- and DVD-burning applications can read these files and create a final disc from that information.

PX Files (Photodex Stream Files) are ProShow Web shows that are created when you choose the Web Show or Share Show output format. The file is a compressed Web stream that is copied to a Web server for playback over the Internet. A PX file cannot be edited or used to recover lost content. To play a PX file, you must install Producer or the Presenter Web plug-in.

Temporary Video Files are created by Producer when you select any output format that requires video rendering. This file is stored in the same folder as the PSH file. This file contains video rendered by the application and has an .mpg file extension. These files allow you to create multiple copies of the show without re-rendering the video. You may delete these files at any time, but you will have to re-render the video to do so.

Show Cache Folders store video created for output (such as DVD and VCD) in Producer. This allows you to easily create multiple copies of the show without re-rendering the video. These files are stored in a folder created by Producer. The folder is named using the name of your show file, followed by _psdata. *Do not delete this folder unless you want to re-render the video for that show.*

Workspace Files

DPR Files (Window Layouts) are saved window layouts. From Producer's Window menu, you can save and load custom window layouts for your workspace. These files are saved in the Layouts folder in Producer's installation folder.

Up Next

There is one type of output we haven't covered yet. Both Gold and Producer offer users a variety of ways to reach viewers via users' own Web sites or online sharing and to take advantage of free hosting on high-speed Photodex servers.

13

ProShow and the Web

We use ProShow to please viewers with our work. Both Gold and Producer offer powerful features for sharing content via the Internet, making our productions available to anyone with Web access. This chapter explores how to prepare a show for online use and make use of free hosting via the Photodex high-speed Web server, as well as the options for hosting shows on your own Web site and third-party sites like YouTube.

Internet Hosting Basics

You should be familiar with surfing the Internet, so I'll skip the basics of browsers and viewing Web sites. Not all readers may be as knowledgeable about how to place multimedia information on the Web for others to see, so a quick introduction is in order. Feel free to skip to the next section if you already know about Web hosting and streaming video and audio programs.

ISPs and Bandwidth

When you surf the Web, you are accessing files using a global network. The remote server holds the files and sends them on request. That requires moving the data over high-speed (broadband) trunks, even when the last bit goes over a slower dial-up connection. (Dial-ups are not advised for working with multimedia and streaming content.) Usually an Internet Service Provider (ISP) owns the remote computer and broadband connection.

The fees ISPs charge to host sites are based on the features they provide and the amount of downloaded data they move to visitors each month. Web sites that have only text pages and small images almost never reach the monthly limit for basic service. Sites that provide high-resolution movies to visitors often do. Owners pay accordingly. They either buy deluxe accounts with a higher limit or pay extra charges for consuming excessive bandwidth. If you plan on hosting your own movies, plan ahead or limit the amount of downloads to control access. Exceeding the contract limits gets expensive fast. It's a lot like running over the monthly minutes on a cell phone contract—not good.

Consider the options. Photodex offers a high-quality solution if you don't need to present your shows on a custom Web page. Owners of Gold or Producer can share movies in Presenter PX format for free by opening an account on the Sharing section of Photodex's Web site (http://www.photodex.com/sharing). There are no limits on how many movies you can share or on their size. You can play them in full-screen mode complete with high-quality sound and make use of all of ProShow's features, including menus and branding.

Figure 13.1 shows Photodex.com's welcome page for the Sharing section. Visitors can browse by member names to see shows. Members can log in here to manage their accounts directly. Shows are stored on the site in PX format. This is the native

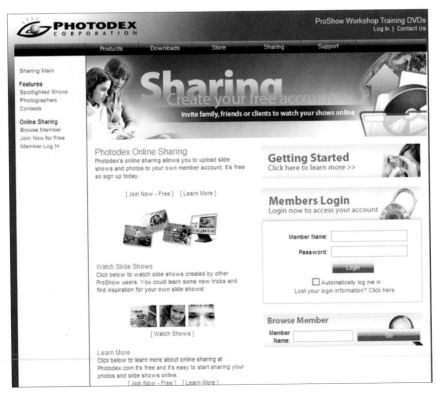

Figure 13.1
Photodex.com's main Sharing page.

format for Photodex Presenter files. You can also use ProShow's e-mail output feature to send a show directly to the intended viewer. It's not the same technology as surfing, but it does let you share your work online.

If you want to host slide show pages on your own custom Web site, look for a provider that caters to multimedia content. PhotoIdentities.com is a good example. It specializes in Web solutions for photographers and other visual professionals, offering templates with pages that can easily host ProShow-generated online output. The template approach means that you don't have to do much more than add a link and perhaps a thumbnail image to the page and then upload the show file.

Figure 13.2 shows a sample page built using the site's technology with one of my Flash movies and hyperlinks for both Presenter and QuickTime versions of the same presentation. As you can see, the show in progress uses masking and makes use of Producer's advanced features. That's something you can't do with a SWF Flash format. This site format is the one my own Web site is moving to, complete with a featured show on the home page, traditional information and contact pages, Flash portfolio galleries, a blog, and a multimedia page with Flash movies and links to the Presenter and QuickTime versions.

Figure 13.2
A PhotoIdentities page showing a ProShow-developed Flash movie playing. The page also has links to other formats generated by ProShow.

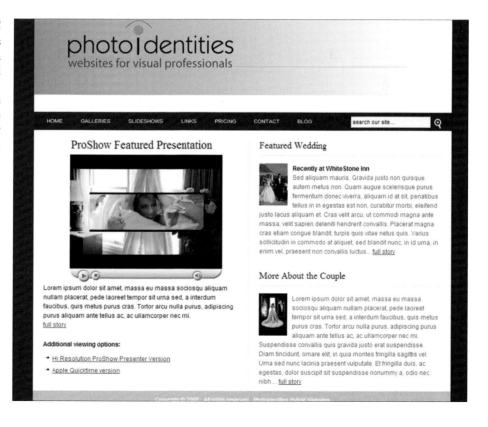

Reducing the resolution of the show and using a compressed format are one solution. That reduces the file size and thus the amount of data moved over the Internet. ProShow lets you output files as Flash FLA movies. These are low-resolution shows viewable in any browser with a Flash-compatible browser plug-in. These are very popular and work on PC, Mac, and Unix.

I usually place the Flash show on my Web page and then have a link to the Presenter version in Photodex's online Sharing section. That approach gives me live content on my pages without my having to worry about the bandwidth load. The big PX-format files are all handled by Photodex, and the QuickTime shows can be downloaded from my site via the link.

ProShow also interfaces directly with YouTube's sharing application, and you can output files right into a user account from the Create menu. This lets you post movies without worry about bandwidth at all. Of course, you forfeit having a custom page and offering high-resolution content.

Copyright Considerations

When we share shows with others, we are *publishing* our work, and it is important to know about copyrights. If you personally produced all of the content of the show—including images, videos, music, drawings, and designs—or have the right to use and distribute all of the content, then all is well. If you are including content from another source, you need to be aware of copyright issues. A person owns creative works just like physical property. That is true for writing, pictures, music, and any other type of intellectual property. Before we can use images and music that we didn't create in our shows, we must have permission. Copyright laws are also there to protect your work from being used without permission.

Some items are in the public domain. Items created before there were copyrights, or that are old enough that the copyright has expired, can be used freely. Quotes from Shakespeare are fine—he won't complain (although the fact that an author is dead does not mean his or her work is in the public domain). The creators of some works, like the Shenandoah soundtrack we used in this book, have placed them in the public domain. Sometimes creators impose restrictions, such as permitting use for non-commercial purposes only.

There are also limited rights: using items only for certain purposes or for a limited time. The images in the book's exercises have been published under a limited-use arrangement. TriCoast photographers Mike Fulton and Cody Clinton, the Texas Woman's University, and I have granted use only for practice with this book—not for any other purpose.

For all other uses, you have to pay. That may be a flat fee. Sometimes the amount paid is based on how many times the item will be used or shown. There are stock agencies that offer music and images for reasonable prices. "Borrowing" creative works without permission can get very expensive. The person who does so can incur very steep penalties in court and could face criminal charges. Copyright violations are a form of theft.

Sharing Shows with a Free Photodex Account

Using Photodex's free sharing utility is very simple. You can handle the entire process right in ProShow. The program will output the file and place it on the server. You will be given an account to manage and can control access to your content. Let's walk through the steps, and I'll explain the process. If you don't have an account, feel free to follow along and set up a new one.

You will need a fast Internet connection and either Gold or Producer. With a show loaded in the program, open the Create menu and choose the Share Show Online option. (You can use any show, since it can be hidden from visitors or deleted at any time.) The window shown in Figure 13.3 will open.

The Share Show Online window is a one-stop shop. If you already have an account, all you need to do is fill in the login information, choose the folder location on the site, and set any desired viewing restrictions. When you press the Upload button, the file will be rendered and placed on the server.

Figure 13.3
The Uploading pane, for sharing shows on the Photodex Web site.

Click on the Create Account button if you don't already have an account, and the program will launch the computer's default browser and load the new account registration page, partially shown in Figure 13.4. You can also register on the Photodex Web site by visiting the Sharing page. Make a note of your user name and password.

Figure 13.4
Registering for an online sharing account.

Once the form is processed, Photodex will send a confirmation e-mail to the address you used to register. Click on the link in that message to activate the new account, and everything will be ready to use. Return to the Share Show Online window, fill in the blanks, and click Upload. The program will have to go through all the regular rendering steps and then will send the file over the Internet. If the show is large, this can take a good while. There are no limits on the size of a shared show, and the bandwidth is free, but think of viewers when using this feature. If the show is very large, either break it into segments or reduce the image sizes to cut the final size. ProShow will present a notice when the upload is complete. Click OK, and you can view the show online, as shown in Figure 13.5.

The show is attached to a Web page on the Photodex site, operating from a server farm at the company headquarters in Austin, Texas. The site controls access, manages user accounts, and tracks a show's statistics. It also provides tools for customizing information about a show, limiting who can see it, and inviting people via e-mail to view your collection.

The screenshot in Figure 13.6 shows the Edit Content page for the WASP show I uploaded for this chapter. You can set a caption, add a short description about the movie, limit access, and note if the subject matter is intended for mature audiences. Your collection can be divided and placed into folders, and this page also lets you move shows from one folder to another.

Figure 13.5
The WASP show, played online using ProShow's sharing feature on the Photodex Web site.

Figure 13.6
Customizing the options for a shared show on Photodex's Edit Content page.

Hosting Presenter Files on Other Web Sites

The Create Output menu lets you render PX files without uploading them. That gives you the ability to move the files to any Web site, where they can be linked to a Web page and made available to visitors. Load the desired show (or project) in ProShow. Open the Create menu and choose the Web Show option. The Create Web Show window will open. You can set up a menu, add shows, and set a color profile. Figure 13.7 shows the Output Options pane. This lets you set a default display size, limit the maximum size, control the performance settings as well as video and output quality, and use copy protection options to control access.

Figure 13.7
The Output Options pane when creating a Web show.

Raising levels on the several quality settings will produce a larger file. That in turn will require more time for downloading and will increase bandwidth usage (and possibly ISP fees). Lower settings will reduce the clarity of playback but will result in faster loading times and smoother playback. It's always a good idea to test the results before making a new show public.

When the rendering process is complete, the new show will just be a file on your local hard drive. It must be uploaded to the Web site and have a page with a link created. That requires adding some HTML code to the page. Don't worry if you are not a hardcore coder. ProShow will provide the code you need. Click on the View HTML button at the bottom of the Create Web Show window. That will open a dialog box like the one shown in Figure 13.8.

Figure 13.8

Setting up the HTML code for the show's hyperlink.

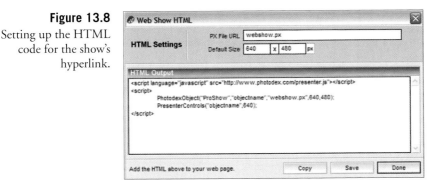

The next steps vary depending on whether you are adding a link to an existing Web page or having ProShow automatically create a show page that you can then add to a Web site. If you want to let ProShow produce a simple Web page that runs the show, just place the name of the show in the PX File URL field at the top of the box and make sure the default size matches your desired resolution.

Place check marks in the three boxes in the Web Page Options section (refer back to Figure 13.7). Then click Done. The program will open an Explorer window so you can choose where to save the files. Both the PX show file and the Web page will be generated in that directory.

Open the Web page to view the show and test the code. You can also view the show by clicking on the show file itself. Then upload both files to your Web site and create a link to the new page so visitors can see the new offering.

If you're placing the link on an existing site, you will need to paste the code into the desired link location on the page. This step requires a basic understanding of HTML and use of a plain text editor like Notepad or an HTML editor like FrontPage. The PX show file must be uploaded to the location you used in the path statement.

Sending a Show via E-Mail

You can send an executable version of a show via e-mail from inside ProShow. This is a regular ProShow Presenter file that can include menus, branding, copy protection, and multiple shows. Keep in mind that the e-mail gateway may limit file sizes. The size can be controlled by reducing the display size, audio quality, and image quality or by increasing image compression.

ProShow needs to know your e-mail account information before it prepares and sends the file. Open the Edit menu and choose Preferences. A window like the one in Figure 13.9 will appear. Click on the Internet tab and fill in the form. Some

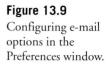

Figure 13.9
Configuring e-mail options in the Preferences window.

e-mail servers may require only the outgoing information, others both. It's easiest to complete the entire form at once.

The next step is to load the show(s), choose the Send an Email option from the Create menu, and then configure any desired output options. That process should be familiar by now, so I won't review it here. Click on the Send option once you're done adjusting all the settings. An e-mail dialog box like the one in Figure 13.10 will open.

Figure 13.10
The E-Mail Show dialog box.

Fill in the blanks, and your show is ready to go. The recipient will be able to play it without having the regular version of Presenter—a runtime version is built in. Its only limitation is that it must run on a Windows-based PC. Mac OS environments don't support Presenter.

Flash FLV Shows and the Web

ProShow outputs Web-ready Flash FLV files much the same way it does the PX Presenter format. The program can render the file and produce the Web page and code required to place it on a Web site. You will need to understand a bit about HTML and use a text or HTML editor to craft the link to the page or show.

You can use menus, but branding isn't supported with this show format. The plus side is that the results are viewable in any Flash-compatible browser. Load the show in Producer or Gold, and then choose the Flash Show option from the Create menu. A window like the one shown in Figure 13.11 will appear.

Figure 13.11
The Flash Show window's Output Options pane with the Custom Flash Video Settings dialog box open.

The Video Bitrate setting should be set to match the speed of the viewer's Internet connection. The drop-down menu lists the common connection speeds, which will work well for most applications. If you feel compelled to tweak the values, choose Custom and click on the Settings button. A dialog box will open, as shown in Figure 13.11, that lets the user configure each element.

If you want the viewer to be able to control play with the Pause and Play controls, enable the Show Controls option. The Output Options section lets you configure both the resolution and the framerate. Remember that higher-resolution and faster framerates will increase file size and download times. Checking the Loop Show option will cause the show to repeat until the viewer leaves the Web page or closes the browser window.

Activating the Web Page Options check boxes will make the program generate code to place the Flash viewer on a page and set all the proper options for the show. If you choose to have the actual page made, it will be blank except for the viewer in the center, just as with the Presenter Web page. You can customize this page in an HTML editor, or you can add the code that appears in the HTML Output section of the window to an existing page (see Figure 13.12).

Figure 13.12
The HTML code generated by ProShow for a Flash Web show.

The YouTube Connection

ProShow can automatically access an existing YouTube account to upload and register a show. This is a variation on the Flash format that is limited to the options YouTube provides. The procedure is simple. Open the show in ProShow. Menus and branding are not supported. (You can "brand" a show by adding a first slide that displays your information.) Choose the Upload to YouTube option from the Create menu, and the box shown in Figure 13.13 will appear.

Figure 13.13
The YouTube
Upload dialog box.

Wrapping Up

It's easy to see that ProShow offers a range of Web-based output solutions that meet virtually every need. The key is to choose the output format that matches the quality and slide show features you want with the bandwidth and speed requirements that the Web site and your viewers require.

All of those are important to success. The goal is a show that sizzles without compromising speed or incurring excess bandwidth costs. Make sure to test your show once it is on the Internet and evaluate both the visual and playback quality. Do the links work? Does the show load in a reasonable amount of time? Are the images sharp, and do the transitions move smoothly?

Broken links need to be edited and retested. Shows that are slow to load may need to be split into segments or use lower resolution.

Since this is the last chapter, we are wrapping up more than just the discussion of Internet output. I hope that this book has expanded your knowledge and appreciation of ProShow—a wonderful application—and that your new understanding will lead to increased success in crafting your shows. Enjoy the ongoing creative process and sharing your work with others.

ProShow Product Comparison Guide

Workflow and User Interface	Producer	Gold	Standard
Redesigned Dialogs	✕	✕	✕
Add Slides with Drag and Drop	✕	✕	✕
Real-Time Preview	✕	✕	✕
Integrated Photo Browser	✕	✕	✕
Light Box View	✕	✕	✕
Manual Show Control	●*		
Custom Keyboard Control	●		
Built-in Audio Trimmer	✕	✕	✕
Built-in Video Trimmer	✕	✕	
Find-Missing-Files Utility	✕	✕	✕
Back Up Collected Show Files	✕	✕	✕
Slide Options Hot Keys	✕	✕	✕
Favorites Pane	✕	✕	✕
Copy Settings Feature	●		
Resizable Slide Previews	✕	✕	

*● = ProShow Producer only.

Workflow and User Interface (cont.)	Producer	Gold	Standard
Slide Preview Grid	✕	✕	
Hot Folder/Live Show Support	●		
Interactive Waveform in Timeline	✕	✕	✕
Timeline View	✕	✕	✕

Image/Video Options			
RAW File Support	●		
Unlimited Layers Per Slide	✕	✕	
Loop Video Clip	●		
Set Video Clip Speed	●		
Set End-of-Slide Action	●		
Gradient as Layer	●		
Solid Color as Layer	●		
Masking	●		
Opacity Settings for Photos and Videos	●		
Transparency Support for PSD, PNG, TIFF, and GIF	✕	✕	
Gradient Backgrounds	●		

Editing			
Apply Outline or Drop Shadow to Layers	✕	✕	
Control Drop Shadow Color and Opacity	●		
Control Layer Outline Size	●		
Chroma Key Transparency	●		
Vignettes	●		
Red-Eye Removal	✕	✕	✕
Rotate and Crop Photos	✕	✕	✕
Rotate and Crop Videos	✕	✕	
Color-Correction	✕	✕	✕
Adjustment Effects Keyframing	●		

Caption Effects and Options	Producer	Gold	Standard
Add Multiple Captions to a Slide	×	×	×
Add Global Show Captions	×	×	×
Control Color, Font, and Size of Captions	×	×	×
Expanded Set of 100+ Caption Motion Effects	×	×	
Caption Timing Control	●		
Caption Interactivity	●		
Caption Keyframing	●		
Use Textures in Captions	●		
Use Gradients in Captions	●		
Caption Styles	●		
Caption Line/Character Spacing	●		
Caption Rotation	●		
Character Skew	●		

Motion Effects and Transitions

	Producer	Gold	Standard
Add Motion Effects to Photos and Videos (Pan, Zoom, and Rotate)	×	×	
Over 280 Transitions	×	×	
Specify Random Transition Effects Usage	×	×	×
Customize Transitions per Layer Within a Slide	●		
One-Click Randomization of Transition Effects	×	×	×
Multilayer Motion Effects	×	×	
One-Click Randomization of Motion Effects	×	×	
Motion Effects Timing	×	×	
Increased Zooming Range for Motion Effects	×	×	
Motion Smoothing (For Creating Smooth Motion Paths)	●		
Motion Keyframing (Advanced Motion Timing)	●		
Zoom X and Y Coordinates Individually	●		

Business-Oriented Features	Producer	Gold	Standard
Copy-Protect CDs	●		
Watermark Images and Videos	●		
Customizable Branding Features	●		
End-of-Slide Actions	●		
Color Profile Awareness	●		
Custom Templates	●		
Capture Frames	●		

Output Options

	Producer	Gold	Standard
Burn Slide Show to CD/VCD	×	×	×
Burn Slide Show to DVD	×	×	
Output to Streaming Web Slide Show	×	×	
Free Online Sharing/Slide Show Hosting at Photodex.com	×	×	×
YouTube Uploading	×	×	
Device Output	×	×	
Autorun CD and EXE Output	×	×	×
Flash Video Output—FLV	×	×	
Compressed AVI Output	●		
Uncompressed AVI Output	●		
MPEG 1 Video	×	×	×
MPEG 2 Video	×	×	
Build Screensavers	×	×	×
E-mail Slide Shows	×	×	×
QuickTime Output	×	×	
Windows Media Video (WMV) Output	×	×	
HD Video File Output for HDTV	×	×	
Custom Slide Show Menus	×	×	
Save and Load Menus	×	×	

Keyboard Shortcuts

Main Menus

File Menu	ALT+F
Edit Menu	ALT+E
Project	ALT+P
Show Menu	ALT+S
Slide Menu	ALT+L
Audio Menu	ALT+A
Create Menu	ALT+C
Window Menu	ALT+W
Help Menu	ALT+H
Create Output Menu	ALT+O

Working with Show Files

New Show	CTRL+N
Open Show	CTRL+O
Save Show	CTRL+S
Save Show As…	CTRL+SHIFT+S
Close Show	CTRL+W

Working with Slides

Undo Last Change	CTRL+Z
Redo Last Undo	CTRL+Y
Cut	CTRL+X

Working with Slides (cont.)

Copy	CTRL+C
Paste	CTRL+V
Select All Slides	CTRL+A
Select None	CTRL+ALT+A
Add Selected Files to Show	CTRL+SHIFT+A
Add All Files to Show	CTRL+SHIFT+ALT+A
Select Inverse	CTRL+I
Slide Options	CTRL+L (or Enter w/slide selected)
Move Slide Left	>
Move Slide Right	<
Go to Slide #	CTRL+G
Insert Blank Slide	ALT+I
Insert Title Slide	CTRL+SHIFT+I
Fill Frame	ALT+6
Fit to Frame	ALT+7
Fill Safe Zone	ALT+8
Fit to Safe Zone	ALT+9
Stretch to Frame	ALT+0
Delete Slide	DEL
Slide List/Timeline Toggle	TAB
Randomize Slide Order	CTRL+SHIFT+1
Randomize Slide Motion	CTRL+SHIFT+2
Randomize Transitions	CTRL+SHIFT+3
Change Layer (1–10)	CTRL+1 ...CTRL+0
Slide - Layers	F2
Slide - Edit	F3
Slide - Motion	F4
Slide - Captions	F5
Slide - Sounds	F6
Slide - Background	F7
Slide - Adjustment Effects	F8
Slide - Caption Motion	F9
Show - General	CTRL+F2
Show - Captions	CTRL+F3
Show - Soundtrack	CTRL+F4
Show - Background	CTRL+F5
Show - Watermark	CTRL+F6

Working with Audio

Show - Soundtrack	CTRL+F4
Sync Selected Slides	CTRL+SHIFT+Y
Sync Selected Slides to Track	CTRL+ALT+Y
Sync Show	ALT+Y

Preview and Playback

Resume and Pause	SPACEBAR
Play	CTRL+P or SPACEBAR
Stop	CTRL+T or ESC
Full Screen	ALT+ENTER

Creating Output

Create Output Menu	ALT+O
DVD	CTRL+ALT+D
Video CD	CTRL+ALT+Q
Video File	CTRL+ALT+V
Share Show	CTRL+ALT+U
Web Show	CTRL+ALT+W
E-mail Show	CTRL+ALT+M
Autorun CD	CTRL+ALT+C
Executable	CTRL+ALT+E
Screen Saver	CTRL+ALT+R
Flash Video	CTRL+ALT+F
Video for Device	CTRL+ALT+G
YouTube	CTRL+ALT+T

User Interface

Help	F1
Slide List/Timeline Toggle	TAB
Default Window Layout	CTRL+SHIFT+ALT+0
Save Window Layout	CTRL+SHIFT+ALT+S
Load Window Layout	CTRL+SHIFT+ALT+L
Thumbnail File List View	ALT+1
Detail File List View	ALT+2
Hide/Show Slide List	ALT+F1
Hide/Show Favorites	ALT+F2
Hide/Show Preview	ALT+F3

User Interface (cont.)

Hide/Show Task Monitor	ALT+F5
Hide/Show Project Pane	ALT+F6
Hide/Show Toolbar	ALT+F7
Hide/Show Info Bar	ALT+F8
Hide/Show Size Bar	ALT+F9
Hide/Show Lightbox View	ALT+F11
Exit	ALT+X

File List

Input Focus must be in File List

Jump to File	1st Letter of Filename
Select All	CTRL+A
Select None	CTRL+ALT+A
Select Inverse	CTRL+I
Properties	ALT+ENTER

Executable Playback

Select Show from Menu	# of Show
Return to Menu	ESC or Home
Exit	ESC (from menu or playback w/o menu)
Toggle Full Screen Playback	ALT+ENTER
Next Slide	PAGE DOWN
Previous Slide	PAGE UP
Pause/Resume	PAUSE or SPACEBAR
Resume	ENTER

C

About the CD-ROM

The companion CD-ROM contains all the shows, images, and other files needed to work on the exercises in each chapter. Insert the CD-ROM in a CD or DVD drive on your computer and then copy the desired files onto your C hard drive for best performance.

If any of the files are not in the proper folder, ProShow may not be able to automatically locate all the content for an exercise. In that case you will be prompted to identify the actual location of the missing files. Once you have correctly identified the missing items, the show will load and operate properly.

The CD-ROM also contains trial copies of both ProShow Producer and ProShow Gold. These programs are fully functional and able to work with all the exercises in the book. If you have a valid license for the program, enter the code provided by Photodex to convert the trial to a fully licensed version.

Index

A

acceleration style, 71

Action setting for interactive captions, 134–135

Activate Layer With Mouse Click option, 165

Add All Files to Show option, 7–8

Add Macro button, 115

adjustment effects, 191–193. *See also* Opacity

 Colorize controls, working with, 194–200

 grayscale masking, combining with, 240–241

 keyframes for, 144–145

 theme, variations on, 217–221

 transitions and opacity, creating composition with, 204–207

Adjustment Effects window, 191–193

Adobe Flash. *See* Flash

Adobe Photoshop, 45. *See also* PSD files

 TriCoast wedding pictures, 46

Adobe Type Foundry, 98

alignment of captions, 110–112

alpha channel masks, 225

 color, working with, 241–243

 isolating portions of frame with, 231–234

 simple transparency mask, creating, 226–228

anchor points for captions, 110–112

anti-flicker filters

 for DVD output, 307

 for video CD output, 309

Arial Black font, 105

aspect ratio, setting, 46–47

assembling show, 34

audio, 22. *See also* audio fades; offsets; voiceovers; volume

 adding, 10, 78–79

 CD, adding tracks from, 91–92

 crossfades, creating, 87–89

 deleting, 79

 end point, setting, 82–83

 individual slides, adding soundtracks to, 92–94

 menu soundtracks, adding, 291–292

 for portable device output, 314

 positioning audio files, 78–79

 as screen saver option, 311

 Show Soundtrack tools, 78

 slide timings, adjusting, 89–90

 start point, setting, 82–83

 synchronizing, 79–80

 Timeline, editing soundtracks with, 84–85

 working with files, 77–80

audio fades, 83–84

 menu-based fades, 90–91

 Timeline, adjusting with, 85–86

Audio Trimmer, 80–81

 fades, adjusting, 83–84

authoring environment, 34
Autorun CD Output Options window, 310–311
Autosave files, 316
AVI files, 305

B

backgrounds, 22
adding images, 20
colorizing, 26–27
custom background, adding, 35–36
overriding background options, 37
Slide Background window, 36–37
solid color background, setting, 35–36
backup show files, 315
bandwidth considerations, 319–322
bitrate for portable device output, 314
bitsetting option, 308
black and white. *See also* **grayscale masking**
colorizing, 194–200
converting color to, 33–35
blank slides
for captions/credits, 9
and ending transition, 144–145
blowing up layers, 187–190
body fonts, 104–105
bold italic fonts, 104–105
boldface fonts, 104–105
borders, vignettes for, 245
branding, 281, 292–297
disc label, setting, 296
executable files and, 293–294
icons, setting, 295
Include About Show, adding, 295–296
intro shows, creating, 292–293
startup screen, customizing, 294–295

tab options, 293–296
title bar, relabeling, 295
watermarks to slide, adding, 296–297
brightness
adjusting, 27
keyframes adjusting, 15
slider, 192
broadband connections, 319
broadcasting captions, 135–136
Burns, Ken, 18
buttons on interface, 3

C

cache folders, 317
cameras for live shows, 277–279
Caption Color tool, 107
Caption Format section, 101, 132–133
Caption List, 101
behaviors of captions, modifying, 120–122
order of captions, controlling, 122
Caption Motion window, 137–138
Caption Placement section
align icons, 111
icons, 28
Caption window, 22, 102, 132
captions, 95–126. *See also* **global captions; Keyframe Timeline; keyframes**
adding, 9–10, 28, 146–149
adjusting, 146–149
alignment of, 110–112
anchor points, 110–112
behaviors, modifying, 120–122
blank slides for, 9
blending text and motion in, 98–100
colors for, 107–108
copying, 135–136

design considerations, 122–123
fine-tuning, 136
interactive captions, 134–135
for live show slides, 273
macros for, 112–115
matched effect for, 123–125
menu captions, working with, 290–291
motions, adjusting, 22
multiple slides, placing on, 135–136
order of captions, controlling, 122
placement controls, 133–134
positioning, 107
script fonts for, 106–107
selecting fonts, 101–103
styles, 132–133
text effects, 98–100
 moving with, 108–110
types of fonts, 103–105
Visibility setting, 121
Captions menu, 102
CDs, 3. *See also* **executable files; video CDs**
adding tracks from, 91–92
file size considerations, 302
selecting output formats for, 307–310
cell phones. *See* **portable devices**
center alignment of captions, 112
Choose Caption Effects window, 109–110
Choose Transitions window, 40
Chops_.tff, 96
Chroma Key, 223, 250–261
adjusting effects with, 253–254
clouds example, 256–261
enabling transparent area with, 254–255
existing color, setting index on, 252–253
fading to black, 255–256
hue adjustments, 253

intensity adjustments, 253–254
suppression of colors, 254
traditional Chroma Key colors, 254–255
video clips, working with, 256–261
Clinton, Cody, 44, 96, 182, 322
cloning hue effects, 215–216
clouds example with Chroma Key, 256–261
collages
motion effects with, 74–76
second collage, creating, 184–186
Collect Show Files function, 315
Color Profile window, 302–303
color profiling, 302–304
Colorize Image box, 26–27
colorize slider, 193
colorizing, 33
backgrounds, 26–27
keyframes, 194–200
scrubbing and, 197–198
working with, 194–200
colors. *See also* **backgrounds; Chroma Key; colorizing**
alpha channel masks and, 241–243
black and white, converting to, 33–35
for captions, 107–108
for masks, 228
content
adding, 56–58
live shows, adding to, 273–274, 276–277
primary content, developing, 33–37
template layers, adding to, 266–267
continuity, previewing for, 62–63
contrast
adjusting, 27
slider, 193
copies of DVDs, making, 308
Copy Captions window, 135–136
Copy Layer to Next Slide function, 70

Copy Settings window for multilayer motion effects, 175–177

Copy Start to End (All Layers) option, 75–76

copying. *See also* layers

captions, 135–136

slides, 56

copyright symbol, 113–114

as fixed element, 117–118

copyrights, 296–297

limited rights, 322

sharing shows and, 322–323

correct safe zone, determining, 47–48

Create DVD Disc dialog box, 282–283, 301

Create Gradient dialog box, 236–237

Create Output dialog box, 50, 300–301

credits, 19–20

blank slides for, 9

Crop window, 23–24

cropping

foreground images, 23–24

for multilayer motion effects, 168–169

Crossfade (Blend)-Linear Transition, 39

crossfades

audio crossfade, creating, 87–89

transitions, 39–40

CRT-based televisions, safe zone for, 47

CUE/BIN files, 305, 309–310, 316

Current Keyframe marker, 152–153

movement of, 160

Current Location marker, 82

Custom Device Output dialog box, 314

Custom Slide Sound Settings pane, 93

Customize menu for menus, 285–286

cut transitions, 40

for multilayer motion effects, 189

CVC files, 305

D

Darken Inactive Layers option, 165, 172

deceleration style, 71

decorative fonts, 97, 104

Default Image Settings menu, 48–49

defaults

adjusting, 36–37

for transition intervals, 38

Defaults for Other Sounds volume, 91

deleting soundtracks, 79

density, adjusting, 27

desaturation

for DVD output, 307

for video CD output, 309

design elements, 24–25. *See also* captions

Destination setting for interactive captions, 134–135

Device option, 304

diagonal captions, 134

dial-up connections, 319

digital cameras for live shows, 277–279

Disc Burning tab, 296

disc media formats, 305

display fonts, 104

double frame, 46

Double Radar-Clockwise-Soft Edge transition, 41

downloading Producer edition trial version, 2

DPR files, 317

drag-and-drop images into slides, 18

drop shadows

adding, 35

for captions, 107, 146–147

Duplicate Layer command, 55–56, 57

DVD Disc Burning window, 307–308

DVDs, 3, 299
 Create DVD Disc dialog box, 301
 disc-burning options, 307–308
 equipment for creating, 300
 file size considerations, 302
 options for creating, 304
 selecting output formats for,
 307–310
 supported formats, 305

E

e-mail, 299
 Executable option, 305
 sending shows via, 327–329
E-Mail Show dialog box, 325–326
edges of slide, softening, 245–246
Edit Content page, 324–325
**Edit Fades and Timing window,
 80–81**
 fades, adjusting, 83–84
editing. *See also* **audio**
 global captions, 118–119
 sessions, 2–3
 Slide Options window editing tools,
 21
Editing window
 adjustments in, 23
 layers, setting up, 212–213
Effects window, 21
**elastic Fly In/Fly Out effects,
 108–110**
ellipse shape vignettes, 247
encoding quality for video CDs, 309
End Here button, 82–83
EXE files, 305. *See also* **executable
 files**
 subfolder, 12
executable files
 as branding option, 293–294
 color profile settings for, 303–304
 e-mail, sending shows via, 327–329

 live show, creating, 271–272, 273
 output formats for, 310–311
 PC Executable Creation option, 305
EXIF data
 live shows, playing, 272
 macros, 115
external editors. *See also* **Adobe
 Photoshop**
 icon, 30
 image editors, 13
eyedropper tool
 backgrounds, colorizing, 26–27
 with Chroma Key, 252–253

F

fades. *See also* **audio fades; crossfades**
 Fly In/Fly Out effects, 108–109
Favorites pane, 30
File List, 3, 30
file management, 314–317
fill alignment of captions, 112
Fill Frame option, 48
Fill Safe Zone option, 49
fills. *See also* **gradient fills**
 solid filles, 25
Fit Frame option, 48
Fit to Safe Zone option, 49
FLA movies, outputting files as, 322
Flash, 3, 299. *See also* **FLV files**
 FLA movies, outputting files as, 322
 PhotoIdentities page showing movies
 in, 321
 sharing FLV shows, 329–333
 Show Creation option, 305
FLV files, 305
 sharing FLV shows, 329–333
Fly In/Fly Out effects, 9–10
 captions, moving, 108–110
 Keyframe Timeline and, 138
Folder List, 3
folders, collecting images into, 8

Folders pane, 30
fonts, 103–105. *See also* captions;
 script fonts
 adding fonts, 98
 decorative fonts, 97
 design considerations, 122–123
 styles, 104–105
 type, classes of, 103–104
foregrounds
 adjusting images, 23–24
 cropping images, 23–24
frame rate, 14
frames, 24–25. *See also* layers
 demonstration of, 44–46
 double frame, 46
 masks, isolating portions of frame
 with, 231–234
 scaling images in, 48–49
frames per second (fps), 14
freeware fonts, 98
FrontPage, 327
Fulton, Mike, 44, 96, 182, 322

G

galactic scroll Fly In effect, 108–109
game consoles. *See* portable devices
Gaussian Blur effect, 97
General Show Options window,
 47–48
GIF files for transparency, 46
global captions
 adding, 116
 behaviors, modifying, 120–122
 editing, 118–119
Gold edition, 2
gold-toned gradient fills, 128–129
gradient fills, 25
 for captions, 10
 gold-toned gradient fills, 128–129
 with grayscale mask, 235–238

graduation wishes slide, 97
grayscale masking, 225, 234–241
 adjustment effects, combining,
 240–241
 gradient fills with, 235–238
 multiple masks, working with,
 243–245
 reversing layers, effects of, 238–239
 stencil, creating, 235–238
grow Fly In effect, 108–109

H

HDTV
 color profiling, 302–304
 output resolution for, 50
High-Definition Video formats, 305
horizontal composition, adjusting for,
 274–276
HTML code
 for Flash Web show, 330
 for Presenter show's hyperlink,
 326–327
hue
 Chroma Key adjustments, 253
 cloning effects, 215–216
 layers, setting up, 211–213
 movement of layers and, 213
 slider, 193
 theme, variations on, 217–221
 working with, 209–216

I

ICC color profiles, 303
icons
 branding and, 295
 Caption Placement icons, 28
 External Editor icon, 30
 for transitions, 4

images
folders, collecting images into, 8
foreground images, adjusting, 23–24
placement of, 25
sizing of, 25
Slide List, adding images to, 7–9
importing/exporting
audio files, 78
Slide List, files to, 8
templates, 268–269
inactive layers. *See also* **Chroma Key**
darkening, 165, 172
showing, 61
Include About Show, adding,
295–296
Include Additional Content folder
for video CDs, 310
Include Additional ContentfFolder
for DVDs, 308
Include original files on DVD option,
308
Insert Macro window, 113–115
intensity adjustments, 253–254
intensity masking. *See* **grayscale**
masking
interactivity. *See also* **menus**
captions, interactive, 134–135
interface, 2–4
customizing, 29–32
International and University
Exposition, Montreal, 1967,
43–44
Internet hosting. *See* **Web hosting**
intervals. *See* **transitions**
intro shows, creating, 292–293
iPods. *See* **portable devices**
ISO Creation option for DVDs, 308
ISO files, 305, 316
isolating portions of frame with
masks, 231–234
ISPs (Internet service providers),
319–322
italic fonts, 104–105

K

kerning for captions, 10
Keyframe Timeline, 73. *See also*
multilayer motion effects
adding and adjusting keyframes,
142–143
adjusting keyframe timing, 147–149
Colorize controls, working with,
194–200
fades, adjusting, 85–86
hue effects, cloning, 215–216
middle, adding keyframe in,
156–157
mouse with, 84–85
moving objects on, 139–140
multiple keyframes, working with,
140–142
offsets, adjusting, 85–86
Opacity control, working with,
202–204
overlay with opacity, creating,
208–209
in Precision Preview window,
163–164
scrubbing, 183
soundtracks, editing, 84–85
volume, adjusting, 85–87
working with, 138–139
keyframes, 13–14. *See also*
adjustment effects; Keyframe
Timeline; multilayer motion
effects
adding and adjusting, 142–143
adjusting, 147–149
adjustment effects, setting, 144–145
brightness of images, adjusting, 15
closing the square of, 161
Colorize controls, working with,
194–200
controls, 137–138
defined, 128–131
motion path for, 159–160
moving, 139–140

multiple keyframes, working with, 140–142

Opacity control, working with, 202–204

position, adjusting, 158–161

skew setting for, 142–143

smoothing effect, adding, 153

timing, adjusting, 158–161

L

LAY files, 316

Layer Matching function, 68–69

Layer Settings, 58

layers, 24–25, 50–56. *See also* inactive layers; masks; motion effects; multilayer motion effects; panning; rotation; templates; zooming

copying, 55–56, 56–57
 for collages, 75–76
 to next slide, 70

current order of layers in stack, 53

full-screen previewing, 62–63

hue controls for, 211–213

lining up, 66

matching, 68–69
 motion speed between layers, 72–74

Motion Path of, 54

motion speed between layers, matching, 72–74

motion styles, 70–71

mouse, positioning with, 57–58

new layers, adding and ordering, 59–60

numerical coordinates, positioning with, 59

order
 adjusting, 60
 for stacking, 52

planning to move, 61–62

positioning, 57–59

size of layer, adjusting, 60–63

in Slide Options window, 21

slides containing, 5

theme, variations on, 217–221

transitions for, 145

X and Y values, adjusting, 67–68

Layers List, 52–53
 for masks, 226

leading for captions, 10

left alignment of captions, 111

Light Box Slide View, 31

light fonts, 104–105

linear motion, 71

lining up layers, 66

live shows, 270–279. *See also* menus

camera connections for, 277–279

content, adding, 273–274, 276–277

executable live show, creating, 271–272, 273

fixed slides, setting, 273–274

horizontal composition, adjusting for, 274–276

loop condition, creating, 272

options, setting, 276–277

playback options, 272

Preview mode, 271–272
 loop condition, creating, 272
 testing in, 277

random order, playback in, 272

templates, creating with, 273

vertical composition, adjusting for, 274–276

logos. *See* branding

looping

executable files, option for, 311

live show, creating condition for, 272

M

macros
 for captions, 112–115
 special characters with, 113–115
malware, 98
masks, 25, 55, 223. *See also* **alpha channel masks; grayscale masking**
 channel type, 225
 disappearance of, 233
 example of, 224–226
 isolating portions of frame with, 231–234
 multiple masks, working with, 243–245
 simple transparency mask, creating, 226–228
 spotlight effect, creating, 229–230
 vignettes, combining with, 229–230
Master Volume slider, 91
matching. *See also* **layers**
 multilayer motion effects to keyframe timing, 170–171
MediaSource
 importing music, 78
 transparency with, 45
menu bar interface, 3
Menu Captions pane, 290–291
Menu files, 314, 316
Menu Image Adjustments pane, 289–290
Menu Music pane, 291–292
Menu Pages pane, 285–292
menus, 281
 adjusting images, 288–289
 captions, working with, 290–291
 customizing menus, 285–292
 designing, 282–292
 editing image layers, 289–290
 enabling images, 288–289
 Menu Music pane, 291–292
 with multiple shows, 284–285

 Navigation Settings section, Pages pane, 286
 Pages pane, 285–292
 Position controls, using, 288
 projects for, 284–285
 saving designs, 201
 Shows for Menu window, 287–288
 soundtracks, adding, 291–292
 titles, setting, 287–288
 Zoom controls, using, 288
Menus window, 283–284
MiniDVD format, 305
MNU files, 316
monitors
 color profiling, 302–304
 executable files, option for, 311
 output resolution for, 50
motion effects, 44, 63–71. *See also* **captions; masks; multilayer motion effects; panning; rotation; zooming**
 collages with, 74–76
 copying all layers for, 75–76
 lining up layers, 66
 matching motion speed between layers, 72–74
 text effects, 98–100
 timing layers, 66
Motion Effects window. *See also* **masks**
 with second/third keyframes selected, 152–153
 working with, 64–71
Motion Path of layer, 54
motion paths
 and hue, 213
 for keyframes, 159–160
motion styles, 70–71
Motion window, 21
mouse
 layers, positioning, 57–58
 rotation with, 69
 with Timeline, 84–85

MOV files, 305
moving
 images in slides, 25
 keyframes, 139–140
MPEG 1 and 2 files, 305
multilayer motion effects, 164–166
 additional keyframes, adding, 172–173
 adjusting
 images, 167–169
 keyframes in layers, 178–181
 blowing up layers, 187–190
 copying layers, 175–177
 Cub transition for, 189
 first keyframes, setting, 169–170
 matching layer position to timing, 170–171
 motion keyframing with, 164–181
 placing images, 167–169
 preview area for, 164–166
 Real Deal slide show, 182–190
 rotation, adding, 173–175
 second collage, creating, 184–186
 segments, breaking action into, 182
 shrinking layers over layers, 187–190
 workflow rules for, 166–167
Music button, 10

N

names. *See also* titles
 for templates, 266
narrow fonts, 104–105
new shows, creating, 19
New Slide Show dialog box, 46–47
Nikon Camera Control Pro Software, 278–279
Nikon D3/D300 camera, 277–279
nonlinear crossfade transitions, 40
Notepad, 327
NSTC standard, 302

O

offsets
 adjusting, 85–86
 menu-based offsets, 90–91
opacity, 13–14
 composition with transitions and, 204–207
 overlay with opacity, creating, 208–209
 slider, 192
 on title slide, 12–13
 with vignettes, 248
 working with, 201–204
order of layers. *See* layers
organization of contents, 4–7
outlines
 adding, 35
 for captions, 10, 107
output formats, 315, 316–317
 choosing, 300–304
 color profiling, 302–304
 different formats, selecting options for, 306–310
 for DVDs, 307–308
 for executable files, 310–311
 file size considerations, 302
 options for, 304–305
 Output Options window, 301–304
 for portable devices, 312–314
 for screen savers, 311–312
 standards for, 302
 supported formats, 305
 for video CDs, 309–310
Output Options window, 301–304, 326
output resolution
 determining, 49–50
 limiting, 302
 and zooming layers, 62
overlay with opacity, creating, 208–209
Oz effect, 194–200

P

pace, 64

Pages pane, 285–292

PAL standard, 302

panning, 63, 65
Fly In/Fly Out effects, 108–109
keyframe, adding to, 153, 160
manual and automatic modes,
162–163

PC Autorun window, 302–303

PC executable files. *See* executable
files

Photodex account, sharing shows
with, 323–325

Photodex Presenter. *See* Presenter

PhotoIdentities page, 321

Photoshop. *See* Adobe Photoshop

pictures. *See* images

placing images, 25

Play button, 11

Play menu command, 31

PNG files for transparency, 46

Podcasts, 3

portable devices
audio settings, 314
custom device profile, creating,
313–314
existing profile, creating output
using, 313
output options, 312–314
video settings, 314

positioning
audio files, 78–79
captions, 107
keyframe position, adjusting,
158–161
layers, 57–59
menus, Position controls for, 288

Precision Preview window, 53–54
for caption placement, 117–118
keyframe adjustment sin, 143
Keyframe Timeline in, 163–164
larger images size in, 55
for multiple layers, 166

Presenter, 306. *See also* PX files
e-mail, sending shows via, 327–329
hosting presenter files on other sites,
326–327
sharing movies in, 320

Preview area, 4, 31
for multiple layers, 164–166

previewing. *See also* live shows
full-screen previewing, 62–63
production, 10–11
real time, running in, 32
rotation, 70
by scrubbing, 180
transitions, 40

primary content, developing, 33–37

Producer edition, 2

program workspace, 2–3

projects, 4–5, 7
for menus with multiple shows,
284–285

protection
for executable files, 311
for screen savers, 312

PSD files, 8
transparency with, 46

PSH files, 315
templates as, 265–266

PST files, 316
templates as, 269

public domain, items in, 322

pulse Fly In effect, 108–109

PX files, 305, 316
on other Web sites, 326–327
sharing shows stored as, 320–321

PXC files, 315

Q

quality
of executable file image, 311
for screen savers, 311
QuickTime (MOV) format, 305

R

random transitions, 40
RAW files, 8
viewing, 3
Record Slide Timing window, 89–90
working with, 90
rendering, 299. *See also* output formats
basics of, 299–304
engine, 34
resizing. *See* sizing/resizing
resolution. *See also* output resolution
ISPs (Internet service providers) and, 322
as screen saver option, 312
source resolution, 62
right alignment of captions, 112
rotation, 64, 65, 69–70
Fly In effect, 108–109
of layers, 60–63
manual and automatic modes, 162–163
with mouse, 69
for multilayer motion effects, 173–175

S

sans serif fonts, 103–104
design considerations, 122–123
Save Audio Track window, 91–92
Save Music From CD button, 91–92
Save Show Template dialog box, 265–266

saving. *See also* live shows
menu designs, 201
templates, 265–266
scaling
frames, images in, 48–49
waveform, 81–82
SCR files, 305
Screen Saver Creation option, 305
screen savers
output options, 311–312
Windows Screen Saver (SCR) format, 305
script fonts, 106–107
finding, 96
keyframes with, 129
Script MS. Bold font, 106–107
Selected Caption box, 101
serif fonts, 103–104
design considerations, 122–123
servers, 319–322
Set Color button, 34
Set Value dialog box, 158–159
shapes. *See* vignettes
Share Show Online window, 304, 323–324
shareware fonts, 98
Sharing page, Photodex.com, 320–321
sharing shows
copyright issues, 322–323
e-mail, sending shows via, 327–329
Flash FLV shows, 329–333
HTML for show's hyperlink, 326–327
with Photodex account, 323–325
Presenter files on other sites, hosting, 326–327
on YouTube, 330–331
sharpen slider, 193
Shenandoah soundtrack, 322
show cache folders, 317

Show Composition Lines option, 165

Show Content files, 315

Show files, 314–316

backup show files, 315

Show Grid option, 165

Show Inactive Layers, 61

Show Layer Outlines option, 165

disabling, 172

Show menu

with intro show, 293

Show Templates/Save as Template option, 263–264

Show Motion Path option, 165

Show Options/Captions controls, 116–118

Show Options window, 6

Show Safe Zone option, 165

Show Soundtrack window, 10–11

synchronizing audio, 79–80

tools, 78

Show Templates/Save as Template option, Show menu, 263–264

show thumbnails, adding, 47

shows, 4–5, 6. *See also* live shows; Presenter; sharing shows; Web hosting

Shows for Menu window, 287–288

shrink Fly In/Fly Out effect, 108–109

shrinking layers over layers, 187–190

simulate option

DVDs, writing, 308

video CDs, writing, 310

Size Meter, 4

sizing/resizing

executable files, option for, 311

images, 25

layers, 60–63

screen saver option, 311

skew setting for keyframes, 142–143

slide as Fly In effect, 108–109

Slide Background window, 36–37

Slide Duration time, 37

Slide Images and Video window, 50–52, 225. *See also* masks

for simple transparency mask, 226–228

templates, working with, 264

Slide List, 4, 30

adding images to, 7–9

Open in Editor option, 30

Slide Options window, 5–6, 19–20, 34–35

background, setting, 22

in Caption mode, 9

contents of, 20–22

editing tools, 21

layer tools in, 21

slides, 4–6, 17–19. *See also* captions

drag-and-drop images into, 18

layers in, 5

more slides, adding, 36–37

theme, variations on, 217–221

title slides, 12–13

watermarks to slide, adding, 296–297

slideshows, 17–19

smooth motion settings, 71

smoothing effect, 154–155

softening edges of slide, 245–246

solid fills, 25

sound. *See* audio

Sound List, 79

Sounds window, 22

Soundtrack area, 4

Soundtrack During Other Sounds slider, 91

soundtracks. *See* audio

source resolution, 62

special characters, inserting, 113–115

speed

DVDs, writing, 308

layers, matching motion speed between, 72–74

text effects and, 110

video CDs, writing, 310

spin Fly In/Fly Out effect, 108–109
spotlights
 with masks, 229–230
 with vignettes, 248–250
Start Here button, 82–83
startup screen, customizing, 294–295
stencil, creating, 235–238
Stop menu commands, 31
Streaming Web Show (PX) format, 305
streaming with Photodex Presenter, 306
Stretch to Frame option, 49
strobe Fly In effect, 108–109
styles for captions, 132–133
SVCD format, 305
symbol fonts, 104
symbols. *See also* copyright symbol
 fonts, 103
 macros for, 113–115
Sync Selected Slides button, 80
Sync Show to Audio button, 80
synchronizing audio, 79–80

T

templates, 263–270
 content to layers, adding, 266–267
 creating template file, 265–266
 designing slides for, 267–268
 importing/exporting, 268–269
 live shows with, 273
 modifying, 269–270
 saving templates, 265–266
 using, 269–270
 workflow with, 267–268
temporary files, 316
 video files, 317
Texas Woman's University, 322
text editors, 327
text effects, 98–100. *See also* captions
 speed, controlling, 110
text fonts, 104

theme of slide, variations on, 217–221
THM files, 316
thumbnails, 4. *See also* layers
 show, adding thumbnails for, 47
TIFF files for transparency, 46
Time bar, 31–32
Timeline. *See* Keyframe Timeline
Times New Roman font, 102
timing
 audio, adjusting slide timings for, 89–90
 keyframe timing, adjusting, 158–161
 layers, 66
 matching motion speed between layers, 72–74
 for multilayer motion effects, 170–171
 total timing control, 41–42
title bar, relabeling, 295
title slides, 12–13
 captions for, 146
 creating, 19–20
 graduation wishes slide, 97
titles, 46–47
 show titles, setting, 287–288
total timing control, 41–42
Track bar, 31–32
trailer slides, adding, 29
transitions, 2–3, 17. *See also* audio
 adjusting intervals, 38–39
 all transition times, adjusting, 41
 basic selections, 40–41
 choosing, 39–40
 current transition, displaying, 40
 icons showing, 4
 for layers, 145
 opacity and transitions, creating composition with, 204–207
 previewing, 40
 recently used transition list, 41
 setting, 39
 total timing control, 41–42

Transitions box for captions, 122
transparency, 15–16, 45–46. *See also*
 alpha channel masks; Chroma
 Key; masks
TriCoast wedding pictures, 44, 46
Trim Video Clip window, 258
TrueType fonts, 96
type family, 103
type sizes, 103
typefaces, 103
 design considerations, 123
typography for captions, 10

U

URLs (Uniform Resource Locators)
 for executable files, 311
 for screen savers, 312
user interface. *See* interface

V

variable defaults, 37
variations on theme of slide, 217–221
VCD files, 305
vertical composition, adjusting for,
 274–276
video CDs, 299
 burning options, 309–310
 file size considerations, 302
 options for creating, 304
 output options, 309
 selecting output formats for,
 307–310
 supported formats, 305
video clips, 25. *See also* Chroma Key
 working with, 256–261
Video File Creation option, 304
Video for Device option, 312–313
vignettes, 223
 edges of slide, softening, 245–246
 refining layers and masks with,
 245–246

spotlight effect, creating, 229–230
transparent masks, combining,
 229–230
voiceovers
 individual slides, adding voiceovers
 to, 92–94
 recording inside ProShow, 93–94
 volume controls for, 91
volume
 adjusting, 85–87
 menu-based volume, 90–91

W

warp Fly In effect, 108–109
WASP show, 324–325
 Comparison.exe, 12
 Gold.exe, 12
 Producer.exe, 12
watermarks to slide, adding, 296–297
waveforms, 79. *See also* audio
 interactive waveform, 85–86
 scaling, 81–82
 Timeline waveform, 84
Web hosting, 299, 319–327. *See also*
 sharing shows
 content, Web-ready, 299
 creation options, 304
 Flash FLV shows, 329–333
 HTML for show's hyperlink,
 326–327
 output resolution for, 50
 Presenter files on other sites, hosting,
 326–327
White Balance adjustment of camera,
 278
white point/black point slider,
 192–193
Windows Media Video (WMV) files,
 305
Windows Screen Saver (SCR) format,
 305

Windows/Show submenu, 29–30
Wingdings font, 103
WMV files, 305
workflow, 36–37
Workspace files, 315, 317
writing. *See* CDs; DVDs

X

X-Y coordinate system
 for captions, 110–112
 zooming, adjusting, 67–68
XSVCD format, 305

Y

YouTube, 299
 direct interface with, 322
 Output option, 304–305
 sharing shows on, 330–331
YouTube Upload dialog box, 332–333

Z

zooming, 60–61, 64, 65
 adding Zoom effect, 163
 in Fly In/Fly Out effects, 108–109
 manual and automatic modes,
 162–163
 menus, Zoom controls for, 288
 X and Y values, adjusting, 67–68

ProShowExpert.com

ProShowExpert.com is your online source for everything ProShow!

- News
- Interviews with ProShow experts
- Product reviews
- Users forum

Hosted by James Karney, author of *The Photodex Official Guide to ProShow* and *Mastering Digital Wedding Photography*, ProShowExpert.com is the place to go for the latest information on ProShow conferences and seminars, to share templates and ideas with other users, to find useful updates to the ProShow book, and to get tips and tricks from the pros.

Visit www.ProShowExpert.com

Please note, this is an independent site and is not affiliated with the Photodex® Corporation.

License Agreement/Notice of Limited Warranty

By opening the sealed disc container in this book, you agree to the following terms and conditions. If, upon reading the following license agreement and notice of limited warranty, you cannot agree to the terms and conditions set forth, return the unused book with unopened disc to the place where you purchased it for a refund.

License:
The enclosed software is copyrighted by the copyright holder(s) indicated on the software disc. You are licensed to copy the software onto a single computer for use by a single user and to a backup disc. You may not reproduce, make copies, or distribute copies or rent or lease the software in whole or in part, except with written permission of the copyright holder(s). You may transfer the enclosed disc only together with this license, and only if you destroy all other copies of the software and the transferee agrees to the terms of the license. You may not decompile, reverse assemble, or reverse engineer the software.

Notice of Limited Warranty:
The enclosed disc is warranted by Course Technology to be free of physical defects in materials and workmanship for a period of sixty (60) days from end user's purchase of the book/disc combination. During the sixty-day term of the limited warranty, Course Technology will provide a replacement disc upon the return of a defective disc.

Limited Liability:
THE SOLE REMEDY FOR BREACH OF THIS LIMITED WARRANTY SHALL CONSIST ENTIRELY OF REPLACEMENT OF THE DEFECTIVE DISC. IN NO EVENT SHALL COURSE TECHNOLOGY OR THE AUTHOR BE LIABLE FOR ANY OTHER DAMAGES, INCLUDING LOSS OR CORRUPTION OF DATA, CHANGES IN THE FUNCTIONAL CHARACTERISTICS OF THE HARDWARE OR OPERATING SYSTEM, DELETERIOUS INTERACTION WITH OTHER SOFTWARE, OR ANY OTHER SPECIAL, INCIDENTAL, OR CONSEQUENTIAL DAMAGES THAT MAY ARISE, EVEN IF COURSE TECHNOLOGY AND/OR THE AUTHOR HAS PREVIOUSLY BEEN NOTIFIED THAT THE POSSIBILITY OF SUCH DAMAGES EXISTS.

Disclaimer of Warranties:
COURSE TECHNOLOGY AND THE AUTHOR SPECIFICALLY DISCLAIM ANY AND ALL OTHER WARRANTIES, EITHER EXPRESS OR IMPLIED, INCLUDING WARRANTIES OF MERCHANTABILITY, SUITABILITY TO A PARTICULAR TASK OR PURPOSE, OR FREEDOM FROM ERRORS. SOME STATES DO NOT ALLOW FOR EXCLUSION OF IMPLIED WARRANTIES OR LIMITATION OF INCIDENTAL OR CONSEQUENTIAL DAMAGES, SO THESE LIMITATIONS MIGHT NOT APPLY TO YOU.

Other:
This Agreement is governed by the laws of the State of Massachusetts without regard to choice of law principles. The United Convention of Contracts for the International Sale of Goods is specifically disclaimed. This Agreement constitutes the entire agreement between you and Course Technology regarding use of the software.